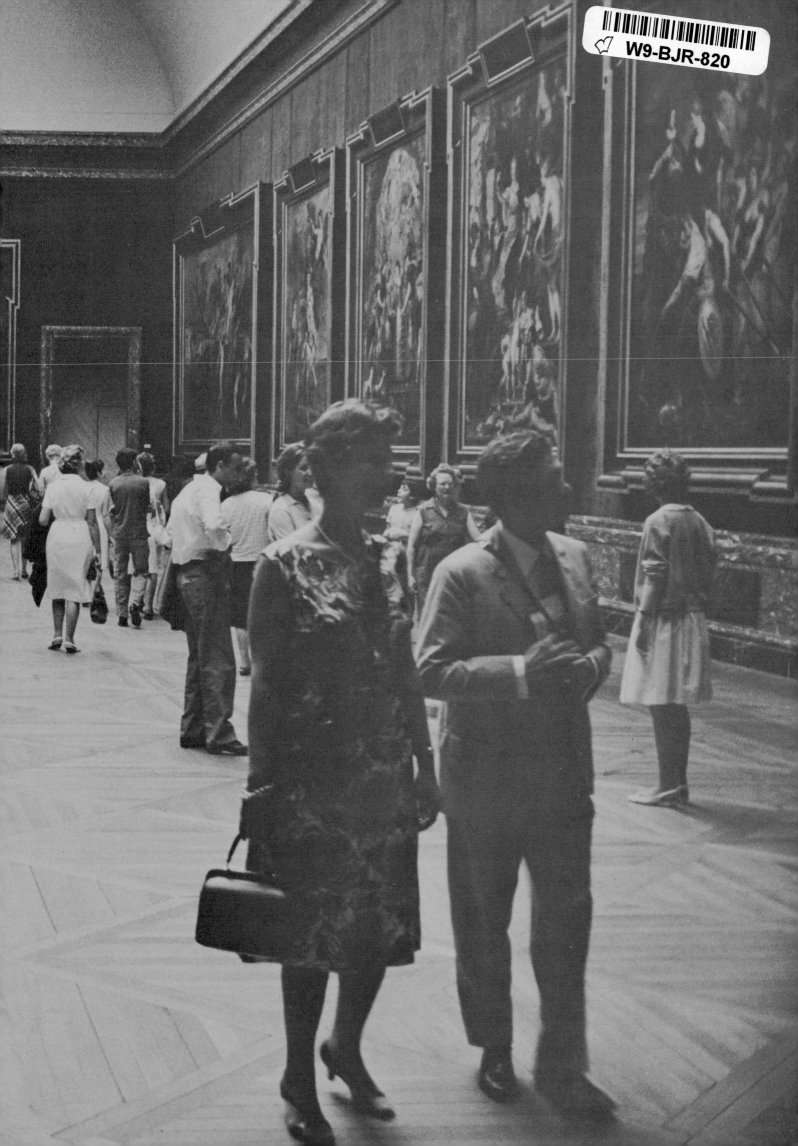

Seven Centuries
of Art

LIFE WORLD LIBRARY

LIFE NATURE LIBRARY

TIME READING PROGRAM

THE LIFE HISTORY OF THE UNITED STATES

LIFE SCIENCE LIBRARY

GREAT AGES OF MAN

TIME-LIFE LIBRARY OF ART

TIME-LIFE LIBRARY OF AMERICA

FOODS OF THE WORLD

THIS FABULOUS CENTURY

LIFE LIBRARY OF PHOTOGRAPHY

Seven Centuries of Art

SURVEY AND INDEX

by the Editors of TIME-LIFE BOOKS

TIME-LIFE BOOKS, New York

The Authors

The introductory chapter for this book was written by Dr. H. W. Janson, who also served as consultant. The rest of the chapters and the picture essays were written by members of the TIME-LIFE BOOKS staff: Tony Chiu, Lee Greene, Robert Morton, Lucille Schulberg, David S. Thomson and L. Robert Tschirky.

The Consulting Editor

H. W. Janson is Professor of Fine Arts at New York University, where he is also Chairman of the Department of Fine Arts at Washington Square College. Among his many publications are *History of Art* and *The Sculpture of Donatello.*

On the Slipcase

Pop Art emerged in England and the United States early in the 1960s, partly in reaction to Abstract Expressionism, the dominant style of the previous decade. In *Brush Strokes Yellow and White,* Roy Lichtenstein, one of the American pioneers of Pop, uses his characteristic comic-book technique to make painting itself his subject.

End Papers

Front and back: Visitors crowd the Louvre's Galerie Medicis to view one of the greatest treasures of Baroque art — a series of superb canvases by Peter Paul Rubens depicting highlights in the life of Marie de' Medici, mother of King Louis XIII of France. It took the Flemish master less than three years to complete the 21 large paintings, which were commissioned in 1621 to decorate a ceremonial gallery in the Luxembourg Palace, the Queen Mother's residence in Paris. The pictures, full of the swirling movement and rich color characteristic of Rubens' style, are a blending of historical truths and allegory in which not only 17th Century French courtiers but the Greek gods and goddesses play subservient roles to the regal figure of Marie.

TIME-LIFE BOOKS

EDITOR: Jerry Korn
Executive Editor: A. B. C. Whipple
Planning: Oliver E. Allen
Text Director: Martin Mann
Art Director: Sheldon Cotler
Chief of Research: Beatrice T. Dobie
Picture Editor: Robert G. Mason
Assistant Text Directors: Ogden Tanner, Diana Hirsh
Assistant Art Director: Arnold C. Holeywell
Assistant Chief of Research: Martha T. Goolrick
Assistant Picture Editor: Melvin L. Scott

PUBLISHER: Walter C. Rohrer
General Manager: John D. McSweeney
Business Manager: John Steven Maxwell

Sales Director: Joan D. Manley
Promotion Director: Beatrice K. Tolleris
Public Relations Director: Nicholas Benton

TIME-LIFE LIBRARY OF ART

SERIES EDITOR: Robert Morton
Editorial Staff for *Seven Centuries of Art:*
Text Editor: David S. Thomson
Picture Editor: Kathleen Shortall
Designer: Paul Jensen
Staff Writers: Tony Chiu, Lee Greene, Paula Pierce,
Lucille Schulberg, L. Robert Tschirky, Peter Yerkes
Chief Researcher: Martha T. Goolrick
Researchers: Evelyn Constable, Margo Dryden,
Villette Harris, Lynda Kefauver, Susanna Seymour
Design Assistant: Mervyn Clay

EDITORIAL PRODUCTION
Production Editor: Douglas B. Graham
Quality Director: Robert L. Young
Assistant: James J. Cox
Copy Staff: Rosalind Stubenberg, Patricia Miller,
Florence Keith
Picture Department: Dolores A. Littles,
Elizabeth A. Dagenhardt
Traffic: Arthur A. Goldberger

The following individuals and departments of Time Inc. helped to produce this book: LIFE photographers Henry Groskinsky, Dmitri Kessel, Gordon Parks; Editorial Production, Robert W. Boyd Jr., Margaret T. Fischer; Editorial Reference, Peter Draz; Picture Collection, Doris O'Neil; Photographic Laboratory, George Karas; TIME-LIFE News Service, Murray J. Gart; Correspondents Maria Vincenza Aloisi (Paris), Margot Hapgood (London), Elisabeth Kraemer (Bonn), Traudl Lessing (Vienna), Ann Natanson (Rome).

Contents

I Of Style and Styles 7

II The Rebirth of Painting 13

III The High Renaissance 33

IV Awakening in the North 49

V Grandeur and Glory in the Arts 69

VI An Age of Pleasure 85

VII From Romance to Revolution 103

VIII A Century of "Isms" 125

The World of Museums and Galleries: 146

Acknowledgments and Credits: 166

Index: 167

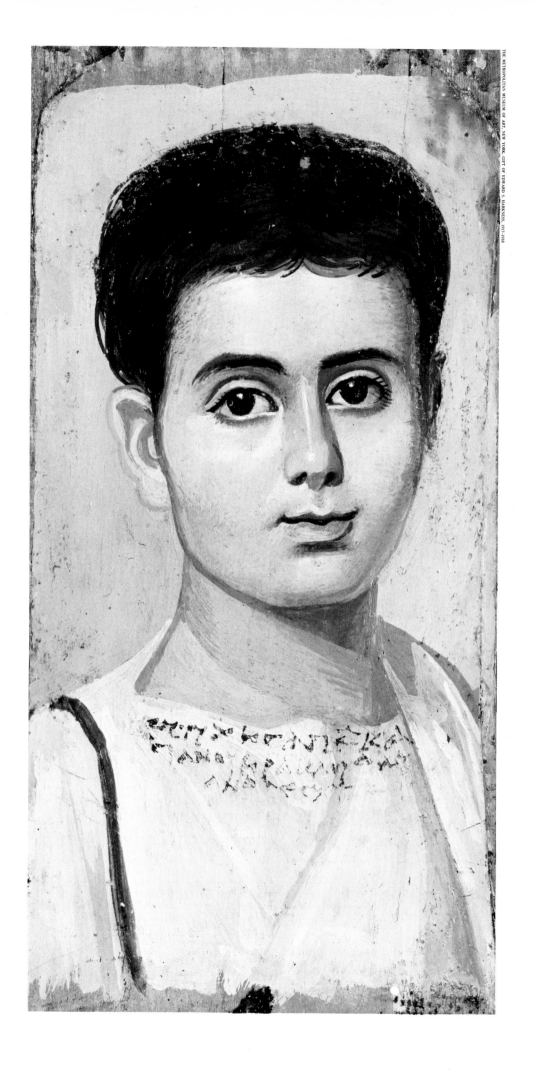

I

Of Style
and Styles

A bird's-eye view of strange country is not likely to be very instructive; we need landmarks by which to orient ourselves. But once we have come to know the territory at ground level, seeing it from above can be a thrilling experience. Because we are less close to the scene now, we become aware of continuities that had escaped us before; broad patterns of development will seem more important than individual achievements. And the perspective we thus gain makes it possible for us, in turn, to arrive at new insights when we focus once more on the details of the scene.

This final volume of the TIME-LIFE Library of Art is intended to provide such perspective on the world of Western art from the end of the Middle Ages to the present day. Whereas previous books in the series stressed the roles of the great individual masters—the landmarks, as it were—of the past 700 years, this concluding volume views the larger framework within which they operated, summing up the major developments in art during those seven centuries as seen in the changing concepts of "style."

A look at the word "style" itself will be useful. The history of words is a curious thing. Some keep the same meaning year in and year out, while others behave in odd and surprising ways. Like pebbles dropped in a pool, they make a pattern of waves—waves of meaning—that continue to spread outward in ever-widening circles long after the brief splash that caused them has been forgotten. "Style" is such a term. Its parent word, *stilus*, was the name of the metal needle the ancient Romans used for writing on wax-covered tablets. Originally, therefore, style referred to distinctive ways of writing—the shape of the letters as well as the choice of words. Since then, the meaning of style has been stretched further and further, so that nowadays we can speak of style in the fine arts, in music, in fashion, in sports; in short, style has come to mean "the distinctive way a thing is done" in any human endeavor.

It is also a term of praise: "to have style" means to have distinction, to stand out. Something that "has no style," on the other

A boy gazes bright-eyed from this remarkably well-preserved portrait, produced about 1,800 years ago and unearthed in Egypt in modern times. Painted on a wood panel with encaustic —colored pigment mixed with wax—this work has a lifelike human quality that vanished from artistic efforts after the Roman Empire collapsed in the Fifth Century. An interest in the classical style was revived only with the onset of the Renaissance in the 15th Century.

Egyptian: *Portrait of a Boy*, Second Century A.D.

hand, is not only undistinguished but also undistinguishable; we do not know how to classify it, how to put it in its proper place, because it seems to be pointing in several directions at once. A thing that "has style" must be consistent within itself, it must have a sense of wholeness, of being all of a piece. This is the quality we admire in it, for it impresses itself upon us even if we do not know what particular kind of style is involved.

Style, then, is a means of classification, and that is why its study is of such central importance to art historians. Not only do they have a greater variety of things to classify (art history covers a span of some 50,000 years) than their colleagues in other fields; most of the time, style is all they have to go by in establishing the age or origin of works of art. A piece of literature whose source is unknown can be classified by its language—14th Century English, say, or 17th Century French—but in art, materials rather than words are the medium, and many of these materials are so common that their age and origin cannot be established. This very fact, however, implies a compensating advantage. Since works of art are made up of molecules, which are very tiny units compared to words, they permit us to make infinitely finer distinctions of style.

We acknowledge this difference between words and shapes whenever we sign our names as a means of identification; what identifies us is not the name itself but the unique way we sign it. That every one of us should have his own unmistakable handwriting is astonishing indeed if we consider that we all use the same alphabet —a very limited set of conventional signs—and that we all learned how to write by copying the standard shapes of letters in our schoolbooks. Even more astonishing is the fact that no two versions of a signature are ever wholly alike; no matter how often we sign our names, we cannot do it twice in exactly the same way. The expert comparing two signatures that match too closely will immediately suspect that at least one of them is a forgery. What he looks for is "family resemblance" rather than a perfect matching of every detail. This "family resemblance," this quality of style which identifies the hand of the signer, is difficult to describe with any precision, since it involves such elusive things as rhythm and pace. Yet we can learn how to recognize it by careful observation, just as we learn how to recognize an individual face without being able to describe it in exact detail.

From signatures it is but a short step to the personal style of an artist. Every work of art embodies the "handwriting" of its maker —his distinctive way of handling his tools, the distinctive quality of his imagination that prompts him to prefer certain shapes or patterns, the distinctive mood he habitually creates. And since he is not limited to a set of conventional signs such as numbers and letters, his "handwriting" has an infinitely greater range of variations. But an artist's own "handwriting," however distinctive it may

be, always shares important qualities with those of his contemporaries, forming a "collective" style that differs from that of another period in time (rather the way an 18th Century signature varies from one today). It is this period, or group, style that enables the art historian to fix the date and place of origin of a work —even if its author remains unknown—within fairly narrow limits. In order to identify an individual artist's style, we need at least one reliably authentic example of his work, but another condition must also be fulfilled: the work must have been produced within a culture that encouraged individuality, otherwise we will be unable to distinguish personal style from period style, and the work will look anonymous even if we can attach an artist's name to it.

Most of the world's art, covering a span of time from the Old Stone Age to the present and every corner of the earth where men have lived, was created under conditions of anonymity. It was the ancient Greeks, some 2,500 years ago, who discovered the value of individual artistic achievement. For the most part, the work of the greatest Greek masters is known to us only indirectly, so that we cannot form a clear picture of their personal styles. Yet the fact that the few rare exceptions whose identities we do know were thought important enough to be written about set an example for later times, and the legendary fame of these ancient artists stimulated the revival of artistic individuality in the time of Giotto, at the beginning of the 700-year span covered by the Time-Life Library of Art.

There is one fundamental difference between individual style and period style. Looking at a great master such as Rembrandt, whose production is known to us in many examples from the time he was 20 until his death at 63, we realize at once that his style underwent important changes in the course of his career. The early work tends to reflect the influence of older artists under whom he studied or whose art he admired; the middle years show the full unfolding of his powers; and the work of his old age has a deeply subjective, almost confessional quality. These changes constitute Rembrandt's artistic development. We may be able to account for them to some extent by the circumstances of his life and times, but the central element, which persists through all the phases of his art, is Rembrandt's unique personality, and this the art historian must accept as "given" since he cannot explain it (psychologists have tried, without much success).

Period styles, in contrast, demand explanation, and so do the differences between them. Why is it, for instance, that Egyptian art established, and maintained for some 2,500 years, a rigid set of conventions that gave it a very distinct identity and limited its range, while the art of neighboring Mesopotamia during this same time span shows little continuity of style? What were the impulses behind the rapid pace of change in Greek art from the Ninth Century

B.C. to the Second Century B.C.? How can we account for the succession of styles in medieval art, or for the emergence of Renaissance art?

In thinking about these problems, we are once again the heirs of the ancient Greeks. Apart from discovering artistic individuality, they were the first to show an awareness of period styles and of the fact that art has a history. The fullest ancient account of Greek art was written at the time of Christ by the Roman encyclopedist Pliny, who used many older sources now lost. He tells us not only about the lives and achievements of individual masters but arranges them so that they fit an evolutionary scheme based on the notion of progress—progress toward an ever more perfect representation of the visible world. The source of this idea becomes evident from the context of Pliny's account, which occurs, surprisingly enough, in his *Natural History*.

To Pliny, art was simply a branch of technology, and there clearly was progress over the centuries in men's use of the raw materials of nature. But progress in art, unlike technological progress, had a limit; Pliny believed that perfection in the rendering of reality had been reached by Greek artists of the period 450 to 300 B.C., and he therefore proclaimed their style "classic" (that is, as the standard for all time to come).

During the Middle Ages, nobody gave any thought to the history of art. But when the Italian Renaissance took up the subject once more, it used Pliny's account—by then almost 1,500 years old —as a model. Giorgio Vasari, the mid-16th Century Florentine to whom we owe so much of our knowledge of Renaissance art, arranged his *Lives of the Painters, Sculptors and Architects* in "progressive" order, beginning with Cimabue, and he too saw the climax of the development of art in a "perfect" style, that of the High Renaissance masters Michelangelo and Raphael, the new "classics" whom he regarded as greatly superior to the artists of his own generation, indeed unsurpassable. However, Vasari no longer thought of art as analogous to technology; the artist, to him, was not a craftsman but a peer of poets and philosophers, and his notion of the goal of artistic progress was a good deal more subtle than Pliny's. He thought of it as a mastery, not of nature as it was with all its imperfections, but as it ought to be: in short, as a mastery of "ideal nature." This goal, he felt, had been attained by the best of the ancients, who were in turn equaled and, indeed, outdone by the great 16th Century "classic" artists. The interval was a vast void, the Middle Ages, or "time in between," when art was dominated by barbarians.

It is surprising how much of Vasari's historic vision affected our own names for the major period styles of Western art. Except for Classic, Renaissance (the rebirth of the Classic) and Neoclassic (a return to the Classic), they all started out as terms of abuse. Early

medieval art was dubbed Romanesque (decadent Roman), and was followed by Gothic (named for the Germanic tribes that destroyed Roman civilization), after the High Renaissance came Mannerism (a superficial imitation of High Renaissance style), Baroque and Rococo (terms coined by Neoclassicists to denote extravagance and playfulness), and Romanticism (which meant Neomedieval).

Today, needless to say, we no longer attach any negative implications to these labels. Yet we still use them—they have proved difficult to replace—and in doing so we perpetuate a tradition that needs to be questioned. Future art historians may well divide the development of Western art into entirely different period styles. For the present, we shall have to be content with the insight—an insight gained only in our own century—that there is no such thing as "progress" or "perfection" in the history of art. Every gain in one direction involves a loss in another. If we want to understand Giotto, we must not assume that he really wanted to paint as Michelangelo subsequently did but couldn't quite make it. Nor can we do justice to Bernini by assuming that he tried to produce statues like Michelangelo's but was carried away by his own virtuosity. The Surrealists had to repudiate the formal discipline of Cubism in order to gain the imaginative freedom they craved. In short, we have learned that no style is ever "outmoded" by its successors. Unlike a technological discovery, which retains its value only until it is replaced by a better discovery, a style is a permanent achievement. Once created, it becomes part of the growing fund of human experience, one that later generations may draw upon if they choose to do so. This vitality, beyond any limits of time and space, is one of the most fascinating lessons of the seven centuries of artists and their styles that are shown in this volume.

H. W. JANSON

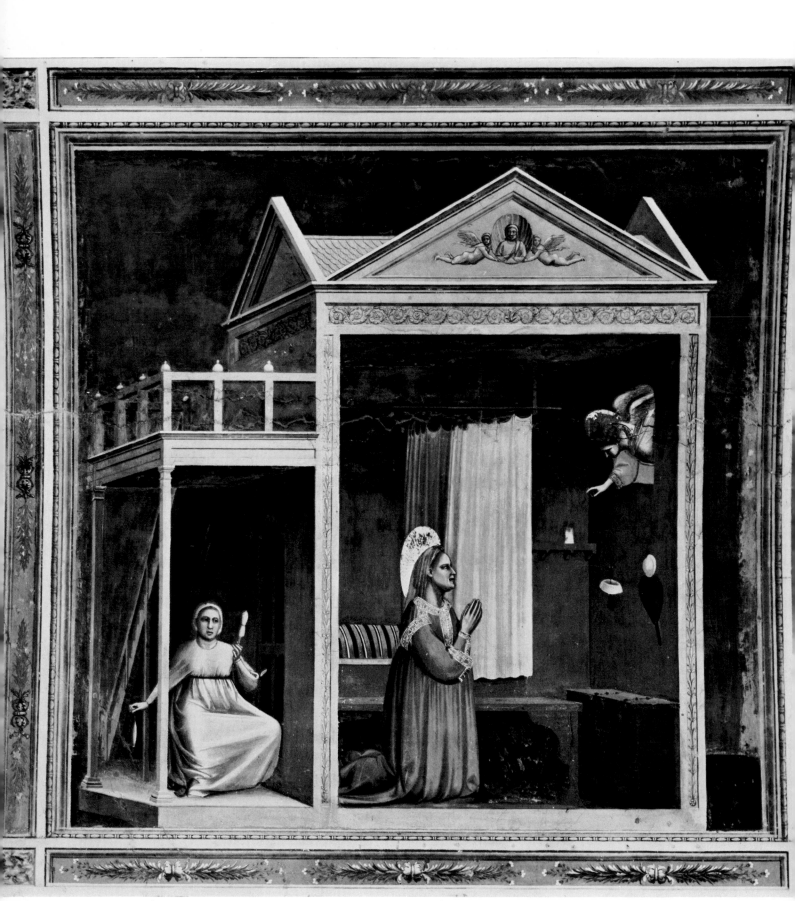

II

The Rebirth of Painting

An oft-told tale about Renaissance art concerns the great 15th Century sculptor Donatello. As the story goes, Donatello was hard at work, chipping away with his chisel on a nearly completed statue of the Biblical prophet Jonah *(page 22)*. The statue was, and remains, an extraordinarily lifelike image of an elderly, bony man, dignified and wise, but hardly idealized or sacrosanct. The sculptor, in fact, had already given his prophet a homely nickname, such as a real old man might acquire. Donatello called him "Zuccone," a name anybody who has eaten zucchini will readily translate as "Squash Head." As Donatello applied the finishing touches on this thoroughly convincing figure, he suddenly looked up at it and cried, "Speak, speak or the plague take you."

This story, scholars say, is almost certainly apocryphal. But if it is not true, it should be. For it sums up as well as any brief anecdote the central thrust of Renaissance art and the overmastering motive that drove Renaissance artists. They passionately wanted to make their images real—so real that they seemed to breathe, to talk, to move. And they wanted to place these people in credible space, to surround them with breathable air.

These were precisely the qualities the art of the previous era had lacked. The sculptors and painters of the Middle Ages seldom had either the skill or the desire to represent humanity persuasively; they were intent on producing holy images designed to inspire religious devotion and thoughts of heaven. Their painted figures of the Madonna and Child, or of Christ on the Cross, were generally stiff and remote, with stylized gestures and ill-proportioned bodies. And they existed in a space as flat as the panels on which they were painted. Many of these works are strikingly beautiful, glowing with gold and gorgeous blues and reds. But lifelike they are not. The illusion of life—the suggestion that the figures might move or speak—is seldom there.

All this changed radically—as did many aspects of human life —in that remarkable period known as the Renaissance. The word

Masterfully simple and moving, this fresco by Giotto —one of his great series in Padua's Arena Chapel —shows a servant girl pausing from carding wool to eavesdrop as an angel announces to St. Anne that she will bear a child—the Virgin Mary. For the first time since antiquity, Giotto depicted human beings who looked and behaved like real people and inhabited believable space.

Giotto: *The Annunciation to Anne,* c. 1306

CAPPELLA DEGLI SCROVEGNI (ARENA CHAPEL), PADUA

13

means "rebirth," and the era saw the rebirth of painting along with a renewal of other arts and sciences that had lain virtually comatose since the age of ancient Greece and Rome.

The first painter to herald this movement was Giotto, born about 1267, probably in Vespignano, a town 20 miles from Florence, the teeming Italian city that was to become the focus, the powerhouse, the primal source of the rebirth of art and thought. Giotto was a one-man revolution in art, the first great innovator in European painting. Suddenly, in his works, the people have weight, substance, reality. Their gestures are those that real people might make and their faces register a variety of emotions. His figures are not symbols; they are flesh-and-blood individuals, living in a recognizable world. Giotto's signal breakthrough was appreciated by painters of his own time and thereafter. Two hundred years later Giorgio Vasari, who was a mediocre artist but the author of an invaluable series of biographies, *The Lives of the Painters, Sculptors and Architects*, wrote of Giotto, "Certainly it was nothing short of a miracle, in so gross and unskillful an age, that Giotto should have worked to such purpose that design . . . was revived to a vigorous life by his means."

Giotto finished his magnum opus, the series of frescoes *(page 12)* in the Arena Chapel in Padua, about 1312. Almost a century was to pass before other Florentine artists took the next great leaps forward in the pursuit of the real. The interim was, however, by no means devoid of painterly efforts to render nature realistically. After Giotto, the scene shifted to the Tuscan hill town of Siena, and then to northern Europe, notably Flanders.

One of the memorable achievements of this era was a vast fresco entitled *The Effects of Good and Bad Government*, painted for Siena's city hall, the Palazzo Pubblico, by a native son, Ambrogio Lorenzetti. About half of this painting is a panorama of Siena, with identifiable buildings and streets filled with busy groups of citizens who have much of the solidity and reality of Giotto's figures. The other half of Lorenzetti's painting is yet more revolutionary; it is a view *(page 17)* of the Sienese countryside, fringed by distant mountains—the first true landscape since imperial Roman times.

News of Ambrogio's masterwork—and of others by his brother Pietro and their Sienese colleagues Duccio and Simone Martini —spread northward, where it influenced such Flemish artists as Melchior Broederlam. The result was a fusion of Italian and northern styles that art historians call International Gothic, a style that, back in Italy, came to brilliant fruition in the crowded panels of Gentile da Fabriano. Both Gentile and Broederlam tried their hands at landscape *(pages 18-19)* and the rational rendering of space, but they seem to have been at least equally interested in precisely rendered detail and in graceful patterns of shape and color.

This love of detail and of brightly colored, meticulously painted surfaces continued to be hallmarks of northern painting, but after 1400, Flemish painters raised the International Gothic style to

breathtaking new heights. The supreme technician was Jan van Eyck, who brought to a perfection never since surpassed the newly discovered technique of painting with oil. This made possible, as no previous medium could, both the handling of detail and a smooth blending of colors and tones. Van Eyck's paintings glow with light, his space seems to recede as real space does, growing hazy in the distance, and his pursuit of microscopic detail is relentless.

A number of gifted northern painters joined Van Eyck in exploring the potentialities of this new approach to art. Perhaps the greatest was Rogier van der Weyden, who substituted a sense of emotional warmth for Van Eyck's rather dispassionate touch. These Flemish masters were soon emulated by painters from other countries, such as the Swiss-born Conrad Witz and the Frenchman Jean Fouquet. Ultimately the Flemish influence, especially in the technique of painting with oil, was to reach across the Alps into Italy, with a consequent impact on Italian art.

But this impact was not yet felt in the early 1400s. At that time something quite different, and more profoundly important, was afoot in Italy and especially in Florence. Innovators as radical as Giotto were rising on the scene. Among them were three men of genius—each, happily for posterity, representing a major branch of the arts: the architect Brunelleschi, the sculptor Donatello and the painter Masaccio.

According to Vasari's *Lives*, Brunelleschi and Donatello were close friends who sometimes shared a meal of hard-boiled eggs, cheese and wine while they worked. They also shared a determination to discover the principles, the rules—the essential forms—of their respective arts. In pursuit of this goal, both as young men journeyed to Rome to study the antique architecture and sculpture to be found there. They measured everything, Vasari tells us, to discover the proportions used by classical artists. The results for architecture were far-reaching. The buildings Brunelleschi designed after his return to Florence set the basic pattern of all Renaissance architecture. His works were severely symmetrical but harmonious structures employing disciplined classic forms, in contrast to the exuberant ornateness of the Gothic.

Donatello's work was almost as revolutionary. He not only achieved a technical excellence rivaling that of the ancient masters of sculpture but also went far beyond them in endowing his figures with a sense of humanity. Some of his works, such as the gaunt *Mary Magdalen*, are even more brutally believable than the "Zuccone." Even Brunelleschi was taken aback, Vasari says, by one of Donatello's Crucifixions. Upon first viewing the sculpture, Brunelleschi exclaimed that his friend had not depicted Christ on the Cross but had hung a peasant on a stick. Whether Brunelleschi so realized, this capsule criticism sums up the essence of Donatello's contribution. Most of his work has the power that comes only from stark simplicity and unblinking realism.

Masaccio, the youngest of this trio of early 15th Century Flor-

entine masters, doubtless benefited from the pioneering of both Donatello and Brunelleschi. The figures in his frescoes have the monumental dignity of Donatello's sculptures and, like them, suggest the human anatomy under the folds of clothing. From Brunelleschi, Masaccio seems to have learned mathematical perspective —how to create the illusion of depth on a flat surface not by guesswork but according to exact rules. Masaccio was the first painter to employ this scientific method to give an impression of depth in his works, the first painter to render human anatomy convincingly, and among the first to experiment intensively with chiaroscuro—a way of defining forms by the use of light and shadow. What this rough bear of a man—Masaccio was a nickname, translatable as "Hulking Tom"—accomplished in his brief 27-year life span was to create the seminal paintings of the Renaissance, paintings that long served as a school for other artists, including the High Renaissance masters Leonardo, Raphael and Michelangelo. More immediately, he influenced the work of a great near-contemporary, Piero della Francesca. Piero not only invested his frescoes with the same noble gravity as Masaccio's but became a devoted student of perspective, writing a treatise on the subject.

As the 15th Century progressed, painters probed further in the directions Masaccio had pioneered. In general they sought ways to copy nature ever more exactly. Portraiture advanced amazingly and the rendering of anatomy also became more precise, in large part through the efforts of a sculptor and painter named Antonio del Pollaiuolo. (The word "Pollaiuolo," another of those amusing Florentine nicknames, derives from the artist's father's business, chicken farming.) Pollaiuolo was apparently the first artist to dissect corpses to learn how bones and sinews are really put together, and many of his works show men in violent action, every muscle straining. These lessons were absorbed by a contemporary, Botticelli (still another nickname, meaning "Little Barrel"), who then made his own unique contribution to artistic advance—the rendering of the human body with a new lyricism and poetic grace.

With Botticelli the artistic revolution set in motion by Giotto came to a temporary halt. The tough, hard-working Florentine artists of the Early Renaissance had created the tools, so to speak, of the trade: perspective, anatomy, chiaroscuro, the realistic rendering of face and form—to which was added, from the north of Europe, a new delicacy in the handling of oil paint. The creator of Squash Head, Hulking Tom, the chicken farmer's son, the Little Barrel and the others had set art on a new path, away from the spiritual and the stylized and toward a deep concern with earthly man and with the actual look of his world. Significantly, two of the last great Early Renaissance painters—Andrea Mantegna and Giovanni Bellini— were not Florentines. Mantegna was from Padua and Bellini from Venice, where many of the masterpieces of the next era were to emerge. With their work the stage was set for the magnificent triumphs of the High Renaissance.

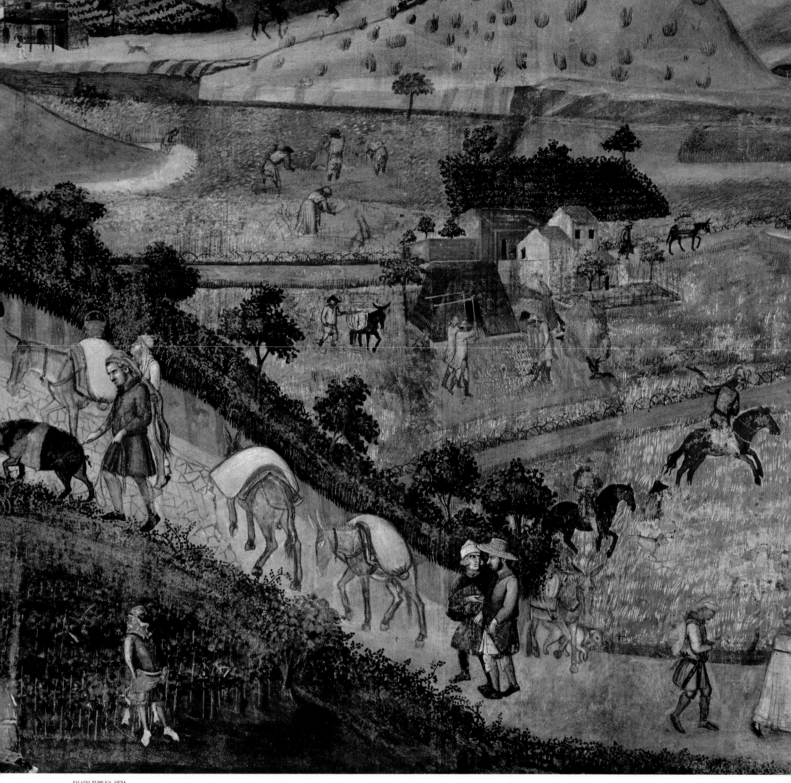

Ambrogio Lorenzetti: *The Effects of Good and Bad Government*, detail, 1337-1339

A Search for Reality

The history of art from the age of Giotto on through the Early Renaissance—roughly 1300 to 1500—can be summed up as a search for ways to capture accurately, in painting or in sculpture, the actual look of man and his world. In the century after the Florentine Giotto gave substance to his human figures and planted them in persuasively three-dimensional space, painters elsewhere in Italy, and especially in Siena, pursued the quest. One notable triumph in picturing the visible world was the deep and orderly landscape above, filled with peasants working at their various seasonal tasks, painted by Ambrogio Lorenzetti as part of a large allegorical fresco for Siena's town hall.

17

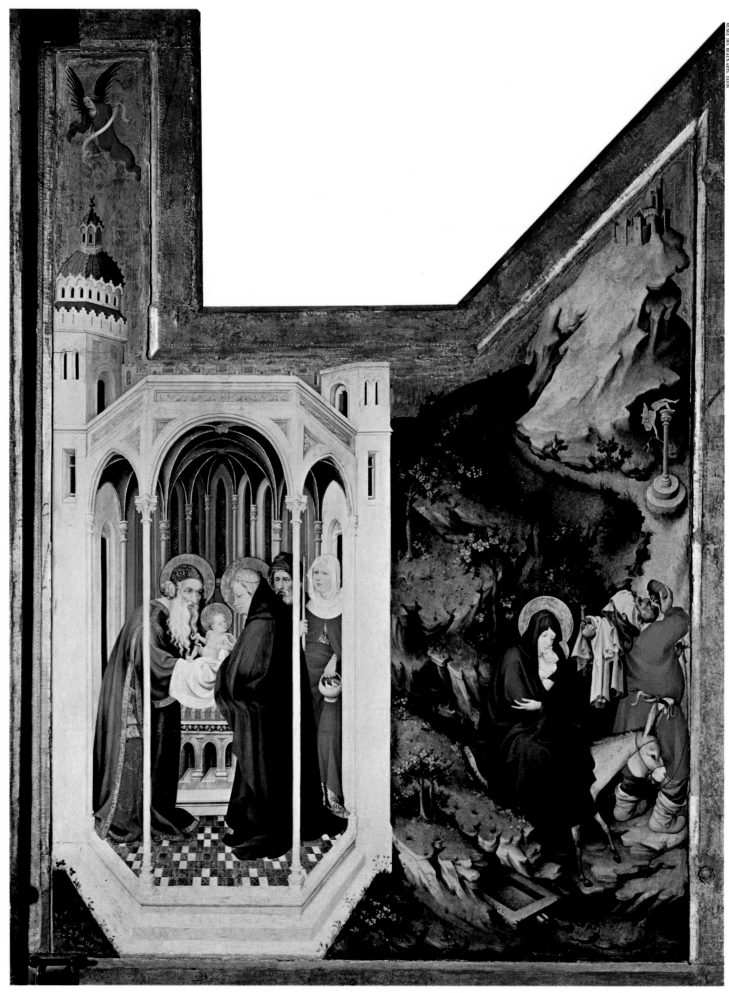

Melchior Broederlam: *The Presentation in the Temple and the Flight into Egypt,* 1393-1399

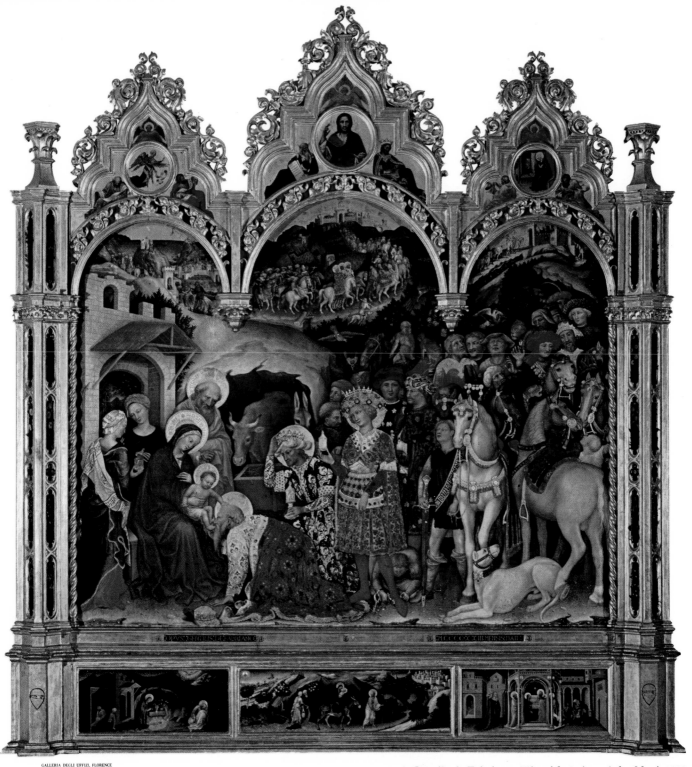

Gentile da Fabriano: *The Adoration of the Magi,* 1423

The early Italians' zest for recording the world around them—even in the context of traditional religious themes—was shared by painters in northern Europe. In the late 14th Century their common interest resulted in a style called International Gothic. A northern example of this style is the work at left, one of a pair of shutters for an altar shrine by Melchior Broederlam, a Flemish artist. Broederlam crowded two scenes —Christ's presentation in the Temple and the Holy Family's flight into Egypt—within a single frame in an ambitious effort to depict two kinds of space, interior and exterior. Although the landscape is out of scale with its figures and the two scenes do not mesh, Broederlam effectively achieved a sense of light and air and demonstrated his gift for realistic architectural detail. The Italian master of International Gothic, Gentile da Fabriano, was more successful. In his brilliantly colored *Adoration of the Magi (above)*, jeweled fabrics, horses, dogs, are all lovingly rendered, and a believable landscape winds deep into the distance.

19

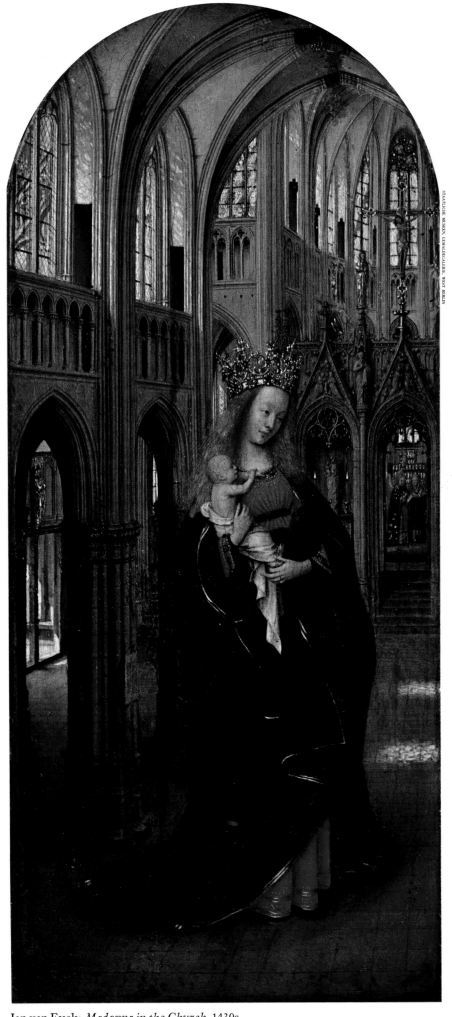

Jan van Eyck: *Madonna in the Church*, 1430s

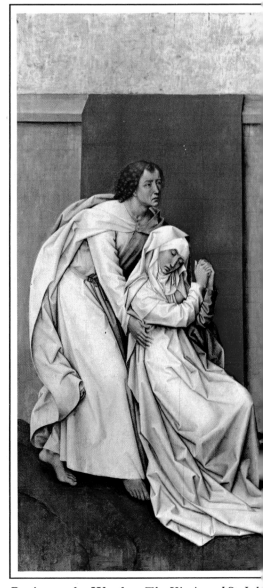

Rogier van der Weyden: *The Virgin and St. Joh*

20

A Magical Skill with Paints

Northern painting reached a new level of perfection in the hands of the remarkable Flemish artist Jan van Eyck. Using alternate layers of tempera—pigment mixed with white of egg—and translucent oil glazes, he was able to convey the exact textural quality of almost any object, as well as to bathe his pictures in soft, radiant light. For all his innovations, Van Eyck remained within the medieval artistic tradition with its emphasis on religious symbolism. In his *Madonna in the Church (left)* every detail of the cathedral interior is rendered with precision and yet the figure of the Virgin is out of scale, perhaps four times too large for the setting. Moreover, since the altars in all Gothic churches face east, Van Eyck has made the sunlight stream through the windows from the north, a manifest impossibility. The explanation for these apparent errors lies in the medieval religious view that the Virgin *is* the Church. Van Eyck painted her as a symbol of the Church, standing in a pool of supernatural light.

A somewhat younger Flemish master, Rogier van der Weyden, rivaled Van Eyck in the superb finish of his paintings but substituted drama for detachment. His suffering Virgin in the diptych at left, below, is a striking study in pathos.

The Flemish influence spread to Switzerland, where Conrad Witz combined Van der Weyden's humanity with Van Eyck's accuracy of observation in his moving portrayal of a saint *(below)*.

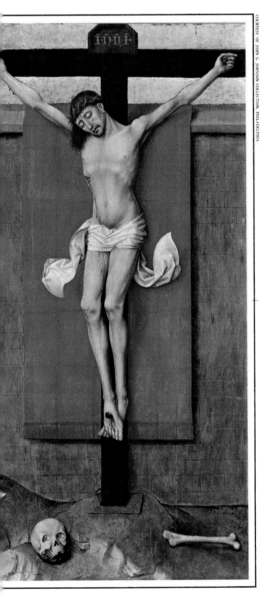

The Crucifixion, c. 1455

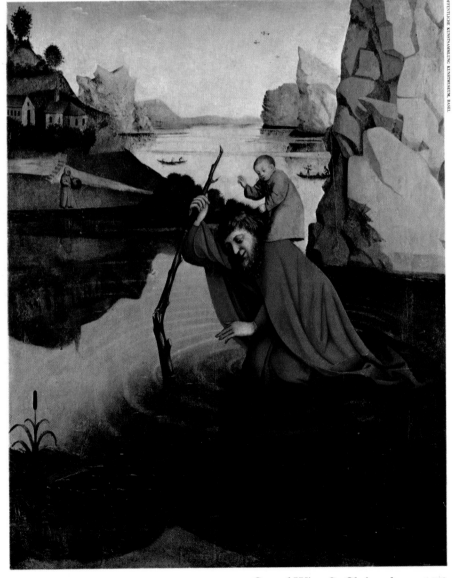

Conrad Witz: *St. Christopher*, c. 1440

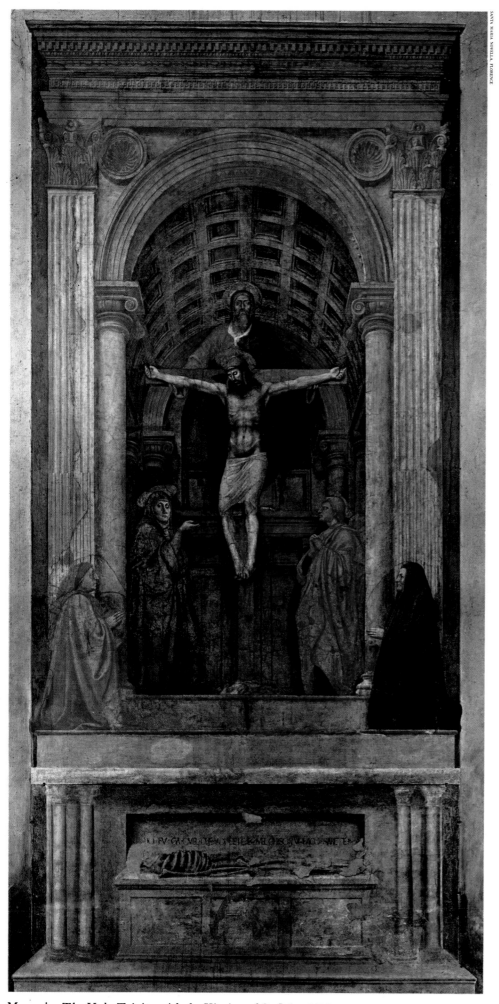

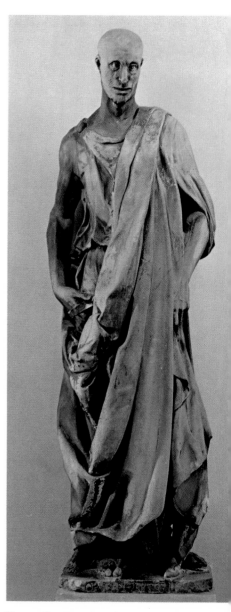

Donatello: *Prophet (Zuccone)*, 1423-1425

Three Florentine Innovators

Masaccio: *The Holy Trinity with the Virgin and St. John*, 1425

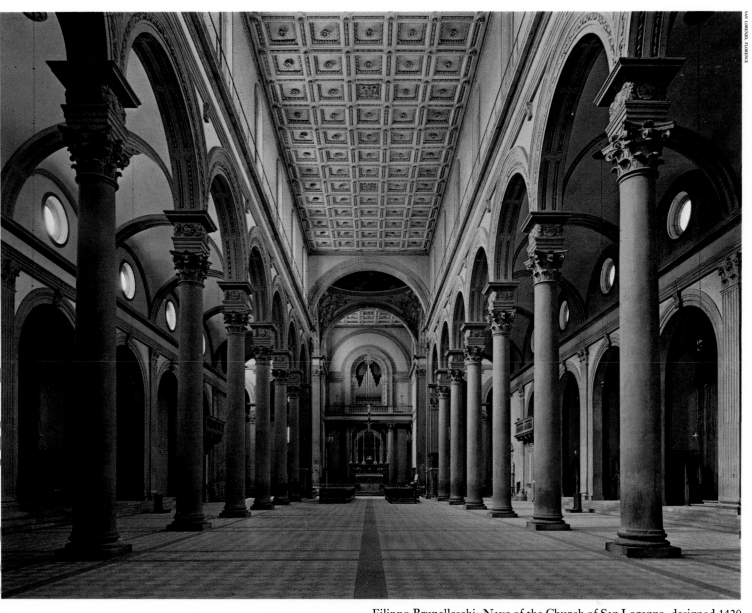

Filippo Brunelleschi: Nave of the Church of San Lorenzo, designed 1420

In 1425 the 24-year-old Florentine painter Masaccio produced a masterpiece that was to shape the entire course of Renaissance art. The *Holy Trinity (opposite)* combined two qualities that were to become hallmarks of that art, intellectual daring and an emphasis on the human aspects of the artist's theme. Masaccio showed God the Father not as an ethereal vision but as a solid figure firmly planted, holding the Cross of His crucified Son. The barrel-vaulted chamber is drawn in accurate perspective, all proportions are perfect, and the space so convincingly deep that the figures —themselves anatomically correct—seem eminently capable of moving around in it.

Masaccio's friend, the architect Filippo Brunelleschi, pursued a similar goal of perfection in his craft. Singlehandedly he conceived Renaissance architecture—the precise, mathematically proportioned system of design seen in the nave of the Church of San Lorenzo *(above)*. Everything is as ordered and stately as the semicircles of the Roman arches, and in marked contrast to the exuberant irregularities of Gothic architecture.

The third revolutionary artist of early 15th Century Florence was the sculptor Donatello, whose astonishingly realistic statue of the prophet Jonah appears at center. This strong, anatomically convincing figure foretells all the great later sculpture of the Renaissance, including Michelangelo's. Most important, Donatello's aged prophet is man in all his individuality, even ugliness, put triumphantly at the center of art.

23

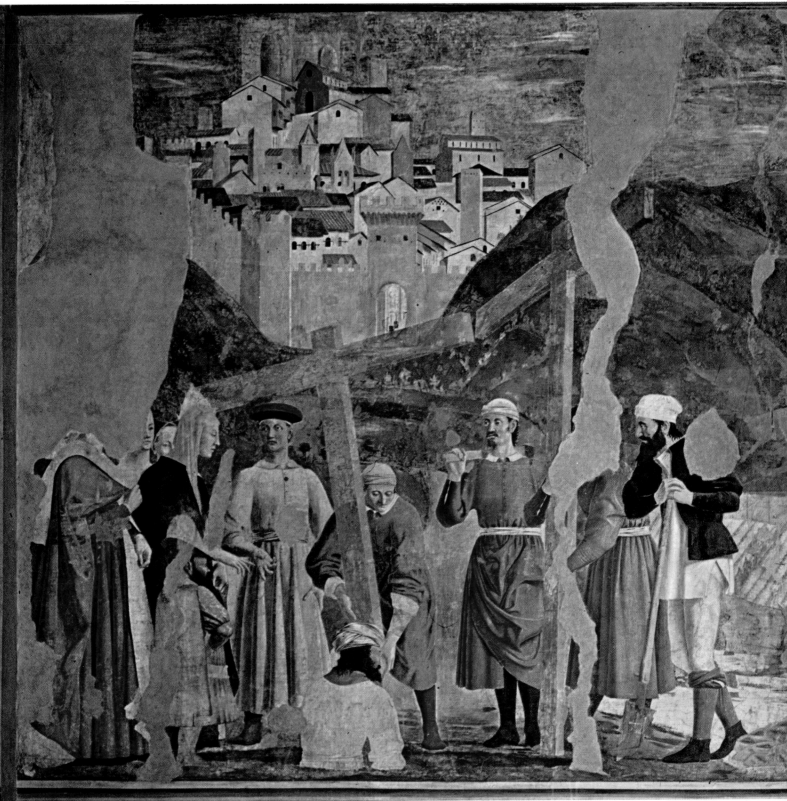

SAN FRANCESCO, AREZZO

Masaccio's direct impact continued to be felt long after his untimely death at 27. At that time the painter who was to be his greatest follower, Piero della Francesca, was only 12. Born in the small town of Borgo San Sepolcro in southeastern Tuscany, Piero served part of his apprenticeship in Florence, doubtless knew Masaccio's colleagues Donatello and Brunelleschi, and without question studied Masaccio's great frescoes. He came to share both Masaccio's fascination with perspective and his desire to create grave, even noble figures in a perfectly ordered universe.

These qualities can be seen in the painting above, a section of a great cycle of frescoes—some critics think them the most impressive frescoes ever done —that Piero painted in a church in Arezzo over a

24

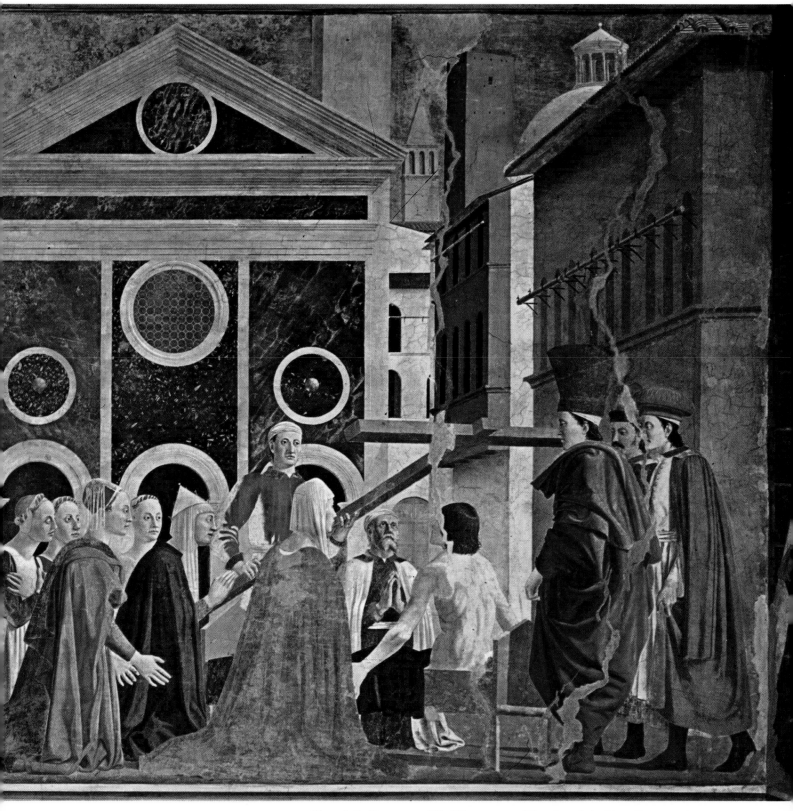

Piero della Francesca: *The Discovery and Proving of the True Cross,* c. 1460

period of 12 years in the mid-15th Century. The cycle tells the story of the Cross used for Christ's Crucifixion. On the left of this section, the True Cross is found and excavated together with the crosses of the thieves who died beside Christ. On the right, the authenticity of the True Cross is proved when it miraculously brings a dead youth back to life. In both halves of the painting the figures have a harsh grandeur that recalls those produced by Giotto as well as Masaccio. But they are unified by a bright light that also highlights details and are composed of simplified shapes that are Piero's alone. Distinctive also are the colors that made up Piero's frugal but harmonious palette—the colors, as British critic Sir Kenneth Clark has noted, of a Tuscan vineyard.

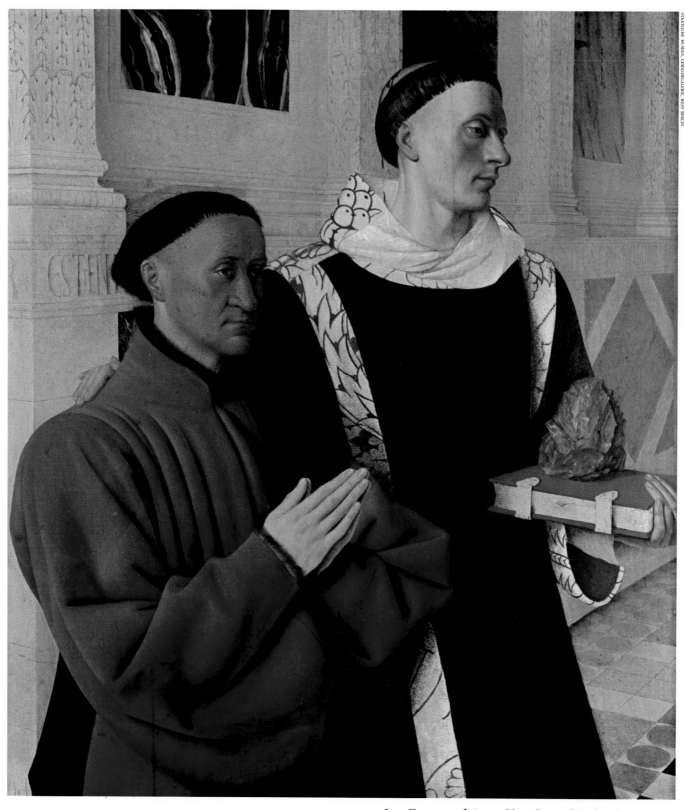

Jean Fouquet: *Étienne Chevalier and St. Stephen*, c. 1450

The Look of Real People

Portraiture crept into painting by a side door, as it were. Before the start of the Renaissance, portraits were seldom produced for their own sake. But they were often included in religious paintings to honor a patron. An artist would include the man who had commissioned the painting among those shown worshiping the Madonna or witnessing the Crucifixion. In Masaccio's *Holy Trinity (page 22)*, for example, the two kneeling figures flanking the

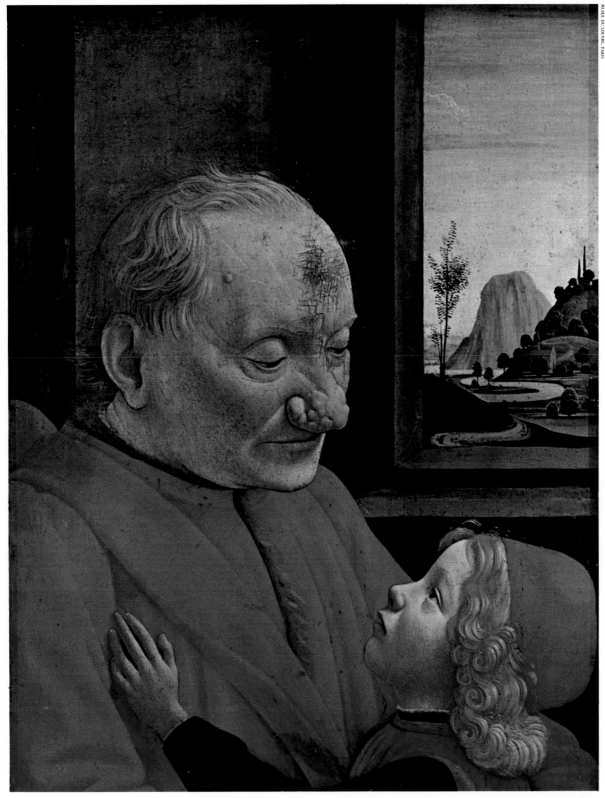

Domenico Ghirlandaio: *An Old Man and His Grandson*, c. 1480

vaulted chapel represent the donor and his wife.

As painterly skills increased, portraits of donors became more and more lifelike and revealing of individual character, as can be seen in the marvelous double likeness by Jean Fouquet *(above left)* of Étienne Chevalier, a French court official, and of a prayerful young man posing as his patron saint. Originally a wing of an altarpiece commissioned by Chevalier, this work shows how Fouquet, the greatest French painter of the Early Renaissance, combined the realistic detail developed by the Flemish artists with a breadth and power he had learned on visits to Italy. It was but a step from this to such secular portraits as Ghirlandaio's *An Old Man and His Grandson (above)*, which captures both the contrast between the old man's ugliness and the fresh beauty of the child and the poignant interplay of their love for each other.

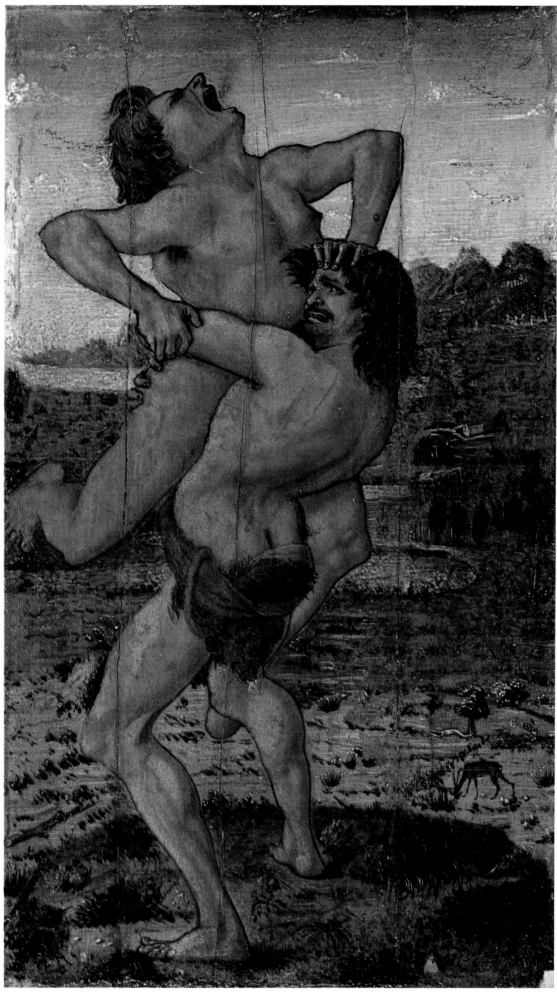
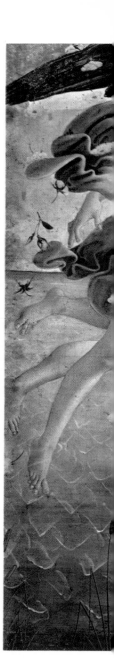

Antonio del Pollaiuolo: *Hercules and Antaeus*, 1460

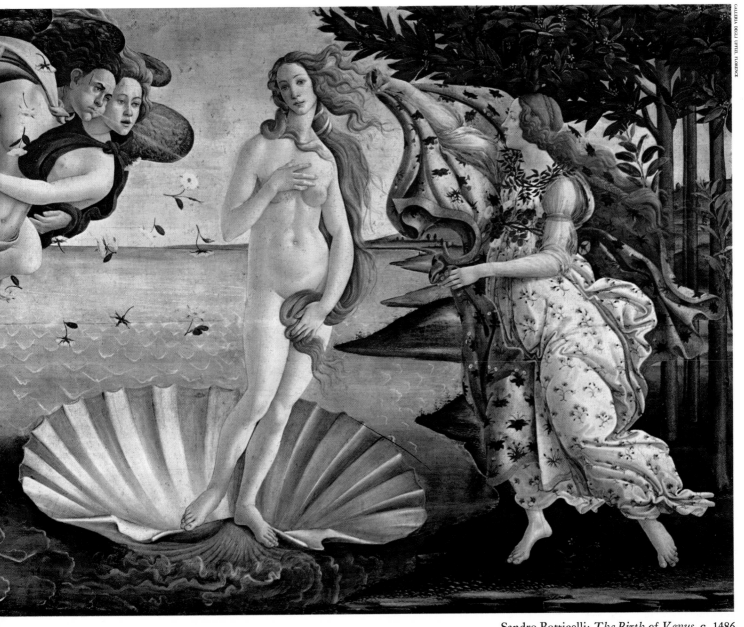

Sandro Botticelli: *The Birth of Venus*, c. 1486

A full mastery of human anatomy was added to the new realism in portraiture largely by a hard-working, intellectually adventurous Florentine named Antonio Benci—better known as Pollaiuolo. Apparently the first artist to dissect cadavers—an uncommon practice then even among medical students—Pollaiuolo translated his accurate knowledge of how bone and sinew work into such violently expressive paintings as the mythological scene opposite, in which Hercules, every muscle straining, heaves Antaeus off the ground prior to crushing him. Not only do the muscles strain, the faces are also contorted by effort and rage, an integration of physical and emotional stress that was to appear often in later Renaissance art.

Another vital contribution to the treatment of the human figure was made by Botticelli. In the painting above, Botticelli reveals his grasp of normal human proportions, but he distorts the figures for deliberate effect. In her sinuous grace, his Venus is perhaps the greatest image of Ideal Beauty ever painted. According to humanist scholars of Botticelli's time, the Greek and Roman ideal of beauty symbolized by Venus could invite a contemplation of the Divine just as surely as could the Christian ideal of female perfection, the Virgin. Botticelli's Venus inspired innumerable nude goddesses by painters in the next century.

29

New Departures in the North

Rocks with razor-sharp edges, agonizingly detailed anatomical studies, deep perspectives—these characteristics stamp the muscular style of Andrea Mantegna. Considered by some scholars the most important painter of the Early Renaissance after Masaccio, Mantegna in many respects sums up the era's startling advances in art. He was not a Florentine, but Padua, where he served his apprenticeship, was a stopping place for Florentine

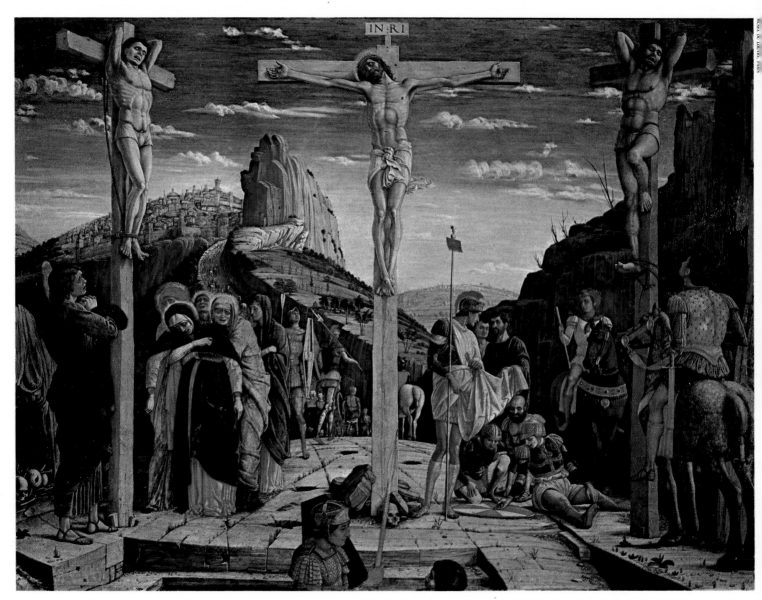

Andrea Mantegna: *Crucifixion,* 1457-1459

artists, including Donatello, when they came north to fulfill commissions. The influence of the ideas from Florence left an indelible mark on Mantegna's work. Traces of Donatello and Masaccio are unmistakable in his *Crucifixion (below, left)*, in which artful perspective, correct anatomy and a dramatic sense of composition combine to create a work of great power.

The influence of Mantegna, in turn, can be seen in the work of his brother-in-law, the Venetian Giovanni Bellini, whose *Resurrection (below)* depicts Christ rising from His tomb. But there are striking new elements in Bellini's work, notably shimmering light, luminous color and a new lyrical tenderness. These qualities would be the hallmarks of Venetian painting when, in the later years of the 16th Century, the city on the Adriatic became Italy's greatest center of painting.

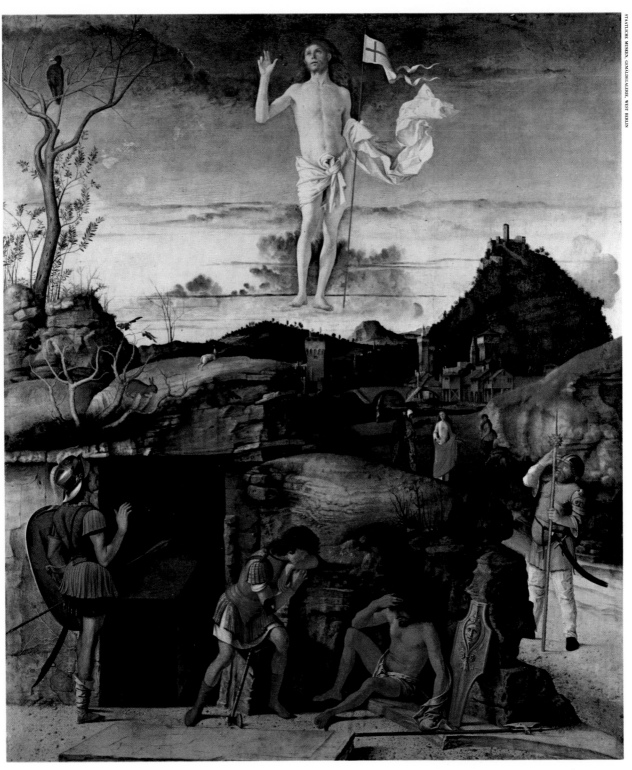

Giovanni Bellini: *The Resurrection*, c. 1479

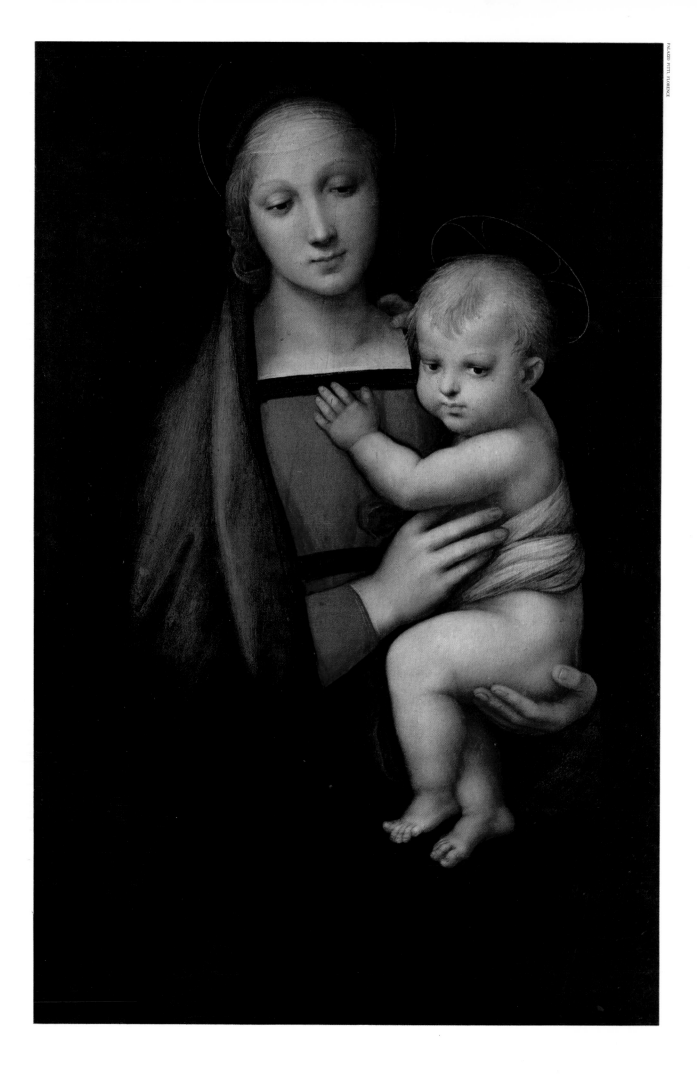

III

The High Renaissance

The High Renaissance—a second flowering of Italian painting and sculpture that occurred in the early 1500s—was powered by another trio of great artists: Leonardo, Michelangelo and Raphael. Like Brunelleschi, Donatello and Masaccio, the three innovators who had spurred the Early Renaissance almost a hundred years before, all brought to a new excellence the techniques pioneered by earlier artists. But they also possessed something else—a driving ambition to reach the limits of artistic expressiveness, to discover and portray absolute truths about man and the universe.

The oldest of the three, Leonardo, was born in 1452 in the small Tuscan town of Vinci; he was trained as an artist in nearby Florence, in the workshop of Verrocchio. Verrocchio was a superb sculptor but only an indifferent painter and he soon perceived that his young apprentice could handle the painting assignments his workshop received far better than he could. Leonardo, in fact, brought a delicacy to the handling of pigment. He could render gradations of light and shadow as no artist had been able to before, employing *sfumato*—a slight smokiness or haziness—to deepen and soften his lyrical yet precise landscapes and to give an air of mystery to the figures in his foregrounds. He used bold contrasts of light and shadow, called chiaroscuro, to make his figures more three-dimensional. Above all, he could paint the human face with exquisite subtlety. The result, of course, was such masterpieces as *Madonna of the Rocks* and the *Mona Lisa*, as well as an undeniable impact on painters of his own and subsequent times.

But painting alone could not satisfy Leonardo's restless mind. Perhaps it came too easy. At any rate, he spent much of his later life wandering from one Italian city to another, serving as both artist and military engineer, beginning a number of grandiose projects and finishing few, and all the time becoming more and more engrossed in a mind-boggling variety of scientific pursuits. He was fascinated by such seemingly antithetical subjects as botany and the invention of new engines of war, including the first hypothet-

Grave and serene, Raphael's luminous Madonna achieved goals toward which the painters of the Early Renaissance had struggled: a new perfection in the handling of paint, the natural portrayal of the human face and the delineation of monumental forms.

Raphael: *Madonna del Granduca*, c. 1505

33

ical designs for a machine gun and a tank. He was devoted to anatomy, filling notebook after notebook with meticulous drawings of muscles and bones, of both men and animals, trying to find, it would seem, common denominators that might explain the principle of life itself. The drawing on page 37 is a demonstration of the ideal proportions of the male body, and of the fact that a man's reach equals his height. Leonardo himself thought that his scientific researches were more important than his art, but he remains for us first and foremost a painter whose works reached a new level of power combined with grace and lyrical tenderness.

On Leonardo's death in 1519 his pupil Melzi lamented that "it is not in the power of nature to produce such another man." He underestimated not only nature but also the city of Florence, which had already produced, in 1475, a man of the same degree of genius —Michelangelo. Although he too became a great painter, Michelangelo's chosen art was sculpture. His preference, Michelangelo himself felt, was significant. Painting, he once remarked, was an art of "laying on" whereas sculpture was "an art that takes away superfluous material"—in other words, sculpture laid bare the inner form, the essence, of the human body by removing the inessential. Not for him Leonardo's endless notebooks full of detailed, often random information, or layer after layer of meticulously handled paint. His art, both his sculpture and painting, was bold, massive, monumental. In this respect he went back to the roots of Florentine art, to Donatello and Masaccio, and even Giotto. Like them he concentrated on the nobility of the human body. But he also extended to new realms of expressiveness the attempts of Pollaiuolo and others to picture the body and face contorted with effort or emotion. Michelangelo's 17-foot-high marble sculpture of the Biblical David is one of the ultimate expressions of the magnificence of the human body in all its nobility and grace. It is charged with energy, but energy held in check. The fresco of the *Last Judgment,* of which a detail is shown on page 40, demonstrates the extraordinary power with which Michelangelo could portray, in painted form, the human body possessed by profound emotion.

A Florentine by birth, Michelangelo spent much of his later life in Rome executing works commissioned by a succession of popes. Often he overreached himself, conceiving schemes so ambitious no artist could ever have completed them even if he had worked, as Michelangelo did, with maniacal dedication. The Sistine Chapel ceiling, a project he did complete, was a gigantic undertaking; in a punishing four years he frescoed some 5,800 square feet of plaster with more than 300 figures, and did it virtually unaided (he fired the assistants he hired because he thought them incompetent). He was an overreacher by nature, wanting to wrest from art some final magnificence, and by perfecting the portrayal of the human body, to arrive at an ultimate statement about man and the purposes of his Creator.

Raphael, the third of the giants of the High Renaissance, was in

temperament quite unlike his dynamic, somewhat older, peers. The historian Vasari reports that Raphael was "graceful," "modest," "gentle," "always ready to conciliate" and "considerate of everyone." A favorite of the ladies (one envious contemporary claimed that Raphael died at the early age of 37 from overindulgence in women), he was a far less deeply driven, less emotional man than Michelangelo. Nevertheless, he was a superb synthesizer who brought together not only the achievements of the previous century, but also those of Leonardo and Michelangelo. As Vasari neatly put it, "At the moment when nature was vanquished by the art of Michelangelo, she deigned to be subjugated by Raphael."

Raphael was born Raffaello Sanzio in Urbino in 1483. He was apprenticed to a painter named Pietro Perugino, a native of the nearby Umbrian city of Perugia. Perugino's paintings have the characteristic Umbrian virtues; they are charming, delicately painted and placidly harmonious. And so were Raphael's earliest works. But about 1504, at the age of 21, Raphael journeyed to Florence, where Leonardo and Michelangelo, although they both were soon to leave, were then at work. That he studied Leonardo's work is more than evident from his *Madonna del Granduca (page 32)*, painted soon after he arrived in Florence. As Raphael's technical virtuosity increased, his fame quickly spread and by 1509 he had been summoned to Rome by Pope Julius II, the imperious patron who already had Michelangelo at work on the Sistine ceiling. Raphael spent the rest of his short life in Rome living like a prince (as the ascetic Michelangelo complained) and painting a number of fine portraits and a series of frescoes in the Vatican. The most famous of the latter is *The School of Athens (pages 38-39)*, which in its bold, muscular figures reveals the impact of both Masaccio and Michelangelo, and in its balanced composition shows Raphael's own special abilities. It also epitomizes the sense of abundance and assurance, both technical and philosophical, that characterizes the art of the short period from about 1500 to 1520.

This assurance was soon to disappear. New philosophical winds were blowing, undermining the belief that had sustained much of Early and High Renaissance art—the belief that the universe was harmonious, obeying an ideal order that could be discovered and even rendered in paint or stone. Michelangelo in his late works, such as the writhing cataclysm of *The Last Judgment*, seems to have been tormented by this doubt that divine order actually existed, and the painters that followed him evidently suffered from the same misgivings. In addition, this next generation of artists felt impelled to go beyond the often stark simplicity of earlier styles, to seek a more decorative, personal and emotional way of painting. In their works the old sense of order and harmony disappeared, to be replaced by almost nightmarish visions.

These artists came to be called Mannerists, from the Italian word *maniera*, which originally connoted "mannered" or "artificial." They elevated a personal, often highly eccentric art above the re-

alism and classical harmony that Renaissance artists had been seeking. Characteristic of their works is *The Descent from the Cross (page 41)* by a painter known as Rosso Fiorentino ("The Redheaded Florentine"). Apparently Rosso had the fiery temperament associated with red hair—he was frequently involved in brawls—and some of this violence can be seen in his painting, in the theatrical lighting, the twisted human forms, the lurid colors.

Less violent but still far from the balanced, sober and profoundly human art of a Raphael or a Masaccio are the works of Jacopo Pontormo, a contemporary and friend of Rosso's. A marvelously skilled painter, Pontormo was acclaimed Florence's leading artist after Michelangelo had left the city for good and Raphael had died. But in his mature years he became increasingly eccentric and solitary, haunted by a private anguish that comes through in such strange works as *The Deposition (page 41)*, with its crowded, gesturing figures that seem insubstantial and wraithlike. Even less real are the odd, slithery creatures in *An Allegory (page 42)*, a work by Pontormo's pupil Bronzino.

The greatest artist to emerge from Mannerism was El Greco, a Cretan-born Greek who absorbed some of the style of the Mannerists while studying painting in Venice. His elongated figures and his strange, dramatic lighting plainly derive from the tempestuous paintings of the Venetian Tintoretto; Tintoretto's work, in turn, echoes the haunted art of the Florentine Mannerists. The essence of Mannerism had always been exaggeration—exaggeration used to express a personal vision, to emphasize emotion. In El Greco's work everything combines to express an intensely personal and highly emotional vision of the world.

Long before El Greco arrived in Venice after 1560, that city had emerged to rival Florence as the great center of Italian art, largely in the person of a painter named Tiziano Vecellio—Titian —who deserves to stand alongside the Florentine triumvirate of Leonardo, Michelangelo and Raphael as the fourth towering artist of the High Renaissance. His painting, though, was very different from theirs. He was no artist-philosopher searching for truth, but a painter pure and simple, in love with the sensuous delights of this world. He picked up where his great Venetian predecessors in the use of color, Giovanni Bellini and Giorgione, had left off, and he set the style and tone of Venetian art for the next two centuries. Paint—generous, glowing brushfuls of it—was his passion, as it was for Correggio and Paolo Veronese and the others who followed. Michelangelo grumbled that he wished those Venetians would learn how to draw, but the Venetians seemed to care little for the bones and sinews. In their ability to paint the rich textures and colors of things, Titian and his followers have never been equaled, and it was their kind of painting that prepared the way for the period we call the Baroque, in which the sensuous, mixed with a taste for the grand, the emotional and the dramatic, dominated not only painting but sculpture and architecture as well.

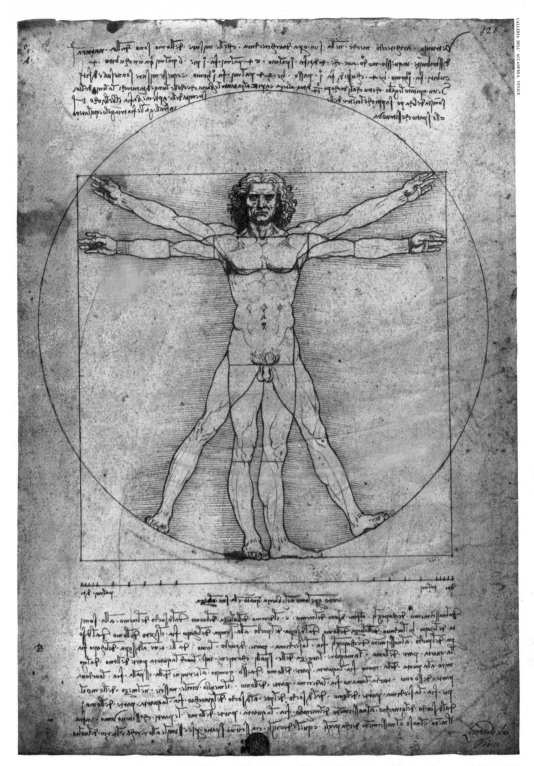

Leonardo: *Human Figure in a Circle, Illustrating Proportions*, c. 1485-1490

Triumphs of Technique

The astonishing period of artistic fulfillment called the High Renaissance lasted only from around 1500 to the death of Raphael in 1520. But in that brief span Leonardo perfected his art in such drawings as the one above, Michelangelo carved his *David* and *Moses* and painted the Sistine ceiling, Raphael did all of his important work, including his great frescoed rooms for the Vatican (*pages 38-39*), and Titian began an incredibly productive career in Venice. These men brought art to a new level of beauty and meaning, and provided a technical mastery that enabled those who followed to explore new areas of emotional expressiveness and to create works of unparalleled dramatic power.

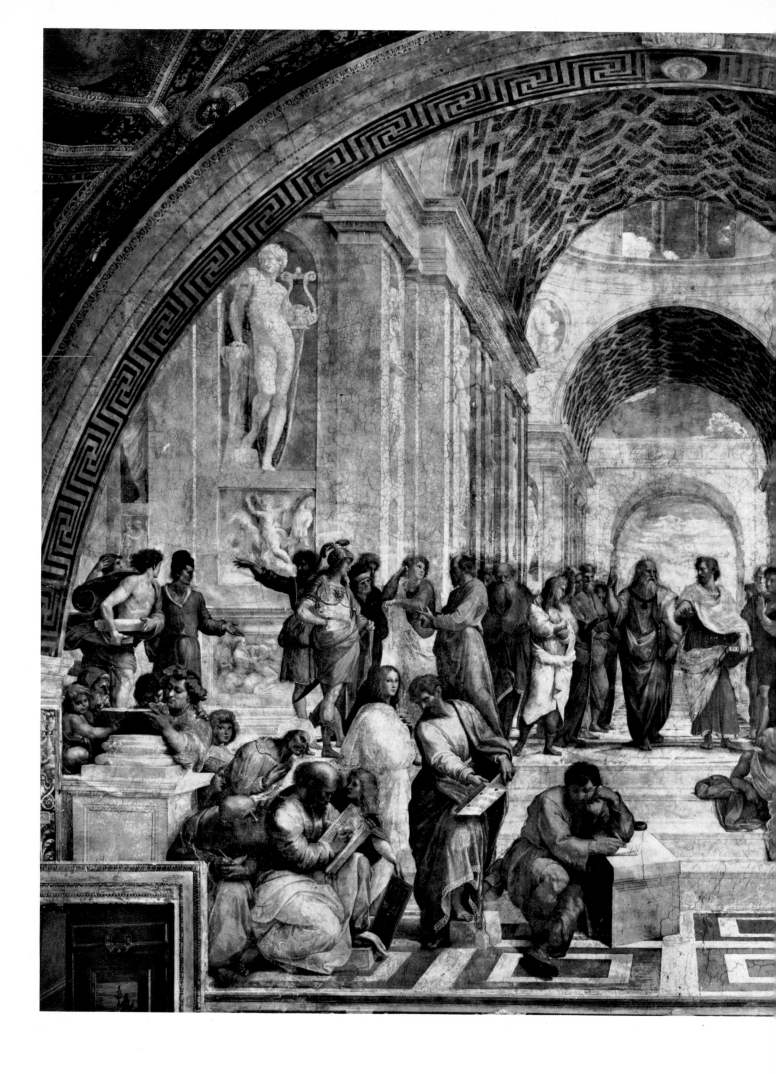

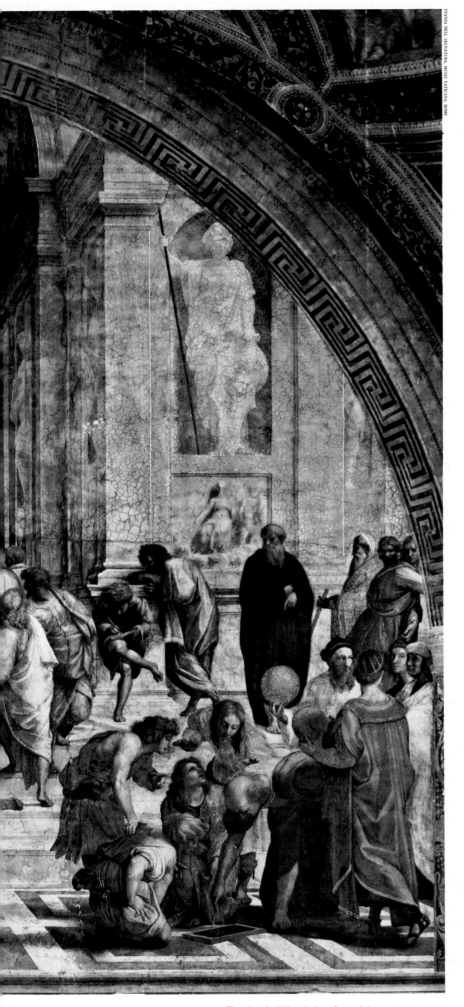

Raphael: *The School of Athens*, 1510-1511

A Classic Order

The great fresco by Raphael at the left is in many respects the key painting of the High Renaissance, bringing together various strands of the era's art and thought. The subject reflects the humanist scholars' fascination with the classical philosophy they had rescued from medieval oblivion, and their belief that Plato and Aristotle—shown conversing at center—had discovered the same truths later revealed by Christianity.

The balance and harmony of the fresco's elements, its spatial grandeur, sum up all previous attempts to create monumental but completely lucid pictures. The energy and power of the figures in this imaginary "school" of ancient learning, and their dramatic grouping, show how Raphael had absorbed the tradition of Giotto, Masaccio and Piero della Francesca, and how he was indebted also to his great contemporary Michelangelo. He graciously acknowledged this debt by including Michelangelo *(seated in the foreground, left of center)* among the ancient worthies. The vast, vaulted background derives from the classically inspired structures of Renaissance architecture.

Indeed, the whole effect is one of majestic confidence in a universal order, in the dignity of man and the nobility of his thought. Raphael finished this work in 1511 at the age of 28. By the time he had died, nine years later, the serene confidence reflected in the fresco, a characteristic of the whole High Renaissance, had been lost.

39

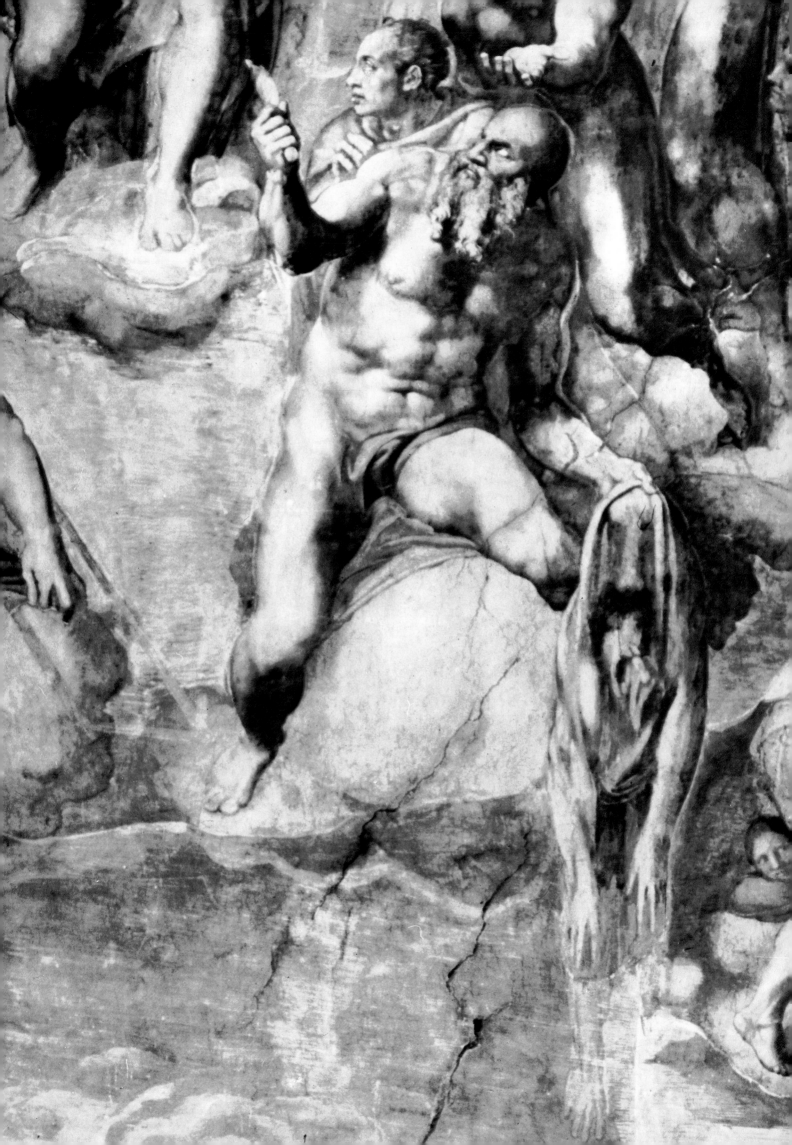

Rosso Fiorentino: *The Descent from the Cross*, 1521

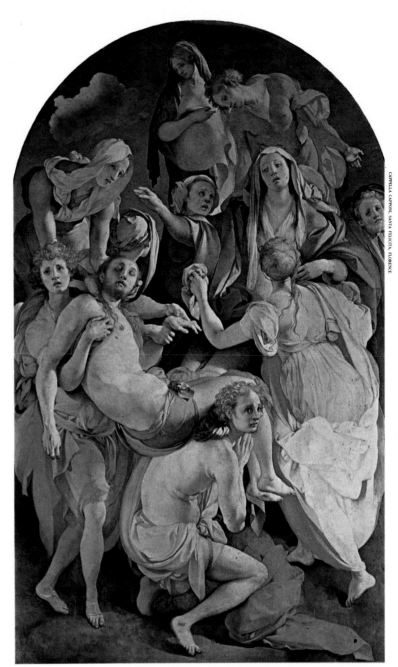

Jacopo Pontormo: *The Deposition*, 1526–1528

Raphael was vibrant, healthy, self-confident and fond of people, and his art shows it. In contrast, the older Michelangelo became more and more eccentric as he was increasingly tormented by doubts concerning the value of art and the meaning of existence—and his *Last Judgment* shows this. In the detail of the fresco at left, a nude and muscular St. Bartholomew looks upward with grim approval at an avenging Christ who condemns sinners to hell. Michelangelo added a sardonic note to this scene by painting a portrait of himself on the limp skin—St. Bartholomew had been flayed alive—that the saint holds in his left hand.

Two Florentine painters who came after Michelangelo, Rosso Fiorentino and Jacopo

Pontormo, were equally eccentric personalities who produced visionary works. Rosso's *Descent from the Cross (above, left)* is a haunting version of an often-painted theme, a high, arching composition of strangely brittle figures lit as if by a flash of lightning against a dark sky. Pontormo's *The Deposition (above, right)*, despite its delicate colors, presents a swirling host of tormented figures with moody faces and odd, half-completed gestures. Both painters suffered their own personal torments. Pontormo was a solitary hypochondriac who shut himself in his house for weeks on end. Rosso reportedly committed suicide after accusing his best friend of theft and learning that the man had been tortured for the offense.

Michelangelo: *The Last Judgment*, detail, 1536–1541

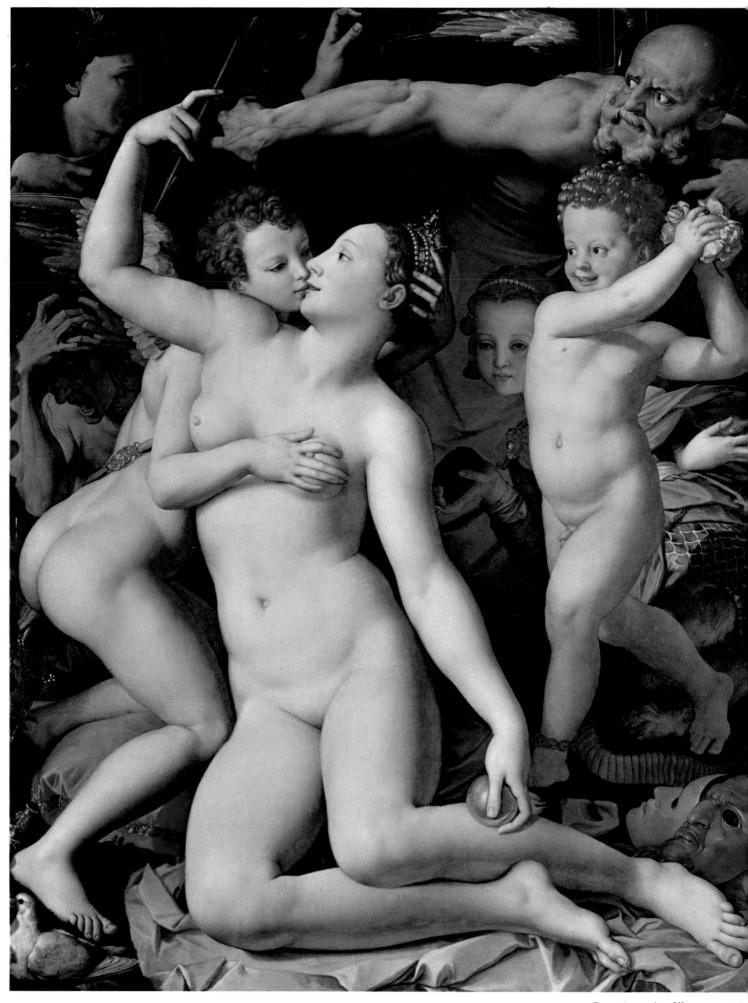

Bronzino: *An Allegory*, c. 15

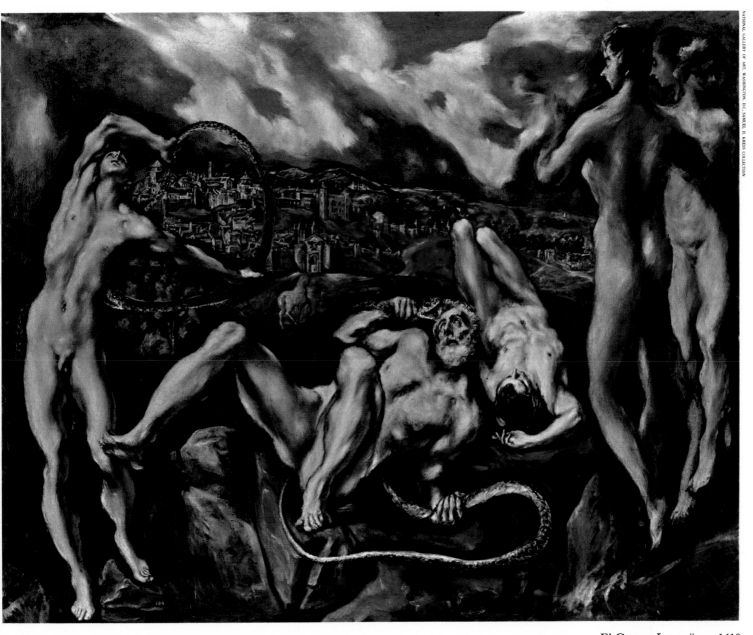

El Greco: *Laocoön*, c. 1610

Extremes of Mannerism

The Mannerist style, which grew in part out of
Michelangelo's late works and was elaborated upon
by Rosso and Pontormo, was carried to different
extremes by the Florentine Bronzino and by
Domenikos Theotokopoulos, the Greek-born
genius who as El Greco became one of Spain's
greatest artists.

Bronzino, who learned to paint in Pontormo's
studio, was an exquisite draftsman, as befitted
Florence's court painter. He conveys a sense of
cool, formal detachment even in the intricately
composed nude allegory at the left, commissioned
by his Medici patron Cosimo I as a gift to Francis I
of France. Bronzino's meticulous detail, polished
flesh tones and sinuously elongated forms delighted
the taste of many of Italy's aristocrats, who prized
elegance in art above a show of emotion.

El Greco used similarly complex compositions
and extravagant gestures, but he charged the
Mannerist conventions with spiritual drama. Best
known for his religious pictures, El Greco
occasionally treated classical themes. Above is his
version of the story of Laocoön, a priest of Apollo
who angered the gods by warning the Trojans
about the Greeks' wooden horse *(center)*. For his
perfidy, Laocoön and his sons were set upon by sea
serpents. El Greco's Troy is a loosely brushed
composite of the skyline of the artist's adopted
Spanish home, Toledo, which spreads across stark
hills under a storm-torn sky.

43

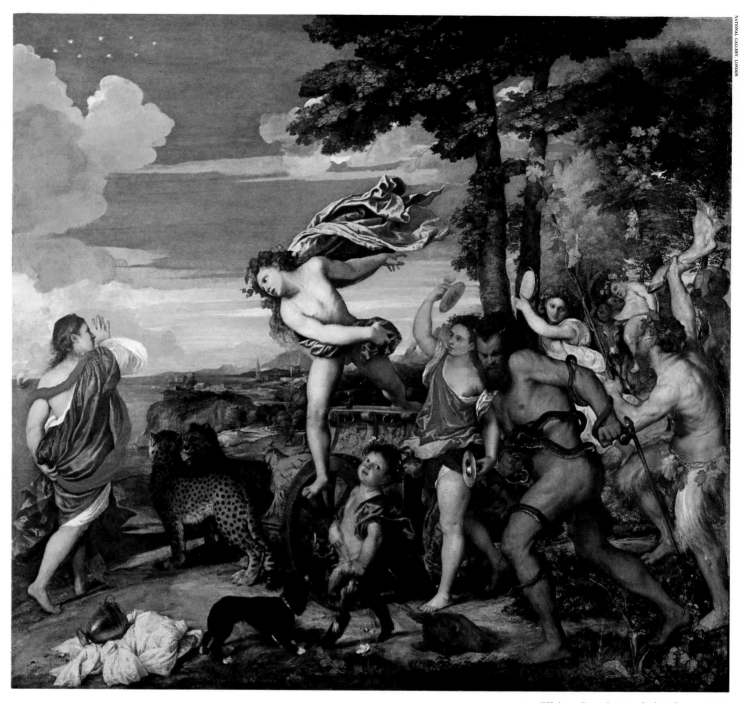

Titian: *Bacchus and Ariadne*, c. 1522

The Sensual Venetian School

While painters in Florence and Rome pursued cool classical ideals, their colleagues immediately to the north were lavishing their skills on pictures warmed by sensual subjects and bright hues. In the mythological scene above, the Venetian painter Titian portrayed Bacchus leaping from his chariot to comfort the Cretan princess Ariadne *(left)*, who had been forsaken by her lover Theseus. Bacchus and his attendant satyrs fill the scene with energetic movement and color—a specialty of painters from the rich, gaudy city of Venice.

Even more unabashedly erotic is the work at right, done by the painter Correggio, who worked chiefly in one of Venice's satellite cities, Parma. In the painting the god Jupiter has assumed a cloudlike form to hide from the eyes of his jealous wife as he embraces the lovely, acquiescent nymph Io. Correggio depicted Io's ecstatic languor so realistically that even the figures in Titian's scene appear somewhat stiff by comparison. The painter's use of warm, luminous color makes his subject's flesh seem literally to pulse with life.

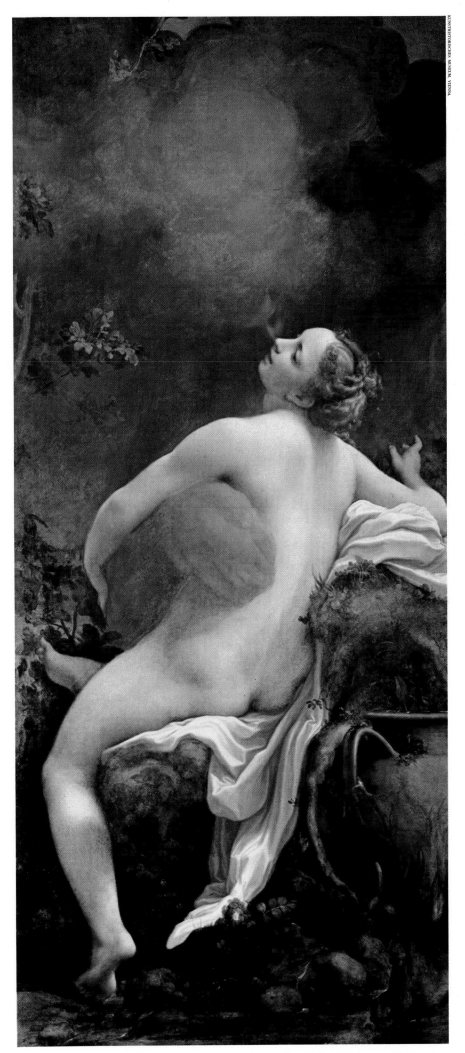

Correggio: *Jupiter and Io*, c. 1530

In the hands of northern Italian artists, even religious paintings were made to glow with an aura of sensual pleasure. Veronese's picture below, radiant with color, seems to portray not a scene from the life of Christ but a lavish dinner party in Venice, where the painter made his home.

Exquisitely garbed nobles cluster about the table; Christ, shown at the center, stands out by His modesty amidst such elegance.

Veronese, in fact, concentrated so hard on creating splendor in this work that he neglected to make clear what New Testament incident he was

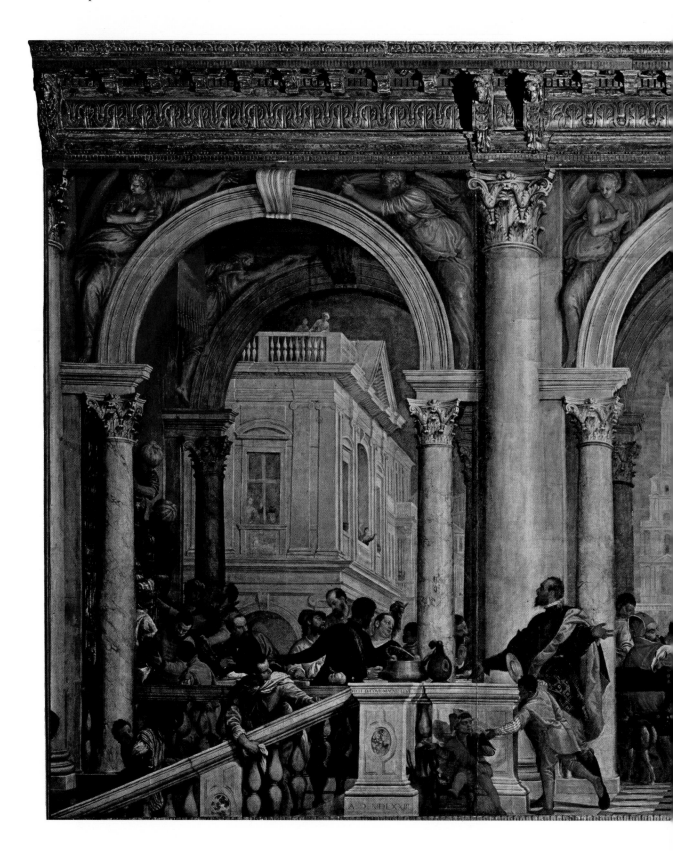

portraying. He seems originally to have titled the work "The Last Supper." At any rate, the Inquisition took it as such and charged Veronese with irreverence for portraying Christ and the disciples surrounded by "buffoons, drunkards . . . and similar vulgarities." In a masterful evasion, Veronese invented a new title, announcing that his subject was the dinner at the house of Levi, the tax collector, where Christ, criticized for associating with low characters, said, "I come not to call the righteous, but sinners to repentance." Outwitted, the Inquisition dropped its charge.

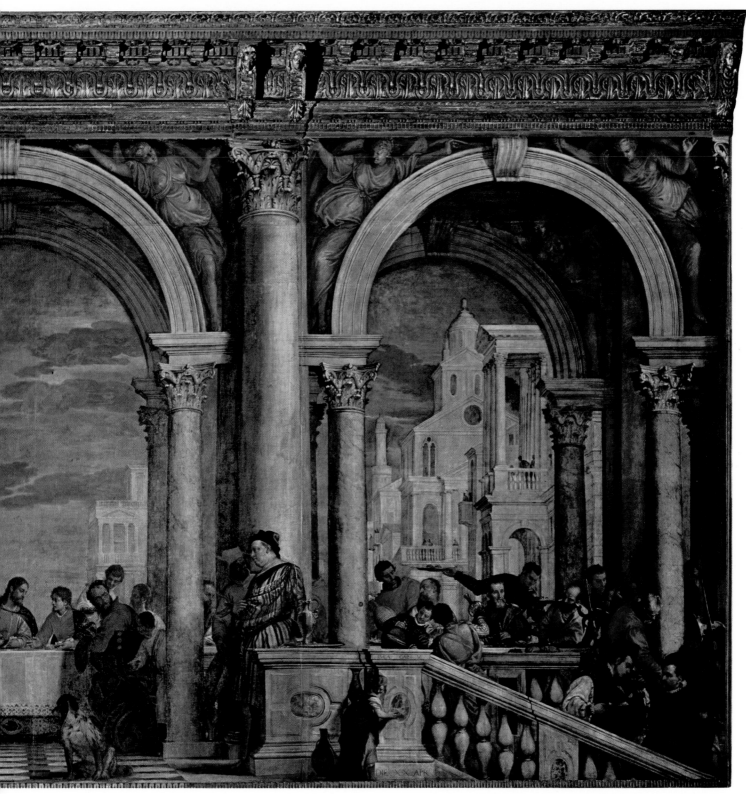

Paolo Veronese: *Feast in the House of Levi*, 1573

IV

Awakening in the North

At the beginning of the 16th Century, northern Europe was ready to welcome the light of learning and the humanistic spirit already being enjoyed in Renaissance Italy. The Habsburg Empire, which had dominated much of the Continent for more than five centuries, was relaxing its grip under internal pressure from some 300 political entities controlled by the Church or noble families or existing as free cities. The kings of France and England had ceased fighting temporarily and Flanders and Holland were enjoying a new prosperity as merchants and bankers to the Continent.

In the mid-15th Century a new awareness of classical civilizations had begun to spread through Europe. At about the same time, the dissemination of ideas was revolutionized by the invention of movable type, the improvement of the printing press and the cheap manufacture of paper; by 1500 some nine million printed books —many illustrated with woodcuts—had already been produced for an increasingly interested and literate audience. There were no more compelling ideas in this age of change than those of Martin Luther and John Calvin, who sparked the Protestant Reformation and, coincidentally, stimulated secularization in the arts.

Northern art, however, responded to change slowly. In approach it was still severely limited by the prevailing religious view that man was sinful and that the world was a field of battle where God and the devil fought for men's souls. However, it had achieved a sophisticated interest in perfection of detail; artists like Jan van Eyck and others had developed a technique that could picture textiles and fur and metal so palpably that one could almost feel them. These qualities were to be infused with a burst of energy from the south; the classical ideals revived by the Italians would soften the austere Germanic figures; the sunny color of the Mediterranean would illuminate the wintry northern light. Numerous hands played a part in the cross-pollination of artistic ideas, but the greatest of all was the Nuremberg genius Albrecht Dürer.

Born in 1471, Dürer was the third child of a goldsmith and grew

Saints Augustine *(left)* and Gregory sit in ornate Gothic niches in an altarpiece by the Tyrolean artist Michael Pacher. As in most northern European painting of the time, each precise detail has allegorical or symbolic meaning. The dove is a sign of the Holy Spirit; the little boy with the wooden spoon relates to an anecdote in the life of St. Augustine; a crowned Christ rises from the floor to instruct the writer, St. Gregory.

Michael Pacher: *The Altar of the Four Latin Fathers,* detail, 1483

up in a house where art was a fact of everyday life. His father's trade encompassed not only the making of tableware and other practical household objects but the decoration of them by engraving, a meticulous and exacting craft. From an early exposure to such craftsmanship, Dürer grew up to become perhaps the most prolific, inventive and successful graphic artist of all time. As a boy, however, he yearned not for his father's trade but for the allied craft of painter. On the basis of a remarkable proficiency for drawing that he had demonstrated at an early age, he was apprenticed to a Nuremberg painter, and thus began an education that would take him across Europe and to Italy twice. He was the first of many distinguished artists to make that pilgrimage.

Dürer was fascinated by the idealized beauty of the figures that he saw in Italian paintings, yet despite his remarkable powers of analysis and the deftness of his touch, he was never fully able to emulate them. He remained, perhaps, too much of a northerner to give himself over completely to a sensuous enjoyment of physical beauty, a beauty that was almost too perfect to be true. He once wrote that "the more exact and like a man a picture is, the better the work. . . . Others are of another opinion and speak of how a man should be . . . but in such things I consider nature the master and human imaginings errors." Dürer's nudes, like the terrified Orpheus on page 53, exist with all the blemishes and occasional ugliness of real men, not gods. Nevertheless, Dürer learned his lessons from the south, where he had the good fortune to spend time in the workshop of the great Venetian painter Giovanni Bellini. He discovered how to handle color, how to integrate figures into landscapes convincingly, how to suffuse a work with an atmosphere that unified it. In this respect he corrected a common fault of northern painters, which was to concentrate so much attention on details that each stood as an entity and not as part of a whole.

The lessons that Dürer learned he generously spread abroad in his woodcuts and engravings, which sold by the thousands across Europe. Although his work was widely admired and envied by artists, his influence was more strongly felt by younger men than by his immediate contemporaries, many of whom were isolated in their own regions, pursuing their own variants on older styles. His greatest contemporary, for example, a man best known as Matthias Grünewald, has been called the last Gothic master. His crowning work, the *Isenheim Altarpiece*, is so filled with agonized physical suffering that it was said to cheer even the dying patients in the monastery hospital for which it was painted. Dour, dark and full of demons and the torments of the saintly, it is a masterpiece of religious art; his viewers must have longed for a release to heaven from a world so awful. This quality of intense emotionality is seen in Grünewald's *Stuppach Madonna*, shown on page 57.

Another who seemed little influenced by Dürer was Albrecht Altdorfer, who almost singlehandedly formed a school of landscape painting long before it was considered a significant subject

50

for an artist. His passion for the beauties of his native countryside, a region in the upper Danube Valley, led Altdorfer to create works in which the human presence was kept as diminished as possible and the great majesty of trees and sky stood forth undisturbed. Also interested in landscape was Lucas Cranach, although he became so celebrated as a painter of sinuous nudes that it is difficult to think of him in any other way. Working for the courts of three Saxon princes, Cranach led a highly successful career creating scenes from classical mythology, scenes peopled not by lush Italianate nymphs but by lithe, small-breasted Germanic nudes with elegantly long limbs and coiled golden hair.

The one German contemporary of Dürer's who seems truly to have been influenced by him was Hans Baldung Grien, who had met Dürer when the Nuremberg painter was making his traditional "wanderyear" journey after completing his apprenticeship. Some years later Baldung joined Dürer's workshop, where he remained for several years before going off on his own.

Unlike Germany, where the inspiration of the Renaissance filtered gradually northward in the work of isolated native artists, France, through its Royal Family, imported the new style virtually wholesale. The main patron was Francis I, an extraordinary young man who was proud of his sobriquet "The Gentleman King." Early in his reign, Francis showed his enthusiasm for what the Italians were doing in the south and collected not only Italian paintings but as many Italian painters as he could entice to his court. Andrea del Sarto came to France for a year's service; Leonardo da Vinci spent the end of his restless life in a manor house at Cloux, which Francis put at his disposal in exchange for the opportunity to talk occasionally to the wise old man about philosophy and art. The great goldsmith Benvenuto Cellini was lured by Francis' not altogether appetizing promise "I will choke you with gold."

In 1528 Francis outdid his previous efforts by importing a whole colony of Italian artists to rebuild his castle at Fontainebleau. These men, settling in the countryside and mingling with French artists, infused France with the new gospel. Under the direction of the brilliant designer and sculptor Francesco Primaticcio, the Italians lavished upon Fontainebleau elaborate mythological scenes and languid stucco figures that made the castle the centerpiece of French Renaissance art. Giorgio Vasari went so far as to praise Fontainebleau as a "new Rome." It was not, of course, a new Rome; it was distinctively French, and under its bright Italian superstructure lay an old feudal gloom. This undercurrent from the Middle Ages was particularly noticeable in contemporary French poetry, whose chief patron was Francis' sister Marguerite of Navarre ("The body is only a low dungeon in which languishes the refined and noble spirit"). It was also reflected in the sculpture of Germain Pilon, whose somber turn of mind appeared in the monumental tombs and funeral effigies that were one of the major art forms of the period (*pages 62-63*).

In England the arts took another course, flowering in literature of all kinds, from Thomas More's monumental *Utopia* to the brilliant Bibles of William Tyndale and Miles Coverdale—which developed finally into the classic King James Bible of 1611—to the drama and poetry of Shakespeare and Edmund Spenser. At the same time the visual arts lay neglected; when the nobility wanted a portrait painter, for example, they usually imported someone. The only native painter of any distinction was Nicholas Hilliard, a talented goldsmith who also painted portrait miniatures *(page 61)*. The greatest force in English painting of the time was Dürer's younger countryman Hans Holbein, son of a noted painter and himself a magnificent portraitist and jack of all artistic trades.

As a young man, Holbein had worked in Basel. Although the Swiss city was a center of intellectual excitement, Holbein left it because the particularly dour form of Protestantism embraced by the Swiss—an almost total asceticism—made it difficult for him to find commissions. "The arts are out in the cold here," wrote Erasmus in a note he gave Holbein to take to influential friends in England. Holbein fairly soon got into the good graces of Henry VIII, for whom he designed silverware, jewelry, elaborate swords and daggers, robes of state, and even jewel-encrusted shoe buckles and buttons. As official court painter, he also portrayed many members of the royal household, including the King and three of his wives. It was in portraiture that Holbein's magnificent skill came to the fore. He was able to look at even the most imperious of noblemen with penetrating detachment, combining candor with a suggestion of regal monumentality. Singlehandedly, Holbein created the English court portrait style that would serve as a model to native and foreign artists for the next two hundred years.

While the arts flourished mainly at court in England and France, in the Netherlands they became the province of the people. In the Netherlandish tradition, still life, landscape and scenes of homely intimacy had long figured as elements in religious works. As the emphasis shifted to secular painting, supported by a growing middle class, these became subjects on their own. Such artists as Lucas van Leyden and Pieter Aertsen turned their attention to everyday scenes and depicted them with enthusiasm and skill.

The towering figure of painting in the Netherlands, however, was Pieter Bruegel. He was a highly educated artist who worked in Antwerp, the commercial center of all Europe, yet he chose most often to paint the lumpish peasants and rough pleasures of country life. At the same time, Bruegel's work was often filled with philosophical overtones: in his landscapes he captured a sense of man's being inexorably linked to nature; in his genre paintings he showed a compassion and humanity of almost religious depth. Like Dürer, Bruegel responded to Italian ideas of harmonious composition, and thus avoided in his crowded scenes a feeling of confusion. His pictures illustrate how well the Renaissance sense of order came to complement the detail and realism of the north.

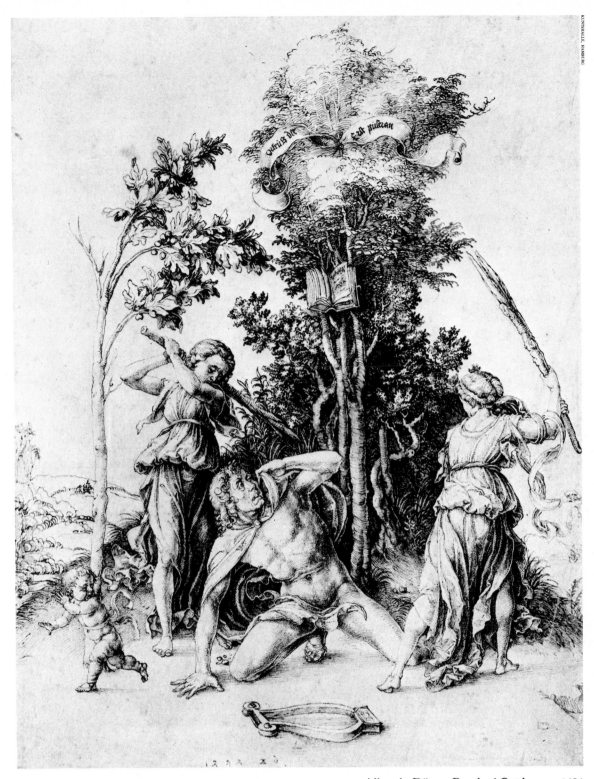

Albrecht Dürer: *Death of Orpheus*, c. 1494

New Styles beyond the Alps

As the spirit of the Italian Renaissance began to filter across the Alps at the start of the 16th Century, many northern European artists struggled eagerly to assimilate the new ideas and techniques. The first and most notable to succeed was the German master Albrecht Dürer. In his etching above, Dürer chose a classical theme, the slaying of Orpheus by the Bacchae, in keeping with the Italian revival of Greek myths. Yet his execution remains distinctively northern in the use of literal symbolism (a book of music and a lyre to identify Orpheus the musician), in the careful rendering of details, and in the still-Gothic aura of violence and fear.

53

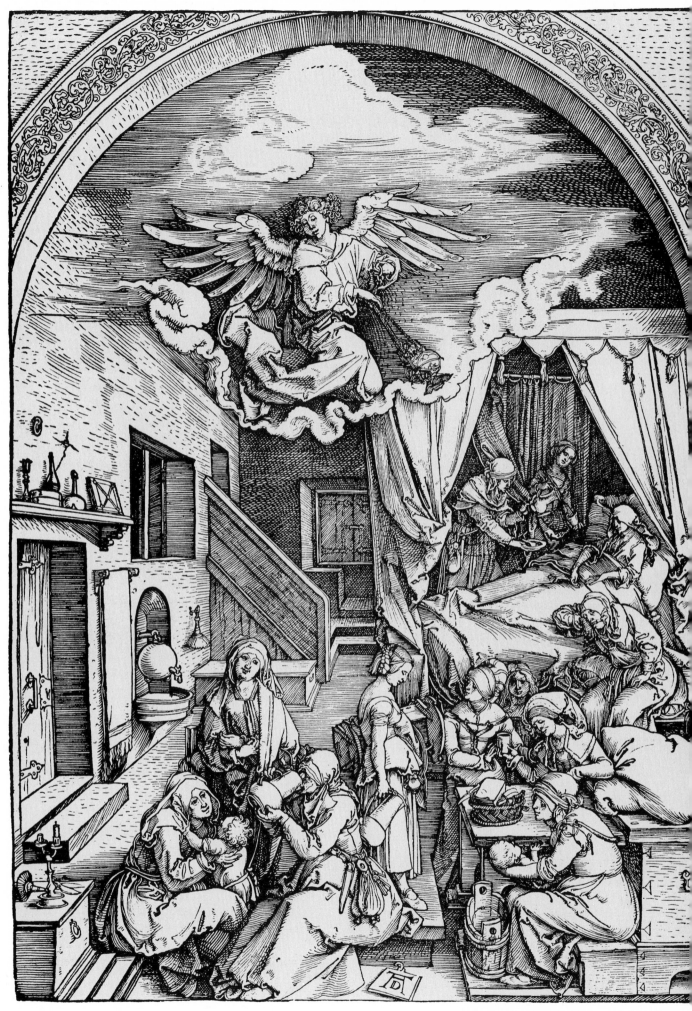

Albrecht Dürer: *Birth of the Virgin*, 151

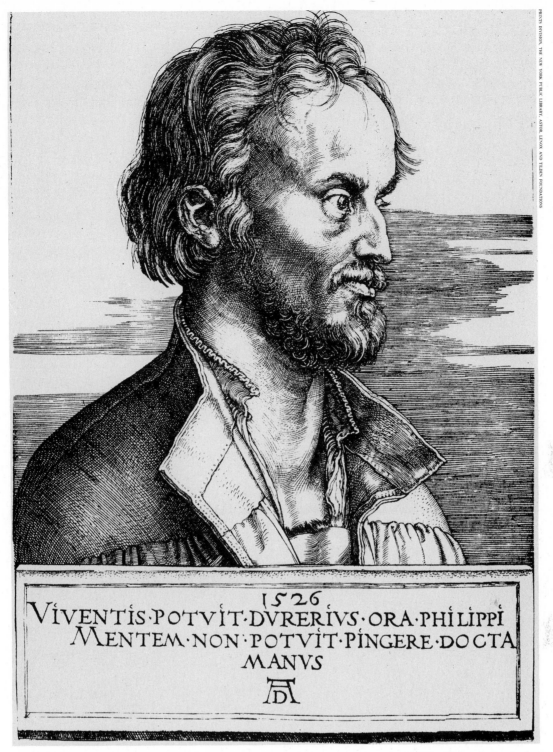

1526

VIVENTIS·POTVIT·DVRERIVS·ORA·PHILIPPI
MENTEM·NON·POTVIT·PINGERE·DOCTA
MANVS

Albrecht Dürer: *Portrait of Philip Melanchthon, 1526*

The German Masters

More than any German artist of the northern Renaissance, Dürer appealed to his countrymen, in part because of his genius for interpreting subjects in realistic, contemporary terms. The woodcut at left, one of 17 prints relating the life of the Virgin, portrays her birth in surroundings much like those of a 16th Century burgher's house. Beneath a heraldic arch where an angel swings a censer like a priest, St. Anne, the aged mother, lies in a curtained bed, too exhausted after her labor to accept a bowl of food. Attendant women, dressed like German hausfraus, go about their chores while one lovingly bathes the Infant *(right foreground)*.

In the penetrating portrait above of Philip Melanchthon, a noted humanist who in 1524 organized Germany's first free schools, Dürer applied his skill at realism to a fully contemporary subject. The large caption in Latin modestly regrets the artist's inability to capture the man's intellect as well as his features.

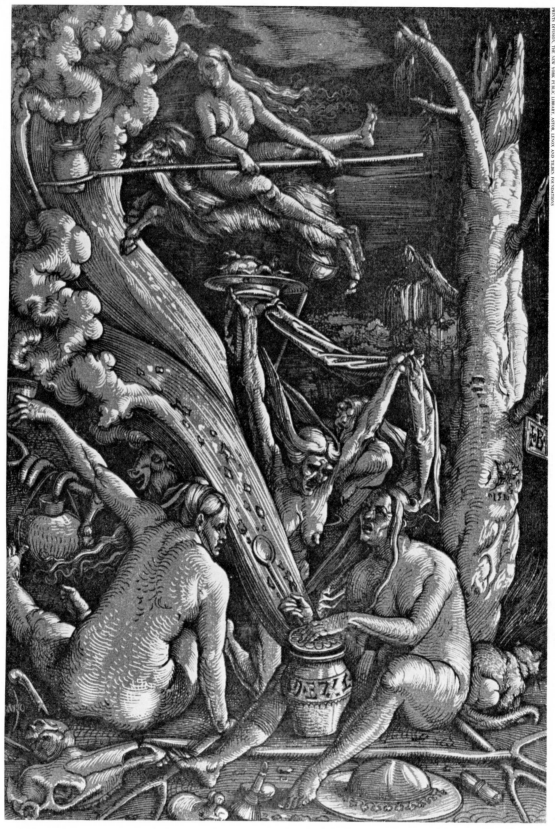

Hans Baldung Grien: *Witches' Sabbath*, 1510

German artists had long been adept at re-creating the dark side of men's minds, but in the re-awakening of the Renaissance they began to view their subjects in more humanistic ways. Hans Baldung Grien, a student of Dürer's and a leading painter, engraver and designer of woodcuts, revealed this changing attitude in the woodcut above, in which the witches of German legend, concocting their evil brew, are rendered as voluptuous, almost Michelangelesque nudes.

Grünewald: *Stuppach Madonna*, c. 1518

A new rejoicing in color and naturalism can be seen in the work of Dürer's greatest contemporary, Mathis Gothart Nithart, long known as Grünewald, a masterful painter of religious scenes. His radiant Madonna above suggests the union of celestial and earthly paradises; the Virgin's halo is a flaming rainbow and she sits in an enchanted garden containing beehives that symbolize her words: "I was in verity a beehive, when the most sacred bee, the Son of God, took abode in my womb."

Lucas Cranach the Elder: *Rest on the Flight to Egypt*, 1504

The precise and methodical observation of nature that characterizes Dürer's art was also manifest in the work of his contemporaries Lucas Cranach and Albrecht Altdorfer. In Cranach's version of the popular scene showing Joseph and Mary resting during their long journey into Egypt, the pine woods, the grasses and rocks are pictured with a vibrant reality that suggests a loving familiarity with the outdoors and a remarkable devotion to craft. Cranach later adopted an elegantly artificial style, especially in his treatment of nudes, when he became a court painter in Saxony, but early works

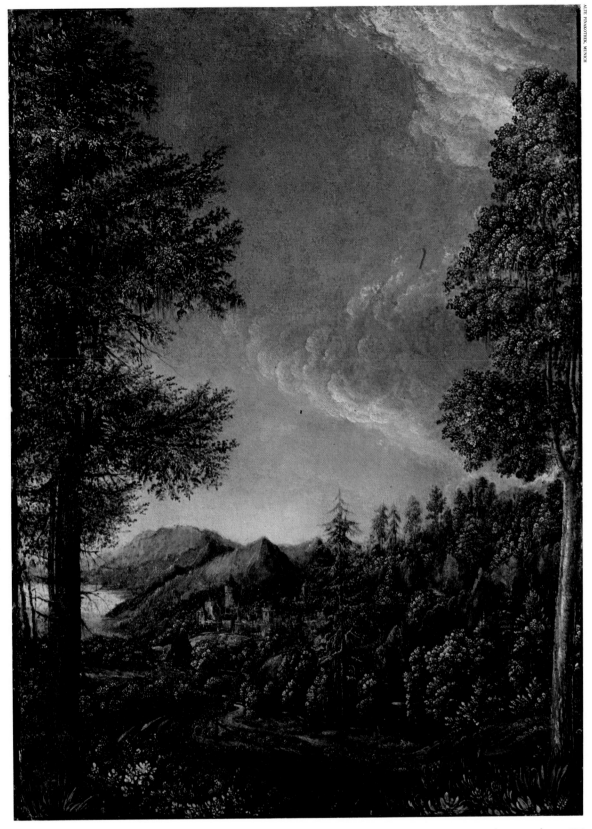

Albrecht Altdorfer: *View of the Danube Valley near Regensburg*, c. 1520-1525

like this one reveal an unaffected naturalism.

To Altdorfer, landscape, pure and simple, was so compelling a subject that he often abandoned figures or Biblical storytelling entirely and painted nature for its own sake. Seldom leaving his home in Regensburg in the upper Danube Valley, he rendered the countryside with an almost religious reverence. The soaring quality of his trees, seen against delicately painted skies, has been compared to the lofting spirituality of Gothic cathedrals. His painting above is one of the first true landscapes in the history of art.

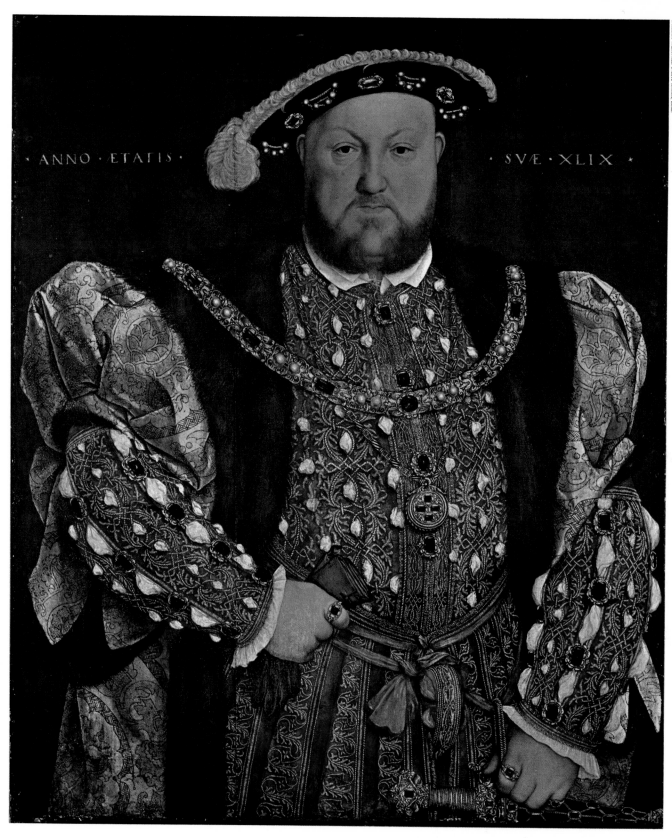

· ANNO · ÆTATIS · · SVÆ · XLIX ·

Hans Holbein the Younger: *Henry VIII*, 1540

Courtly Portraits in England

The regal hauteur, ample girth and splendid attire
of England's Henry VIII are all faithfully recorded
in the powerful portrait above by Hans Holbein.
One of the greatest portraitists of the Renaissance,
Holbein combined a mastery of technique with an
unwavering objectivity, producing works that are
almost photographic in their clarity of detail yet

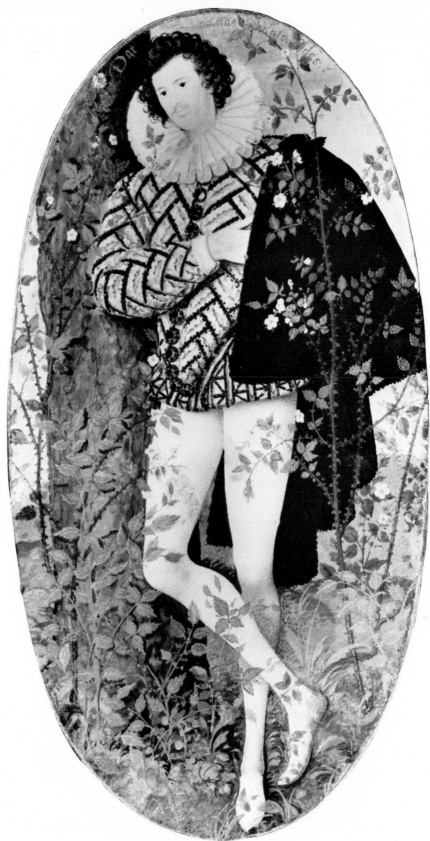

Nicholas Hilliard: *A Young Man Leaning against a Tree among Roses*, c. 1588

are imposingly monumental.

Although the German-born Holbein spent his later years in England and set the style for court portraiture throughout Europe, his presence failed to stimulate English painting as a whole. The only noteworthy native artist of the period was Nicholas Hilliard, a goldsmith who also painted elegant miniatures. Hilliard's portrait of the unknown young courtier above, done on parchment and reproduced here about 50 per cent larger than its actual size, combines the elongated grace of Italian Mannerism with the detail of Holbein. Rather stiffly posed, it nevertheless conveys a soft, poetic quality.

A New Humanism in France

The Italian influence on French Renaissance art reached its peak in the rebuilding of the royal palace at Fontainebleau, beginning in 1528. Among the hundreds of individual decorations commissioned for it by the enthusiastic art patron Francis I was the bas-relief group shown at left; in it, Francesco Primaticcio's painting of an artist at work is surrounded by graceful plaster figures by Jean Goujon that echo the Mannerist elegance of their painted counterparts.

Jean Goujon and Francesco Primaticcio: Decoration at Fontainebleau,

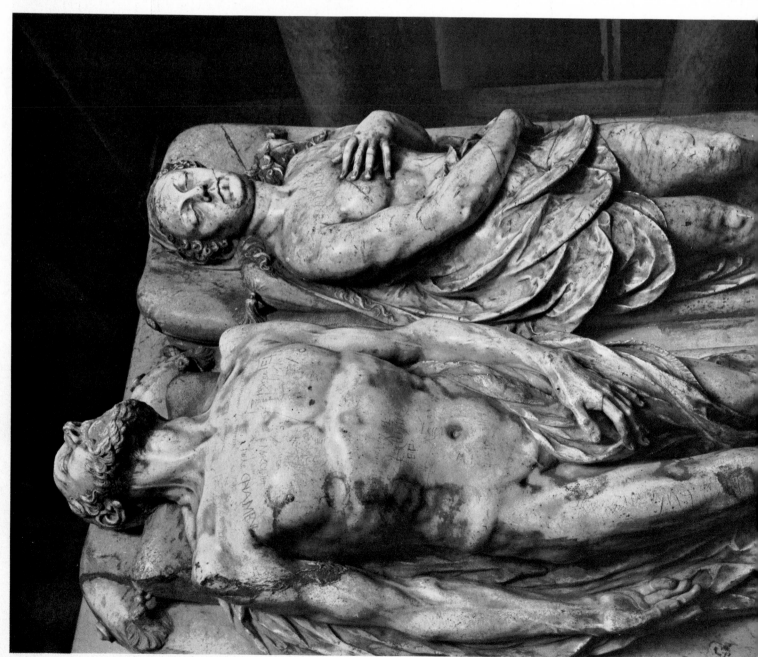

Germain Pilon: *Gisants* of the King and Queen, detail of funerary monument of Henry II and Catherine de' Medici, 1560-1573

The Italian style acquired more of a French flavor in the funerary monument to Henry II and Catherine de' Medici *(below)*, created a decade or so later for the Abbey of Saint-Denis. For the freestanding tomb *(lower right)*, whose architectural framework was designed by Primaticcio, Germain Pilon, the leading French sculptor of the period, created bronze figures of the King and Queen kneeling in prayer on top and four Virtues guarding the corners. Below, Pilon portrayed the royal pair as partially draped corpses *(lower left)*, a traditional way of memorializing nobility while expressing the transient nature of all flesh. Many such nude funerary figures had been sculptured in stages of decomposition, sometimes with vermin crawling over them, to drive home the point. By transforming the Queen into a sleeping Venus and giving the King the appearance of a dead Christ, Pilon substituted for this Gothic gruesomeness a new Renaissance humanity.

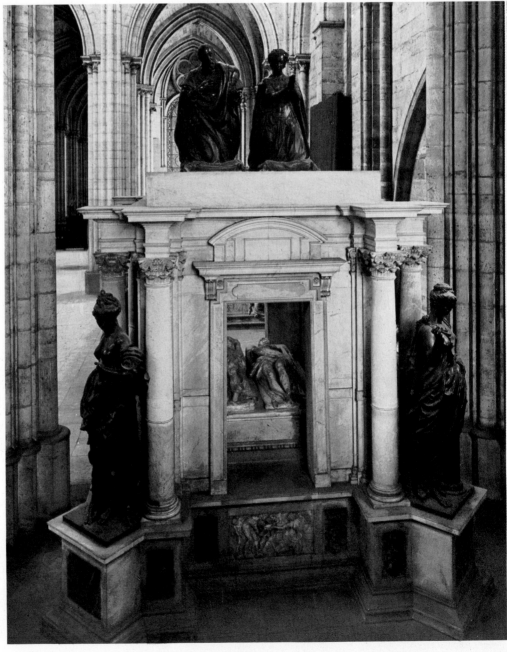

Germain Pilon and Francesco Primaticcio: Tomb of Henry II, 1563-1570

63

Pieter Aertsen: *Still Life*, 1552

The Earthy Netherlanders

Protestantism came early and strong to the Netherlands and brought with it a particularly virulent form of iconoclasm, a conviction that religious paintings were idolatrous. As a result, when religious scenes appeared at all in Dutch Renaissance painting, as they do in Pieter Aertsen's work above, they served usually as backgrounds to secular themes. In the left-hand side of this painting is a traditional group representing Christ at the home of Martha and Mary, but the religious content is completely subordinate to the still life in the foreground. The great leg of mutton and the fresh loaves of bread exist for their own voluptuous

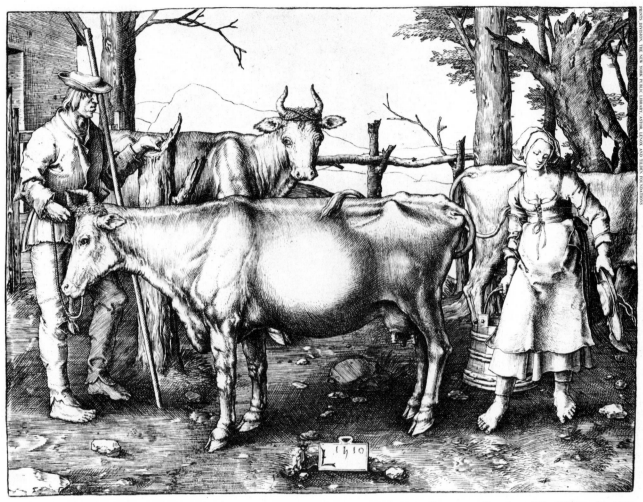

Lucas van Leyden: *The Milkmaid*, 1510

sakes, as do the glimmering pewter jug, the vase of flowers, the well-worn leather pouch, the pile of linen and the basket of pottery. Aertsen began emphasizing secular motifs in such work as this after seeing many of his altarpieces destroyed by Protestant zealots. In time he dropped even the suggestion of religion, becoming one of the first still-life painters in European art.

Another contribution to the increasing secularization of art—the depiction of scenes from everyday life—was made by the Dutchman Lucas van Leyden. In his engraving above, a milkmaid and a farmer are preparing for their daily task of milking the cows. The farmer holds the lead of one cow while the girl approaches, sturdily gripping her milking pail. In technique, a Gothic quality lingers in the spikiness of the branches of trees, the tree trunks and the sharp horns of the cow in the background. Yet the theme of the engraving is strikingly new: a simple moment in the lives of ordinary people. Called genre, it became a staple of Dutch art. Van Leyden, a prodigy who was doing masterful paintings and engravings at the age of 14, was a follower of Dürer and, echoing the German master's custom, signed this work on a plaque bearing his initial and the date.

When Pieter Bruegel went to Italy around 1552, he returned deeply impressed by the southern Renaissance feeling for nature as an infinite yet ordered whole, pulsating with life. He was especially affected by the grandeur of the Alps and produced a sheaf of drawings of them, including the one at right. Like most landscapes of the time, this work was not sketched directly from a single scene in nature but was a careful rearrangement of various natural features he had observed earlier. Above all, Bruegel's composition emphasizes the vitality of nature and the way it dominates man. The looming mountains overpower the cluster of dwellings in the valley; even the proud castle sitting high on a crest in the foreground is insignificant compared to the Alpine scenery behind it.

In technique as well as spirit, Bruegel learned much from the Italians. In this picture he used an aerial point of view, a device Leonardo had explored, to allow the viewer to look down into the scene; he also applied Renaissance principles of perspective to move the eye deep into space. The magnificent, rolling forms of Bruegel's later landscapes would reflect the lasting influence of the lessons illustrated here.

Pieter Bruegel the Elder: *Mountain Landscape with River Village and a Castle,* c. 1553-1554

67

V

Grandeur and Glory in the Arts

For much of the 16th Century, Europe had been in crisis. Emotionally it was torn by the Protestant Reformation and the Catholic Counter Reformation; physically it was ravaged by religious wars and the strife accompanying the emergence of France, Germany and other countries as national entities. The prevailing mood had been one of distrust of the present and doubt about the future.

But by 1600 tensions had eased, and as pessimism gave way to a brighter outlook, Europe entered one of the most dynamic eras in its history. The 17th Century would see centralized states ruled by kings of unlimited power and unprecedented grandeur; the Catholic Church, well on the way to recovery from the damages wrought by the Reformation, would reassert its Faith with new confidence and intensity; brilliant scientists and theorists, among them Galileo, Isaac Newton and William Harvey, would add new dimensions to man's knowledge about his immediate physical world and the heavens above it.

The exuberant spirit of the age was mirrored in its art, nearly every aspect of which was dominated by the vigorous style known as Baroque. Originally the term "Baroque" was one of disparagement used by critics to describe the grotesque or overelaborate. Today, however, the Baroque style is properly recognized as a casting off of artificial conventions and restraints that had invaded art toward the close of the Renaissance in favor of a more naturalistic form of expression, full of imagination, vitality and emotion.

Rome, seat of the rejuvenated Catholic Church, saw the first flowering of the Baroque under the enthusiastic patronage of the popes and other princes of the Church. With the inroads of Protestantism still fresh in their minds, Catholic leaders saw in the energetic new style, with its powerful emotional appeal, a potent method for increasing the drama surrounding the mysteries of the Faith and thereby strengthening the worshiper's devotion. Moreover, the Baroque's rich and dynamic design was eminently adaptable to the ambitions of popes determined to make Rome the

69

most splendid city and pilgrimage center in the Christian world.

The towering figure of Roman Baroque was Gianlorenzo Bernini, the greatest sculptor-architect of his day. Patronized by a long line of popes and prelates, Bernini fulfilled a prodigious number of commissions ranging from the design of churches, chapels and palaces to the creation of floats for religious pageants. One of his major tasks, occupying him on and off for 56 years, was the completion of the interior decorations of the great basilica St. Peter's, begun in Michelangelo's time, and the construction of the great oval plaza before the church. With a sense of climax typical of the Baroque, Bernini conceived the plaza as a prelude to St. Peter's; he designed the two sweeping arms of its colonnades to suggest the embracing arms of the Catholic Church and to draw the spectator's eye to the edifice containing the grave of St. Peter, the first pope.

Bernini repeated this feeling for climax within the church. First, to supply a focus for the enormous interior, he raised a 90-foot-high bronze baldachino, or canopy, beneath the dome and over the traditional site of St. Peter's tomb. Supported by spiral columns and crowned by statues of angels, the baldachino was a brilliant fusion of architecture and sculpture epitomizing the sensuous magnificence of Roman Baroque. Then, as a grand finale to a pilgrim's journey to the church, Bernini encased the wooden chair said to have been St. Peter's in an elaborate bronze throne and placed it, surrounded by a burst of golden rays and swirling heavenly figures, at the end of the main nave where it could be seen through the frame of the baldachino.

As typically Baroque as St. Peter's was the emotional intensity and immediacy that Bernini expressed in his sculptural works. His saints in bronze or marble *(page 68)* were often shown at the very instant of divine inspiration and with such astonishing forcefulness that the viewer feels himself sharing in their ecstatic experience.

During the final years of the Renaissance, Rome had emerged as the greatest creative center in Europe, and throughout the 17th Century it attracted painters, sculptors and architects from all over the Continent. Some came chiefly to contemplate the creations of old masters like Michelangelo and Raphael. Others also studied more recent works by Bernini or by such early Baroque painters as Caravaggio and Annibale Carracci *(pages 76–77)*. When these visiting artists returned to their homes in Spain, France, Flanders, Holland and elsewere they carried with them the canons of the Baroque style, and before the middle of the century all Europe was feeling the influence of Italy, in many different, often interrelated, ways.

In traditionally conservative Spain the influence was less flamboyant and less striking than elsewhere. The dignified, formal portraits of Philip IV and his family by Diego Velázquez, the greatest 17th Century Spanish painter, show little emotion or animation, but they are subtle revelations of character that Bernini would have admired. And Velázquez' dramatic use of light and shadow in court

portraiture, as well as in his naturalistic scenes of ordinary Spanish life, also show a debt to Italy.

France, too, adopted a modification of the Baroque that emphasized dignity and formality. A major role in the development of the French variant was played by the expatriate painter Nicolas Poussin, who spent almost all of his career in Rome. Scorning the ebullient Baroque of Carracci and Bernini, Poussin evolved a style echoing the classicist discipline, heroic forms and noble ideals of the Renaissance masters. Poussin's work *(page 81)* was greatly admired in his native France, and when Louis XIV began to emerge as the resplendent Sun King and the most powerful monarch in Europe, he found Poussin's classical adaptation of the Baroque admirably suited to exalt his person and to glorify his reign.

The supreme expression of the personal style of Louis XIV—a patron of art rivaling the Medicis and the Roman popes—is the sumptuous palace he built for himself at Versailles, a few miles outside Paris. It is the most imposing royal residence in Europe, set amid magnificent formal gardens and fountains. Its interior provides a dazzling display of opulence, with multicolored marbles and glittering mirrors, and tapestries, sculptures and paintings that allegorically portray Louis as a triumphant warrior, mighty statesman or the incarnation of the sun god Apollo.

Flemish and Dutch artists journeyed to Italy in the 17th Century and were directly inspired by its Baroque art. The most brilliant was the Flemish painter Peter Paul Rubens. Rubens lived in Italy from 1600 to 1608 and was deeply influenced not only by the old masters but also by the early Baroque paintings of Caravaggio and Carracci. He especially admired Caravaggio's naturalism, dramatic lighting and sensuality and Carracci's heroic, dynamic compositions. Back in Flanders, Rubens synthesized these qualities in his own work to achieve in painting the exuberance and rich effects that Bernini and his followers realized in sculpture and architecture. Religious and courtly subjects, events from mythology or ancient warfare, landscapes, portraits—all came within the sweep of his brush, and he painted them all with tremendous vitality and a strong feeling for grandeur. Rubens' battle scenes are whirlwind compositions, pulsing with life and filled with the glint of armor and the sheen of rich fabrics against bronzed flesh *(pages 82-83)*. The wildly struggling figures and frenzied horses seem almost to burst from their frame to involve the viewer in the picture's action in a characteristically Baroque manner.

While Rubens was dominating Flemish painting with his robust works, artists in neighboring Holland were developing their own distinctive versions of the Baroque. The outstanding Dutch master, Rembrandt van Rijn, never went to Italy to study, but still he was indirectly influenced by the Baroque style. His early portraits and religious or mythological pictures were painted with an intense realism and sharp lighting reminiscent of Caravaggio. Some of his earlier works *(page 79)* also are imbued with a splendor and

excitement not unlike that of the full-blown Baroque of Rubens. But following the death of his beloved wife in 1642, Rembrandt's paintings became softer and more introspective, concentrating less on the external aspect of people and events and more on their spiritual qualities and the emotional relationships between them.

Contemporary with Rembrandt was a large and flourishing school of Dutch painters specializing in less lofty matters. After almost one hundred years as part of the Spanish empire, the Netherlands won its struggle for independence, while Flanders remained under the rule of Spain. During the period of Spanish domination, Dutch merchants had grown wealthy on trade with the New World and the East, and many of them wanted paintings to adorn the walls of their homes. Their new sense of freedom engendered such a love of the land that a native landscape school developed, pioneered by such masters as Hercules Seghers *(page 78)*. The demand for pictures in 17th Century Holland was so great —not only among the rich burghers but among ordinary people as well—that a visiting Englishman noted in amazement that "it is an ordinary thing to find a common farmer lay out two or three thousand pounds in this commodity. Their houses are full of them, and they vend them at their fairs to very great gain."

The artistic tastes of the merchants and the Dutch public in general ran toward representations of the daily life around them —portraits of solid Dutch citizens of all classes, scenes of quiet domestic activity and lusty tavern lowlife, and views of the native countryside or of the sea that had brought Holland its prosperity. Such works proliferated, and in many of them the Baroque touch was apparent. Frans Hals's portraits of vivacious peasant characters and jovial soldiers captured the essence of a moment, the fleeting expression that Bernini caught in his sculptured busts. Striking contrast of light and shadow, another Baroque hallmark, can be seen not only in dramatic landscapes, but also in such homely scenes as a mother rocking a cradle in a room where deep shadows lurk while sunlight pours through an open door.

In its many national and personal expressions the Baroque style was as varied as the personalities of the artists who created it—from the hard-working, pious Bernini to the carouser Hals, who married twice, fathered at least 10 children and died a pauper in his middle eighties. If it is perhaps imprecise to apply the term too widely, at least it serves to characterize an age and art that was filled with vivacity and an attachment to life. In the following centuries, Italy, the fountainhead of the Baroque, would lose its artistic dominance —held for almost three hundred years—while Holland would continue in its quiet, domestic vein and Spain and England would produce occasional brilliance but no broad-scale or unified artistic pattern. The new leader in the arts would be France, where, in the next two centuries, a series of delightful and fascinating styles, evolving at an ever-accelerating pace, would place French art at the very threshold of the modern world.

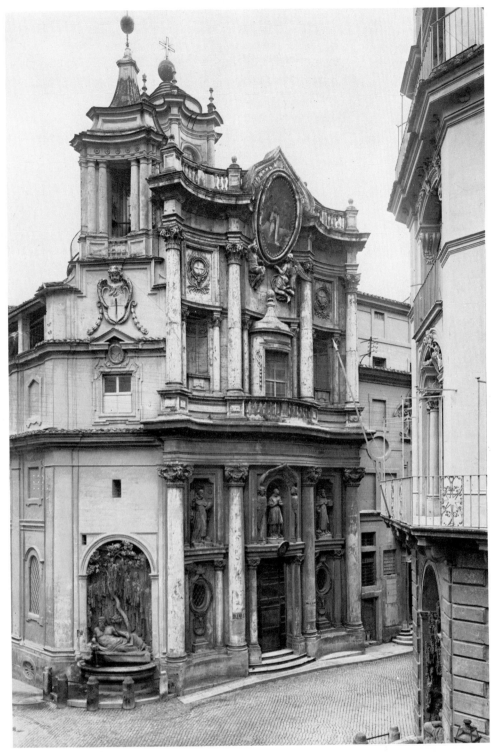

Francesco Borromini: San Carlo alle Quattro Fontane, Rome, 1664-1667

The Vitality of the Baroque

Baroque art deals with strong emotions—its subjects often seem to shriek, sob or moan; its lines twist and swirl with energy. The style was developed in Italy at the end of the 16th Century, partly in response to the Catholic Church's need to reassert its dominance and bolster its flagging membership. Even Baroque architecture was passionate: the ornate façade of Francesco Borromini's Church of San Carlo in Rome *(above)* strikes the eye with a rich surface accentuated by strong verticals, undulating horizontals and shadowed sculpture niches. The new style spread from Italy to the rest of Europe, and in each country it found a varied and inventive expression.

Monuments to Might

Baroque architecture bespeaks not only passion but grandeur. When the Frenchman Jules Hardouin Mansart drew up plans for Paris' Church of the Invalides (*left*), he tried to create not merely a well-designed place of worship, but a monument to impress the beholder with the glory of God—and of Louis XIV, who commissioned the church. Mansart fused dome and façade into a single huge, towering form. Similarly, England's Blenheim Palace (*below*) was conceived as more than a nobleman's private house. The English people presented it to the Duke of Marlborough as a reward for the Battle of Blenheim and other victories over the French, and intended it as a memorial to English armed might through the ages. Blenheim's architect, Sir John Vanbrugh, built it on an overwhelming scale. In Italy, Guarino Guarini gave Baroque grandeur a most imaginative expression. He designed the dome of the Church of San Lorenzo (*right*) to impress observers not by its heaviness but by its lightness. The dome, pierced with numerous windows, seems too delicate even to support its own weight, creating for worshipers the illusion of a miracle in the form of a glowing hemisphere open to heaven.

Jules Hardouin Mansart: Dôme des Invalides, Paris, 1679-1706

Sir John Vanbrugh: Blenheim Palace, begun 1705

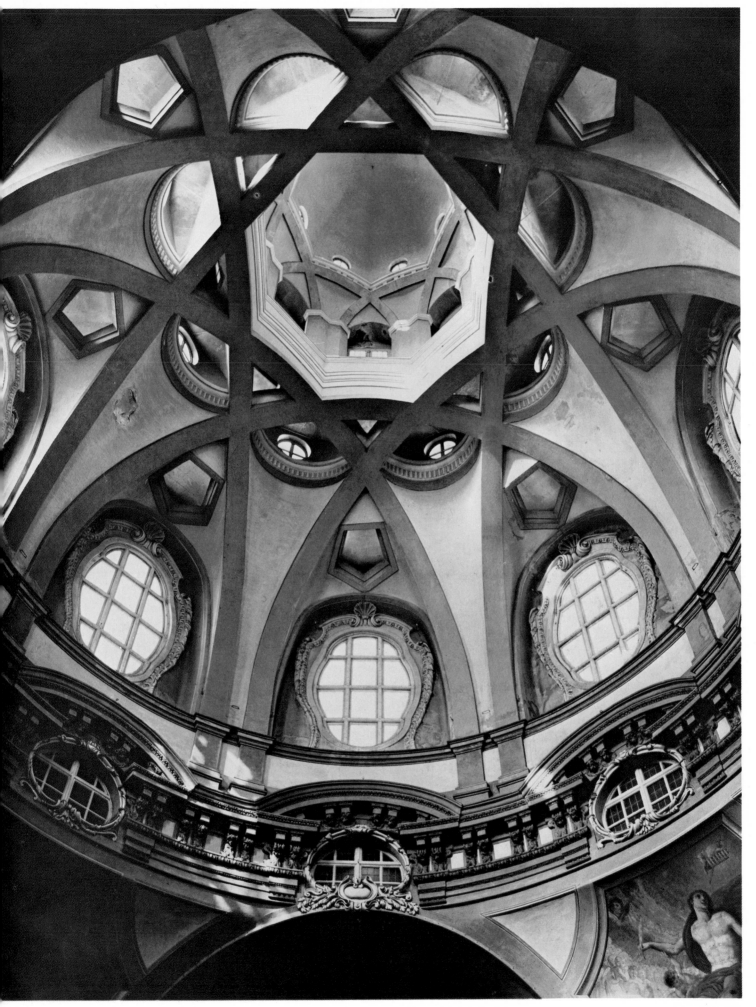

Guarino Guarini: Dome of San Lorenzo, Turin, 1668-1687

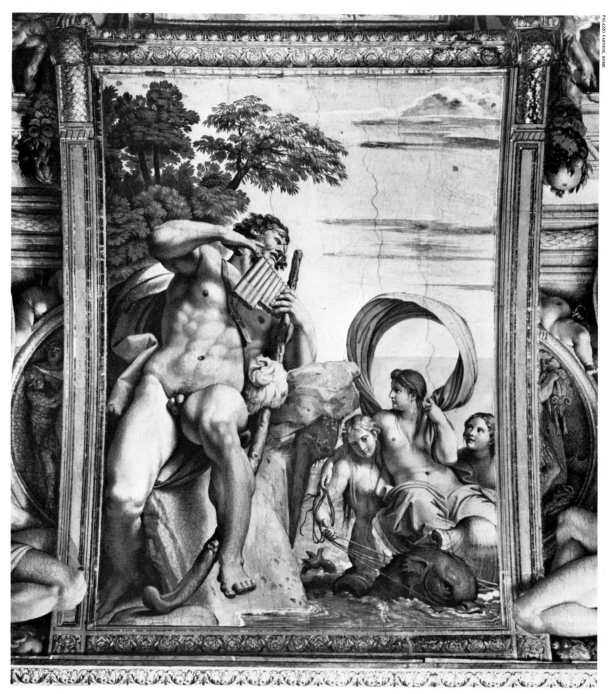

Annibale Carracci: *Polyphemus and Galatea*, 1597-1601

Italian Giants

The two Roman masters of Italian Baroque painting were Annibale Carracci and Michelangelo Merisi, better known as Caravaggio. Caravaggio, the more inventive and fiery of the two, possessed both an extraordinary gift for painting as well as a remarkable capacity for getting into hot water. He was in and out of jail (once for throwing stones at a policeman) and committed a murder. In works such as *The Deposition (right)* he cast aside Renaissance practice and depicted Biblical characters not as idealized heroes but as everyday people. He also added great drama to his canvases with sharp contrasts of light and shadow.

Annibale Carracci was a more sober and controlled craftsman who spent as much time perfecting his drawing as Caravaggio did cooling his heels in prison. Carracci loved the ideal world of mythology. Gods and goddesses had been, of course, common subjects for Renaissance artists, but Carracci endowed his scenes with unprecedented vitality. In the panel above, from his frescoed ceiling in the Farnese Palace in Rome, he used dramatic foreshortening to enliven the muscular figure of the lovesick cyclops Polyphemus serenading a disdainful sea nymph attended by two servants.

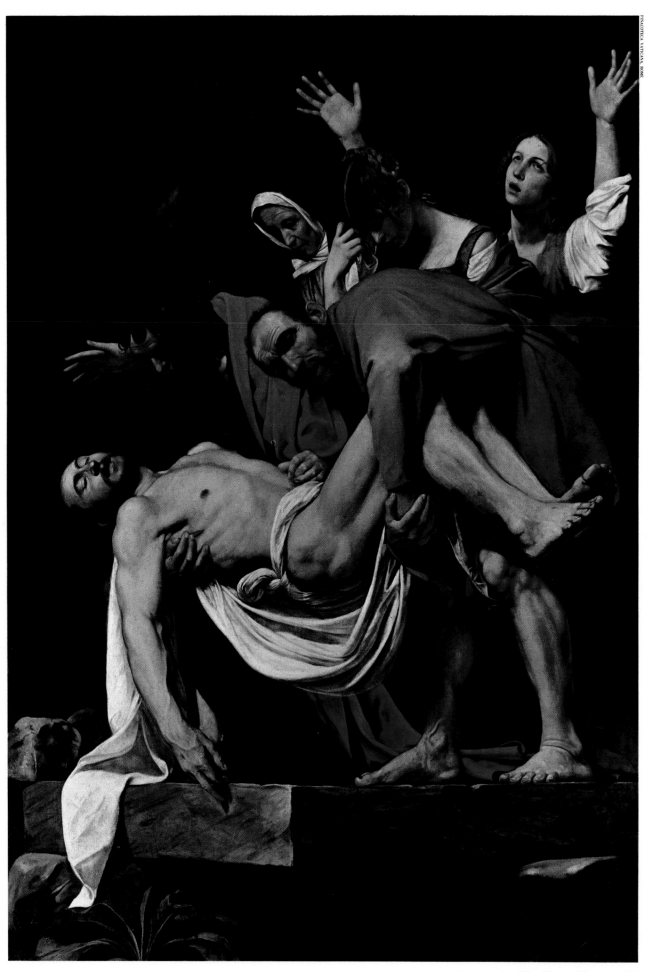

Caravaggio: *The Deposition*, c. 1603

Inspiration from the South

Caravaggio's realistic yet dramatic treatment of religious themes came as a revelation to 17th Century Dutch painters. Hendrik Terbrugghen spent years in Rome studying the Italian master's work, and throughout his life he showed himself a loyal follower: in his painting at right, down-to-earth detail is set off by a lively interplay of light and shade. Hercules Seghers, primarily a landscapist, shared Terbrugghen's esteem for Caravaggio; the skimpy records of his life mention no trips to Rome, but the lighting effects in the painting below make his allegiance clear. Rembrandt absorbed Caravaggio's influence through the works of Terbrugghen and Seghers. His *The Woman Taken in Adultery (far right)* shows a debt to the others but has an aura of moving spirituality that is uniquely his own.

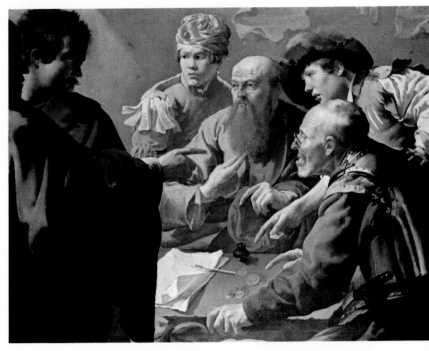

Hendrik Terbrugghen: *The Calling of St. Matthew*, 16

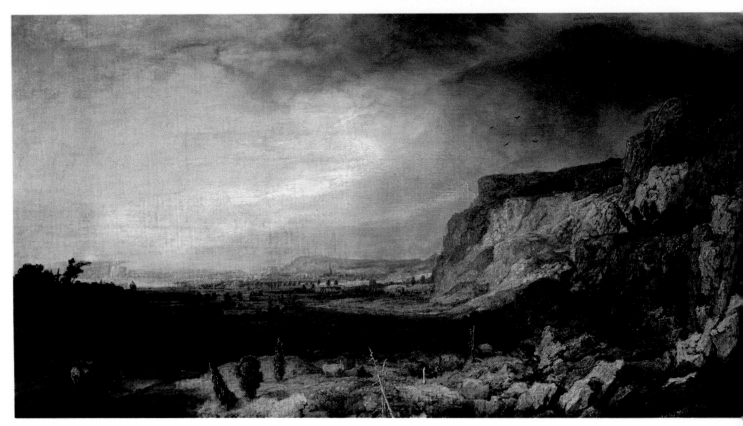

Hercules Seghers: *Mountain Landscape*, c. 1620-162

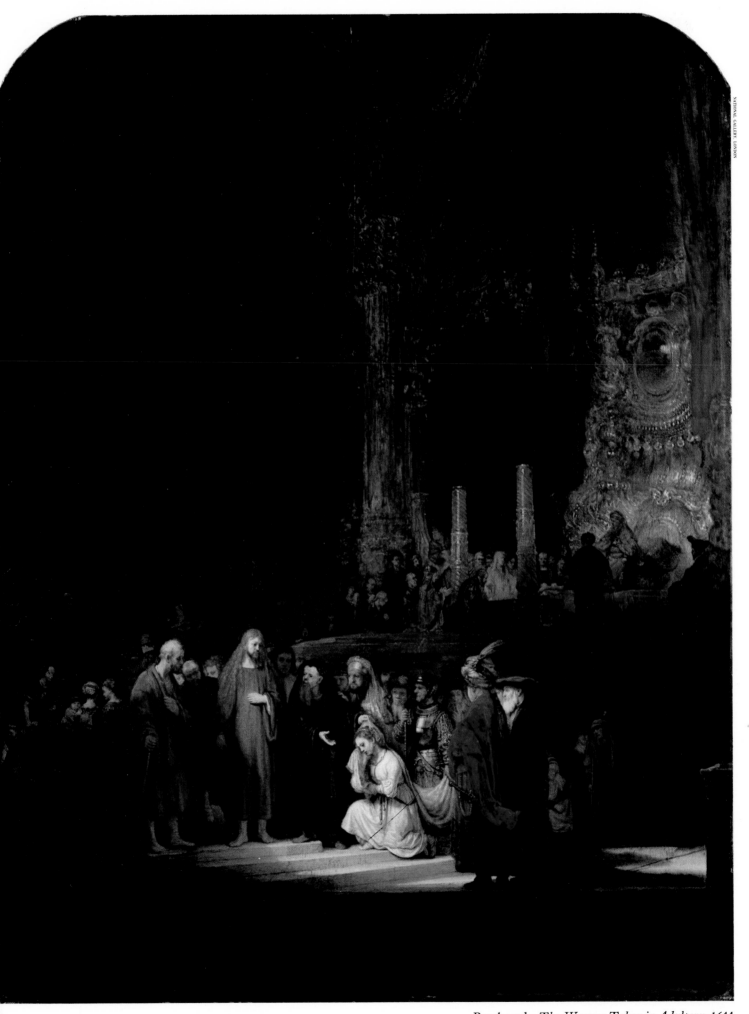

Rembrandt: *The Woman Taken in Adultery*, 1644

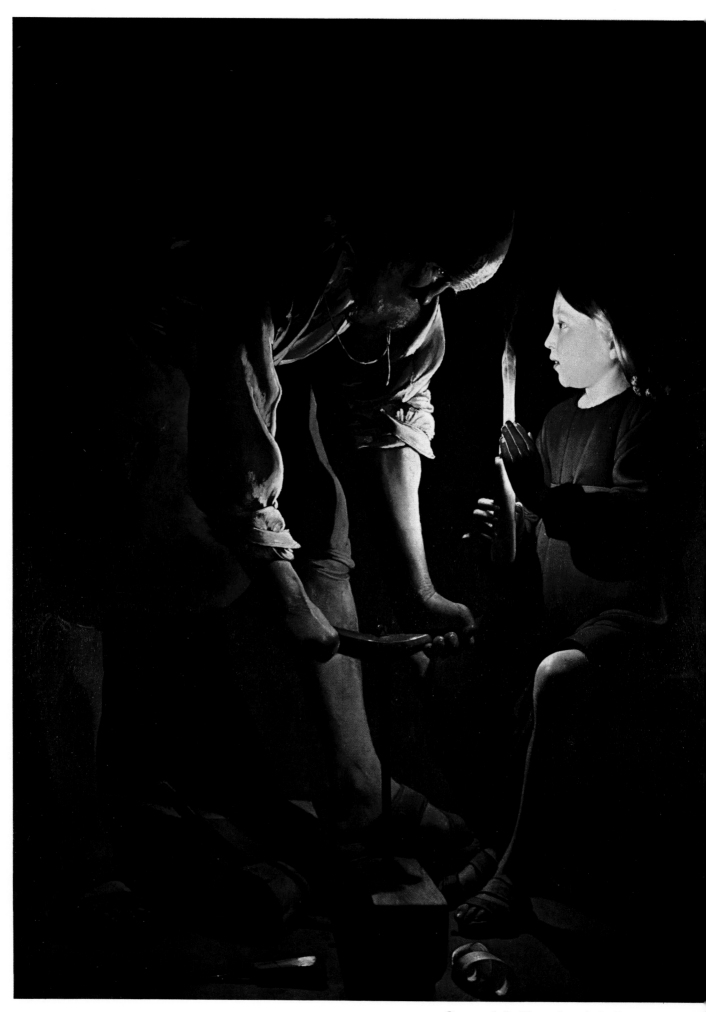

Georges de La Tour: *Joseph the Carpenter*, c. 1645

Claude Lorraine: *Seaport at Sunset*, 1639

Baroque à la Française

Two paradoxes underlie the history of
French painting of the Baroque era. A most
Italianate Frenchman, Georges de La Tour
probably never visited Italy, but modeled his
style *(far left)* on the work of Terbrugghen
and other Dutch *Caravaggisti*. On the other
hand, Nicolas Poussin and Claude Lorraine,
who lived in Rome much of their lives, owe
little to the Italian Baroque. They developed
a more classical style that came to
dominate 17th Century France: its hallmark
was an atmosphere of cool perfection.

Nicolas Poussin: *The Inspiration of the Poet*, 1636-1638

The Florid and the Terse

The diversity of styles that Italian Baroque painting stimulated testify to its vigor. The portrait of Don Baltasar Carlos *(below)* by the Spanish painter Velázquez and the *Battle of the Amazons (left)* by Rubens, a Flemish artist, appear a world apart. But both artists actually had come under the influence of the same masters, Caravaggio and Carracci, whose paintings they had studied in Rome. In *Battle of the Amazons,* Rubens' dramatic use of strong lights and deep shadows, his realism and precise drawing, all stem from Roman studies. The heightened brilliance of his color and the extraordinary complexity of the swirling composition, however, were his own inventions. Velázquez, like Rubens, refined his handling of light and line while in Italy. But the dramatic elements of the Italian style are less seen in his work, for he applied his new knowledge to his own specialty, rich yet austere royal portraits painted with remarkable psychological insight.

Peter Paul Rubens: *Battle of the Amazons,* c. 1618

Diego de Silva Velázquez: *Don Baltasar Carlos,* 1639-1641

83

VI

An Age
of Pleasure

The 18th Century was a crowded, restless age that saw profound changes in nearly every major field of human endeavor. Industrialism began to reshape European life; new ideas about the rights and dignity of the common man arose to challenge the established order of state and society. Before the century had run its course, those ideas had erupted into violence, and the era of autocratic kings ruling by divine right gave way to the era of the American and French Revolutions, heralding the birth of modern democracy.

Art, always sensitive to turns in the affairs and attitudes of men, reflected the confusion and complexities of the times. The first significant shift toward new directions came soon after 1715, when Louis XIV of France died amid the splendors of his palace of Versailles. During the Sun King's 72-year reign, the longest in Western history, France had dominated Europe not only politically but culturally, and its monarch's artistic taste had become an international model, eagerly emulated by lesser royalty all over the Continent. Louis favored a classicistic version of the Baroque, an opulent, theatrical style that was eminently adaptable to exalting a temporal ruler as well as a divinity.

But with Louis no longer present as pacemaker of this resplendent art, most of Europe's courts turned to a less formal, more light-hearted style in their architecture, sculpture and painting. Known as Rococo and intended solely to beguile, the new style took its name from the French term *rocaille,* referring to the playful encrustations of small stones and sea shells that adorned artificial grottoes on lordly estates.

Originating among French nobles bored with the pompous magnificence that had long prevailed at Versailles, the Rococo spread quickly throughout Europe in the first half of the 18th Century. Instrumental in its rise to popularity was a general casting off of old courtly restraints as the elite abandoned the rigid, tiresome etiquette of the Louis XIV epoch and eagerly subscribed to a new philosophy of pleasure summed up in the dictum of Madame du Châtelet,

the mistress of Voltaire: "We must begin by saying to ourselves that we have nothing else to do in the world but seek pleasant sensations and feelings."

The shift from Baroque grandeur to the sparkling gaiety of the Rococo was strikingly evident in the lavish, frivolous, even giddy way the wealthy decorated their houses. In the past, order and symmetry had been the architectural ideal, but with the trend to carefree living the expression of individual fancies became the goal. Rooms were built on more intimate proportions: easy, curving lines, freely used both in architectural details and in furnishings, generated a sense of sprightly, never-ending movement. They also provided graceful frames for gilded or brightly painted decorations whose chief motifs were cupids, flowers, garlands and shell-like shapes. Even religious buildings were enlivened by the Rococo, notably in southern Germany, where church walls and ceilings were embellished with fantastic curvilinear forms and festive ornaments in white, gold and pastel hues.

Painting, too, proclaimed the new cult of pleasure. Whereas French Baroque artists had dwelt mainly on grand religious and mythological themes, Rococo artists concentrated on charming trivialities. Delicately tinted pictures of contemporary aristocratic life showed exquisitely clad men and women amusing themselves with masquerades, acting out pastorales or playing at love in confectionery landscapes. Scenes based on mythology no longer centered on such formidable deities as Jupiter or Juno but on frolicsome, provocative, pink-fleshed goddesses attended by swarms of nymphs, bacchantes and dimpled cupids.

One artist who achieved resounding success with this frilly kind of painting was François Boucher, who became the protégé of Madame de Pompadour, mistress of the French King Louis XV, and ultimately First Painter to the King and president of the French Academy. A man of enormous creative energy, Boucher not only carried out multiple painting commissions for Madame de Pompadour and her royal protector, but extended his decorative style to include, among other things, the design of objects manufactured at the Crown-controlled porcelain factory of Sèvres, sets for ballet and opera, and cartoons for tapestries woven at the famous factory of Beauvais. Through his own varied works and those of his pupils, Boucher's style was widely disseminated, making him for a while the most influential painter and decorator in Europe.

Most of the paintings of Boucher and other Rococo artists were sheer froth, as shallow as the patrons who commissioned them. A few artists, however, triumphed over the Rococo's limitations. The greatest was the French painter Antoine Watteau, whose portrayals of gay fetes and coquettish love affairs were often tinged with a poetic melancholy, and skillfully blended fantasy with a close observation of nature. And probably no artist more deftly captured the *joie de vivre* of the Rococo era than the Venetian Giovanni Battista Tiepolo, whose frescoed ceiling paintings for palaces and

churches featured hosts of airborne figures joyously afloat in boundless blue skies. In his own time Tiepolo enjoyed international fame. Besides decorating important buildings in his native Italy, he was called to Germany to embellish the palace of the Prince-Bishop at Würzburg, and later he spent four years painting the ceilings of the Spanish royal palace in Madrid.

By 1750, however, a reaction was growing against the ornateness and sensuousness of the Rococo style and against the hedonistic society that supported it. The reasons for dissatisfaction were many and complex, among them a growing resentment of artifice, a consequent rebirth of interest in nature and a rediscovery of the ideals of ancient classical art. Of equal if not greater importance, however, was the spread of democratic ideas and the rise of a new philosophy of reason, propounded by such enlightened thinkers as Voltaire in France and Immanuel Kant in Germany. The pursuit of happiness began to take on a different meaning for most people. Artists responded by seeking a means of expression that was less limiting than the Rococo. Their quest was to produce significant changes in both the substance and style of European art.

In England a distinctively national school of painting emerged whose practitioners catered not to wellborn patrons alone—as did most of their Continental colleagues—but also to the more down-to-earth tastes of an increasingly prosperous and powerful merchant class. Thus William Hogarth, England's first great native painter, won wide success with his "modern moral subjects"—paintings and engravings that ridiculed the foibles of high society and exposed the plight of the poor while extolling such middle-class virtues as temperance, industry and honesty. Thomas Gainsborough's portraits of aristocrats showed them in all their finery —yet at the same time probed beneath the elegant exterior to capture a sitter's essential character.

Even in France, birthplace of the Rococo, signs of a new approach in art could be glimpsed. While most artists continued to devote themselves to scenes of fashionable frivolity, Jean-Baptiste Chardin—now esteemed as one of the authentic masters of his time —produced pictures of ordinary, unpretentious people going about their homely tasks, as well as still lifes that glorified such humble objects as the copper pots and food stuffs found in any 18th Century kitchen. A further shift from Rococo playfulness appeared in the works of Jean-Baptiste Greuze. Although his canvases of French bourgeois life could be excessively sentimental, they also reflected the growing emphasis on emotion urged by Jean Jacques Rousseau and other influential writers calling for man's "return to nature."

Coincident with the trend toward naturalism in art, a new fascination with the works of the ancient Greeks and Romans began to preoccupy artists all over Europe. The rekindled interest in antiquity was sparked in large part by excavations at the old Roman cities of Herculaneum and Pompeii, and by a re-evaluation of classical art made by the brilliant German archeologist and art historian

Johann Joachim Winckelmann, who eulogized "the noble simplicity and calm grandeur" of the ancient Greeks. This resurgence of Classicism, called, more properly, "Neoclassicism," also came to have political and social overtones. Some of the revolutionary concepts that were increasingly undermining the authority of the ruling class in France and other European nations as the century approached its final third were modeled upon ideas of republicanism that had flourished in the days of classic Greece and Rome. As views about democratic equality and rule by reason rather than by caprice took root, a serious mood settled over Europe. The insouciant art of a privileged minority was no longer regarded as an adequate representation of real life.

Even the aristocracy succumbed to the Neoclassical movement, although sometimes only as a new form of diversion. Suddenly antiquity became high fashion. Salons were stripped of their sensuous Rococo curves and curlicues and were redone in a more austere and orderly decor inspired by the simplicity of Greek and Roman interiors. Fussy furniture fell from favor, to be replaced by furnishings with clean, symmetrical lines. Paintings of amorous goddesses and scenes of genteel dalliance gave way to glorifications of virile figures from mythology and the stern, self-sacrificing heroes of ancient Rome.

By far the most influential artist to embrace sober classical themes was the French painter Jacques-Louis David, whose canvases idealized such Roman virtues as civic duty and resistance to tyranny. One of David's most famous pictures, completed in 1789 and purchased for Louis XVI of France, showed the Roman praetor Brutus seated stoically in his home as soldiers carry in the bodies of his sons—condemned to death by Brutus himself for plotting against the Roman Republic. When the picture was shown in Paris some spectators admired its dramatic lights and shadows, its suppression of all but essential details, the restrained passion of its central figure. Others, including the King and his court, probably took its theme of patriotism and public duty to imply loyalty to the Crown. But many later viewers have seen the picture as both an attack on the class whose profligacy had brought France to the brink of economic and political chaos and a warning that only by putting the state above personal considerations could the country be saved. How consciously David intended *The Lictors Bringing Brutus the Bodies of His Sons (page 97)* as revolutionary propaganda cannot be known, but within four years after its exhibition the French monarchy and its effete nobility were swept away in the bloodbath of the French Revolution.

As official arbiter of the arts under the new Republic, David was for some years virtual dictator of esthetic tastes in France, and his use of classical themes to point out modern moral lessons was widely copied. But with the rise of Napoleon and a new French Empire, the Neoclassical style lost much of its idealism and became merely an evocation of imperial splendor and luxury.

François Boucher: *Pastorale*, 1761
WALLACE COLLECTION, LONDON

Frivolity and Frankness

Blending pastoral themes with coy eroticism, François Boucher created an art eminently suited to the intimate Rococo decor of 18th Century salons and to the amorous tastes of their wellborn occupants. Boucher, the favorite artist of Madame de Pompádour, mistress of Louis XV of France, was accused of "elegant vulgarity" by some contemporary critics, but he proved an enormous success and for a time was the most influential painter and decorator of his era. Typical is his *Pastorale* above: lounging in an idealized rustic setting, a love-smitten young shepherd and shepherdess appear oblivious to all but the satisfaction of their desire.

Rococo's Many Faces

No French Rococo artist treated the theme of pleasure with greater charm, freshness and variety than Jean-Honoré Fragonard, Boucher's star pupil. In *Women Bathing (right)*, he deftly balances a playfully erotic mood with a lyrical feeling for nature and a genuine zest for life.

Fragonard was preoccupied with the delights of love, but did not bind himself to a formula as Boucher tended to do with his provocative nudes. While many Fragonard works—full of rumpled beds, unlaced bodices and bare bottoms—were intended to titillate patrons, other paintings by his hand are scenes of romantic love that happily blend sensuality with innocence, wit and tender feeling. Still other Fragonards rank among the most exquisite idyllic landscapes ever created. In them lords and ladies in shimmering silks and satins romp through leafy grottoes or enchanted gardens against a background of plumelike trees and sun-flecked clouds.

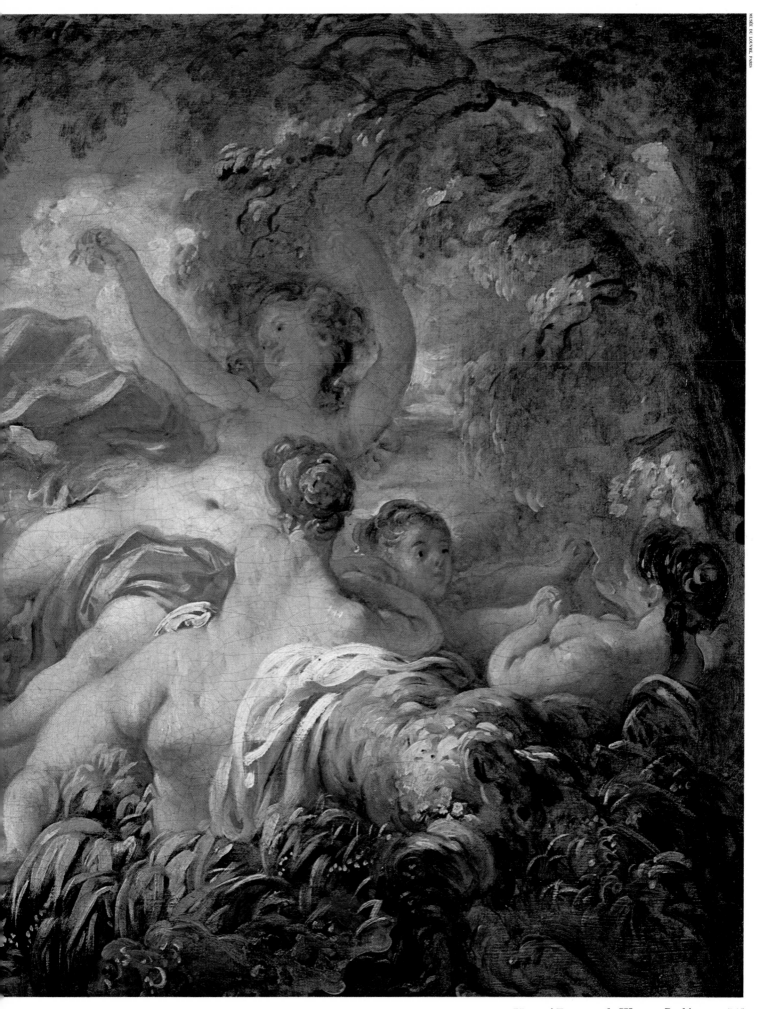

Jean-Honoré Fragonard: *Women Bathing*, c. 1765

While Boucher and Fragonard were painting frolicsome nudes and lighthearted amours to adorn the homes of French aristocrats, another master, Giovanni Battista Tiepolo, the greatest Venetian artist of the 18th Century, applied the vivacity of the Rococo style on a much larger scale—the fresco decoration of churches and palaces.

Whether his theme was religious or mythological or historical, Tiepolo was usually less concerned with conveying a profound message than with creating a feast for the eye, replete with swirling forms and joyous colors. His most notable works

Giovanni Battista Tiepolo: *Apollo Conducting Beatrice of Burgundy to Barbarossa*, 1751-1752

are his illusionistic ceiling paintings that seem to dissolve the architecture overhead and to open onto an expanse of sky across which move scintillating pageants of saints, gods and heroes.

Illustrated here is a particularly sumptuous ceiling fresco, one of Tiepolo's decorations for Kaisersaal, a great ceremonial hall in the princely Residenz at Würzburg in south-central Germany. The scene shows the god Apollo driving his sun chariot through the clouds as he conducts Princess Beatrice of Burgundy to her wedding with the German Emperor Frederick Barbarossa.

93

In the great wave of church-building that stirred southern Germany in the 18th Century the festive Rococo style served a special purpose, adding a unique air of gay piety to the interiors of church edifices both in major urban centers and in the countryside as well.

One exuberant expression of German Rococo appears in the Benedictine abbey church *(top, right)* whose twin spires rise above the village of Zwiefalten and its adjoining fields. Designed in the 1740s by architect Johann Michael Fischer, the church has a relatively austere exterior that offers little hint of the overwhelming richness of ornamentation inside *(opposite page)*. Flooded by natural light, the interior architecture, painting, stucco decorations and sculpture—like the brightly colored angel at right—are fused into a fantastic but unified whole whose focal point is a huge fresco on the ceiling of the nave showing St. Benedict receiving divine inspiration from the Virgin. Rarely have heavenly and earthly splendors been combined with greater vitality and sensual appeal.

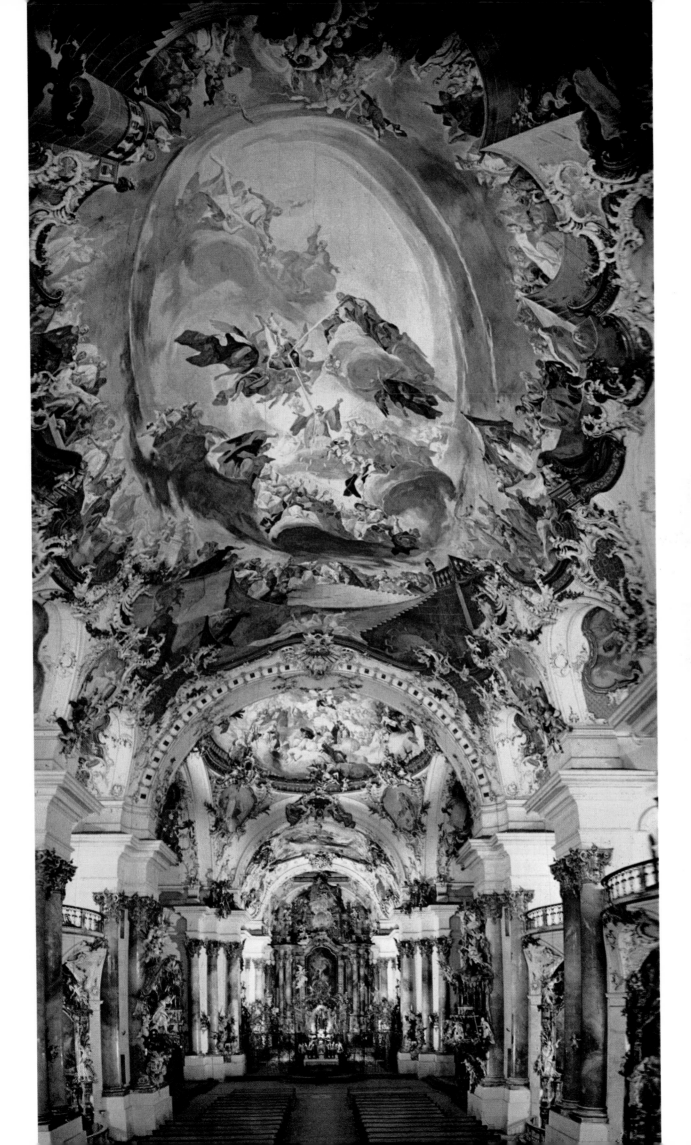

Jean-Baptiste Chardin: *Still Life of Kitchen Utensils*, c. 1730-173

Jean-Baptiste Greuze: *The Village Betrothal*, 176

A Changing Mood in France

As the 18th Century wore on, an inevitable reaction against Rococo superficiality set in. The first major French painter of the period to proclaim his belief that art should instead reflect the realities of life was Jean-Baptiste Chardin, who drew his inspiration not from the elite world of masquerade but from his own bourgeois background. Many of his works, including *Still Life of Kitchen Utensils* (*top, left*), consist of a few ordinary objects harmoniously arranged and painted with sensitivity and naturalness. As a result, Chardin has achieved a timeless, universal appeal few of his contemporaries have matched.

Another French artist of the era who preferred simple subjects to Rococo frivolities was Jean-Baptiste Greuze. His pictures of lower-class family life, represented here by *The Village Betrothal* (*bottom, left*), reflect the influence of Jean Jacques Rousseau, whose philosophy seemed to extol the superior virtue of the common man. But Greuze tended to overload his paintings with heart-jerking sentimentality, and today they seem mawkish and contrived. Shortly before the French Revolution this type of painting was overshadowed by somber Neoclassical works like Jacques-Louis David's *The Lictors Bringing Brutus the Bodies of His Sons* (*below*), extolling the stoicism and noble self-sacrifice of ancient Roman patriots.

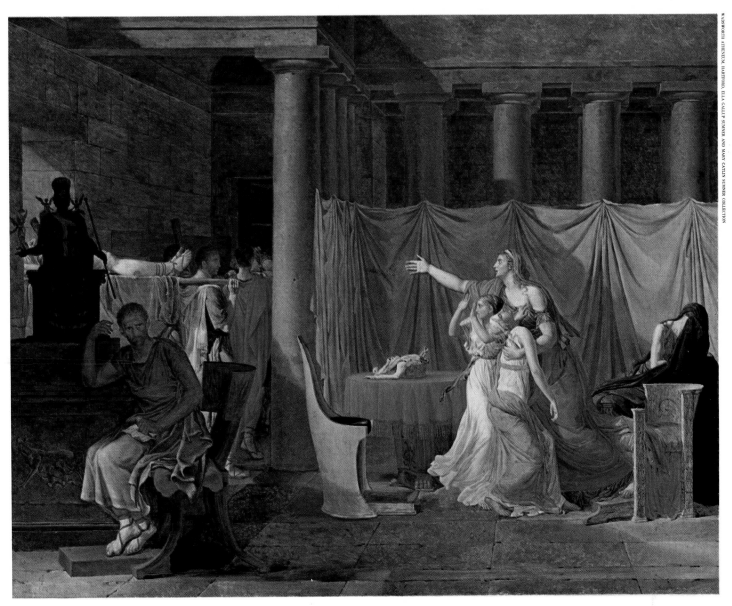

Jacques-Louis David: *The Lictors Bringing Brutus the Bodies of His Sons,* 1789

97

William Hogarth: *A Rake's Progress, Scene in a Tavern*, c. 173

A Worldlier Art

Painters across the English Channel were less inclined than their Continental 18th Century counterparts to view the world through rose-tinted Rococo glasses. William Hogarth, the first native-born painter to develop a distinctively English style, preferred to see the contemporary scene as it really was, with its crudities as well as its refinements, and to portray it accordingly. There is little of Rococo fantasy and a great deal of lusty realism in the orgy scene above, an episode from *A Rake's Progress*, one of a series of eight paintings in which Hogarth satirized the evils and extravagances of London society. Here the

debauched son of a minor nobleman, his inheritance fast dwindling, indulges in a last revel in a London tavern while a bevy of cooperative females help to relieve him of his valuables.

On a more elegant level, but also strikingly realistic, is Thomas Gainsborough's painting of the aristocratic *Mrs. Henry Beaufoy (right)*. Although the poetic landscape background is reminiscent of those in works by the French Rococo master Watteau, Mrs. Beaufoy's likeness itself demonstrates Gainsborough's remarkable gift for naturalism in portraying his sitters as living personalities rather than as fashionably clad effigies.

Thomas Gainsborough: *Mrs. Henry Beaufoy*, 1780

Francisco de Goya: *The Countess of El Carpio*, c. 1792

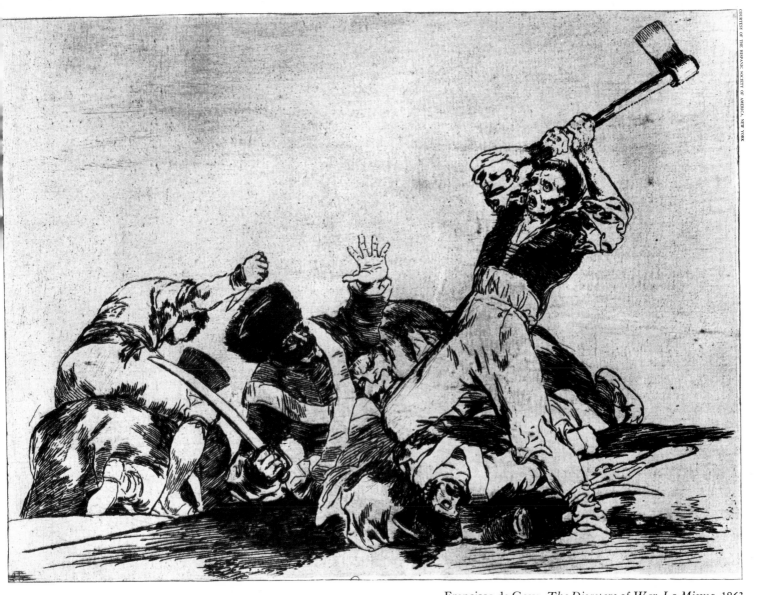

Francisco de Goya: *The Disasters of War, Lo Mismo,* 1863

Spain produced one painter of genius in the 18th Century: Francisco de Goya. Unlike most painters of the time, Goya created an art so far-ranging in style and theme that it cannot be neatly fitted into any one category such as the sensual Rococo of Fragonard or the Neoclassicism of David. But varied though Goya's works are, they are linked by a deep concern for humanity.

During the first stage of a long career that extended nearly three decades into the 19th Century, Goya depicted the Spanish scene and its decadent nobility with a mixture of Rococo-like grace and penetrating characterization, both apparent in his portrait of the proud, melancholy Countess of El Carpio *(left)*, painted around 1792. Soon afterward came a sharp break in Goya's style; dismayed at the corruption of the Spanish regime,

he began to paint members of the ruling class with candor that revealed not only their physical shortcomings but their moral turpitude as well. Increasingly preoccupied with the hypocrisy and irrationality of human behavior, Goya eventually executed a series of etchings, *Los Caprichos,* filled with distorted monsters and intended "to banish harmful, vulgar beliefs and to perpetuate . . . the solid testimony of truth." When Napoleon's troops invaded Spain in 1808, the artist had a firsthand view of war, the ultimate in human irrationality. Appalled by the atrocities he witnessed, Goya produced a scathing indictment of man's baser side in a collection of powerful etchings entitled *The Disasters of War.* In the one above, Spanish peasants armed with knife and ax are locked in savage combat with French soldiers.

101

VII

From Romance to Revolution

In the early years of the 19th Century the Neoclassical style, which had begun as an artistic protest against the Rococo tastes of 18th Century aristocrats, became overblown, turning into an official "heroic" art that glorified first Napoleon and then a succession of lesser autocrats throughout Europe. Established institutions ruled the artistic scene with an iron hand. In France the Académie des Beaux Arts, through its Salon exhibitions and its schools, virtually dictated the subject matter and techniques an artist could employ. In England the Royal Academy of Fine Arts also exerted a dominating influence; for the most part its leaders were cautious men who insisted that their young students hew to tradition and learn their craft by copying plaster busts of ancient Roman emperors and scaled-down versions of the *Laocoön*.

Still, there were subversive spirits about, and gradually new signs of artistic individualism began to emerge. Independent-minded painters, sculptors and architects, irked at academic dictates that demanded the vistas of antiquity, the sculpting of smooth-limbed statues of nymphs and the building of pseudo-Corinthian façades, moved away from Neoclassicism. In time the gathering forces of dissent in France, England and Germany produced their own full-blown movement, called Romanticism. The name came from a widespread revival of literary interest in the medieval tales known as romances, but the movement itself had myriad sources of inspiration: the exploits of the fictional heroes of such contemporary authors as Lord Byron, Sir Walter Scott and Victor Hugo; the vigor of the new industrial age, as manifest in the steamship and the railway; the high drama of nature at its most elemental—storms at sea, Alpine landslides—as well as the melodramas of home and hearthside; the allure of foreign lands and locales.

In architecture, Romanticism first found fulfillment in a growing use of "Gothic" elements. Lordly estates in England sprouted crenelated towers and thick walls pierced by narrow windows. Later, these medieval features were admixed with Italianate, Moorish

The Parisian reputation for sophistication was deftly deflated in this sketch of an enthusiastic theater audience by Honoré Daumier, a 19th Century artist famed for his satirical drawings of everyday city life. A superb painter and skilled printmaker, Daumier ignored the prevailing styles of his day, Neoclassicism and Romanticism, to pursue his own realistic manner.

Honoré Daumier: *They Say the Parisians Are Hard to Please*, 1864

and Oriental decorative elements; many English buildings, public as well as private, seemed suddenly to have been attacked by a pack of time-bewitched architects. In fact, however, such structures were often the products of the most cultivated men of the age: the writer Horace Walpole's home near London *(page 108)* is a delightful example of this eclecticism. If the buildings lacked the clean lines and ordered harmonies of Neoclassical edifices, what did it matter? They were fascinating to look at, and more important, they were the unfettered expressions of individual taste.

As Neoclassicism had been, in a sense, a reaction against the florid, sometimes overdramatic Baroque style and the often vapid Rococo, so Romanticism was a revolt against the rational qualities of the Neoclassical. Indeed, the evocation of emotion became the chief goal of the Romantic artist. Among the French painters who fomented this rebellion the foremost was Eugène Delacroix, a master colorist with a notable flair for the exotic. Set against him in France, where the lines of the Classic-Romantic battle were more sharply drawn than elsewhere, was Jean-Auguste-Dominique Ingres, one of the greatest draftsmen of all time, and a genius at conveying cool elegance. Simply expressed, the struggle was one of color against line, or in terms familiar from previous centuries, the "Rubenistes," devotees of Rubens' high colors and swirling compositions, versus the "Poussinistes," admirers of the early French classicist's stately arrangements and quiet earth tones.

Delacroix and Ingres were not so far apart as it seemed, however. On the one hand Delacroix included in his Romantic credo a belief in the nobility of ancient peoples; he detected this quality in his own time in the Arabs of North Africa—the counterparts, he argued, of the inhabitants of classical Greece. On the other hand, Ingres, for all his preoccupation with line, was as intrigued as Delacroix was by the exotic and erotic and produced a stunning series of pictures of the voluptuous inmates of a Turkish harem.

In England the Romantic movement in painting centered on the beauties—and terrors—of nature. Joseph Mallord William Turner preferred to show its violent side; his *Snowstorm (page 115)* is a study in the raw fury of the sea as it threatens to overwhelm a barely seen ship. Turner's fellow landscapist, John Constable, preferred nature's serener side, and his scrutiny of its components—the green of vegetation, the shimmer of placid water, the puffy insubstantiality of clouds—found fruition in canvases of great charm. Seemingly not an innovator, Constable nevertheless made a powerful impact on other painters, particularly in France: the clarity of his colors, derived from his close observation of nature, caused Delacroix to retouch one of his own canvases after seeing some Constable landscapes in Paris.

Romanticism continued to hold sway for decades, but toward mid-century, as rumblings of political and social unrest swept Europe, a revolutionary new view of the function of art came to the fore. In 1846 the French poet and critic Charles Baudelaire boldly

declared that painting should express "the heroism of modern life." To depict contemporary events, to record the everyday life of the streets, was unthinkable to most artists. With the exception of Honoré Daumier *(page 102)*, best known as a satirist and cartoonist but also a superb painter, few Romantics or Neoclassicists occupied themselves with the look of daily reality. The first French artist to meet Baudelaire's challenge head on was Gustave Courbet, whose canvases captured ordinary, hard-working men and women exactly as he saw them. Courbet's retort to critics who denounced the lack of spirituality in his work was: "I cannot paint an angel because I have never seen one." Realism was what Courbet called his approach, and while it found few staunch adherents it attracted young Edouard Manet, who was then groping for a style.

A wellborn, well-educated Parisian, Manet set about painting the crowds at a race track, the habitués of cafés, the Sunday sailors on the Seine—all interested him equally. With his artist friends Claude Monet and Auguste Renoir he painted out of doors, using colors as close to those in nature as oil paints and the imprecision of the human eye could make them. Monet and Renoir went on to make a personal forte of such *plein-air* (open-air) painting—their chief aim being to capture the evanescent effects of light and movement in landscape. The style acquired its enduring label in 1874, when a critic derided the works as mere "impressionism."

Along with another artist friend, Edgar Degas, Manet eventually abandoned his interest in the goals of Impressionism. He grew less concerned with the problem of recording natural light in the open air and more absorbed in the larger problem of rendering form. The age-old artistic dilemma of deciding how to represent the three dimensions of normal visual perception on the two dimensions of a canvas led Manet to one of the major breakthroughs on the road to modern art. Painters from Cézanne to Jackson Pollock would be indebted to him, for he began to break down the notion—prevalent since the Renaissance—that the canvas is to be treated as a window on the world, a frame in which the painter's task is to create the illusion of three-dimensional reality. Manet and subsequent painters rejected this idea, insisting instead that a painting should be nothing more nor less than an arrangement of colors, lines and shapes on a flat surface. That arrangement, they argued, had its own logic, its own beauty. Wide acceptance of this startling idea was long in coming, but Manet heralded its day.

In the last third of the 19th Century, French painting was the liveliest, the most experimental and most prolific creative force in the world of art. Paris became the mecca of artists everywhere; it was there they flocked to study, to exhibit and to exchange ideas with their contemporaries. The Americans James McNeill Whistler, John Singer Sargent, Winslow Homer and Mary Cassatt came to Paris; so did the Dutchman Vincent van Gogh. Gifted Frenchmen from the provinces also arrived, sometimes to remain, sometimes to stay only briefly. One of these transients was a bril-

liant eccentric from Aix-en-Provence, Paul Cézanne. Cézanne worked on and off in Paris during the heyday of Impressionism and enjoyed the tutelage of one of its pioneers, the fatherly Camille Pissarro. But he soon began to evolve his own style, believing that the Impressionists, in their preoccupation with color, had neglected form. Eventually Cézanne forged a philosophy expressed in the famous dictum that everything in nature should be seen in terms of the "cylinder, the sphere and the cone."

Skittish and asocial, Cézanne spent most of his later years as a recluse, making a life's work of painting the Provençal countryside, especially the Mont Ste. Victoire, which loomed over the valley he knew so well. In his mind's eye he would disassemble the rocks, the trees and the squat houses of his native region, and put the component forms together again on canvas, using color to suggest degrees of depth and create harmonies on the picture surface.

By now innovation was an irreversible trend in French art. Paul Gauguin, Vincent van Gogh, Georges Seurat and Henri de Toulouse-Lautrec, loosely grouped together as Post-Impressionists, followed the lead of their rebellious predecessors in their own individual ways. Gauguin became associated with a movement called Symbolism, whose devotees used color of high intensity to suggest emotional qualities rather than to reproduce simple reality; he once painted a figure of Christ on the Cross in a vivid yellow to evoke the sense of searing agony. Van Gogh also deployed a palette of extraordinarily bold colors, which he laid on thickly in short dashes to express his own inner turmoil. He had no difficulty, he wrote his beloved brother Theo, in expressing "sadness and extreme loneliness." The more intellectual Seurat attempted to codify the Impressionists' concern with sunlight by inventing a distinctive and methodical painting technique called Pointillism, in which pure hues were applied in tiny dabs of paint to merge not on the canvas but in the viewer's eye. Toulouse-Lautrec echoed the flat-patterned simplicity of Japanese art in his decorative paintings and lithographs of Paris life, compiling a record of "La Belle Époque" that has persisted as the portrait of a city at its peak of enjoyment.

The world of art saw many other innovations during the last third of the 19th Century. The authority of the Academy was defied not only by strongly individualistic artists but by the public as well, which preferred to make its own broadened and more enlightened judgments on art. The belief that art was no longer the preserve of the elite gained impetus from the founding of many museums and public galleries, the rise and proliferation of art dealers, the increasing coverage of exhibitions by newspapers and journals and, with the invention of photomechanical methods of reproducing art, a boom in the production of art books—which the French writer André Malraux has rightly called "museums without walls." The next century would see much more of all this, and would also witness a profound upheaval in which the very nature of art would be rigorously scrutinized and challenged.

106

Thomas Jefferson: Monticello, Charlottesville, Virginia, 1770-1784; remodeled 1796-1806

An Era of Bold Change

Unlike earlier and more stable eras in art, the 19th Century saw a procession of styles. When the century opened, the vogue favored Neoclassicism, a revival of Greek and Roman forms that had begun 50 years earlier with the rejection of the Rococo, and manifested itself as far away as America in Thomas Jefferson's design for his stately Virginia home *(above)*. The next major style was Romanticism, as architects, painters and sculptors vented a passion for the medieval, the exotic and the untamed. In the final third of the century the Impressionists and Post-Impressionists asserted the supremacy of the artist's personal vision over any conventional collective esthetic.

Horace Walpole with William Robinson and others: Strawberry Hill, Twickenham, 1749-1777

Charles Garnier: The Opera, Paris, 1861-1874

arles Barry and A. Welby Pugin: The Houses of Parliament, London, begun 1836

The Romantic movement in architecture began in England with a widespread revival of interest in the Middle Ages. A rage for Gothic forms resulted in buildings intended to evoke what the art critic Sir Kenneth Clark has called a "mood of agreeable melancholy." When the wealthy dilettante Horace Walpole completely "Gothicized" his country estate, Strawberry Hill *(opposite, top)*, he started an architectural trend that lasted for almost 100 years, reaching its peak with the reconstruction of the Houses of Parliament in London *(left)* in the wake of a fire that gutted them. After much debate, they were rebuilt in the modified style known as Victorian Gothic. In France the Gothic revival was overshadowed by a resurgence of monumental Renaissance and Baroque forms—notably exemplified in the lavish Paris Opera *(above)*—that reflected the prosperity and grandeur of Napoleon III's Second Empire.

109

Thomas Telford: Craigellachie Bridge, Scotland, 1815

Even as 19th Century architects continued to use stone and wood as basic building materials in their reworking of old styles, a new breed of pragmatic engineers turned to metal to create dynamic new forms to meet the needs of recently industrialized nations. Graceful iron bridges like the one above spanned rivers to add a note of geometric beauty to the landscape. The greatest of the iron structures was the magnificent Crystal Palace in London *(right)*, built to house England's Great Exhibition of 1851. Ingeniously adapted from a greenhouse design favored by the Prince Consort, it consisted of 300,000 oversized panes of glass set into more than 5,000 prefabricated iron columns and girders. The Palace took only nine months to build and offered more than a million square feet of exhibition space. The building's popularity touched off a wave of imitation Crystal Palaces in Dublin, New York, Munich and Amsterdam. Although the fad for giant iron-and-glass edifices was short-lived, it was revived to become the basic style of the post-World War II skyscraper age.

110

Sir Joseph Paxton: Crystal Palace, London, 1850-1851

Jean-Auguste-Dominique Ingres: *Louis Bertin*, 1832

A Clash of Styles

The two most influential painters of the mid-19th Century were a pair of Parisian contemporaries whose styles were poles apart. Jean-Auguste-Dominique Ingres, the outspoken champion of Neoclassicism, was a master of meticulous line drawing who could produce a wealth of detail even in a study like the one above. No such precision marks the work of Eugène Delacroix, greatest of the Romantic artists. Concerned less with literal rendition than with conveying drama and emotion, Delacroix filled his works with brilliant bursts of light, bright color and energetic movement. The painting at right, a typically Romantic amalgam of sensuality and violence, depicts a key moment from Sir Walter Scott's novel *Ivanhoe*, in which the heroine is carried off by the villain.

112

Eugène Delacroix: *The Abduction of Rebecca,* 1846

113

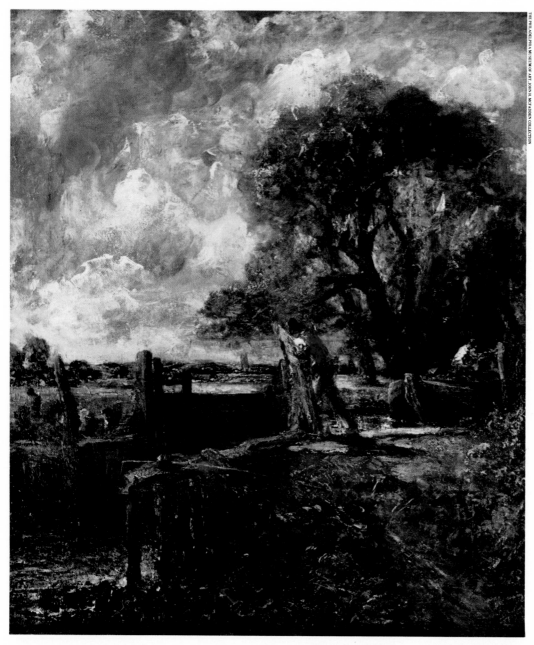

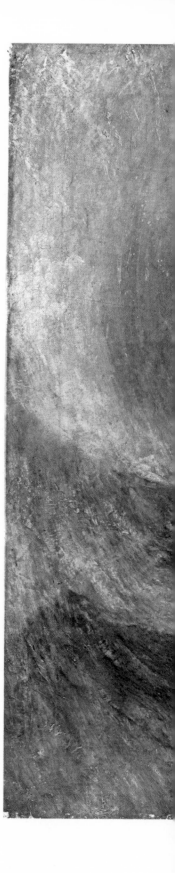

John Constable: *The Lock, Dedham,* 1824

In England painters of the Romantic era were largely preoccupied with portraying the many and varied faces of nature. John Constable celebrated the serenity of the Suffolk countryside where he spent his boyhood. "Painting is with me but another word for feeling," he said, and he worked sensitively to achieve the calm vistas and glowing tones—a style dubbed "à la Constable" by admiring French artists—that lend such pleasurable recognition to his pastoral scenes. To modern eyes, some of Constable's finest achievements are unfinished studies like the one above, showing a canal boat about to enter a lock on the River Stour. This oil sketch has a freshness and vibrancy lacking in the final version: to satisfy the public's taste for "finish," Constable took greater pains with details

J. M. W. Turner: *Snowstorm: Steamboat off a Harbour's Mouth*, 1842

and omitted such charming casual touches as the unattended fishing pole in the foreground.

A very different approach to nature appears in the paintings of Joseph Mallord William Turner, who was so fascinated by the raw power of the elements that his greatest admirer, the influential critic John Ruskin, once grouped a whole series of Turner's works under the heading "flood and fire and wreck and battle and pestilence." The swirling snowstorm at sea shown above is one Turner painted after personally experiencing it. Like many of his works, it is strikingly abstract, a token of Turner's obsession with color and light and dynamic movement, often at the expense of form and realistic rendering; the steamship at the center of the storm is only dimly perceived.

115

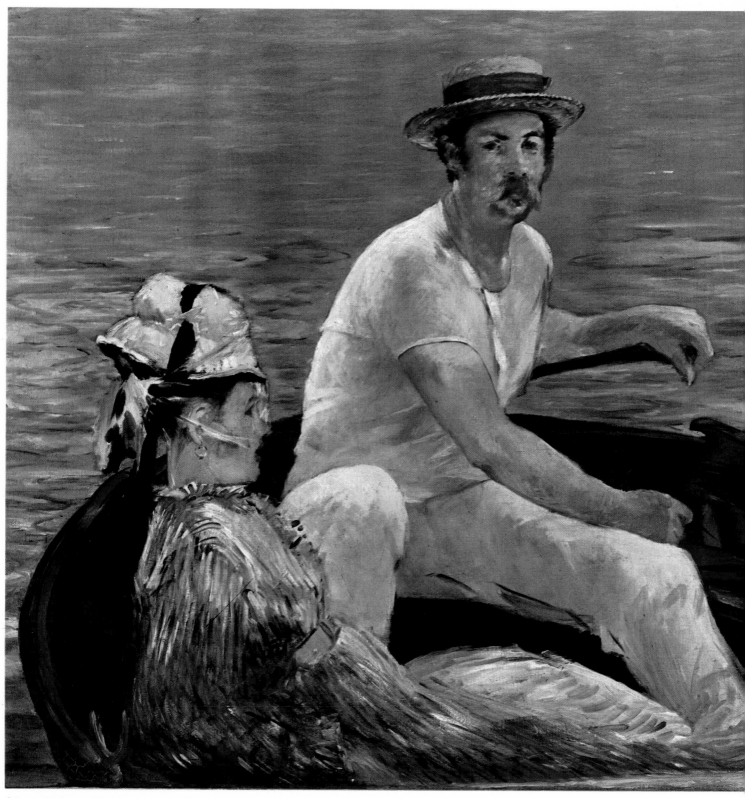

Édouard Manet: *Boating*, c. 1874

The Sparkling World
of Impressionism

Impressionism flowered along the banks of the
Seine in the 1870s as a new generation of artists
moved outdoors to record nature's light and colors
at first hand. In the riverside village of Argenteuil,
north of Paris, Claude Monet, Auguste Renoir and
several friends devised a technique for capturing
the dazzling tones created by sunlight reflecting off

Claude Monet: *Basin at Argenteuil*, c. 1875

Auguste Renoir: *Oarsmen at Chatou*, 1879

water. Unable to match those shimmering effects with a palette of mixed paints, these "impressionists" instead dabbed on flecks of pure color which, when viewed from a distance, merged into softly defined luminous waterscapes like the one at the upper right. Édouard Manet came to Argenteuil in 1874 to study the work of his friends and to experiment with their new-found technique brilliantly but briefly *(above)*. Renoir, who painted the scene at lower right, later became Impressionism's most popular exponent, creating an incredibly bright Parisian world of faces, figures and movement, all caught in fleeting moments by the painter's quick, keen eye.

117

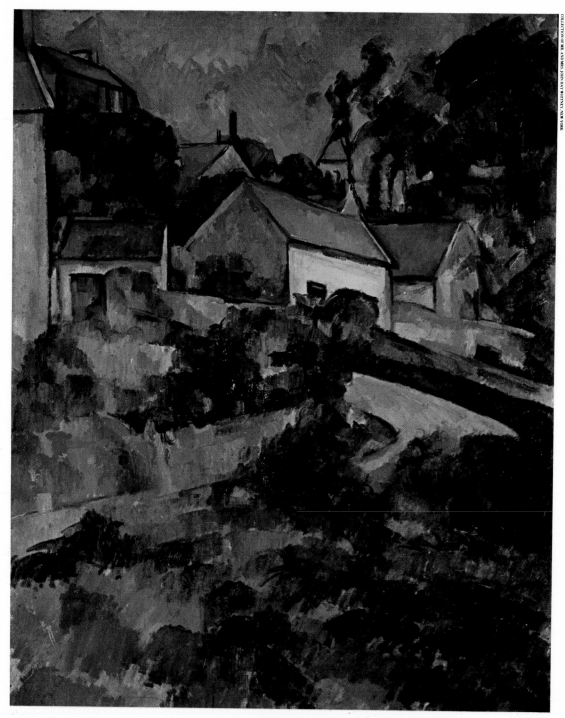

Paul Cézanne: *Turning Road at Montgeroult,* 1898

Modern Art's First Rebels

In the widening search for new means of expression that marked the final decades of the 19th Century, the greatest innovator was Paul Cézanne. In the landscape above, he ignored traditional precepts of perspective, color and narrative to concentrate on harmonizing man-made forms with the geometry he perceived in nature. Paul Gauguin hit his stride in primitive Tahiti, where he painted semi-imaginary scenes in a blaze of color. The Gauguin work at upper right, presumably based on a South Seas legend, depicts a ceremony performed before an ancient god. Georges Seurat found a wholly different source of inspiration in new theories of optics and color, and devised a painting technique called Pointillism. Applying paint in small points of pure color, he tried to capture nature's reality by using a rational system to achieve what the Impressionists had explored only intuitively. His misty riverside scene at lower right epitomizes his unique approach.

118

Paul Gauguin: *The Day of God*, 1894

Georges Seurat: *The Bridge of Courbevoie*, 1886

Vincent van Gogh: *Portrait of the Superintendent of St. Paul's Hospital*, 1889

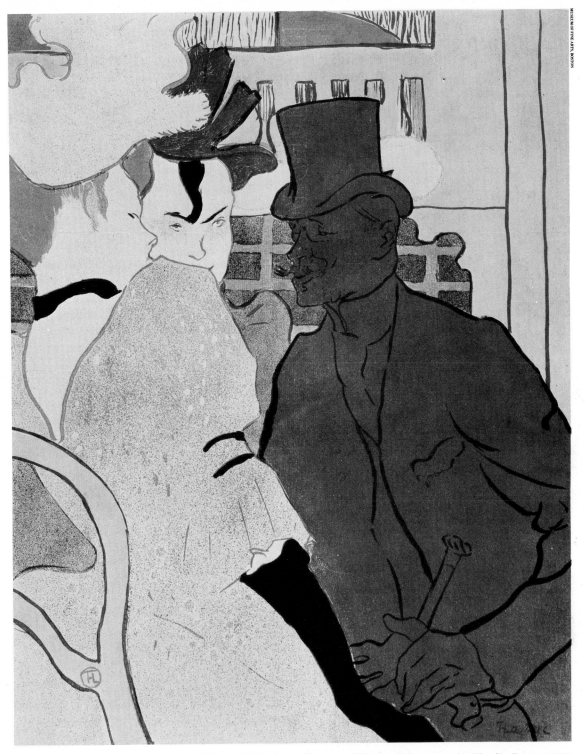

Henri de Toulouse-Lautrec: *The Englishman at the Moulin Rouge*, 1892

As one after another artistic tradition toppled toward the end of the 19th Century, painters increasingly injected their subjective viewpoints into their works. The anxieties that wracked Vincent van Gogh are evident in paintings like the one at left, a haunting portrait of an official at one of the mental hospitals to which the artist was committed. Van Gogh's thickly applied, intense colors and emphatic patterns of lines betray the frenetic state of his own emotions.

The aristocratic, crippled Henri de Toulouse-Lautrec sublimated his personal unhappiness by choosing the dance halls, cabarets and bordellos of Paris as his artistic milieu. An instinctive caricaturist, he caught the shape and personality of the demimonde with a few lines, flat blocks of color and bold silhouettes. In the lithograph above, Toulouse-Lautrec coolly recorded a typical scene: a pair of dance-hall girls flirting with a foppish English visitor.

121

Antonio Canova: *Pauline Borghese as Venus*, 1805

Jean-Baptiste Carpeaux: *The Three Graces*, 1874

The Transformation
of Sculpture

122

The evolution of sculpture in the 19th Century paralleled that of painting. The Neoclassical style that dominated the early years is typified by Antonio Canova's portrayal of Napoleon's sister, Pauline Borghese, as a goddess of love *(left, top)*. Canova borrowed the pose from a Titian painting and the body from Greek statuary to create a flawless, idealized but static masterpiece. The more dynamic thrust of the Romantic style is seen in a lively group of dancers created by the sculptor Jean-Baptiste Carpeaux: below, at left, is his original terra-cotta model. It remained for the great Auguste Rodin to presage sculpture's move toward modernity. The simplified, powerful, impressionistically modeled figures in his *Three Shades (below)*, which stand atop his monumental *Gates of Hell*, reflect Rodin's own view of life, an intensely subjective statement of man's fate.

Auguste Rodin: *The Three Shades,* c. 1880

VIII

A Century of "Isms"

Responding to the rapid acceleration of life in the 20th Century—the progression from the Electric Age to the Nuclear Age—art has seen a proliferation of styles unmatched in history. In painting, the innovative mood was established by Manet and the Impressionists in mid-19th Century Paris and continued undiminished past the turn of the century. In architecture, the lead was taken in Germany and in the United States, where booming industry and high-rising cities capitalized on new materials and technology to reshape the physical environment in which men lived. In sculpture, the liberating example of Rodin provided fresh stimulation to other practitioners in the field. Amid these departures from an esthetic based on the Renaissance, the artists questioned the very definitions of art and, in doing so, expanded its horizons.

The first major 20th Century movement in painting was Fauvism, so named by a stunned French critic who, after seeing the works of Henry Matisse, André Derain and Maurice Vlaminck, compared the artists to *fauves*, or wild beasts. First introduced to the public in 1905, Fauvism was based on an unprecedented distortion of natural colors. Earlier painters like Van Gogh and Gauguin had evoked emotion and mood with heightened, unrealistic color; Matisse insisted that there was no valid esthetic reason for the sky to be blue or leaves to be green. Although they continued to paint recognizable subjects, the Fauvists arbitrarily, and brilliantly, substituted their own colors for those of nature.

At the height of the furor over Fauvism, another radically unconventional style, Cubism, was invented by Pablo Picasso and Georges Braque. As Matisse and the Fauves had warped colors, so Picasso and Braque were the first to fracture form. Cézanne had successfully demonstrated that traditional perspectives were unnecessary when he painted landscapes in which the usual visual clues to the relative distance of objects were omitted. The Cubists went a step further by completely flattening images and depth in their paintings. To them, any three-dimensional object could be, and

This graceful bronze, one of the 20th Century's most celebrated sculptures, sums up much about modern art. The sculptor, Rumanian-born Constantin Brancusi, has brilliantly evoked the feeling of his title, yet he has created a pure abstract form that needs no referent in nature to stand on its own.

Constantin Brancusi: *Bird in Space*, 1919

was, reduced to an arrangement of two-dimensional shapes.

Paradoxically, the Cubists soon discovered that in flattening an object they could actually give it a new dimension, that by breaking it into its component parts they could show it from more than one viewpoint at a time. This meant, for example, that a girl's face might be shown half in a front view and half in profile. Thus, the Cubists' final destruction of Renaissance perspective proved not less, but more revealing of the nature of things.

Fauvism and Cubism were short-lived as full-fledged movements, both ending with the outbreak of World War I, but their impact on color and form in art was epochal. Matisse went on to explore the potentialities of color in a long series of highly decorative canvases—sunlit interiors of rooms overlooking the Mediterranean, lush odalisques reclining in Oriental splendor. In his old age, close to mid-century, he provided a fresh inspiration to young painters by radically simplifying his style, creating mural-sized works that consisted of flat patterns of colored paper cut out and pasted down to evoke luxurious gardens of color. In the 1920s Picasso and Braque abandoned the monochromatic, hard-edged precision of their earlier Cubist works. Braque went on to evolve a more sensuous style in still lifes of great beauty. Picasso, with fabulous energy, exploded into other media—ceramics, metal sculpture, murals, lithography, book illustrations, poster design.

Numerous other related styles grew out of the impact of Fauvism and Cubism on European painting. In Italy a group of artists sought to evoke the speed and dynamism of the machine age in Futurism; one of the more famous paintings of this school is Giacomo Balla's study of a walking dog, whose pattering feet are shown in a whirring blur, like the image produced in multiple-exposure stroboscopic photography. In Russia the Constructivists rebuilt nature in their art along the lines of industrial geometry. In Germany, artists allied themselves with such provocatively named groups as *Der Blaue Reiter* (The Blue Rider) and *Die Brücke* (The Bridge) to shape the collective esthetic known as German Expressionism, in which the raw colors of the Fauves were often used to lash out at the social abuses of the day. (A former member of The Blue Rider group, Wassily Kandinsky, created the first fully abstract, nonobjective paintings.) In Holland, members of a movement called *De Stijl* (The Style), whose leader was the master modernist Piet Mondrian, refined Cubism to a pure, linear geometry.

All these movements had grown out of a restless concern to find the true criteria of art, and many of them sought to express in new ways the changing quality and tempo of life. During World War I, however, a movement coalesced in neutral Switzerland that expressed its deep disillusionment with war and the world in general by creating a form of anti-art. Dada, its very name a nonsense word picked at random from a dictionary, deliberately poked fun at traditional art—one of its better-known jokes, by Marcel Duchamp, consisted of drawing a mustache on a reproduction of the *Mona*

Lisa and adding an obscene caption. The Dadaists also created a new multimedia kind of art combining painting, sculpture, dance, drama and social satire in wild public performances that seemed to have no logic or meaning, nor any lasting form that could be evaluated by critics. The cabaret-style art was revived in the late 1950s in the staging of events called "Happenings."

During the 1920s, the newly popular theories of Freud sparked an interest in the unconscious mind and, again in France, a new style was born. Surrealism found artists like Max Ernst, Joan Miró, Salvador Dali and others creating through realistic means a sort of super-reality that delved into the world of dreams. Juxtaposing unrelated objects or inventing free-floating organic shapes, they explored a whole new subject matter for art and experimented with a variety of new techniques.

Among the Surrealists' experiments was a method by which unconscious ideas, feelings and images were encouraged to flow freely from the artist's mind. Called automatism, it was a potent catalyst for a movement that erupted in the United States in the late 1940s and became known as Abstract Expressionism. The technique was practiced first in a limited way by Arshile Gorky, and eventually found fruition in the explosive style of Jackson Pollock. Seeking a powerful nonobjective art that would involve the viewer in a world of sensation and response, artists produced paintings that grew to wall-sized dimensions and featured an application of paint unlike anything seen before. The Americans rejected the meticulous brushwork of European art and splattered, slashed, dripped and flowed paint on canvas in ways that challenged not only the viewer's sensibilities but everything that art had previously stood for. The new style, however, proved more than a shocking rejection of old-fashioned values. The painters who created it were deeply involved with art, and demanded freedom to be heard as individuals. In the hands of men like Pollock, and his New York-based colleagues Franz Kline and Willem de Kooning, Abstract Expressionism evolved into a viable style that others adapted individually.

During the course of the first half of the century, painting had undergone a series of major revolutions. But the accelerating changes of the time were reflected in equally significant breakthroughs in the other arts. As early as the turn of the century Frank Lloyd Wright, the eccentric American genius, had begun to advocate the use of new materials and to urge an organic relationship between buildings, their functions and their sites. In Germany the founders of the Bauhaus school, which sought to bring the arts and crafts together by providing fine design even in mundane household objects, promulgated two doctrines relating to architecture that remain in force today: Mies van der Rohe used his celebrated dictum "Less is more" to encourage simplicity and clarity of form in his buildings; Walter Gropius, the first director of the Bauhaus, argued that "form follows function," and designed buildings accordingly. A similar slogan, by the great Swiss architect Le Cor-

busier, that a house should be "a machine for living," caught the imagination of architects all over the world.

Soon after the turn of the century many sculptors began to experiment with abstraction in three-dimensional form. In the late 1920s the American sculptor Alexander Calder, taking a clue from the Russian Constructivists, devised sculptures that were motor-driven. He is best known, however, for the so-called "mobile," hung on fine wires and balanced so delicately that a mere breath of wind would change its pattern of free-form shapes. In the late 1950s the Swiss sculptor Jean Tinguely produced his first in a series of works that were motorized, and even some that systematically destroyed themselves. And so magnets, electric motors and even explosive charges were added to the traditional clay and stone as materials of the sculptor's craft.

Much of the new interest in sculpture that had developed by mid-century was due, in part, to the dilemma in which painting found itself. Following the great burst of energy of Abstract Expressionism, painters discovered the doors to freedom of style so wide open that they hardly knew which way to turn or what new avenue to explore. In America and Britain, Pop Art signaled a return to recognizable subject matter; the stuff of everyday life —soup cans, highway signs, movie stars—and the techniques of advertising became concerns of the artist. Op Art, in its turn, experimented with stimulating purely visual sensations in the eye of the beholder. Minimal Art strictly limited the artist's means in both painting and sculpture: some Minimal works were so large that the artist simply sketched what he wanted and then turned it over to a metal fabricator for completion.

Finally, in the late 1960s, the crisis of choice facing modern artists led to the development of a style, if it can be called that, in which works of art became part of the environment. One "ecological" artist carved five 12-foot-long trenches in a Nevada desert and then lined them with wood. The collector who had commissioned the work had to charter a plane to see it. Another "sculptor" wrapped a mile of Australian coastline in plastic sheeting and declared that as his artistic conception. Indeed, the conception rather than the art object itself became so much the thing that artists were declaring valid works of art in which no physical product was created and nothing sold to the buyer by the artist except the idea for the work. Even the lack of an idea could be used as an idea: exhibited in a New York museum in 1970 were 271 blank sheets of paper representing 271 days on which one artist rejected concepts that had occurred to her.

At the beginning of the last third of the 20th Century, art as it had been known for thousands of years seemed in need of new definitions. The questions of style were still being posed but new questions relating to the basic nature of art were also asked. As always, it remained up to the artists to provide answers; the public and the historian could only wait and see.

Georges Braque: *Oval Still Life (Le Violon)*, 1914

Experiments in Abstraction

Modern art encompasses so many styles, so much restless movement, that no single esthetic can be discerned—unless it is simply that of constant rejection of older traditions in favor of continuing change. Beginning with the form-fracturing Cubist style *(above)*, invented by Picasso and Braque early in the century, the art of the past seven decades has moved away from strict representationalism and older ideals of beauty toward expressions of pure sensations or intellectual stimulation. One "ism" has followed another —Cubism, Fauvism, Surrealism, Abstract Expressionism—in the ongoing search for fresh insights into the nature of man and art.

Pablo Picasso: *Nude in the Forest*, 1908

Pablo Picasso: *The Painter and His Model*, 1963

Picasso's Lifelong Quest

Throughout his extraordinarily long, inventive and productive career, the most celebrated modern artist, Pablo Picasso, has returned again and again to time-honored themes, trying to reinterpret them in a variety of new ways. In the early Cubist painting at left, he analyzed an age-old subject, the nude, in terms of planes and cubelike forms. In the painting above, made 55 years later, he reworked a familiar painter's theme, the artist and model, distorting forms into a complex, expressive whole.

131

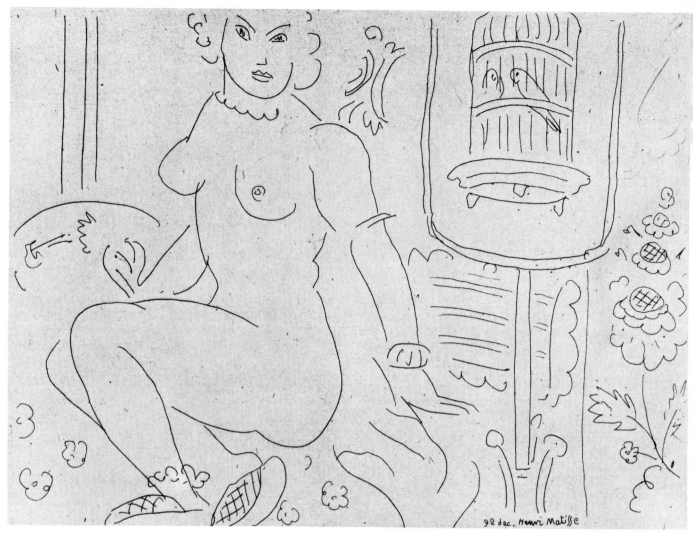

Henri Matisse: *Seated Nude with Parrots in Cage*, 1929

Matisse: Master of Line and Color

When Matisse and some of his fellow artists showed their aggressively colorful paintings at Paris' Salon d'Automne in 1905, they were called *Fauves* —"wild beasts." It seems a little ridiculous today that a man like Matisse, with such a delicate sense of design, line and color, could ever be called a "beast." Nonetheless, his colors were and are highly arbitrary, often representing not the real hues of the object painted, but how Matisse felt about the object, or how he believed his color would harmonize with the overall effect of his composition. But however abstract the colors, or juxtapositions of colors, in his works, the overall effect almost always seems right, as in the lovely painting opposite. In this work, too, can be seen Matisse's ability to evoke whole forms with a few simple, sinuous lines. The earlier drawing above, although more detailed and realistic, also shows how Matisse, whom some critics consider the greatest artist of the century, could convey an atmosphere, full of detail, action and character, with but a few expressive strokes of his pen.

132

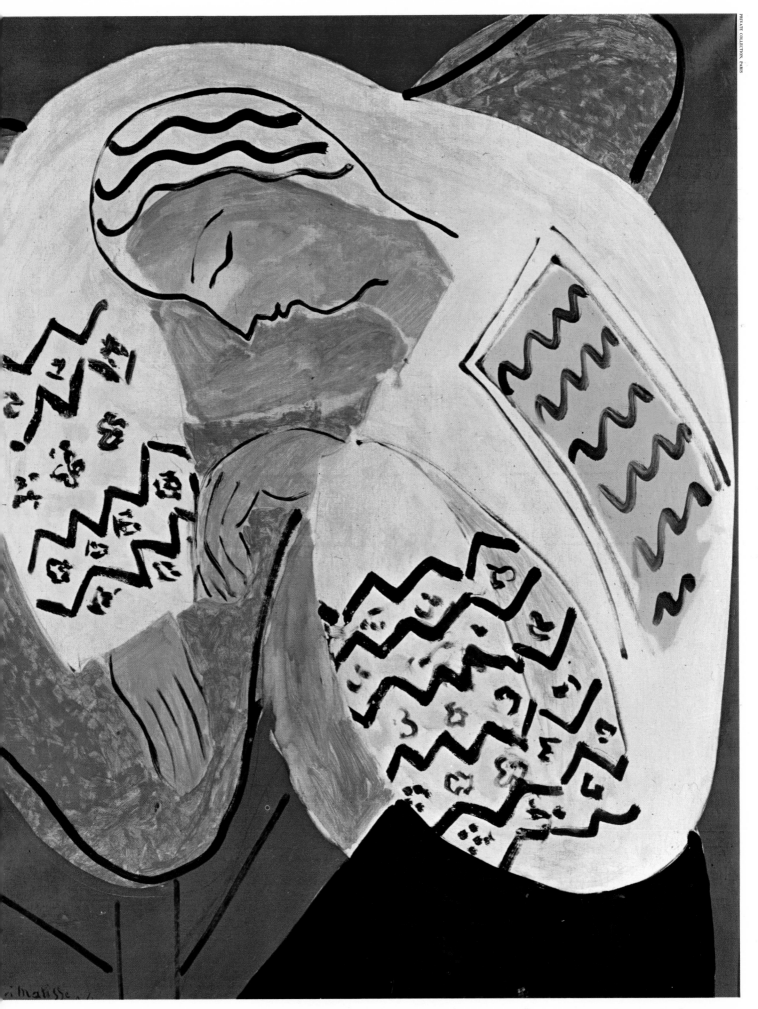

Henri Matisse: *The Dream*, 1940

Abstraction Achieved

Wassily Kandinsky and Piet Mondrian pioneered two quite different styles of nonobjective painting. Kandinsky's philosophy was based in part on Fauvism. But while Matisse and the other Fauvists, who painted recognizable subjects, had contended that colors did not have to be true to nature, Kandinsky went a step further; he progressively abolished all traces of subject matter from his canvases, and relied on abstract shapes and strokes of color alone to engross the viewer. His works are rich mixtures of bright and subtle hues and a variety of evocative forms *(below)*.

Mondrian used Cubism as the springboard for his abstract compositions. His early works are typified by *Color Planes in Oval (right)*. His later paintings, for which he is best known, are pure hard-edged geometry, constructions in black and the primary colors of red, yellow and blue.

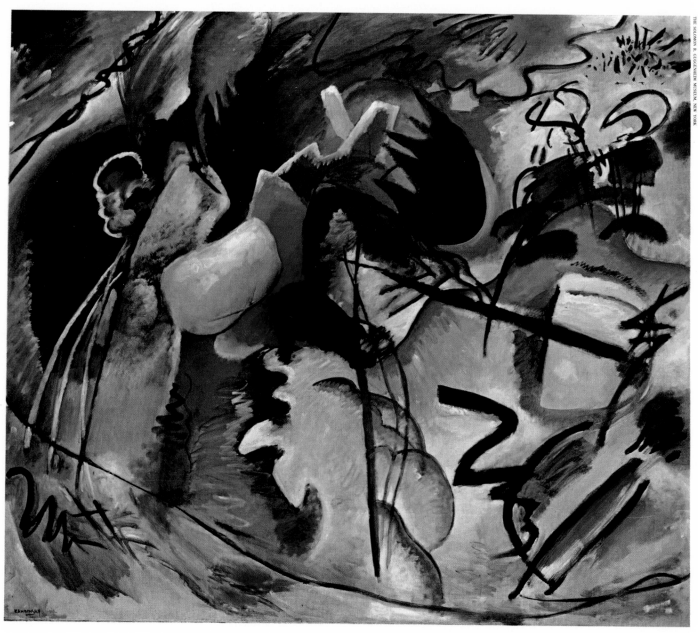

Wassily Kandinsky: *Painting with White Form No. 166*, 1913

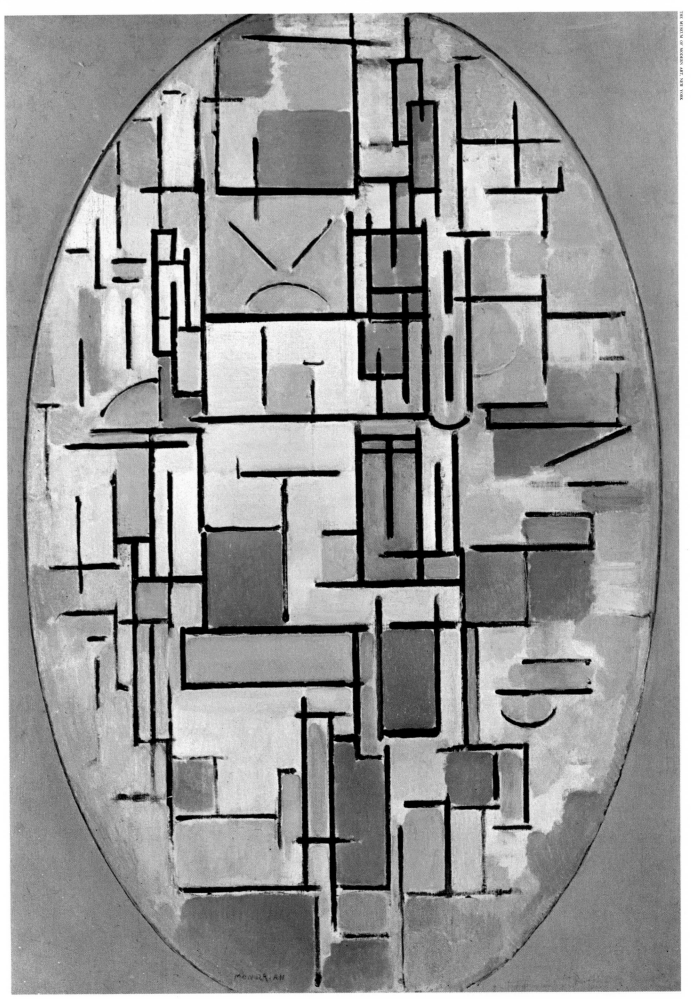

Piet Mondrian: *Color Planes in Oval*, c. 1914

135

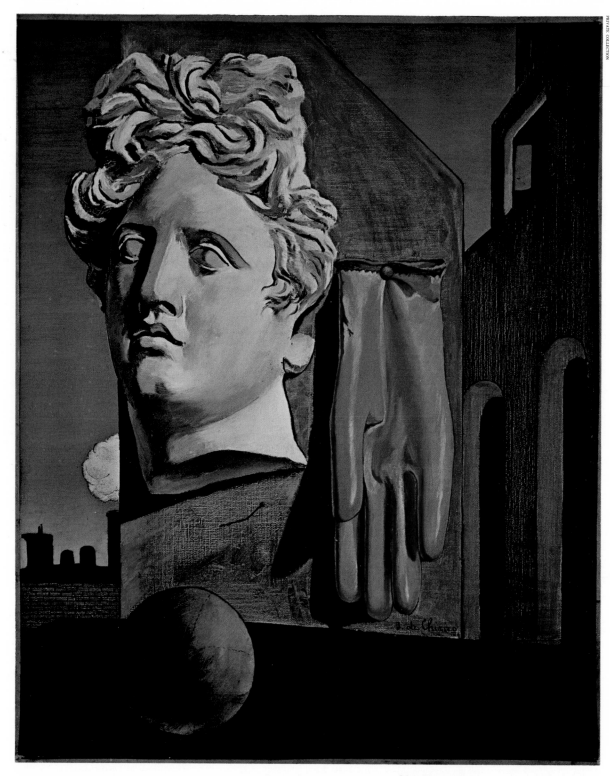

Giorgio de Chirico: *Song of Love*, 1914

The Fantastic World of the Mind

Surrealist paintings seem to spring from the furthest reaches of the unconscious minds of their creators. Giorgio de Chirico, a pioneer of the Surrealist style and a man who later repudiated it, juxtaposed recognizable but unrelated objects to create mysterious tableaux that suggest timelessness and a sense of foreboding *(above)*. Interested more in formal abstraction, Joan Miró, like a master juggler, balanced free-form organic shapes to compose airy scenes that sometimes seem to be in motion *(upper right)*. Paul Klee, a fantasist of incisive wit, combined cryptographic elements, as in the painting at right, which suggest the potent symbolism of a prehistoric cave artist.

136

Joan Miró: *Composition*, 1933

Paul Klee: *Around the Fish*, 1926

137

Pollock's Magnificent Swirls

The huge 16-foot-wide painting above by Jackson Pollock has been acclaimed one of the great signposts in art history, rivaling in revolutionary importance Manet's *Déjeuner sur l'Herbe*. If this judgment seems a bit extreme, *Blue Poles* is nevertheless an unassailable masterpiece.

Pollock was the galvanic leader of the Abstract Expressionist movement, also called Action Painting—the first art movement to originate in the United States and influence painting the world over. Abstract Expressionism combined two

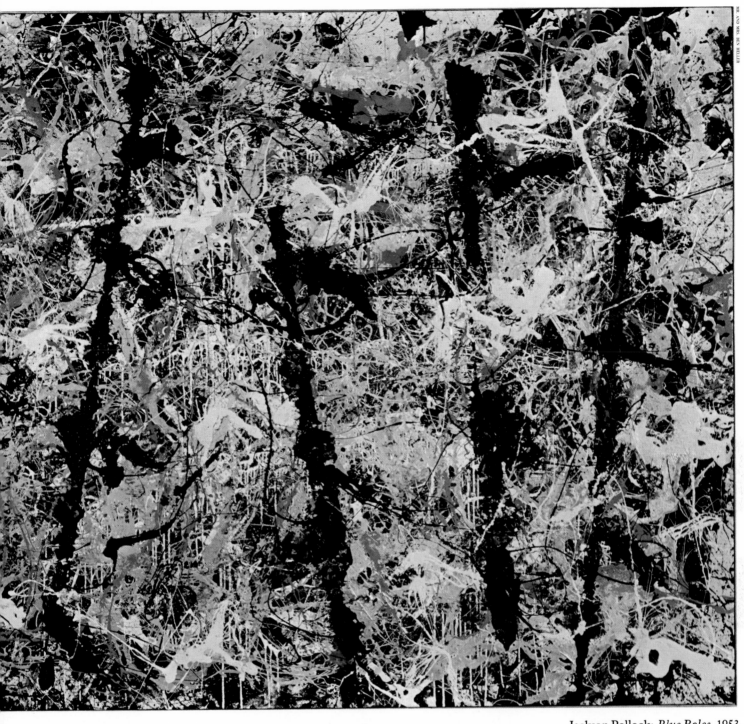

Jackson Pollock: *Blue Poles*, 1953

tendencies already evident in 20th Century art: the drive to create totally abstract works, as seen in the paintings of Kandinsky *(page 134)*, and the movement, growing out of the work of Matisse and others, to express emotion through the use of brilliant colors. Pollock's colors are brilliant indeed (he often used industrial or automobile enamels), and he has clearly refrained from depicting any recognizable objects unless it be the eight blue verticals, or poles, that march rhythmically across the composition, creating a tension with the skein of sinuous lines, emphasizing the flatness of the surface and unifying the whole work.

The term Action Painting was coined to describe how Pollock worked. He tacked canvases to his studio floor, then walked around them dribbling and spattering paint straight from the can, involving himself physically in the act of painting perhaps more strenuously than any painter before. In this way, Pollock felt, he could become emotionally at one with his work and through it communicate his emotions to the viewer.

Frank Stella: *Darabjerd III*, 1967

Andy Warhol: *Ethel Scull 36 Times*, 1963

140

Bridget Riley: *Current*, 1964

Pop, Op and Minimal

Abstract Expressionism continued to dominate art through the 1950s, but by the early 1960s, still newer styles had begun to thrust themselves into the forefront. Three of them, dubbed Pop, Op and Minimal, went to extremes of unemotional impersonality. Pop Art, an emphatic return to representationalism, depicted everyday objects and images in techniques borrowed from advertising and the comics. Andy Warhol's portrait of art patroness Ethel Scull *(left)* is a prime example of Pop's whimsical methods. The artist took Mrs. Scull to a Times Square snapshot machine; there, he fed in several dollars in quarters and then enlarged and transferred 36 of the photos onto a 12-foot-wide montage. The absence of the artist's personal touch also characterizes Minimal and Op Art. Minimalist Frank Stella deployed slivers of fluorescent color in geometric patterns, sometimes on irregularly shaped canvases *(above, left)*. The shimmering designs of Bridget Riley *(above)* are typical of Op Art, which induces the viewer to sense motion—so much so that in some cases he can actually get dizzy.

141

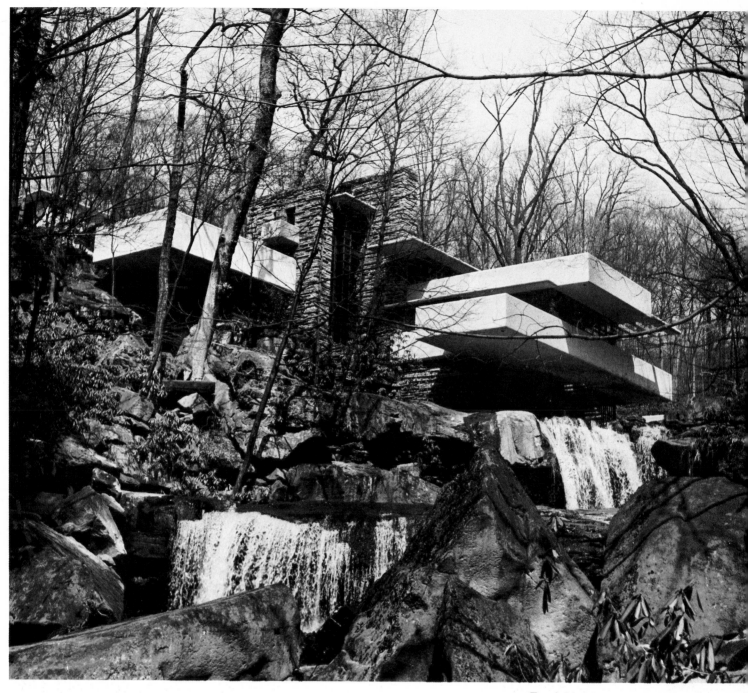

Frank Lloyd Wright: Falling Water, 1936

The New Art of Architecture

Architecture in the 20th Century, like painting and sculpture, struck out boldly in new directions. The most daring and inventive of the earlier American architects was Frank Lloyd Wright. It was Wright's contention that a building should not rigidly follow any set style but should instead reflect the designer's personality, yet at the same time be so organically related to its site and to the materials used that land and structure would become inseparable. An eloquent expression of Wright's approach is Falling Water *(above)*, a home built at Bear Run, Pennsylvania, in 1936.

White concrete slabs, reinforced with steel, project dramatically over a mountain stream in harmony with the ledges of natural rock.

Perhaps the most famous American contribution to architecture has been the skyscraper, a product of technology as well as of design. The architect who brought this art form to its purest expression —a steel cage sheathed in glass—was the Dutch-born, naturalized American Ludwig Mies van der Rohe. His apartment houses in Chicago *(right)* show the simplicity and economy that mark the best contemporary urban structures.

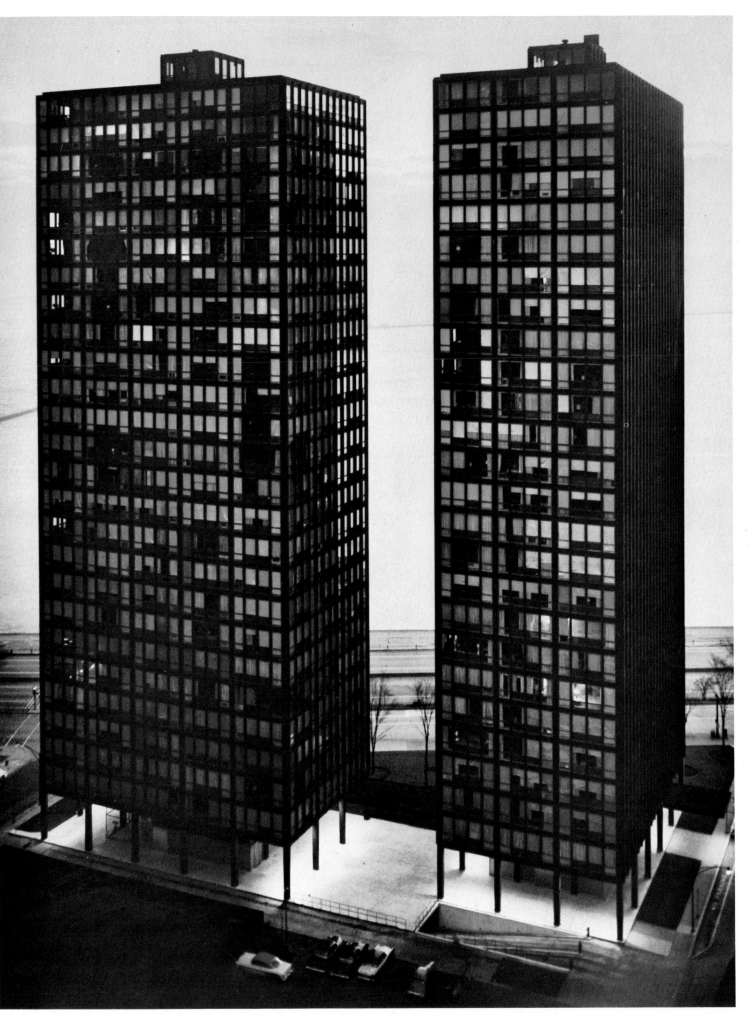

Ludwig Mies van der Rohe: Lake Shore Drive Apartment Houses, Chicago, 1950-1952

143

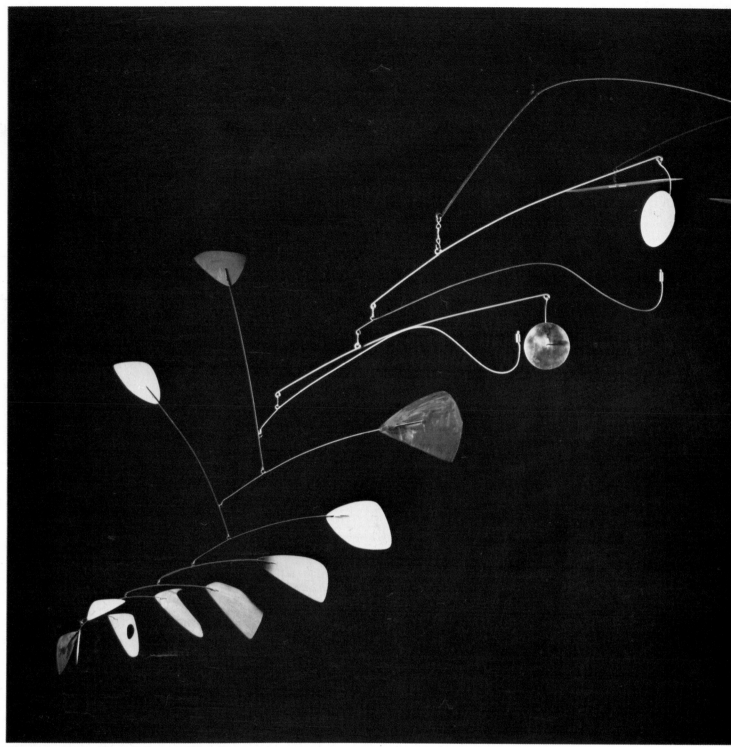

Alexander Calder: *Red, Yellow and Blue Gong*

Movement and Monumentality

Modern sculpture has undergone a transformation every bit as dramatic as painting, as 20th Century sculptors have largely turned away from commissioned busts and formal monuments in stone to create expressionistic, nonrepresentational works in a variety of materials. Among the most celebrated innovations have been Alexander Calder's mobiles—fragile, delicately balanced works *(above)*, usually of sheet metal and wire, which change shape and pattern in the slightest breeze. Other sculptors, among them David Smith, have used industrial materials and techniques like sheet steel and welding to create abstract constructions, often of heroic proportions *(right)*.

David Smith: *Cubi XXII*, 1964, with *Two Circles, Two Crows*, 1963, in the background

The World of Museums and Galleries

Art Galleries of Europe

Following is a list of all the major art galleries of Europe, plus a number of smaller museums that have interesting collections. Also included where appropriate are mansions that contain fine art, and churches decorated by great artists. They are listed alphabetically by nation and by city. The entries include brief notes on the painting and sculpture each gallery contains so that the reader may know where works of the artists who most interest him are to be seen. The emphasis throughout is on European and American painters and sculptors who worked during the period covered by the Time-Life *Library of Art, roughly 1300 to the present. For art galleries and museums of the United States, see pages 157–165.*

AUSTRIA

VIENNA

Graphische Sammlung Albertina. The Albertina's unrivaled collection of prints and drawings is based on acquisitions by the ruling Habsburgs and various noble families of the Holy Roman Empire. It includes some 40,000 drawings, sketches and watercolors and more than a million etchings, engravings and prints. The catalogue of this vast array reads like an encyclopedia of European artists from the Middle Ages to the 20th Century, among them Bosch, Bruegel (including his only signed and independently executed etching, *The Rabbit Hunt*), Leonardo, Michelangelo, Titian, Rembrandt, Rubens, Raphael and Giorgione. The Albertina's glory, however, is its unique treasure of Dürers, the most comprehensive in the world, including such marvels of draftsmanship as his precocious silverpoint *Self-Portrait at Thirteen*, exquisite watercolors like *Young Hare* and *The Great Piece of Turf*, as well as detailed preparatory studies for paintings. These studies are masterpieces in their own right; the most famous of them is *Praying Hands*. Only a fraction of the Albertina's riches can be on display at any one time, but a reading room is available where selections from the stock may be studied on request.

Kunsthistorisches Museum. Founded, like the Albertina, on the Habsburg imperial collections, Vienna's museum of art history is rich in paintings from former Habsburg realms, particularly the Netherlands, Spain and Venice. The Flemish and Dutch works include Vermeer's luminous *Artist in His Studio*, several major Rubens paintings (*Self-Portrait, The Little Fur*), a Van der Goes diptych, Van Eyck's *Cardinal Albergati*, two remarkable Rembrandt self-portraits and the world's finest group of Bruegel works. Among 15 major pictures—more than a third of Bruegel's 40 or so authenticated paintings—are three of the famous calendar series: *The Dark Day, Hunters in the Snow* and *Return of the Herd*. His treatment of religious subjects in contemporary terms can be seen in *The Massacre of the Innocents, The Carrying of the Cross* and *Conversion of St. Paul*. His characteristically hearty representations of the life of common people, *Peasant Dance* and *Peasant Wedding*, are among the works that earned Bruegel the nickname "Peasant." The museum's German works include Cranach's charmingly naïve *Garden of Eden;* Dürer's *Adoration of the Trinity, Portrait of a Young Venetian Girl* and *Martyrdom of the Ten Thousand;* and Holbein's portrait of Henry VIII's third wife, Jane Seymour. Velázquez' elegant paintings of royal children decked in jewels and rigid brocades grace the extensive Spanish collection of formal court portraits and religious pictures. The great paintings com-

missioned or bought from the Holy Roman Empire's transitory domains in Italy include the best collection, outside that in Madrid's Prado, of Titian's canvases, notably such portraits as *John Frederic, Elector of Saxony* and the seductive *Girl in a Fur* on which Rubens modeled his painting of his fur-clad young second wife, Hélène Fourment. Correggio's *Jupiter and Io*, Giorgione's *Three Philosophers*, Tintoretto's *Susanna and the Elders* and Veronese's *Judith* are other prizes of the Italian collection. Only 1,200 of the museum's 10,000 or so pictures can be hung at any one time, but such unique treasures as the Bruegels are always on display.

BELGIUM

ANTWERP

Cathedral de Notre-Dame. Antwerp's largest church—a mixture of medieval, Renaissance and Baroque styles—contains some superb paintings that Rubens produced specifically for it: two triptychs, *Elevation of the Cross* and *Descent from the Cross*, and an altarpiece, *The Assumption*.

Koninklijk Museum voor Schone Kunsten. Antwerp was one of the chief cities of old Flanders, and in its Royal Museum of Fine Arts the main collection of some 2,500 major works emphasizes Flemish art, from the 14th Century to the present. Inevitably the museum has a number of canvases by that most prolific of all Flemish artists Peter Paul Rubens, including *Le Coup de Lance, Communion of St. Francis* and *The Adoration of the Kings*. The museum also contains excellent works by Van Eyck, Van der Weyden, Patinir, Memling and Quentin Massys, as well as canvases by the modern Belgian artists James Ensor and Constant Permeke.

Museum van den Bergh. Housed in a Baroque mansion, the Van den Bergh owns a small but choice collection of 16th and 17th Century Flemish paintings, among them Bruegel's *12 Flemish Proverbs* and *Mad Meg*, and works by Jordaens and Broederlam.

Rubenshuis. Rubens' home displays a few of his paintings; the handsome house, little changed since he lived there in the early 17th Century, is worth seeing in its own right.

BRUGES

Groenigemuseum. Although small, this municipal art gallery has first-rate works by a number of the most important Flemish painters, including the Master of the Legend of St. Lucy, Van Eyck, Van der Goes, Memling, Bosch and Gerard David.

Musée Memling. Hans Memling, the 15th Century Flemish painter of portraits and religious works, is honored here by a limited (one room) but nonetheless impressive collection of his paintings. Among them are the *Shrine of St. Ursula* and *The Adoration of the Magi*.

BRUSSELS

Musées Royaux des Beaux Arts. Once the leading city of Flanders, Brussels retains in its Royal Museums of Fine Arts a particularly noteworthy array of the works of celebrated native artists, including Memling, Van der Weyden, Petrus Christus, Bouts, Bruegel (*The Numbering at Bethlehem*), Rubens, Jordaens, Gerard David, Teniers, Van Dyck and Brouwer. In another branch of the Royal Museums (until a new museum of modern art is completed) is a collection of 19th and 20th Century painting, from both Belgium (James Ensor, René Magritte and Rik Wouters) and the rest of Eu-

rope, especially from neighboring France (Seurat, Gauguin, Matisse).

GHENT

Cathedrale St. Bavon. Adorning this lovely cathedral, built between the 13th and the 16th Centuries, is one of the greatest treasures of Early Renaissance art in the North, the large triptych called the Ghent Altarpiece. This work (actual title: *The Adoration of the Lamb*) was begun, art scholars generally agree, by Hubert van Eyck and was finished by his better-known brother Jan. The cathedral owns a few other paintings, among them Rubens' admirable *Conversion of St. Bavon.*

CZECHOSLOVAKIA

PRAGUE

Národní Galerie. The Czech National Gallery's unique collection of medieval Czech art—as well as fine works by 16th and 17th Century Dutch and Flemish artists—is housed in the eastern corner of Prague's Hradčany, a thousand-year-old palimpsest of palaces, courtyards, churches, gardens and a jousting hall. Paintings, drawings and prints by such 19th and 20th Century artists as Daumier, Corot, Matisse and Marc Chagall are displayed in another wing of the castle. Mosaic panel doors of the 14th Century, called "The Golden Door," adorn the Cathedral of St. Vitus, at the heart of the complex, where the coronation jewels of former rulers are exhibited.

FEDERAL REPUBLIC OF GERMANY (WEST GERMANY)

COLOGNE

Wallraf-Richartz-Museum. This museum offers an outstanding collection of works by German artists from the Middle Ages (Stefan Lochner and the Cologne Artist of the "Life of the Virgin") to the 20th Century (Lovis Corinth, Emil Nolde and Ernst Barlach). It also has German and Netherlandish paintings of the 16th through the 19th Centuries, by Cranach, Dürer, Hals, Rubens, Rembrandt and the Dutch-born Van Gogh.

FRANKFURT

Städelsches Kunstinstitut. The Städel art institute's small but admirable collection is one of the best in West Germany. It includes German and Flemish paintings of the 15th and 16th Centuries—by The Master of Flémalle, Van Eyck, Cranach, Elsheimer, Grünewald and Holbein—and of the 19th and 20th Centuries. The Städel also owns representative Italian paintings of the 14th through the 18th Centuries by Fra Angelico, Botticelli, Bellini, Tintoretto, Veronese and Tiepolo.

MUNICH

Bayerische Staatsgemaeldesammlungen: Alte Pinakothek. This museum, which houses the old-master gallery of the West German national collection, offers, among other riches, the world's most important group of paintings by the Flemish master Rubens, more than 60 canvases in all. It also owns works by other German and Netherlandish artists, including Cranach, Dürer, Holbein, Brouwer, Van Dyck, Snyders and Rembrandt. Italian Renaissance and Baroque masters include Raphael, Leonardo, Tintoretto and Veronese.

Neue Pinakothek and *Neue Staatsgalerie.* This second national collection illustrates the progress of German art from the 18th to the 20th Centuries in the work of Ferdinand Olivier, Arnold Böcklin, Emil Nolde, Ernst Ludwig Kirchner and Max Liebermann.

WEST BERLIN

Staatliche Museen, Gemäldegalerie. West Germany's finest collection of old masters is on display in this state-owned gallery, which is often called the Dahlem Museum since it is in a section of Berlin bearing that name. Among its treasures are works by German Renaissance painters (Dürer, Cranach and Holbein), by Dutch and Flemish artists of the Renaissance and Baroque periods (Van Eyck, Bosch, Rubens, Van Dyck, Hals, Hobbema and Rembrandt, who is represented by 26 works), by Italian artists of the Late Gothic, Renaissance and Baroque periods (Giotto, Fra Angelico, Domenico Veneziano, Filippo Lippi, Botticelli, Mantegna, Tintoretto and Correggio), and by 18th Century French painters (Poussin, Claude and Watteau). The Dahlem's collection of graphic art is also outstanding, with Dürers, Rembrandts, Goyas and works by Toulouse-Lautrec. Among the artists represented in its fine drawing collection are Botticelli, Dürer, Grünewald, Holbein, Altdorfer, Cranach, Rembrandt, Fouquet and Watteau.

Galerie des 20. Jahrhunderts and *Nationalgalerie.* A pair of subsections of Berlin's State Museum, these galleries exhibit sculptures and paintings by 19th and 20th Century artists from all over Europe. France is represented by Manet, Monet, Renoir, Picasso, Braque, Vlaminck and Marc Chagall; Spain by Salvador Dali and Joan Miró; and England by Graham Sutherland and Ben Nicholson. The best collection, however, is of paintings by the German artists Caspar David Friedrich, Philipp Otto Runge, Karl Schmidt-Rotluff, Adolf Menzl, Lyonel Feininger, Lovis Corinth, Karl Hofer and Max Beckmann.

FRANCE

AIX-EN-PROVENCE

Cathedral of the Holy Savior. Besides the remarkable Fourth Century Baptistery, the 11th Century Cloister and the carved 15th Century walnut doors, the cathedral's major treasure is Nicolas Froment's 15th Century triptych *The Burning Bush.* The former archbishop's palace, near the cathedral, contains collections of 17th and 18th Century tapestries and furniture.

AIX-LES-BAINS

Musée du Dr. Faure. An art historian's own collection, bequeathed to the town, includes paintings by Fantin-Latour, Daumier, Corot, Degas, Cézanne, Renoir, Pissarro, Sisley, Sargent, Bonnard and Utrillo, as well as numerous sculptures by Rodin.

ALBI

Musée d'Albi. Thanks to the location in Albi of Toulouse-Lautrec's family home, the town's museum owns the largest single group of his paintings, drawings, prints and posters. Also on exhibit is an extensive collection of paintings by contemporaries of Toulouse-Lautrec and later artists, including Gauguin, Bonnard, Matisse, Dufy, Rouault, Vuillard and Vlaminck, and sculptures by Maillol and Rodin.

ANTIBES

Musée Picasso. The Grimaldi Castle houses a collection devoted to Picasso's paintings, sculptures, drawings, engravings and ceramics.

BESANÇON

Musée des Beaux-Arts. Besançon's museum contains representative works by old masters, especially 18th Century French painters, and a large collection of European drawings from the 15th to the 20th Centuries.

CHANTILLY

Musée Condé. One of the great treasures of French art can be seen in this handsome château on the outskirts of Paris: *Les Très Riches Heures du Duc de Berry,* a 15th Century manuscript in miniature, noted for its brilliant illuminations. A

Museums and Galleries (continued)

contemporaneous—and almost as beautiful—illuminated manuscript exhibited at Chantilly is Fouquet's *Book of Hours.* The museum also contains a good collection of paintings of many European schools and periods. Outstanding are works by the Sienese School and the school of Giotto, the Flemish artists Memling, Rubens and Van Dyck, and the Frenchmen Clouet, Poussin, Ingres and Delacroix.

CHARTRES

Cathedral of Notre Dame. Considered by many art historians the greatest of all Gothic cathedrals, Chartres is decorated with some of the finest sculpture from the middle of the 12th and the 13th Centuries. The figures of the west façade are integral parts of the pillars around the great portals; those on the north and south sides of the church, carved half a century later, around 1250, are more realistic and almost freestanding. The cathedral's celebrated stained-glass windows, nearly all of which are the 13th Century originals, comprise the largest series to survive among major Gothic cathedrals, and include the breathtaking window called *Notre Dame de la Belle Verrière.*

DIJON

Musée des Beaux-Arts. Housed in the former palace of the dukes of Burgundy, Dijon's museum contains a prize collection of 15th and 16th Century Flemish, French, German and Swiss paintings, statues, *objets d'art* and ecclesiastical furniture. Many of the items were purchased or commissioned by Burgundian dukes, who were avid patrons of the arts; among the most notable of these acquisitions is an *Adoration of the Shepherds* by The Master of Flémalle. Later paintings include works by Hals, Rubens, Teniers, Tintoretto, Veronese and Annibale Carracci. The ornate tombs of Dukes Philip the Brave and John the Fearless are excellent examples of Late Gothic sculpture.

GRENOBLE

Musée des Beaux-Arts. In addition to notable 17th Century French, Spanish and Flemish paintings, the museum of this ancient mountain city boasts one of France's most extensive collections of modern art, including works by Monet, Gauguin, Bonnard, Matisse, Braque, Dufy, Picasso, Utrillo, Vlaminck and Modigliani.

LYON

Musée des Beaux-Arts. One of France's major museums, the Beaux-Arts is situated in a former Benedictine Abbey. Its first-rate collection ranges from a Fourth Century B.C. Attic statue to paintings from virtually every European school since the Renaissance. Among the older masters represented are Perugino, Cranach, Tintoretto, Veronese, Domenichino, El Greco, Claude, Rubens, Jordaens, Teniers and Van Dyck. Early 19th Century paintings include canvases by Géricault, Ingres, Delacroix, Daumier and Corot. The late 19th and 20th Century collections are rich in works by the Impressionists and Matisse, Dufy, Utrillo, Pascin and Giorgio de Chirico. Lyon's nearby Museum of Textile History contains a remarkable display of Oriental and European cloth, ranging from ancient Coptic, Byzantine and Sassanid materials to samples of the most delicate webs woven in Lyon since the beginning of the 12th Century.

MEUDON

Musée Rodin. Insight into Rodin's creative methods is offered by this collection of rough sketches, clay models and molds that are displayed in the sculptor's onetime country house.

NANCY

Musée des Beaux-Arts. The museum's most interesting possessions are paintings by 19th and 20th Century French artists, including Courbet, Manet, Bonnard, Dufy, Matisse, Pascin and Vuillard, but there is also a small collection of older works by Rubens, Tintoretto, Philippe de Champaigne, Perugino and Ruisdael.

NICE-CIMIEZ

Musée Matisse. The late painter's residence, the Villa des Arènes, contains oils, gouaches, drawings, prints and sketches as well as personal souvenirs of Matisse's last years.

ORLÉANS

Musée des Beaux-Arts. Orléans' collections of painting and sculpture, housed in a 16th Century Town Hall, include some 17th and 18th Century French works and an important early painting by Velázquez, *Saint Thomas.* There are sculptures by such famous French artists as Houdon, Rodin and Maillol. A room is devoted to the works of the Modernist Max Jacob.

PARIS

Musée de Cluny. As one of Europe's art centers for nearly a thousand years, Paris produced medieval artists who were just as remarkable as its more renowned modern painters. Some of the best of the medieval art is preserved in the Cluny Museum, housed in a 15th Century palace. Exhibits include painting, enamelware, jewelry, furniture, stained glass, and wooden and marble statuary. Outstanding are two tapestry series, "*La Vie Seigneuriale*" ("A Nobleman's Life") and "*La Dame à la Licorne*" ("Lady with the Unicorn").

Musée du Jeu de Paume. This museum displays the Louvre's matchless collection of Impressionist and Post-Impressionist paintings, including such landmark works as Manet's *Déjeuner sur l'Herbe,* Monet's studies of Rouen Cathedral at different times of day, Renoir's *Moulin de la Galette,* Cézanne's *The Bathers* and Van Gogh's *The Artist's Room at Arles.* The museum's excellent lighting is due in part to the fact that it was designed in the 18th Century as a court for an ancient form of tennis called *jeu de paume.*

Musée du Louvre. The sumptuous in-town palace of the later French kings houses the national collection of paintings, dating from the Middle Ages to the mid-19th Century. Among the world-famous works on display in the Louvre's galleries are Leonardo's *Mona Lisa* and *Madonna of the Rocks,* Cimabue's *Madonna with Angels,* Fra Angelico's *Coronation of the Virgin,* Mantegna's *Crucifixion,* Titian's *Man with a Glove,* Bruegel's *The Beggars* and Rubens' series of paintings of scenes from the life of Marie de' Medici. Native-born painters from the 16th to the 19th Centuries are, of course, richly represented, including Clouet, Poussin, de la Tour, Boucher and Watteau. Particularly noteworthy among the 19th Century works are David's *Portrait of Mme. Recamier* and *Coronation of Napoleon,* Delacroix's *Liberty Leading the People,* Ingres' *The Turkish Bath,* Géricault's *The Raft of the Medusa* and Courbet's *The Artist's Studio.* In addition to its painting treasure, the Louvre contains a vast collection of 90,000 drawings and some of the world's greatest sculpture, including two *Slaves* by Michelangelo and, among many ancient works, the *Winged Victory* and the *Venus de Milo.* In the northwest wing the Musée des Arts Décoratifs displays superb examples of French applied art from the 12th Century to the present. The collections of Egyptian and Oriental art are also outstanding.

Musée d'Art Moderne de la Ville de Paris. Specializing in works by 20th Century Frenchmen, this museum contains paintings and sculptures by Vuillard, Braque, Rouault (80 works in all), Matisse, Dufy, de Segonzac, Bourdelle, Maillol and Buffet. Artists of other nationalities, including Wassily Kandinsky, Henry Moore and Constantin Brancusi, are also exhibited. An adjoining section is used mainly for temporary exhibits of experimental art.

Musée de L'Orangerie. The only painting on permanent display in the Orangery, where temporary exhibits of modern art are held, is Monet's spectacular *Water-Lilies,* which completely covers the walls of the large oval-shaped room especially designed to show it off.

Musée du Petit Palais. Along with some medieval French tapestries and Chinese porcelains the Petit Palais owns an

important collection of ancient art. In addition, there are 18th Century French paintings and furniture plus some first-rate canvases by Courbet (*Les Demoiselles des Bords de la Seine, Le Sommeil*) and others by Monet, Vuillard and Bonnard. The museum also owns a number of 17th Century Dutch works, including Rembrandt's *Self-Portrait with a Dog*, and a collection of 19th Century French sculptures.

Musée Rodin. Rodin bequeathed all the works in his possession —including bronzes, marbles and drawings—to the French government on condition that they be displayed in the last house in which he lived in Paris, the Hôtel Biron. The resulting collection is extraordinary, and a must for Rodin admirers. The museum also plays host to temporary exhibits of modern sculpture.

PARIS—CHURCHES

Cathedral of Notre Dame. Built mainly between 1163 and 1250, this monumental edifice is considered a perfect large-scale expression of the Gothic ideal of sacred architecture first defined in the small Abbey Church of Saint-Denis (below). Above the west façade's richly sculptured triple portals the square bell towers rise 207 feet to their gargoyled cornices. The façade's 32-foot-wide rose window forms a brilliant halo for the huge stone Madonna above the porch. Inside the lofty nave a graceful early 14th Century statue called *The Virgin of Paris* epitomizes High Gothic sculpture at its best.

Sainte-Chapelle. The upper chapel of this 13th Century royal shrine is a glowing triumph of Gothic stained glass depicting scenes from the Old and New Testaments.

Saint-Sulpice. Second-largest church in Paris, the 17th Century edifice contains two superb murals by Delacroix.

REIMS

Cathedral of Notre Dame. The 13th Century cathedral, long the site of the coronations of France's kings, is one of the great monuments of High Gothic architecture. Hundreds of statues, a "Bible in stone," adorn the triple portal of the main façade, the niches above the flying buttresses, the nave and the transept. On the north side, three portals are devoted to the saints of Reims, the Virgin and *The Last Judgment.*

Musée Saint-Denis. Besides superb 15th and 16th Century *toiles peintes* (painted cloths), Reims's museum has a number of paintings of the 16th, 17th and 18th Centuries, plus some excellent canvases by such 19th Century French artists as Delacroix, Corot, Courbet, Millet and Gauguin. There is also a fine collection of drawings by the German Cranach.

SAINT-DENIS

Abbey Church of Saint-Denis. This impressive building on the outskirts of Paris is the prototype of all the great Gothic cathedrals. It was constructed between 1137 and 1144, and its proportions were based on a medieval concept of architecture that combined mathematics and theology. At once a prayer in stone and a visual statement of Christian doctrine, it inspired the construction of 12th and 13th Century cathedrals all over Europe. Once the burial place of French kings, the church still contains their tombs, although the royal remains were removed during the Revolution.

SAINT-TROPEZ

Musée de l'Annonciade. The museum of this little Riviera town rejoices in a choice collection of works by Signac, Matisse, Bonnard, Derain, Vlaminck, Rouault and Braque.

VENCE

Chapel of the Rosary. Situated in a hill town behind the Riviera, this small jewel of a chapel is the handiwork of the aging Matisse; he designed everything from its architecture to its stained-glass windows to its altar decorations. Severely simple, the chapel reflects a strikingly modern statement of faith.

VERSAILLES

For years the French government has been restoring the art collection looted during the Revolution from the Palace of Versailles. Today this magnificent stone pile built by Louis XIV contains many fine 17th and 18th Century works of art, among them paintings by Charles Lebrun and other French artists, Gobelin tapestries and Bernini's splendid bust of Louis himself. Many of the sumptuous state apartments have been refurbished, including the famous Hall of Mirrors. A mile and a half from Versailles is the Grand Trianon Palace, built by Louis XIV as a private retreat. Since completion of a four-million-dollar renovation in 1966, the Trianon has served both as a guesthouse for visiting heads of state and as a museum. It possesses some 150 canvases by such 17th and 18th Century French painters as Lebrun and Antoine Coypel. The palace's superb furnishings, with the exception of an eight-room suite done in Louis XVI style, are in 19th Century Empire style.

GERMAN DEMOCRATIC REPUBLIC (EAST GERMANY)

DRESDEN

Staatliche Kunstsammlungen Dresden. Dresden, long a center of porcelain making, naturally has a superb collection of this delicate art. In addition the city's gallery includes paintings by both *Alte Meister* (old masters) and *Neue Meister* (new masters). Among the former are Mantegna, Pintoricchio, Giorgione, Titian, Tintoretto and Veronese. Dutch and Flemish works include paintings by Van Eyck, Rubens, Van Dyck, Rembrandt and Vermeer. The gallery also owns German Renaissance works by Dürer, Cranach and Holbein. Among more modern works, there are paintings by German and French Impressionists and the Romantic painters of the 18th and 19th Centuries.

EAST BERLIN

Staatliche Museen zu Berlin: Nationalgalerie. This museum, which for a hundred years has stood on a tiny island in the middle of the River Spree in downtown Berlin, specializes in Continental European art of the 18th through the 20th Centuries. Among the German painters whose work may be seen here are Anton Raphael Mengs, Adolf Menzl, Karl Schmidt-Rotluff, Emil Nolde and Käthe Kollwitz. The museum also owns paintings by Goya, the 18th Century Spanish master, and by 19th and 20th Century French painters from Courbet to Vlaminck.

GREAT BRITAIN

BEDFORD

Woburn Abbey. One of England's great country houses, and worth seeing on that score alone, Woburn also has a large collection of paintings, started by the wife of the Third Earl of Bedford and enlarged by the Fourth Earl, one of Gainsborough's principal patrons. Visitors to the Abbey may see many portraits by Van Dyck, Velázquez, Holbein and Canaletto.

BIRMINGHAM

Corporation Art Gallery and Museum. Birmingham's municipal museum ranks with Liverpool's as one of the best city-owned galleries outside London. Outstanding are its Pre-Raphaelite paintings, its 19th Century English watercolors by Turner, Girtin, Cotman and John Robert Cozens, and its 20th Century works by Walter Sickert and the local artist David Cox.

BUSCOT

Buscot Park. The pride of the collection in this fine country

house is a series of paintings by Pre-Raphaelite Edward Burne-Jones. The mansion also contains canvases by the 17th Century masters Murillo and Rembrandt and by the 18th Century English portraitist Reynolds.

CAMBRIDGE

Fitzwilliam Museum. The Fitzwilliam contains Venetian paintings by Titian, Tintoretto, Veronese, Canaletto and Guardi; Dutch works by Rembrandt, Hobbema and Ruisdael; and English paintings, including portraits by Hogarth, Reynolds, Romney and Gainsborough and landscapes by Turner and Constable.

DERBYSHIRE

Chatsworth House. After Windsor Castle, Chatsworth has the best private collection of drawings in England. Assembled by the Dukes of Devonshire, it includes work by the Italian Renaissance and Baroque masters Leonardo, Raphael, Michelangelo, Titian, Correggio and the Carracci. There are also outstanding drawings by Rembrandt, Rubens, Dürer, Van Dyck and Holbein.

DURHAM

The Bowes Museum, located outside Durham in the small town of Barnard Castle, the Bowes was built in the late 19th Century and resembles a French château. It houses works by masters from Spain (El Greco and Goya), France (Boucher and Courbet) and Italy (Tiepolo).

EDINBURGH

National Gallery of Modern Art. Built in 1960, this museum has paintings by 20th Century Continental artists (Picasso, Matisse and Fernand Léger, among others), as well as works by Scottish painters (William Gear, Alan Davie, William MacTaggart) and English artists such as Graham Sutherland, Ben Nicholson, Henry Moore and Barbara Hepworth.

National Gallery of Scotland. Of particular note are paintings by 18th and 19th Century Scottish artists, many of whom —like Horatio McCulloch and Sir John Watson Gordon —are unfamiliar to most Americans. In addition, the gallery possesses a collection of French art, particularly strong in Monet and Gauguin, and paintings by Titian, Raphael and Rembrandt.

Scottish National Portrait Gallery. Although Alexander Runciman, William Aikman, Andrew Geddes and some of the other painters whose work is seen here are not well known outside Scotland, their subjects are. On display are portraits of most of the luminaries of Scottish history, including Mary Queen of Scots, Bonnie Prince Charlie, Robert Burns and Robert Louis Stevenson. Work by widely known portrait painters such as Gainsborough and Reynolds can also be seen here.

GLASGOW

Glasgow Gallery. One of the half-dozen paintings attributed to Giorgione hangs here, along with works by such Dutch and Flemish masters as Rembrandt, Rubens and Ruisdael, and a number of paintings by 19th Century French artists Delacroix, Corot, Millet and Rousseau.

LIVERPOOL

Walker Art Gallery. Some 20 blocks from Liverpool's bustling Mersey-side docks, the Walker is one of the best English museums outside the capital. Most notable are the important collections of early Italian and Netherlandish paintings, and European painting and sculpture from 1500 to 1900. The museum also has important works by such English painters as Gainsborough, Reynolds and Turner.

LONDON

British Museum. This immense museum includes two collections devoted to the fine arts. The Department of Prints and Drawings boasts Italian works by Fra Angelico, Botticelli, Leonardo, Raphael, Michelangelo and Titian; English wa-

tercolors by Gainsborough, Constable, Cotman and John Robert Cozens; and more examples of Dürer's work than any museum outside Germany. The famous Elgin Marbles, originally part of the sculptural decoration of the Acropolis in Athens, and among the finest pieces of Greek sculpture in the world, fill a large gallery given especially to house them by Lord Duveen of Millbank. Egyptian, Greek, Roman and Anglo-Saxon art works, including sculpture, jewelry and pottery, are displayed in numerous other rooms.

Courtauld Institute Galleries. On view here are several outstanding collections donated by wealthy art patrons. The Courtauld Collection, presented by the Institute's founder, Samuel Courtauld, has a number of fine—some famous—Impressionist and Post-Impressionist works, among them Cézanne's *Le Lac d'Annecy* and Manet's *Bar at the Folies-Bergère,* plus portraits by Toulouse-Lautrec, Seurat and Van Gogh. The Lee Collection includes canvases by old masters Cranach, Rubens, Van Dyck, Goya and Gainsborough. The Sir Robert Witt Collection, a large group of old-master drawings, is especially strong in works by Caravaggio and Tiepolo. The Fry and Gambier Parry Collections specialize in modern French and early Italian art, respectively.

Dulwich College Picture Gallery. London's first public gallery was founded in 1814 in the suburb of Dulwich, a few miles from the heart of the city. Over the years the collection has become best known for its Dutch paintings by Rembrandt, Cuyp and Hobbema. Dulwich also has Italian Renaissance and Baroque paintings by Raphael, Veronese and Canaletto. French works include canvases by Poussin and Watteau, and there are excellent English portraits by Reynolds, Gainsborough, Lawrence and Romney.

Hampton Court Palace. Once a royal residence (five of Henry VIII's wives are said to have lived here), Hampton Court now houses an important part of the extensive British Royal Collection of art. The paintings include distinguished Italian works by Duccio, Fra Angelico, Raphael, Giorgione, Titian, Mantegna, Tintoretto and Giulio Romano. The Renaissance period in Germany is represented in paintings by Cranach and Holbein and there are some notable Flemish works.

Kenwood, The Iveagh Bequest. In 1925 philanthropist Lord Iveagh decided to create an art collection that an 18th Century gentleman might have assembled. The result of this unique idea is Kenwood, a handsome 18th Century house full of period furniture, surrounded by 74 acres of woodland and farm and displaying paintings by Turner, Romney, Gainsborough, Reynolds, Rembrandt, Vermeer, Cuyp, Hals, Van Dyck and Boucher.

The National Gallery. For visitors going to only one London museum this is a must, largely because of its superb Italian, Dutch and Flemish works. Among the former are paintings by Duccio, Uccello, Filippo Lippi, Botticelli, Titian and Leonardo. Flemish and Dutch paintings include one of Van Eyck's most famous oils, *The Marriage of Giovanni Arnolfini and Giovanna Cenini,* Rubens' *Château de Steen* and Rembrandt's *Woman Taken in Adultery.* The gallery also has an extensive collection of Impressionist paintings by Pissarro, Monet, Degas and Renoir, and several famous Manets, including *Concert at the Tuileries* and the *Firing Party.* Among Spanish paintings there are works by Goya, Velázquez, Zurbarán, El Greco, Ribera and Murillo. The choice selection of British paintings includes works by Constable, Gainsborough, Hogarth and Turner.

National Portrait Gallery. The work of Reynolds, Gainsborough, Romney and many others helps make this England's finest collection of portraits. Nearly 5,000 of England's most illustrious historic and literary figures are portrayed, among them Henry VIII, Queen Elizabeth I, Shakespeare, Ben Jonson, John Donne, John Milton, Jonathan Swift, Thomas Hardy and D. H. Lawrence.

The Tate Gallery. The Tate houses the English national col-

lections of modern painting and of British art. It has two main sections: one is devoted to works of British painters born before 1850, the other to painters—from both Britain and Continental Europe—born after 1850. Among the pre-1850 British works are portraits by Reynolds and Gainsborough; landscapes by Constable; illustrations by William Blake for editions of Dante, Milton and the Bible; the world's finest collection of paintings by Turner; and works by the best of the Pre-Raphaelites, including Sir John Everett Millais, William Holman Hunt, Dante Gabriel Rossetti and Sir Edward Burne-Jones. The Tate's modern collection includes paintings by Cézanne, Matisse, Picasso, Braque and Paul Klee as well as the best of Britain's moderns, among them Graham Sutherland and Francis Bacon.

Victoria and Albert Museum. Tucked away among outstanding Chinese jades and vases, Indian paintings and Gothic tapestries are a number of fine English and European paintings, including the best collection anywhere of the works of Constable, plus works by Gainsborough and Reynolds. Also on display are the great cartoons, or preparatory paintings, that Raphael designed for tapestries for the Vatican. Courbet, Millet and Degas are represented, as are drawings by Leonardo, Tintoretto, Tiepolo, Rembrandt and Rubens.

The Wallace Collection. A small but excellent collection, the Wallace has rare British portraits by Gainsborough (including the famous *Mrs. "Perdita" Robinson),* Romney and Lawrence; one of the best Watteaus outside France; Boucher's *Madame Pompadour* and Fragonard's *The Swing;* and works by early 19th Century French painters such as Delacroix and Géricault. Seventeenth Century Dutch and Flemish paintings include works by Rembrandt, Steen, Hals *(The Laughing Cavalier)* and Van Dyck.

Wellington Museum. Another fine, small collection, assembled by England's great soldier, is displayed in his onetime home. The gem of the lot is probably Velázquez' *Water Carrier.* There are other outstanding Spanish paintings by Murillo and Ribera, and works by the Netherlandish artists Rubens, Steen and Van Dyck.

MANCHESTER
City Art Gallery. The main galleries trace British painting from the 17th Century to the 20th Century through the work of Reynolds, Hogarth, Constable, the Pre-Raphaelites and Augustus John. Other galleries show works by Piero di Cosimo, Van Dyck and Teniers, and 19th Century French artists such as Corot, Fantin-Latour and Rodin.

NORTHAMPTON
Althorp. The Spencers, made earls by James I, have occupied the great estate of Althorp since 1508. They have filled the house with a remarkable collection of old masters, including works by Rembrandt, Rubens, Holbein, Raphael and Murillo. Also displayed here are some fine family portraits commissioned during the 17th and 18th Centuries from Lely, Van Dyck, Gainsborough and Reynolds *(Georgiana, Countess Spencer with Lady Georgiana Spencer).*

OXFORD
The Ashmolean Museum. Founded in 1677, when Elias Ashmole, a British antiquarian and astrologer, offered the University a hodgepodge of archeological oddities, the Ashmolean now houses one of England's most interesting art collections. In addition to Greek and Roman sculpture, it includes paintings by the Pre-Raphaelites and excellent drawings by Michelangelo, Raphael and Rembrandt.

SUSSEX
Petworth House. Nineteenth Century esthetes dubbed Petworth "a nursery of the arts," not only because the great artist Turner frequently visited there, but also because its owner, the Third Earl of Egremont, devoted much enthusiasm, time and money to collecting paintings. Petworth has changed little over the years. The rooms still look much the same as they did when Turner sketched them. Works by Turner himself hang on the walls, along with paintings by Van Dyck, Gainsborough, Reynolds, Romney and many other artists.

WINDSOR
Windsor Castle. The English Royal Family's residence at Windsor boasts an outstanding art collection. It includes England's finest collection of drawings, with many works by the Italian Renaissance artists Leonardo, Raphael and Michelangelo, and by British artists of the 17th to the 19th Centuries, among them Hogarth and Sandby. The paintings at Windsor Castle are almost as notable as the drawings, especially the fine portraits by Holbein, Van Dyck, Rubens, Memling and Dürer.

HUNGARY

BUDAPEST
Szepmüvészeti Múzeum. The collection of Budapest's fine arts museum includes the art assembled by the once-powerful Esterhazy family and bought by the Hungarian government in 1871. The museum's huge Neoclassic building contains dozens of rooms hung with European paintings, ranging from 14th Century works by Ambrogio Lorenzetti and others to canvases by Renoir, Gauguin and Cézanne. The sculpture collections include rare examples by anonymous Gothic artists and Italian Renaissance masters. There are also works by modern sculptors such as Maillol, Rodin and the Yugoslav Ivan Meštrović. The large collection of Italian painting is dominated by Titian's superb *Portrait of the Doge, Marcantonio Trevisani;* it also has works by Verrocchio, Giorgione, Ghirlandaio, Veronese, Gentile Bellini, Correggio and Tiepolo, as well as Raphael's exquisite *Esterhazy Madonna* and his *Portrait of a Youth,* considered a self-portrait by some art historians. Pre-Revolutionary French painting is represented by Philippe de Champaigne, Claude, Greuze and a splendid Chardin, *Still Life with Turkey.* Besides characteristic religious paintings by Zurbarán, Ribera and Murillo, the Spanish selections boast seven El Grecos, five Goyas and Velázquez' *Peasant Repast.* Paintings from Flanders and Holland include a Petrus Christus *Madonna,* an altar triptych by Memling, Bruegel's *Sermon of St. John the Baptist,* two superb Rembrandts, and portraits by Maes, Steen, Van Dyck, Jordaens and Hals. The aristocratic tastes of the 18th Century are reflected in an English section made up mainly of portraits by Reynolds, Hogarth, Raeburn and Gainsborough.

ITALY

ASSISI
Basilica di San Francesco. Assisi's 13th Century church abounds in remarkable paintings of that era, including a *Crucifixion* by Cimabue and frescoes by Simone Martini. Around the nave of the upper church is a splendid series of 28 frescoes depicting the life of St. Francis. Long thought to be by Giotto, the frescoes are now of disputed authorship, although their beauty is undeniable.

BERGAMO
Galleria dell' Accademia Carrara. This museum is best known for its collection of the works of the Venetian School from the 15th to the 18th Centuries and for a rich collection of drawings. Artists represented on its walls include Mantegna, Pisanello, Antonello da Messina, Giovanni Bellini, Carpaccio, Titian *(Madonna with Child),* Tintoretto, Veronese and Tiepolo. In addition the gallery has works by Fra Angelico, Botticelli *(Portrait of Giuliano de' Medici),* Cranach, Dürer, Rubens and Van Dyck.

BOLOGNA

Pinacoteca Nazionale. Among the important works exhibited at this gallery are paintings by Giotto *(Polyptych with Madonna and Child)*, Raphael *(Ecstasy of St. Cecilia)*, Perugino, Parmigianino, Lodovico Carracci, Guido Reni, Titian and Tintoretto.

FLORENCE

Galleria dell' Accademia. One of the smaller galleries of art-rich Florence, the Accademia nonetheless contains an impressive treasure. No fewer than eight of Michelangelo's most famous sculptures are on view here, including the original *David,* and four slaves carved for the tomb of Pope Julius II. Painters whose works are displayed include Gaddi, Daddi, Fra Bartolomeo, Ghirlandaio, Filippino Lippi, Uccello and Botticelli.

Galleria degli Uffizi. The Uffizi, itself a notable example of Renaissance architecture, contains a galaxy of great paintings by Cimabue, Duccio, Giotto, Filippo Lippi, Verrocchio, Pollaiuolo, Ghirlandaio, Botticelli *(La Primavera, The Birth of Venus)*, Filippino Lippi, Andrea del Sarto, Leonardo and Raphael *(Pope Leo X with Cardinals, The Madonna of the Goldfinch)*. Also exhibited are works by Venetian masters, including Titian *(Venus of Urbino)*, Veronese and Tintoretto *(Leda and the Swan)*, and by early Flemish, German and French painters, including Dürer, Cranach, Nicolas Froment and Van der Goes *(Adoration of the Shepherds)*.

Museo del Bargello. Once the palatial headquarters of the Florentine government, the Bargello contains an unparalleled collection of sculpture, including pieces by most of the great Florentines of the 15th and 16th Centuries: Ghiberti, Brunelleschi, Luca della Robbia, Donatello, Verrocchio, Michelangelo, Cellini and Giambologna. Two bronze figures of David by Donatello and Verrocchio offer an interesting comparison of two brilliant approaches to the same subject.

Museo dell' Opera del Duomo. Florence's leading painters and sculptors created works for the city's cathedral, the Duomo. Many of these works have been removed to this nearby museum for easier viewing. Among them are Donatello's marble *St. John the Evangelist* and choir lofts in marble bas relief both by him and by his contemporary Luca della Robbia.

Palazzo Pitti. The most imposing of Florence's palaces, the Pitti is another storehouse of great Italian Renaissance and Baroque painting. Its collection is not as large as the Uffizi's but it is high in quality. The Pitti owns Raphael's famous *Virgin Seated on a Chair,* and among its other stellar attractions are 19 works by Andrea del Sarto (including his *Assumption of the Virgin)*, 18 by Titian *(The Concert, The Young Englishman* and *La Bella)*, and several by Tintoretto and Veronese. Velázquez is represented by one of his celebrated portraits of Philip IV of Spain, and his Flemish contemporary Rubens by *The Consequences of War* and *The Four Philosophers.*

FLORENCE—CHURCHES

Or San Michele. Traditionally this great church was used by members of the city's many guilds, and its exterior is adorned with statues of the guilds' patron saints. The guildsmen of the Renaissance had the judgment to commission their statuary from the best sculptors. As a result of this enlightened patronage, magnificent works by Donatello, Ghiberti and Giambologna can be seen here.

San Lorenzo. Members of the wealthy and powerful Medici clan did their utmost to make San Lorenzo, the family church, designed by the master architect Brunelleschi, a work of art in its own right. The New Sacristy contains two tombs of the Medici dukes by Michelangelo, including his stunning and enigmatic figures of *Dawn* and *Dusk, Night* and *Day,* and his sculpted portraits of Giuliano and Lorenzo de' Medici.

San Marco. While in residence as a friar, the 15th Century painter Fra Angelico decorated much of the wall space in this Dominican monastery, which preserves nearly 80 of his frescoes. For the public rooms he produced several large works, many of them now in the church's nearby museum. For the monks' otherwise austere cells, he did dozens of small ones. Fra Angelico's contemporary, Ghirlandaio, embellished a wall of the refectory with one of his best paintings, *The Last Supper.*

Santa Croce. Rare and beautiful frescoes adorn the walls of this 14th Century church. Several are by Giotto; one scene, in which the painter portrayed St. Francis on his deathbed, moved Michelangelo to tears with its beauty. Other artists who contributed their talents to the church include Donatello, who sculpted the tabernacle of the Annunciation and a wooden crucifix.

Santa Maria del Fiore. This imposing cathedral, which towers over Florence, is one of the largest and most beautiful churches in the world. Begun in 1296, following the designs of Arnolfo di Cambio, it was completed when the dome was added by the great early Renaissance architect Brunelleschi in 1420-1436. The stained-glass windows were based on designs provided by Donatello, Andrea del Castagno, Uccello and Ghiberti, who also designed two pairs of bronze doors for the adjacent Baptistery. Of these the East Doors are particularly noteworthy; Michelangelo thought them so beautiful that he dubbed them the "Gates of Paradise." Michelangelo himself is represented in the cathedral by a stirring sculpture, the *Deposition.* Around the base of the cathedral's campanile, or bell tower, for which Giotto produced the original design, are bas reliefs by the 14th Century artist Andrea Pisano.

Santa Maria Novella. This elegant Gothic church and monastery is a treasure house of fresco painting. Masaccio's *Holy Trinity* is here, a major landmark in the history of Western painting. Other frescoes were done by the Renaissance masters Ghirlandaio, Filippino Lippi and Uccello.

GENOA

Galleria di Palazzo Bianco. The city's most important art collection is on display in this palace. It includes the works of Genoese artists from the 15th Century to the 17th, as well as paintings by Filippo Lippi, Pontormo, Veronese, Rubens and Van Dyck.

MANTUA

Palazzo Ducale. Onetime seat of the autocratic dukes of Gonzaga, the Palazzo now houses a glittering array of paintings by artists such as Pisanello, Tintoretto, Rubens, Van Dyck and El Greco. Frescoed rooms in the palace bear witness to the lavish and inspired patronage of the lordly occupants; of special interest is the *camera degli sposi*—the bridal chamber—where superb paintings by Mantegna illustrate events in the Gonzaga family history.

MILAN

Castello Sforzesco. The Sforza family, which ruled Milan from 1450 to 1535, had its rugged castle designed by Leonardo and Bramante. Today the castle contains an excellent collection of painting and sculpture. Two of its many medieval and Renaissance sculptures are especially noteworthy: Bonino da Campione's 14th Century *Bernabò Visconti* and Michelangelo's last work, the unfinished *Rondanini Pietà.* The Castello also displays Renaissance paintings such as Mantegna's *Madonna Trivulzio* and portraits by Lotto, Pontormo and others.

Pinacoteca di Brera. The Brera, one of Italy's outstanding galleries, possesses paintings by most Italian artists of the Renaissance and Baroque periods. Among the painters represented are Vincenzo Foppa of the northern Italian school, Mantegna (his extraordinary *Dead Christ* is displayed here), Gentile and Giovanni Bellini, Correggio, Tintoretto *(Discovery of the Body of St. Mark at Alexandria)*, Piero della Francesca, Raphael and Veronese.

Duomo. The largest Gothic building in Italy and a remarkable example of Gothic art and architecture, Milan's cathedral has 135 marble spires and 2,245 statues. The interior houses such treasures as the Trivulzio Candelabrum, a 16-foot-high, seven-branched candlestick of 13th Century French workmanship. In the cathedral treasury are such magnificent religious artifacts as Fifth Century ivory carvings and an 11th Century Gospel decorated with precious stones, enamels and pearls.

Sant' Ambrogio. Founded in the Fourth Century and rebuilt in the 12th, this basilica has Fourth Century columns, Fifth Century mosaics, Ninth Century bronze doors, a campanile of the Eighth or Ninth Century, and an altar dating from the Ninth Century that is decorated with gold and silver plates carved in relief.

Santa Maria delle Grazie. Leonardo's fresco *The Last Supper,* one of the most celebrated of all works of art, may be seen in the refectory of the convent adjoining the church. The painting has suffered from humidity and narrowly escaped obliteration by a bomb in World War II, but the painstaking application of modern restoring techniques have brought back some of its former glory.

MODENA

Galleria Estense. Located in Modena's Palazzo dei Musei, this collection of paintings includes excellent works by such Venetian luminaries as Veronese, Correggio and Tintoretto.

NAPLES

Galleria di Capodimonte. Housed in a former royal palace of the kings of Naples are some 2,000 paintings by masters of the Renaissance and Baroque periods in Italy and Northern Europe. The artists represented include Masaccio, Simone Martini, Mantegna, Botticelli, Giovanni Bellini, Titian, Annibale Carracci, Domenichino and Bruegel (*The Blind Leading the Blind*).

Museo Archeologico Nazionale. The mainstay of southern Italy's largest museum is its collection of classical Greek and Roman statuary, mosaics and other objects, many unearthed from the nearby ruins of Herculaneum and Pompeii. Among the many fine pieces on display are the *Farnese Hercules,* a bust of Homer and Roman frescoes of mythological scenes.

PADUA

Cappella degli Scrovegni. More familiarly known as the Arena Chapel because it stands on the site of a Roman amphitheater, this rather small, plain structure is without question the best place in the world to examine the genius of the great painter Giotto. The superb frescoes he painted on the chapel walls number 40 in all, and remain in remarkably good condition.

PERUGIA

Collegio del Cambio. A civic building once used by money-changers, the Collegio is decorated with frescoes by the 15th Century master Perugino and his pupils, among them Raphael.

Fontana Maggiore. Perugia's large marble fountain is decorated with reliefs by the 13th Century Pisan sculptor Nicola Pisano and his son Giovanni.

Galleria Nazionale dell'Umbria. This museum specializes in works of Renaissance painters of the Umbrian (Central Italian) school. Among them are Giovanni Boccati, Piero della Francesca, Pintoricchio and Perugino, the master of the school, whose *Dead Christ* and *Adoration of the Magi* hang here. Other painters represented include Duccio of Siena and Fra Angelico of Florence.

PISA

Museo Nazionale di San Matteo. Pisa's museum, housed in the old monastery of St. Matthew, owns remarkable medieval crucifixes, painted wooden sculptures of the 14th and 15th Centuries, and important paintings by Simone Martini, Masaccio and Fra Angelico.

Piazza del Duomo. Known as the "Square of Marvels," Pisa's cathedral compound encloses three beautiful monuments: the cathedral itself, the Baptistery and the famous Leaning Tower. The Baptistery was begun in 1152; 100 years later Nicola Pisano, one of the master sculptors of his day, enriched it with a marble pulpit that is a marvel of Gothic carving. The magnificent pulpit in the cathedral was produced by Nicola's son Giovanni in 1310; it is another great work of the medieval era. The church is also decorated with 13th and 14th Century mosaics, Renaissance bronzes and paintings by, among others, Andrea del Sarto.

PRATO

Duomo. Prato's cathedral, one of the most beautiful churches in the province of Tuscany, has an exterior pulpit decorated with a frieze of dancing angels by Donatello; the apse has a fine series of frescoes by the mid-15th Century Florentine painter Filippo Lippi.

RAVENNA

Once a stronghold of the Byzantine emperors, this small Italian city south of Venice is liberally sprinkled with rare Byzantine mosaics of the early centuries of the Christian era. The principal buildings where the mosaics, their colors still brilliant, may be seen are the Church of San Vitale, the baptisteries of the Arians and of the Orthodox, the Mausoleum of Galla Placidia, and the Old and New Basilicas of Sant' Apollinare.

ROME

Galleria Borghese. One of Italy's major museums of painting and statuary, the Villa Borghese has an outstanding sculpture collection on its ground floor that includes five important works by the Baroque master Bernini: *David, Apollo and Daphne, The Rape of Proserpine, Aeneas and Anchises* and *Truth Unveiled.* The painting collection, the finest in Rome after the Vatican's (*below*), has Italian Renaissance and Baroque works by such artists as Raphael, Titian (his *Sacred and Profane Love* is displayed here), Correggio and Caravaggio.

Galleria Doria-Pamphilj. This small but first-rate private collection of 15th and 16th Century paintings is open to the public. Outstanding are Jan Brueghel's *Earthly Paradise,* Caravaggio's *Rest on the Flight into Egypt* and Velázquez' *Pope Innocent X,* considered by many to be the Spanish master's most penetrating portrait.

Galleria Nazionale d'Arte Antica. Rome's important national painting collection occupies part of the massive Barberini Palace, where ceiling frescoes by Pietro da Cortona and other Baroque artists provide an imposing accompaniment to the paintings on the walls. Outstanding are works by Simone Martini, Filippo Lippi, Perugino, Bronzino, Raphael (*The Baker's Daughter*), Titian, El Greco and Holbein (*Henry the Eighth*).

Galleria Nazionale d'Arte Moderna. This gallery, which is near the Villa Borghese (*above*), specializes in 19th and 20th Century painting and sculpture, especially by Italian artists. Here are works by Italian Futurist and Metaphysical painters. The non-Italian painters represented include Degas, Cézanne and Van Gogh.

Musei Capitolino and *Palazzo dei Conservatori.* An invaluable collection of classical sculpture is on display in these museums on the city's Capitoline Hill, which face each other across a square (the Piazza di Campidoglio) designed by Michelangelo and decorated with an imposing equestrian statue of the emperor Marcus Aurelius. Among the Greek and Roman statues displayed are *The Dying Gaul,* the *Capitoline Venus, The Boy with a Thorn* and *The Faun* (which inspired the American writer Nathaniel Hawthorne's famous tale "The Marble Faun"). In addition to sculpture,

the Palazzo dei Conservatori has a small, interesting collection of paintings of the Renaissance and Baroque eras by Titian, Caravaggio, Rubens, Van Dyck and Velázquez.

Musei Vaticani. The Vatican museums house one of the largest and finest art collections in the world. Important paintings and statues are to be found in virtually every hallway and room, many of which are open to the public. There are five principal places the visitor should see, however:
(1) *Appartamenti Borgia (Borgia Apartments).* The High Renaissance master Pintoricchio decorated these six rooms with frescoes now considered to be among his best works.
(2) *Cappella Sistina.* From an artistic standpoint the Sistine Chapel is probably Rome's most unforgettable sight, for it contains Michelangelo's famous frescoes. The ceiling is covered with his scenes from the Old Testament; on the end wall is his *Last Judgment.* Elsewhere in the Chapel are frescoes by other great Renaissance painters, including Botticelli, Pintoricchio, Perugino and Signorelli.
(3) *Museo Pio-Clementino.* The Vatican's remarkable collection of antique statuary is housed in this sculpture museum founded by Popes Pius and Clement. Three of the most notable classical Greek statues on display are the *Laocoön,* which Michelangelo saw being unearthed in Rome, the *Belvedere Torso* and the *Apollo Belvedere.*
(4) *Pinacoteca Vaticana.* The Vatican's extensive collection of Italian Renaissance and Baroque art includes some 460 paintings, among them works by Gentile da Fabriano, Fra Angelico, Leonardo (his unfinished *St. Jerome*), Titian and Caravaggio.
(5) *Le Stanze di Rafaello (Chambers of Raphael).* Raphael and several of his students painted the walls of this suite of four rooms for Pope Julius II and his successor, Leo X. Completed in 1511, the frescoes, which are Raphael's best work in this medium, include his *School of Athens.*

ROME—CHURCHES

Basilica di San Pietro. The world's largest church, St. Peter's is a fitting backdrop for many paintings and sculptures of first quality, among them Michelangelo's famous *Pietà.* Bernini is represented by many works: the Baldachin, or ornamental canopy, over the tomb of St. Peter is his, as is the High Altar, the altar of the Chapel of the Sacrament and a monument to Pope Urban VIII. Bernini is also responsible for much of St. Peter's design, especially the colonnaded piazza.
Basilica di San Pietro in Vincoli. Michelangelo's superlative sculpture of Moses may be seen here.
San Luigi dei Francesi. Fine paintings by Caravaggio adorn a side chapel here.
Santa Maria del Popolo. This small church, which has kept its Renaissance character despite later additions, owns some remarkable art, including paintings and sculpture by Pintoricchio, paintings by Caravaggio (among them the *Conversion of St. Paul*) and sculpture by Bernini.
Santa Maria della Vittoria. A sculpture group in this church, *St. Teresa in Ecstasy,* is one of the most dramatic works of the 17th Century artist Bernini.

SIENA

Duomo. Siena's splendid cathedral, Gothic in style, contains some important works of art. Its pulpit, one of the finest examples of late Gothic marble carving, was executed by the Pisan master Nicola Pisano. There are also rare mosaics dating from the Renaissance—a period in which mosaic was little used. In the adjoining Piccolomini Library are 10 frescoes by the Umbrian master Pintoricchio.
Museo dell' Opera Metropolitana. This cathedral museum boasts an impressive altarpiece, the *Maestà,* by the 14th Century Sienese painter Duccio.
Palazzo Pubblico. Siena's City Hall displays works by two native Sienese masters: the *Maestà* and the equestrian portrait of *Guidoriccio da Fogliano* by Simone Martini and

The Effects of Good and Bad Government by Ambrogio Lorenzetti.
Pinacoteca Nazionale. This gallery, housed in a 14th Century palace, the Palazzo Buonsignore, displays works by Sienese painters from the 12th Century to the 16th. Outstanding are Duccio's *Madonna of the Franciscans* and works by Pietro and Ambrogio Lorenzetti.

TURIN

Galleria Sabauda. The gallery of this busy industrial city exhibits paintings by Daddi, Fra Angelico, Pollaiuolo, Mantegna, Veronese, Tintoretto, Annibale Carracci and Tiepolo. It also has an important collection of Dutch and Flemish paintings by Van Eyck (*St. Francis with Stigmata*), Van der Weyden, Memling, Rubens (*Susanna and the Elders*) and Rembrandt (*Old Man Asleep*).

VENICE

Galleria dell'Accademia. This museum has the best collection anywhere of Venetian art from the 14th to the 18th Centuries. Among the painters represented are Giovanni Bellini (an entire room is devoted to him), Giorgione (*The Tempest*), Gentile Bellini (*Miracles of the True Cross*), Carpaccio (the series "Legend of St. Ursula"), Titian (*Presentation of Mary in the Temple*) and Veronese (four canvases of the series called "The Miracles of St. Mark" plus the *Feast in the House of Levi*). There are also some scenes of Venice by Canaletto and Guardi.
Museo Correr. The paintings in this small museum cover all periods of the colorful, sensuous Venetian school. On display are polyptychs in the Byzantine manner by the three Veneziano brothers, Lorenzo, Paolo and Stefano; the *Two Courtesans* of Carpaccio; and masterworks by Jacopo and Giovanni Bellini.
Palazzo Ducale. The Grand Council Chamber of the ornate Doge's Palace is graced by two masterpieces of Venetian art, Tintoretto's *Paradise* and Veronese's *Apotheosis of Venice.* In the gilded splendor of the Doge's apartments, and in nearby rooms, are more fine paintings by Titian, Tintoretto and Veronese (including one of his most famous works, *The Rape of Europa*).
Peggy Guggenheim Collection. A fine collection of 20th Century art can be seen in the Venetian home of the American heiress Peggy Guggenheim. It is particularly strong in Cubist, Surrealist and Abstract Expressionist works; included are Picasso, Max Ernst, Wassily Kandinsky, Giorgio de Chirico, Fernand Léger and Jackson Pollock (11 of his works hang here), who was given his first one-man show in Miss Guggenheim's New York art gallery. Also on view are sculptures by such modern masters as Constantin Brancusi, Alberto Giacometti, Henry Moore and Jacques Lipchitz.
Scuola di San Rocco. The world's largest and most representative collection of Tintoretto paintings—56 works in all —hangs within this huge Venetian "school" (a building used in the 16th and 17th Centuries as a meeting place for a civic confraternity). Among the Scuola's paintings are *The Crucifixion,* which Tintoretto himself thought to be his best work, *Christ before Pilate* and an *Annunciation.*

VENICE—CHURCHES

Basilica di San Marco. An 11th Century church, St. Mark's is a treasure house of art. Over the entrance are four Classical Greek bronze horses, spoils from the sack of Constantinople in 1204. The whole of the basilica, entrance portals and interior, is decorated with mosaics, some dating from the 13th Century, others designed by such later masters as Titian and Tintoretto. The church owns many pieces of Byzantine jewelry captured in Constantinople; outstanding is the Pala d'Oro, an altar screen decorated with gold, cloisonné enamel and precious stones.
San Giorgio Maggiore. The presbytery of the Church of San Giorgio Maggiore, a fine example of Palladian architecture,

boasts two first-rate Tintorettos—the *Harvest of Manna* and the *Last Supper*.

Santa Maria Gloriosa dei Frari. Among other paintings this church has a fine triptych, *Madonna and Saints*, by Giovanni Bellini, and two superb Titians: *The Assumption of the Virgin* and the *Pesaro Altarpiece*.

Santa Maria della Salute. The prime example of Baroque architecture in Venice, the imposing façade of "La Salute" dominates the city's Grand Canal. Four Titian paintings adorn the church's interior, as does a masterpiece by Tintoretto, *The Marriage at Cana*.

LIECHTENSTEIN

VADUZ

Fuerstlich Liechtensteinsche Kunstsammlungen. Liechtenstein's museum has an especially valuable collection of Rubens' paintings, among them such major works as *The Toilet of Venus; A Child's Head; The Artist's Sons, Albert and Nicholas;* and *The Victory and Death of Decius Mus in Battle*. Works by other artists from Belgium and Holland, including Van Dyck, Jan Brueghel and Hals, were also acquired by the cultured rulers of this tiny principality.

NETHERLANDS

AMSTERDAM

Rijksmuseum. The Netherlands state museum is particularly strong in works by Holland's supreme masters, Vermeer and Rembrandt. *The Syndics of the Cloth Guild*—to many Rembrandt's finest work—hangs here, along with two portraits of his son Titus, *The Jewish Bride* and *The Night Watch*. The Vermeers include *Maidservant Pouring Milk, The Love Letter* and *Woman in Blue Reading a Letter*. A great many other Dutch artists, however, are represented, including the early painters Geertgen tot St. Jans and Lucas van Leyden, and such 17th Century artists as Ruisdael, Hobbema, Cuyp, Hals, Ostade and Brouwer.

Stedelijk Museum. One of the two largest collections of Van Gogh paintings in the world hangs in Amsterdam's municipal museum. There are more than 200 of the Dutch-born artist's works in all, among them *The Potato Eaters, The Harvest* and *Wheat Field with Crows*. Other 19th and 20th Century European painters and sculptors whose work can be found here include Cézanne, Renoir, Antonio Saura and Karel Appel.

HAARLEM

Frans Hals Museum. Hanging in this small museum devoted to Hals's work are eight of his most famous group portraits, among them *Assembly of Officers and Subalterns of the Civic Guards of St. Hadrian at Haarlem* and the *Lady Governors of the Old Men's Home at Haarlem*.

OTTERLO

Rijksmuseum "Kröller-Müller." This museum owns even more Van Goghs than Amsterdam's municipal museum—some 270 works, including *The Sower, Portrait of Lieutenant Milliet* and *Road with Cypresses and Stars*. Also on exhibit are a number of old masters and 20th Century works by artists from all parts of Europe. An outdoor sculpture garden includes outstanding modern works by Alberto Giacometti and Henry Moore.

ROTTERDAM

Museum Boymans-van Beuningen. Among the Dutch and Flemish masterworks here are Bosch's *Marriage at Cana*, Van Eyck's *Three Marys at the Sepulcher* and Bruegel's *The Tower of Babel*. The Dutchmen Hals, Rembrandt and Steen are also well represented, as are their modern com-

patriot Piet Mondrian and such 20th Century painters as Oskar Kokoschka, René Magritte and Wassily Kandinsky.

THE HAGUE

Gemeentemuseum. The Hague's municipal museum specializes in 19th and 20th Century European sculpture, but painters of most European nations are represented, including Piet Mondrian, Karel Appel and Guillaume Corneille from Holland; Ernst Ludwig Kirchner from Germany; Oskar Kokoschka from Austria; the English-born Impressionist Sisley; Picasso from Spain; and Rouault from France.

NORWAY

OSLO

Munch-Musset. Displayed in a good, small museum are many of Edvard Munch's fine paintings, prints and drawings.

Nasjonalgalleriet. Besides a modest collection of old masters (Snyders and Rubens among them), Norway's largest museum owns many interesting 19th and 20th Century paintings and sculptures. Cézanne, Gauguin and Rouault are represented, as is the American Andrew Wyeth, along with Norwegian painters from the 19th Century to the present, including the Expressionist Edvard Munch (his famous painting *The Cry* is here) and Ernst Peterssen (his portrait of composer Edvard Grieg).

PORTUGAL

LISBON

Fundacão Calouste Gulbenkian. This relatively new gallery houses an eclectic selection of art acquired by the oil billionaire Calouste Gulbenkian. The collection ranges from a 19th Century B.C. Egyptian portrait-head to paintings by the Impressionists Manet and Monet. It also boasts two magnificent Rembrandts *(Portrait of an Old Man* and *Pallas Athene)*, the first works of art to be sold by the Soviet government from the great Hermitage collection in Leningrad; an adoring portrait by Rubens of his young second wife, Hélène Fourment; Fragonard's exquisite fantasy-landscape *Fête à Rambouillet;* and Boucher's *Cupid and the Three Graces*. A section of the gallery displays perhaps the world's finest collection of Islamic art.

Museu National de Arte Antiga. In addition to an interesting collection of works by Portuguese painters, a number of famous foreign artists are represented at the museum. Among examples of the schools of Northern Europe are Bosch's splendid nightmare, *Temptation of St. Anthony*, Dürer's *St. Jerome*, Cranach's weirdly seductive *Salomé* and a *Virgin and Child with Saints* by Holbein. Spanish art is represented by several religious paintings by Ribera, Zurbarán and Murillo. In its function as a repository of "ancient" art, the museum also puts on an extraordinary display of gold and silver objects, many collected by Portugal's kings, including a massive monstrance made of the first gold brought back from India by the explorer Vasco da Gama in 1499.

SPAIN

BARCELONA

Museo de Arte Moderno. This municipal art collection specializes in European painting of the 19th and 20th Centuries. Spain's celebrated native son Picasso is represented along with lesser-known Spanish artists such as Santiago Rusiñol and Ramón Casas.

Museo Pablo Picasso. Picasso acquired his basic painting skills in Barcelona, and while most of the early pictures he did there have been snapped up by collectors elsewhere, the mu-

seum contains more than 800 works produced by the master in his mature years, including paintings (his famous *Las Meninas* series), engravings and drawings.

MADRID

El Escorial. This enormous monastery-palace, 30 miles northwest of Madrid in the foothills of the Guadarrama Mountains, was built as a religious retreat in the 1560s by the pious Philip II. The King loved painting as well as prayer and he began the Escorial's excellent collection of art, later augmented by his successors. The museum is especially strong in Flemish, Italian and Spanish works of the 16th through the 18th Centuries. Among the artists represented are Van der Weyden *(Christ on the Cross Between Mary and John)*, Gerard David, Bosch *(Mocking of Christ)*, Titian *(Crucifixion, Last Supper)*, Veronese, Tintoretto, El Greco *(Martyrdom of St. Maurice)*, Ribera, Velázquez and Goya.

Museo de Arte Contemporaneo. This museum of contemporary arts exhibits some 300 drawings, paintings and sculptures produced by Spanish-born artists of the last one hundred years, including Juan Gris and Salvador Dali as well as Picasso.

Museo Lázaro Galdeano. A small museum often overlooked by visitors to Madrid, the Galdeano contains some choice European paintings from the 15th through the 19th Centuries. Among the best are works by Goya and by the German Dürer. There are excellent canvases as well by two artists whose work is rare in Spain, the English portraitists Gainsborough and Reynolds.

Museo del Prado. The paintings in the Prado constitute one of Spain's great national resources—as they would of any country. Naturally, masterpieces by Spanish or Spanish-based artists abound. El Greco is represented by, among other works, *The Pentecost* and *Adoration of the Shepherds*, Ribera by the *Martyrdom of St. Bartholomew* and *St. Andrew*, Zurbarán by *St. Casilda*, Murillo by *The Holy Family of the Little Bird*, and Velázquez by no fewer than 50 canvases, among them *The Surrender of Breda*, the *Don Diego de Acedo*, "El Primo," and his masterwork, *Las Meninas*. Even more remarkable is the extent of the collection of Goyas: 115 canvases, among them *The Naked Maja*, *The Clothed Maja*, *The Second of May* and his powerful "black paintings." The Prado's Italian collection contains more Titians than can be seen in his own Venice or any other city —31 in all, among them *The Bacchanal of the Andrians*, *The Worship of Venus* and *Danaë*. Other Italian painters represented are Botticelli, Fra Angelico (his *Annunciation* hangs here), Mantegna, Raphael, Andrea del Sarto, Correggio, Veronese and Tintoretto. Since Spain ruled Flanders for more than 150 years, the Prado comes naturally by its many fine Flemish works, among them paintings by The Master of Flémalle, Van der Weyden, Patinir, Memling, Bruegel *(The Triumph of Death, The Adoration of the Magi)* and 67 works by Rubens. The Prado's claim to greatness is further substantiated by pictures by Dürer (a fine self-portrait), Cranach and Bosch *(Adoration of the Magi, The Garden of Delights, The Haywain)*.

Real Academia de Bellas Artes de San Fernando. Although dwarfed by the Prado, the Royal Academy merits a visit. Its specialty is the art of painters of the 16th through the 18th Centuries, including Murillo, Goya, Rubens and Tiepolo.

MADRID—CHURCHES

San Antonio de la Florida. Frescoes by Goya, depicting a miracle performed by St. Anthony of Padua, adorn the ceiling of this 18th Century church.

San Francesco el Grande. This is one of Madrid's loveliest churches, and contains sculpture by three little-known but interesting Spanish artists, Gerónimo Suñal, Mariano Benlliure and Ricardo Bellver; a number of frescoes, including one by Goya *(St. Francis Preaching)*; and beautifully carved prayer stalls by master craftsmen of the 15th Century.

SEVILLE

Cathedral of Seville. Murillo, Zurbarán and Ribera all helped decorate the cathedral of their native city, and it remains a showcase of their art.

Hospital de la Caridad. Works by Murillo and another 17th Century Sevillian, Valdes-Léal, hang in the city's Charity Hospital, which was originally endowed by the nobleman whose philandering gave rise to the legend of Don Juan.

TOLEDO

Casa y Museo del Greco. The home of Domenikos Theotokopoulos, the Greek-born painter known to his Spanish friends as El Greco, "the Greek," contains a number of works by members of his school and by the master himself, including one version of his famous *View of Toledo*, a *Christ* and a *Twelve Apostles*.

TOLEDO—CHURCHES

Cathedral of Toledo. This is, in effect, Toledo's main art gallery. Among its many Renaissance and Baroque paintings are El Greco's *Disrobing of Christ* and works by Goya, Giovanni Bellini, Titian and Van Dyck.

Santo Tomé. El Greco, commissioned in 1586 to paint an altarpiece for Santo Tomé, created one of his most famous masterpieces: *The Burial of Count Orgaz*. Still in place over the altar of the southwest chapel, it depicts the miraculous appearance of St. Stephen and St. Augustine at the entombment of a benevolent 14th Century nobleman.

SWEDEN

STOCKHOLM

Moderna Museet. A small collection of 19th and 20th Century French paintings hangs here, including works by Matisse, Picasso and Braque.

Nationalmuseum. Paintings by such artists as Rembrandt *(Conspiracy of Julius Civilis)*, Rubens, Goya, Reynolds and Gainsborough hang in the galleries of Sweden's principal art museum. Its collection of 19th and 20th Century Swedish art includes paintings by Carl Larsson and Anders Zorn, both of whom pictured an idyllic, pastoral Sweden.

SWITZERLAND

BASEL

Offentliche Kunstsammlung Kunstmuseum. Among paintings ranging from the 15th Century to today, the museum contains notable works by Conrad Witz and no fewer than 13 Holbeins, including five of his portraits of the humanist scholar Erasmus, who taught in Basel from 1521 to 1529. Other paintings include a Grünewald *Crucifixion*, Cranach's portrait of *Luther and His Wife* and an El Greco *St. James*. There are also works by Rembrandt, Caravaggio and the Swiss-born master of fantasy, Fuseli, and scores of sentimentally macabre paintings by another native artist, Arnold Böcklin. The 19th and 20th Centuries are represented by such painters as Delacroix, Gauguin, Van Gogh, Cézanne, Matisse and Paul Klee, and the sculptors Rodin and Maillol. There is also an excellent collection of Cubist works by Picasso, Braque and Fernand Léger. In addition, Basel has a surprisingly large group of modern American paintings and sculptures by such artists as Mark Rothko, Sam Francis and Alexander Calder.

BERN

Kunstmuseum. This museum is Mecca for lovers of the work of Swiss artist Paul Klee. Housing the Paul Klee Foundation, it owns the most extensive collection of his work anywhere, including some 40 paintings, 200 sketches, more than 2,000 drawings and an almost complete roster of his

prints. The museum also has a wide selection of works from other schools—Italian primitives, mountain landscapes and symbolic scenes by the Bernese painter Ferdinand Hodler, Cézanne's *Self-Portrait* and Matisse's *Still Life*. The collection of French Cubist works is extensive.

GENEVA

Musée d'Art et d'Histoire. Besides a broad spectrum of works by Swiss artists (including works by Conrad Witz and a special collection of Ferdinand Hodler's paintings), Geneva's principal museum owns many Italian, French, German and Flemish paintings, and a number of canvases by artists such as Cranach, Corot, Maurice Quentin de Latour, Rouault and Dufy. The splendid armory hall displays weapons—both captured and Swiss—that were used on the night of the Escalade, December 12, 1602, when Geneva's townsmen defended the walls of their free city from the troops of the Duke of Savoy. Much of the armor is still worn in the annual parade celebrating the victory.

ZURICH

Kunsthaus. Zurich's city art gallery contains a small, select collection of European paintings from the 14th to the 18th Centuries. There are works by the Dutch masters Rembrandt, Ruisdael and Hals; Swiss paintings of the 15th through the 20th Centuries; and representative pictures by such non-Swiss painters as Courbet, Manet, Daumier, Delacroix, Corot, Renoir, Degas, Van Gogh, Cézanne, Monet, Utrillo, Matisse, Munch and Picasso. Modern Swiss works include Arnold Böcklin's *The War* and *Arbor* and Ferdinand Hodler's *Glimpse of Eternity*. The gallery also boasts a fine collection of graphic art extending from the 15th Century to the present, and there is a wide choice of modern sculpture.

UNION OF SOVIET SOCIALIST REPUBLICS

LENINGRAD

State Hermitage Museum. A visit to this complex of palatial 18th Century buildings on the banks of Leningrad's Neva River would in itself make a trip to Russia worthwhile. Its dazzling collection of art, begun rather casually when Peter the Great confiscated a trove of gold artifacts found in Scythian burial mounds in Siberia, was vastly enlarged by Catherine the Great, who not only bought Flemish, Dutch, Italian and French masterpieces, but also built an annex—the Hermitage, after which the museum is named—to the Winter Palace for her private imperial gallery. The collection, nationalized after the Revolution and augmented by private holdings of the nobility and rich merchants, is now of immense size: three million or so works are kept in Leningrad, and many more have been sent to other cities to establish or enrich their museums. Major Italian works include such rarities as *Crouching Youth*, a marble statue by Michelangelo; Simone Martini's almost Byzantine *Virgin of the Annunciation;* and Fra Angelico's austere *Virgin and Child with Sts. Dominic and Thomas Aquinas.* Leonardo is represented by the contrasting *Litta* and *Benois Madonnas*, so called after their former owners. Outstanding Raphaels include *The Virgin and Child with St. Joseph* and *The Conestabile Madonna.* Among the Titians are *Christ Carrying the Cross, Mary Magdalene, Danaë, St. Sebastian* and *Portrait of a Young Woman.* Other notable Venetian paintings are Giorgione's *Judith* and a *Pietà* by Veronese.

The superb Flemish collection, starting with works by such early masters as Van der Weyden (*St. Luke Painting the Virgin*), continues through characteristic Bruegels (*The Fair*) and Van Dycks (*Self-Portrait*) to its high point: half a hundred paintings by Rubens in varied moods—Biblical scenes (*David and Uriah*), mythological subjects (*Perseus and Andromeda*), heroic set pieces (*The Union of Earth*

and Water) and subtle studies of contrasting light effects (*Landscape with Rainbow*).

A score of Rembrandts dominate the Hermitage's Dutch collection, although there are numerous paintings by Hals (*Self-Portrait, Man with a Glove*), Terborch, Steen and Ruisdael. The gem of the Rembrandts is the *Prodigal Son*, one of the master's last and most moving works.

The Hermitage's paintings of the Spanish school number more than 100; there are also English works by Gainsborough, Raeburn and Reynolds. The collection of French painting, starting with 16th Century court portraits (François Clouet's *Duc d'Alençon*), is surpassed only by the Louvre's. There are 15 Poussins, canvases by Watteau, Chardin, Boucher and Fragonard. The next period in French art is represented by David, Ingres' portrait of Count Gouriev, several characteristic Corot landscapes, two Delacroix African paintings and Courbet's *Fallen Horse in the Forest.* In the world-famous collection of modern painting are outstanding works by Cézanne, Van Gogh and Matisse, the latter including the huge, mysteriously moving panels *Dance* and *Music.* Picasso's growth from his early devotion to Gauguin (*The Absinthe Lover*) to the style later called analytical Cubism (*Table in a Café*) can be traced through such key works as *Woman with a Fan.*

MOSCOW

State Pushkin Museum of Fine Arts. Russia's second-largest collection includes ancient Eastern, Greco-Roman and medieval art, and a display of Western European paintings, including works by Titian, Veronese and Guido Reni among the Italians; Rubens, Van Dyck and Teniers among the Flemish school; the Dutch masters Rembrandt, Terborch and Steen; several religious works by the Spanish painter Murillo; and representative canvases by the French 18th Century artists Chardin, Boucher, Fragonard and Greuze. The modern works include a Manet, Van Goghs, Gauguins, Cézannes, Matisses and Picassos.

State Tretyakov Gallery. Besides a broad range of works by Russian painters, sculptors and graphic artists, the Tretyakov contains the world's richest collection of Russian icons, including subtle brilliant panels by the 15th Century master iconographer Andrei Rublev.

Art Galleries of the United States

The following is a list of U.S. museums and galleries that contain important or especially interesting collections of European and American art, with some notes on the works they display. The galleries are listed alphabetically, by state and city. This list is followed by brief entries for Canada and Mexico.

ALABAMA

MOBILE

The Mobile Art Gallery. This is a modest but worthwhile collection of paintings and drawings, many of the latter from 17th and 18th Century Italy, France and England.

ARIZONA

TEMPE

Arizona State University Collection of American Art. A small gallery, it nevertheless displays examples of U.S. painting from most periods and schools.

TUCSON

University of Arizona Art Gallery. Samuel H. Kress, one of the benefactors of the National Gallery in Washington, D.C., gave a small portion of his remarkable collection of Italian art to this gallery. Its other specialty is U.S. painting.

CALIFORNIA

LOS ANGELES

Los Angeles County Museum of Art. The museum owns Gothic and Renaissance paintings and sculptures, American paintings of the 18th through the 20th Centuries, and modern European works, including six Picassos.

University of California at Los Angeles Art Galleries. UCLA's collection leads others on the West Coast in modern sculpture: there are 27 pieces by such distinguished sculptors as Matisse, Alexander Calder, Henry Moore and David Smith.

OAKLAND

Oakland Art Museum. The inventive architectural firm of Eero Saarinen Associates designed this new and beautiful three-gallery complex, which houses Oakland's art collection as well as history and science exhibits. The art collection consists largely of work by California artists or artists who painted California scenes.

PASADENA

The Pasadena Art Museum. This museum is noted for its German Expressionist paintings and other 20th Century art. Especially good are its examples of the work of Lyonel Feininger, Wassily Kandinsky and Paul Klee.

SACRAMENTO

E. B. Crocker Art Gallery. The Crocker collection, which includes a liberal sprinkling of both European and American painting and sculpture, is rich in drawings by such masters as Dürer, Rembrandt, Fragonard and David.

SAN DIEGO

The Fine Arts Gallery of San Diego. A handsome gallery in the city's Balboa Park, the Fine Arts owns a good collection of Flemish, Dutch, Spanish, and Italian painting of the Renaissance, Baroque and 18th Century periods, with fine examples of Venetian art, as well as some modern French and German Expressionist works.

SAN FRANCISCO

California Palace of the Legion of Honor. Despite its name, the Palace is a museum of fine arts and contains one of the largest collections of Rodin's sculpture in the United States. Other collections include paintings of the Italian, French, Spanish, English and American schools, and the Achenbach Foundation for Graphic Arts.

M. H. De Young Memorial Museum. This large museum in Golden Gate State Park—it has 68 galleries—houses the Samuel H. Kress Collection of European painting, which includes a number of major Renaissance masterpieces. The museum also owns a fine group of Flemish tapestries donated by the William Randolph Hearst Foundation. The new Avery Brundage wing houses an extensive collection of Chinese and Japanese art.

San Francisco Museum of Art. The museum specializes in both temporary and permanent exhibitions of 20th Century American, European and Latin American paintings, drawings and prints.

SAN MARINO

Henry E. Huntington Library and Art Gallery. The Gallery, once part of the palatial residence of railroad tycoon Huntington, boasts a fine collection of 18th Century English portraits and landscapes, including one of Gainsborough's best-known masterpieces, *Blue Boy.* There are also a number of Italian and Flemish paintings of the 15th and 16th Centuries.

The Huntington Library is a scholar's heaven, with rich stores of rare manuscripts and books.

SANTA BARBARA

Santa Barbara Museum of Art. Housed in a onetime U.S. post office, this small gallery offers American art from Copley and West through the Hudson River and Ash Can Schools. There are also modern European drawings and watercolors.

COLORADO

DENVER

Denver Art Museum. The galleries here house an interesting selection of medieval and Renaissance art as well as more recent European and American paintings, drawings, sculptures and prints.

CONNECTICUT

FARMINGTON

Hill-Stead Museum. A limited but worthwhile collection of Impressionist paintings by Manet, Monet, Degas and Cassatt, plus some Whistlers, can be found in this small Connecticut town near Hartford.

HARTFORD

Wadsworth Atheneum. The recently modernized Atheneum offers a broad selection of European paintings from 1400 to the present, with special emphasis on Renaissance and Baroque works, plus a number of American paintings. Among the notable works on view are Rubens' *Tiger Hunt*, El Greco's *Virgin and Child with St. Anne* and Caravaggio's *Ecstasy of St. Francis.*

NEW BRITAIN

Art Museum of the New Britain Institute. This small collection is devoted almost exclusively to U.S. painting of the 19th and 20th Centuries—Homer, Eakins, Sargent and Charles Burchfield.

NEW HAVEN

Yale University Art Gallery. Yale's collection includes a wide variety of styles and periods in art. There are a number of excellent European works of the Middle Ages and the Renaissance, and European and American paintings of more recent times. Of special interest is the Société Anonyme collection founded by patroness Katherine Dreier, with artists Marcel Duchamp and Man Ray; it includes works of the Dadaists, Surrealists, Russian Constructivists and German Expressionists—169 artists in all, from 23 countries.

DELAWARE

WILMINGTON

The Wilmington Society of the Fine Arts. The Society owns the Bancroft Collection of English Pre-Raphaelite painting, which is enhanced by manuscripts of the Pre-Raphaelite poet-painter Dante Gabriel Rossetti. Admirers of U.S. painter John Sloan, as well as of the illustrator Howard Pyle, will find good examples of their paintings and drawings.

DISTRICT OF COLUMBIA (WASHINGTON, D.C.)

The Corcoran Gallery of Art. The Corcoran is one of the finest galleries in a capital city rich with art. It has an excellent collection of 19th Century French art and its 19th and 20th Century American works—by such men as Homer, Eakins, Thomas Cole, George Luks, John Sloan, George Bellows,

Maurice Prendergast and Edward Hopper—are outstanding. The gallery also has fine pictures by Flemish, English and Dutch painters (Rubens, Rembrandt, Hals, Gainsborough and Hogarth, among others).

Freer Gallery of Art. The Freer collection is largely made up of Eastern art—Japanese, Chinese, Indian and Islamic—but also includes a large and varied selection of paintings and graphic works by Whistler and, in addition, his famous "Peacock Room" intact.

Joseph H. Hirshhorn Museum. Joseph Hirshhorn, who became immensely rich on Wall Street, gave his remarkable private collection of painting and sculpture to the nation in 1968. A handsome new museum to house it has been designed to join the Smithsonian Institution complex on Washington's Mall. (The Smithsonian also administers the Freer and the nation's collections of fine arts and portraits.)

National Collection of Fine Arts and *National Portrait Gallery.* These are two national collections housed, since 1968, under one roof—the handsome old Patent Office building. The Fine Arts, the oldest U.S. government art collection, includes works by both American and European painters; the 17 canvases by the eccentric American artist Ryder are especially noteworthy, as is a delightful Homer, *Breezing Up.* The Portrait Gallery is a collection of likenesses, many of high artistic quality, of men and women who made significant contributions to U.S. history.

National Gallery of Art. This is one of the most varied and most valuable collections of paintings in the world. Opened only in 1941, by the late 1960s it had accumulated more than 30,000 paintings, sculptures and other items, largely through the gifts of a notable succession of collector-benefactors, including Andrew Mellon, Joseph Widener, Samuel H. Kress, Lessing J. Rosenwald, Chester Dale, and Colonel and Mrs. Edgar W. Garbisch. These collections include important, and often key, works by virtually every major painter since Giotto. Among the Italian paintings of the Early and High Renaissance are works by Masaccio, Castagno, Botticelli, Mantegna, Raphael, Giorgione and Titian. Flemish, Dutch and German art is well represented by Van Eyck, Memling, Grünewald, Dürer, Holbein, Hals, Rembrandt, Vermeer, Hobbema and Ruisdael. There are also important works by Watteau, Gainsborough, Reynolds, Goya, Constable and Turner. In addition, the National Gallery has a remarkably rich collection of Impressionist paintings—many given by Chester Dale, a pioneer collector of late-19th Century French art—and 215 American primitive paintings from the Garbisch collection. Non-primitive American painting is represented by Copley, Stuart (*The Skater*), West, Eakins, Homer, Ryder, George Bellows and others. There are examples of sculpture by Donatello, Verrocchio (including his bust of Lorenzo de' Medici) and Bernini.

Phillips Collection. The Phillips specializes in 20th Century French and U.S. art, but also has earlier American and European paintings—by El Greco, Goya, Constable, Manet, Renoir and Cézanne, among others—that foreshadow trends in modern art. The 20th Century collection includes important works by Picasso, Braque, Matisse, Rouault and Paul Klee, and by the Americans John Marin, Arthur Dove, Edward Hopper and Ben Shahn.

FLORIDA

Cummer Gallery of Art. Jacksonville's Cummer Gallery offers a modest but appealing selection of British, American and European paintings.

John and Mable Ringling Museum of Art. The Ringling collection, founded by the famed circus impresario and the fin-

est in Florida, contains a number of European paintings of the 16th through the 18th Centuries—Titian, Veronese, El Greco, Tintoretto and Tiepolo are included—and several outstanding Rubens tapestries and paintings.

Norton Gallery and School of Art. The Norton displays European painting of the Renaissance through the 18th Century. Nineteenth and 20th Century American and French artists represented include Picasso, Braque, Rouault, John Sloan, John Marin and Alexander Calder.

GEORGIA

Georgia Museum of Art. A small but worthwhile collection of U.S. painting, largely of this century, can be seen here.

Atlanta Art Association. The Association's modern gallery building houses a collection of Renaissance and Baroque works as well as paintings by more modern U.S. artists, among them Ryder, Cassatt, William Glackens, Ernest Lawson, Reginald Marsh and Charles Burchfield.

HAWAII

Honolulu Academy of Arts. The emphasis in Hawaii's one major gallery is, naturally enough, on Pacific island and Oriental arts, but there is also an interesting selection of U.S. mainland art, plus a segment of Samuel H. Kress's vast collection of Italian Renaissance painting.

ILLINOIS

The Art Institute of Chicago. One of America's great galleries, the Art Institute, which will celebrate its 100th anniversary in 1979, is especially rich in Impressionist, Post-Impressionist and early 20th Century French art, including Seurat's Pointillist masterpiece *Sunday Afternoon on the Island of La Grande Jatte,* a number of celebrated canvases from Picasso's Blue and Rose Periods, and some fine Rodin sculptures. This large, handsome gallery, located on the city's Lake Michigan shore front, also owns early French and Flemish paintings, a large number of 18th and 19th Century Italian and French drawings and prints, and a notable collection of American art.

IOWA

Des Moines Art Center. The Art Center has an interesting collection of Dutch, Spanish, French and American painting and sculpture. There are also modern works by Ben Shahn, Mark Rothko, Henry Moore and Alexander Calder.

LOUISIANA

Isaac Delgado Museum of Art. This museum is notable for its Renaissance works and an unusual number of paintings by the group of 19th Century French landscapists known as the Barbizon School. The collection also includes 20th Century American and European paintings, sculptures, prints and drawings, including many by Southern artists.

MAINE

BRUNSWICK

Bowdoin College Museum of Art. Bowdoin has a small but representative collection of European Renaissance and 17th Century works, and 18th and 19th Century American paintings. The museum also possesses a fascinating collection of Homer memorabilia—including his palette, watercolor box and childhood works—and a few Homer paintings.

WATERVILLE

Colby College Art Museum. Colby's collection is not large, but there are many worthy examples of painting, sculpture and graphic arts, mostly American.

MARYLAND

BALTIMORE

The Baltimore Museum of Art. Baltimore's gallery has many works of 19th and 20th Century French painting, sculpture and graphics, as well as paintings by the old masters and 20th Century American works. Its Cone Collection is unusual for its number of Matisses, bought directly from the artist by two Baltimore sisters, Harriet and Claribel Cone. The museum also owns a large collection of lithographs and posters by Toulouse-Lautrec.

Peale Museum (Municipal Museum of the City of Baltimore). This gallery is the best place in the United States to study the works of the remarkable family of American painters that included Charles Willson Peale and his artist sons Rembrandt, Raphaelle and Rubens Peale. The building itself was a project of Rembrandt Peale and it contains many works by, and memorabilia of, himself, his father and his brothers.

The Walters Art Gallery. This wide-ranging collection,which totals some 25,000 items, includes Byzantine and medieval art, Renaissance paintings, and 18th and 19th Century paintings and sculptures.

MASSACHUSETTS

ANDOVER

Addison Gallery of American Art. Part of Phillips Academy, the Addison has a limited but choice collection of U.S. painting. Its gems include fine paintings by Homer, Eakins, Edward Hopper, George Bellows, Maurice Prendergast and Ben Shahn.

BOSTON

Isabella Stewart Gardner Museum. This magnificent imitation of a Venetian *palazzo* was the home of Boston's most flamboyant turn-of-the-century social figure, "Mrs. Jack" Gardner, and contains her excellent collection of painting and sculpture. The paintings, many of which were selected for Mrs. Gardner by Bernard Berenson, include works by Italian masters Fra Angelico, Gentile Bellini, Botticelli, Bronzino, Giorgione, Raphael and Titian, and by Piero della Francesca and Masaccio, two artists whose paintings are rare in the United States. Other artists represented include Holbein, Dürer, Van Dyck, Rembrandt, Ruisdael, Vermeer (his great *Concert*), Turner, Manet and Degas. There are several paintings by American artist John Singer Sargent, a friend of Mrs. Gardner's, including his portrait of her.

Museum of Fine Arts. Boston's 100-year-old museum ranks with New York's Metropolitan, Philadelphia's Fine Arts and Washington's National Gallery as one of the world's major repositories of art. It owns an excellent collection of American art, including several of the premier works of Copley, Stuart and Homer, and a wide selection of paintings by such European masters as Van der Weyden, Rubens, Ruisdael, El Greco, Velázquez, Delacroix, Degas and Van Gogh.

The museum's collection of 200,000 prints makes it second only to the Metropolitan in this category, and its collections of Egyptian and Oriental art are world-famous.

CAMBRIDGE

Harvard University: Busch-Reisinger Museum of Germanic Culture. This impressive collection of German art has especially fine examples of the two 20th Century movements in German painting known as the Bridge and Blue Rider Schools as well as works from the Bauhaus.

Harvard University: Fogg Art Museum. The Fogg's extensive collection is highly varied—as is proper for a gallery whose primary function is to provide students with examples of all the world's art to study. Its paintings range from Italian works by Fra Angelico, Filippo Lippi and Pietro Lorenzetti to modern canvases by Australian Sidney Nolan, and include a number of the best-known pictures by the English Pre-Raphaelites. The Fogg's collection of drawings is superb, especially its 19th Century French works, as are its paintings by David, Géricault, Delacroix and Ingres. In addition, there are works by Rubens, Guardi, Tiepolo, Gainsborough and Copley, and a unique collection of the sculptor Bernini's *bozzetti* (clay sketches). The Fogg also has a fascinating study collection of art forgeries.

NORTHAMPTON

Smith College Museum of Art (Tryon Art Gallery). Included in this small collection are works by French artists Corot, Courbet, Degas, Renoir, Monet, Cézanne, Bonnard, Vuillard and Seurat, and by Spanish-born Juan Gris and Picasso.

SPRINGFIELD

Museum of Fine Arts. The museum's collection presents a survey of the major periods in Western art, as well as an extensive look at Japanese prints and other Oriental art. Major painters represented include the Frenchmen Chardin, Courbet and Delacroix and the American Winslow Homer.

WALTHAM

Brandeis University: Rose Art Museum. Brandeis' new gallery, opened in 1961, has a smattering of Renaissance, Baroque and 19th Century art, but specializes in modern U.S. experimental work by such men as Ellsworth Kelly, Robert Motherwell, Claes Oldenberg, Willem de Kooning and Robert Rauschenberg.

WILLIAMSTOWN

Sterling and Francine Clark Art Institute. The Clark, a major gallery set down in the small Williams College community, is celebrated for its collection of 30 Renoir paintings but also has many other outstanding works, including a good Rembrandt; paintings by Piero della Francesca and Mantegna; portraits by Fragonard and Goya; 11 Corots; two Homers; numerous Degas paintings, sculptures and prints; Toulouse-Lautrec prints that alone would make a visit worthwhile; and Impressionist landscapes by Manet, Pissarro, Monet and Sisley. The silver collection, containing several pieces by Paul Revere, is one of the best.

WORCESTER

Worcester Art Museum. Worcester's highly varied collection —it shows the development of art from early Egypt to the latest Pop—includes important works by lesser-known Renaissance masters Piero di Cosimo, Lorenzo di Credi and Stefano da Verona, and paintings by Rembrandt, El Greco, Goya, Ribera and Gainsborough. Gems of the collection are two of Hogarth's finest portraits.

MICHIGAN

DETROIT

The Detroit Institute of Arts. One of the most important U.S. galleries, the Detroit Institute has rich collections of Italian,

Flemish, Dutch and American art. There are noteworthy paintings by such early European masters as Van der Weyden, Van Eyck, Botticelli, Titian, Bruegel, Rubens and Rembrandt. American art is represented by one version of Copley's famous *Watson and the Shark* and John Sloan's *McSorley's Bar*, among many other works.

MINNESOTA

MINNEAPOLIS

Minneapolis Institute of Arts. This excellent gallery has a notable collection of Flemish and Dutch art—Rubens, Van Dyck, Rembrandt, Hobbema, Ruisdael—and 19th Century French painting—Sisley, Monet, Bonnard, Gauguin, Matisse—as well as American works by Albert Blakelock, Homer and Ryder.

MISSOURI

KANSAS CITY

William Rockhill Nelson Gallery of Art and Mary Atkins Museum of Fine Arts. The Nelson-Atkins offers a survey of European painting as well as a considerable collection of the arts of Egypt and the Far East. Among its treasures is the famous painting *After the Bath* by the American artist Raphaelle Peale.

ST. LOUIS

City Art Museum of St. Louis. A large, handsome gallery, the City Museum houses a collection of which the people of St. Louis are rightly proud. Among its best works are a late Titian, a Veronese, and portraits by Holbein and Rubens. The gallery also has eight major examples of the work of American frontier artist George Caleb Bingham, including his often reproduced *Raftsmen Playing Cards.*

NEW HAMPSHIRE

CORNISH

Saint-Gaudens Museum. A collection of the work of the American turn-of-the-century sculptor is housed in the 1800 tavern that Saint-Gaudens once used as a home.

HANOVER

Dartmouth College: The Hopkins Center Art Galleries; Carpenter Art Galleries. These two college galleries share a collection that includes examples of the work of U.S. artists Eakins, Frederic Church, Albert Bierstadt and John Sloan. The Baker Library contains an important fresco by Mexican artist José Clemente Orozco.

MANCHESTER

The Currier Gallery of Arts. One of the leading small museums in New England, the Currier has paintings by Ruisdael, Constable, Corot, Monet and Picasso.

NEW JERSEY

NEWARK

The Newark Museum. This museum is worth a visit to see its collection of U.S. painting and sculpture, including portraits by Copley and Ralph Earl.

PRINCETON

Princeton University Art Museum. Princeton's collection has Italian Renaissance works and paintings of the Dutch and Flemish schools, including a wonderful Bosch, *Christ before Pilate.* There are also Monets, Constables and a notable Copley, and 18 works by the early U.S. portraitist Thomas Sully.

NEW YORK

BUFFALO

Albright-Knox Art Gallery. One of the most interesting art collections in the United States is housed in the Albright-Knox. The modern sculpture includes important works by Rodin, Maillol, Constantin Brancusi and Alberto Giacometti. The gallery also has notable paintings by American artists, including Ryder's *Temple of the Mind* and Eakin's *Music*, plus works by modernists Jackson Pollock, Franz Kline and Arshile Gorky. *The Lady's Last Stake* is thought by many to be the best Hogarth painting in the United States. In addition there are works by Gainsborough, Daumier, David, Ingres, Cézanne, Renoir, Matisse, Picasso and numerous other European artists.

CANAJOHARIE

Canajoharie Library and Art Gallery. This rather out-of-the-way gallery has a surprisingly good collection of American art, including four oils and 13 watercolors by Homer, a George Inness landscape, early works by Maurice Prendergast and Charles Burchfield, and paintings by John Sloan and Reginald Marsh.

COOPERSTOWN

Fenimore House. As befits a gallery built on the site of the boyhood home of American writer James Fenimore Cooper, the Fenimore House collection of paintings is entirely American. There are good examples of Hudson River School painters Thomas Cole and Asher Durand, plus U.S. genre paintings by David Gilmour Blythe, William Sydney Mount and Eastman Johnson.

GLENS FALLS

The Hyde Collection. The Hyde is a small collection, but it contains several important pieces, including a Dürer portrait, a Rubens *Head of a Negro*, a Botticelli *Annunciation*, a Rembrandt, a Degas, a Whistler, an Eakins portrait and a Picasso.

ITHACA

Cornell University: The Andrew Dickson White Museum of Art. Cornell's collection is not rich in paintings—although there are several good ones—but it does boast some 3,000 etchings, lithographs and engravings by masters as varied as Mantegna, Dürer, Whistler and Toulouse-Lautrec.

NEW YORK CITY

Brooklyn Museum. This museum is especially well endowed in American art from colonial times to the present. Its collection of 19th Century American genre painting is outstanding, as is its collection of watercolors (18 Homers among them). It also has a sculpture garden to preserve ornaments from distinguished U.S. buildings that have been torn down, such as New York's Pennsylvania Station. A Brooklyn Museum innovation is "Listening to Pictures"—taped commentaries on their work by such artists as Edward Hopper, Ben Shahn and Jack Levine.

The Cooper Union Museum. This collection, now administered by the Smithsonian Institution, specializes in drawings and graphic arts. It has, for example, dozens of drawings by the American landscape painter Frederic Church.

Finch College Museum of Art. The museum of this women's college offers varied exhibitions ranging from private collections of old-master drawings to examples of Art Nouveau. Its small but growing permanent collection includes both old masters and contemporary works by Robert Indiana and Roy Lichtenstein.

The Frick Collection. In the Frick, virtually every painting on the walls is a masterpiece of its kind: Rembrandt's *Polish Rider*, El Greco's *St. Jerome*, Holbein's *Sir Thomas More*. There are splendid works by Hals, Van Dyck, Ruisdael, Vermeer, Hobbema, Goya, Turner and others, and Piero

della Francesca's *St. John the Evangelist* is one of the most important paintings on permanent exhibit in the United States. The collection was assembled by the millionaire industrialist Henry Clay Frick, with the help of the master art dealer Joseph Duveen.

Gallery of Modern Art. The gallery's building, designed by Edward Durrell Stone, was commissioned by A&P heir Huntington Hartford and contains his collection of art, a mixed but interesting group of works by such varied artists as the English Pre-Raphaelites and Salvador Dali. The gallery is now owned by Fairleigh Dickinson University.

The Hispanic Society of America. Works by El Greco, Ribera, Zurbarán, Velázquez and Goya are shown in this gallery, which traces every aspect of Iberian culture.

The Metropolitan Museum of Art. The "Met" owns the biggest collection of art in the United States, and perhaps the finest. It has excellent Egyptian, Greek and Islamic sections and paintings from almost every country, period and school. It is rich in Renaissance paintings, the Dutch school (there are 20 Rembrandt and seven Hals oils) and the Impressionists. Its collection of American art is outstanding. Some of the finest Manets in the world hang here, along with some of the best Italian works of the 15th and 16th Century to be seen outside Italy.

The Cloisters. The Metropolitan's medieval collection is housed in this handsome museum overlooking the Hudson River from New York's Fort Tryon Park. The Cloisters itself is built of parts of five medieval structures imported stone by stone from Europe, to which the apse of a Spanish Romanesque church has been added. The collection includes a famous late medieval painting, *Annunciation with St. Joseph and Donors,* by the Master of Flémalle; the "Hunt of the Unicorn" tapestries; the ornately carved Bury St. Edmonds Cross; and a wealth of reliquaries, illuminated manuscripts and other works.

Museum of the American Indian. Owner of the largest collection of Indian art objects in the world, this museum exhibits ceremonial costumes, paintings, sculptures and decorative arts made by Indians of North, Central and South America and the West Indies.

The Museum of Modern Art. The Modern Museum, as it is often called, offers what is probably the best survey of contemporary art (from 1875 to the present) anywhere in the world. Included among some 20,000 works by modern artists from virtually every European nation and the United States are more than 40 major works by Picasso and numerous important canvases by artists such as Cézanne, Matisse, Manet, Rousseau and Rouault. The sculpture garden has works by Rodin, Maillol and David Smith among other masters; the museum's photography collection is among the best anywhere.

Museum of Primitive Art. A collection founded by Nelson A. Rockefeller, the museum contains art produced by primitive peoples of Africa, Oceania and the Americas.

The New-York Historical Society. The Society's bright new galleries exhibit the best collection extant of 19th Century American genre painting plus some Hudson River School canvases. The Society owns all of the original watercolors (some 450 of them) by John James Audubon from which that naturalist-painter's great book *Birds of North America* was printed.

The Pierpont Morgan Library. Primarily a library of rare early books and manuscripts, the Morgan also has a number of works by such painters as Memling, Tintoretto and Cranach.

The Solomon R. Guggenheim Museum. Housed in a striking, spiral-shaped building designed by Frank Lloyd Wright, the Guggenheim specializes in nonobjective art by such 20th Century painters as Joan Miró, Jean Dubuffet, Marc Chagall and Wassily Kandinsky. It also has a number of Impressionist and Post-Impressionist paintings, and no fewer than 34 Picassos. The museum's forte, however, is its interesting temporary exhibitions.

The Whitney Museum of American Art. American art of the 20th Century is the Whitney's specialty, and the museum owns more of it than any other gallery. The permanent collection features an array of "classic" U.S. paintings, including Edward Hopper's *Early Sunday Morning,* Jack Levine's *Gangster's Funeral,* George Bellows' *Dempsey and Firpo* and Ben Shahn's *Passion of Sacco and Vanzetti.* The museum is also known for its frequent and usually fascinating shows that exhibit older U.S. art—or the very latest works by young painters and sculptors.

POUGHKEEPSIE
Vassar College Art Gallery. Vassar's gallery has two specialties—paintings of the Hudson River School and a print collection that includes 45 Dürers and 75 Rembrandts. Other works of value include paintings by the contemporary Britisher Francis Bacon and the American Mark Rothko.

ROCHESTER
George Eastman House. An unparalleled museum of photography, Eastman House also has some fine paintings, especially portraits by Tintoretto, Van Dyck, Hals, Rembrandt, Reynolds and Raeburn.

Memorial Art Gallery of the University of Rochester. Rochester's collection ranges from Assyrian art to works by the modern American painters Stuart Davis and Hans Hofmann, and also includes works by such very different artists as El Greco, Copley and Monet.

SOUTHAMPTON
Parrish Art Museum. A small museum near the tip of Long Island, the Parrish owns an intriguing collection of American painting of the period from about 1870 to 1930. Appropriately, there are canvases by painters who worked on Long Island—the genre painter William Sydney Mount, Childe Hassam and the long-neglected William Merritt Chase. In addition there are paintings by Homer, Whistler, Sargent and George Bellows.

SYRACUSE
Everson Museum of Art. The emphasis here is on American art of the late 19th and early 20th Centuries, including works by lesser-known painters such as J. Alden Weir and Everett Shinn. The collection is housed in elegant modern quarters designed by architect I. M. Pei.

UTICA
Munson-Williams-Proctor Institute. This gallery is worth seeing not only for its contents but also for its handsome modern building designed by Philip Johnson. Its exhibits include a major piece of modern sculpture, the *Great Horse* by Raymond Duchamp-Villon, brother of Marcel Duchamp, and a fine torso by Gaston Lachaise. There are paintings by Picasso and Wassily Kandinsky, and by the American artists Jackson Pollock, Charles Burchfield, Maurice Prendergast and John Marin, among others.

NORTH CAROLINA

CHAPEL HILL
University of North Carolina: William Hayes Ackland Memorial Art Center. A small collection, the Ackland Memorial merits a visit for its canvases by Rubens, Delacroix and Courbet.

RALEIGH
The North Carolina Museum of Art. A number of important paintings grace this collection, which was created *ad hoc* by the state legislature in 1947. Among American paintings there is a fine Copley, Stuart's portraits of England's King George III and his wife Charlotte, and a good early Homer.

The gallery has three Rubens paintings, including a large masterpiece called *The Bear Hunt*. Stefan Lochner's *St. Jerome in His Study* is the only work by that 15th Century German painter in the United States. The museum also has two Rembrandts, a Raphael, several Van Dycks and a selection of German Expressionist works.

OHIO

CINCINNATI
Cincinnati Art Museum. An idea of the riches in the Cincinnati museum can be gained from the fact that it has a roomful of Gainsboroughs—four landscapes and seven portraits—and examples of French painting from Watteau, Boucher and Fragonard through Ingres, David and Delacroix to Cubist works by Picasso and Braque. The museum owns, in addition, a painting by Mantegna (one of only six in the United States), a Botticelli, a Titian and a Fra Angelico. Cincinnati also has notable collections of Oriental and early Mesopotamian art.
Taft Museum. The Taft owns a wonderfully acid Goya portrait of the Spanish Queen Maria Luisa, a pair of Rembrandts, and a good selection of paintings by Hals, Gainsborough and Turner.

CLEVELAND
The Cleveland Museum of Art. One of America's first-rank galleries, the Cleveland Museum is noted not only for its own collection, but also for its publications and the temporary shows it presents. The permanent collection contains Flemish and Italian Renaissance works, Spanish paintings (Zurbarán and El Greco), and 19th and 20th Century French and American art, including Ryder's evocative *Death on a Pale Horse* and Renoir's *Three Bathers*.

COLUMBUS
The Columbus Gallery of Fine Arts. The core of this gallery's collection is a distinguished group of paintings by 20th Century French and American artists, among them Matisse, Derain, Picasso, John Marin, Maurice Prendergast, Peter Blume and Max Weber. The Frederick Schumacher Collection of 17th Century Dutch and 18th Century English paintings is also housed here. It includes a Rubens altarpiece and a Van Dyck. The gallery honors native son George Bellows with a roomful of his works.

DAYTON
Dayton Art Institute. Dayton's collection, housed in an imitation Italian *palazzo,* concentrates on classical, Oriental, Pre-Columbian, primitive and decorative arts. The collection of European paintings is considerable, however, with examples from many periods and schools—Italian, French, Spanish, German and Dutch. British and American works are also on view.

TOLEDO
Toledo Museum of Art. The museum of this glass-producing city naturally has a notable collection of glass—ancient, Islamic, European and American. The collections of painting and sculpture present a survey of Western art. Among the European painters are Rubens, Velázquez, El Greco, Goya, Courbet, Manet and Cézanne. The Rubens, *The Crowning of St. Catherine,* has been called the finest example of his work in the United States; the Impressionist works are also outstanding. American painting is represented by John Smibert, Thomas Cole, Childe Hassam and others.

YOUNGSTOWN
Butler Institute of American Art. The paintings here include an early Homer, two Eakins portraits, a Whistler, Reginald Marsh's *Belles of the Battery,* and works by Copley, Stuart, Charles Burchfield, Ben Shahn and Andrew Wyeth.

OKLAHOMA

TULSA
Thomas Gilcrease Institute of American History and Art. A part-Indian who made millions in oil, Gilcrease invested much of his wealth in a remarkable collection of the art of the American West. His Institute now houses 21 oils and 18 bronzes by Frederic Remington; 29 oils, 28 bronzes and 25 watercolors by Charles Russell; and no fewer than 74 oils and 137 watercolors by George Catlin. There are also a number of good early U.S. portraits.

PENNSYLVANIA

MERION
The Barnes Foundation. The collection assembled by the Argyrol king Dr. Albert C. Barnes, with advice from painter William Glackens, a boyhood friend, is rich in works by Cézanne, Van Gogh, Matisse and Renoir—a total of 360 items by these painters alone. There are also some Blue and Rose Period Picassos, a number of 20th Century American works and a goodly sprinkling of paintings by Monet, Chaim Soutine, Amedeo Modigliani and Paul Klee. The Barnes, which is closed in July and August, accepts only 200 visitors a day (none under 15), 100 by appointment. It is wise to write ahead for a reservation (300 N. Latch's Lane, Merion, Pa.).

PHILADELPHIA
Pennsylvania Academy of the Fine Arts. The permanent collection of this pioneering (1805) U.S. art school is rich in works by the great men of early American art—Vanderlyn, West, Stuart (24 of his canvases) and Charles Willson Peale. The old gallery's space is so limited, however, that only a few of these paintings, or the Academy's 19th Century works, are on view at any one time.
Philadelphia Museum of Art. This museum rivals, and in some respects surpasses, America's other first-rank galleries. Guidebooks call its collection "encyclopedic," and it is, ranging from early Flemish works to Marcel Duchamp's *Nude Descending a Staircase* and "The Large Glass." The John G. Johnson Collection, a separate group of works housed in the Philadelphia Museum, offers fine examples of Western European painting from the 13th Century to the beginning of Impressionism. It is complemented by the Arensberg Collection of no fewer than 500 works, and by the A. E. Gallatin group and the Louis Stern Collection, both strong in French 19th and 20th Century art. There are 20 sculptures by Constantin Brancusi, 55 major paintings and drawings by Philadelphian Eakins, and Cubist works by Picasso, Braque, Juan Gris and Albert Gleizes. The museum administers the nearby Rodin Museum, the largest collection of Rodin's works outside France. Also noteworthy are the print department; the fashion galleries, which trace the development of American costume; and rooms that show work by Philadelphia's renowned cabinet-makers.

PITTSBURGH
Carnegie Institute Museum of Art. A recent gift that included paintings by Hals, Goya, Monet and Matisse indicates the wide range of the Carnegie's collection. Among American artists represented are Homer *(The Wreck),* Whistler, George Bellows and the self-taught 19th Century genre painter David Gilmour Blythe. There are numerous works by Impressionist and Post-Impressionist painters Renoir, Pissarro, Cézanne, Gauguin and Bonnard.

RHODE ISLAND

PROVIDENCE
Rhode Island School of Design Museum of Art. Examples of

works of most of the major periods of Western art can be found in this small gallery; notable are a few excellent paintings by Courbet, Manet, Renoir, Degas and Picasso.

SOUTH CAROLINA

CHARLESTON
Carolina Art Association, Gibbes Art Gallery. This museum should especially appeal to devotees of American portrait painting. There are works by West, Stuart, Rembrandt Peale, Samuel F.B. Morse and Thomas Sully.

COLUMBIA
Columbia Museum of Art. The gem of Columbia's small collection is a Botticelli *Nativity;* there are other Italian paintings by Tintoretto, Canaletto and Guardi, and works by the Americans Copley and Charles Willson Peale.

GREENVILLE
Bob Jones University Art Gallery and Museum. Almost all the paintings here are on Biblical themes—as befits the museum of a university that preaches oldtime fundamentalist religion. The works range from a 14th Century Sienese crucifix to a 19th Century engraving by Doré, *Christ Taking up the Cross,* to an unusual cycle of seven large religious paintings by U.S. artist Benjamin West, hung in the chapel. Also noteworthy is a painting of Salome by Cranach.

TENNESSEE

MEMPHIS
Brooks Memorial Art Gallery. A respected old gallery, with an imposing façade modeled after the Morgan Library in New York, the Brooks has the finest collection of English portraits in the Southern United States. Among the artists represented are Gainsborough, Reynolds, Raeburn, Hoppner, Hogarth, Lawrence, Lely and Romney. The gallery also has a fine Van Dyck and a Copley.

TEXAS

DALLAS
Dallas Museum of Fine Arts. This museum contains a small, eclectic collection of works, strongest in 20th Century painting and the art of the Americas. Some of the artists represented include Pissarro, Stuart, George Bellows, Andrew Wyeth, Henry Moore and Jackson Pollock.
Southern Methodist University: Meadows Museum. A new (1965) gallery, the Meadows concentrates on the arts of Spain. Its paintings include works by Murillo, Zurbarán, Velázquez, Goya, Juan Gris and Joan Miró.

FORTH WORTH
Fort Worth Art Center. The first painting this gallery acquired was Eakins' *Old Swimming Hole.* It is still one of the museum's best, but there are now other fine American works by Stuart, George Inness, Andrew Wyeth, Georgia O'Keeffe and others.

HOUSTON
Museum of Fine Arts in Houston. This museum has an unusual mix of interesting works—Cézanne's *Portrait of Madame Cézanne,* a large mobile by Alexander Calder, a Fra Angelico (*Temptation of St. Anthony, Abbot*), and a whole gallery of works by Frederic Remington, the recorder in sculpture and paintings of life on the Great Plains as lived by cowboys and the Plains Indians.

SAN ANTONIO
Marion Koogler McNay Art Institute. Mrs. McNay, inspired

by the New York Armory Show of 1913, bought the paintings of a number of artists who have strongly influenced 20th Century art. There are works by Bonnard, Paul Klee, Jules Pascin and Charles Demuth, among other Modernists, as well as Post-Impressionist canvases by Gauguin, Cézanne and Van Gogh.

VERMONT

SHELBURNE
Shelburne Museum: Webb Gallery and Webb Memorial Museum. Within the Shelburne Museum—a 33-building complex filled with exhibits of American history, crafts and folk arts—are the two Webb art buildings. The gallery contains U.S. paintings of the 18th and 19th Centuries; the museum has works by such European masters as Rembrandt, Goya, Corot, Degas and Monet.

VIRGINIA

RICHMOND
Virginia Museum of Fine Arts. The most eye-catching exhibits in this gallery are glittering jewelry once owned by the Russian Czars. There are some impressive paintings, too, including works by Cranach, Jan Brueghel, Watteau, Guardi and the Americans Edward Hopper, Stuart Davis and Ben Shahn.

WASHINGTON

SEATTLE
Seattle Art Museum. In common with various other galleries across the nation, this museum boasts a Kress Collection of European, and particularly Renaissance, paintings. There are also a number of works by Fernand Léger, Marcel Duchamp and other modern artists, and a good selection of paintings by native Washingtonians Mark Tobey, Kenneth Callahan and Morris Graves.

WISCONSIN

MILWAUKEE
Milwaukee Art Center. Twentieth Century paintings are the forte of the Art Center, which is housed in a striking building designed by the late Eero Saarinen. French Fauvism and Cubism and German Expressionism are well represented, with works by Bonnard, Emil Nolde, Paul Klee, Oskar Kokoschka, Alberto Giacometti and others.

CANADA

OTTAWA
National Gallery of Canada. The backbone of Canada's national art collection is its works by 19th and 20th Century Canadian painters, including many paintings by the "Group of Seven," a close-knit association of artists who worked in the 1920s and '30s to record, often with techniques borrowed from Impressionism, the look of the Canadian land. There are also paintings by more recent Canadian artists such as the gifted Jean-Paul Riopelle, Michael Snow and others. In addition, the gallery has a small selection of old masters and a collection of 10,000 prints and drawings. The paintings include El Greco's *St. Francis,* Rembrandt's *The Toilet of Bathsheba,* a Rubens *Descent from the Cross* and West's *Death of Wolfe.* There are numerous drawings by Raphael, Van Dyck, Rubens, Rembrandt, Goya, Delacroix,

Van Gogh and Matisse. Modern sculptors represented include Rodin and Henry Moore.

Art Gallery of Ontario. Founded in 1900, the gallery has some 4,000 works, ranging from *Madonna with Saint* by an anonymous 14th Century Italian painter to Picasso's *Seated Woman.* There are major works by a variety of other important Continental and English painters, including Bruegel, Rubens, Hogarth, Reynolds, Gainsborough, Delacroix and Degas. The largest part of the collection, however, is of Canadian art, extending from the 19th Century through the "Group of Seven" (see Ottawa's National Gallery, above).

Royal Ontario Museum. Largely devoted to such sciences as archeology and ethnology, the Royal Ontario also has a good collection of Canadian paintings and drawings, especially by earlier Canadian artists such as Paul Kane, William Bartlett and John Richard Coke-Smith.

MEXICO

Museo Nacional de Antropologia. A striking modern building houses the Mexican government's collection of sculpture, jade carvings and pottery from Mexico's Mayan and Aztec civilizations.

Museo Nacional de Arte Moderna. Paintings by 20th Century Mexican artists (including Diego Rivera, Jose Clemente Orozco and David Alfaro Siqueiros) stand out in a good collection of Modern art that includes work from Europe, the United States and South America.

Acknowledgments

For their help in the preparation of this book, the editors wish to thank the following persons and institutions:
London: The National Gallery, The Tate Gallery, The British Museum Print Room, The Victoria and Albert Museum Print Room, The Courtauld Institute Galleries, The Wallace Collection, The National Portrait Gallery, The Photographic Library, Ministry of Public Building and Works, National Buildings Record, and The Royal Library, Windsor Castle.
Paris: Catherine Bélenger, Service des Relations Extérieures, Musée du Louvre; Madame Georges Duthuit; Madame Guynet-Pechadre, Conservateur, Service Photographique, Musée du Louvre; Denis Rouart; Musée d'Art Moderne de la Ville de Paris; Musée de Cluny; Musée National d'Art Moderne; Musée du Petit-Palais.
Florence: John Clark, Istituto Fotografico Editoriale Scala; Giuseppe Marchini, Director, Galleria degli Uffizi; Guido Morozzi, Soprintendente, Soprintendenza ai Monumenti.
Rome: Étienne Burin des Roziers, French Ambassador, Palazzo Farnese; Bruno Molajoli, Director-General of Fine Arts and Antiquities for Italy, Ministero della Pubblica Istruzione; Deoclezio Redig de Campos, Curator, Pinacoteca Vaticana; Gabinetto Fotografico Nazionale.
Direktor Erwin M. Auer, Kunsthistorisches Museum, Vienna; Marie-Claude Béaud, Conservateur Adjointe de Musée des Beaux-Arts de Grenoble; Marie-Luce Cornillot, Conservateur des Musées de Besançon; Jean Devoisins, Administrateur Délégué du Musée d'Albi; Marianne Haraszti, Szepmueveszeti Museum, Budapest; Christine Hofmann, Bayerische Staatsgemäldesammlungen, Munich; Wilhelm Köhler, Staatliche Museen zu Berlin, Gemäldegalerie, Berlin, Dahlem; Direktor Walter Koschatzky, Graphische Sammlung Albertina, Vienna; François Pomarède, Conservateur des Musées de Reims; Madeleine Rocher-Jauneau, Conservateur du Musée des Beaux-Arts de Lyon; Jean Rollin, Conservateur du Musée d'Art et d'Histoire de Saint Denis; Jaromir Sip, Narodni Galerie, Prague; Francesco Valcanover, Soprintendente, Soprintendenza alle Gallerie, Venice; Gustav Wilhelm, Kabinettsdirektor, Vaduz, Liechtenstein; Chapelle du Rosaire, Vence; Musée de l'Annonciade, St. Tropez; Musée des Beaux-Arts de Dijon; Musée Condé Château de Chantilly; Musée du Docteur Faure, Aix-les-Bains; Musées d'Orleans; Soprintendenza ai Monumenti del Piemonte, Turin.

Picture Credits

Index

The following is a general index to the entire Time-Life *Library of Art. The names of the individual volumes in the Library have been abbreviated in this index; a key to these abbreviations will be found at the bottom of each index page. The numerals given in italics indicate that there is a picture of the subject mentioned.*

Abstract art: Abstract Expressionism, characteristics of, MD 166, 167, *174-175*; birth of, in Kandinsky's 1910 watercolor, MAT *56*; Cézanne's influence on, C 8, 170, 182; characteristics of, C 8, 41, 77-78, 145, MAT *56*, *119*, *173-182*; Cubism and, P 61, 92-94; Dada's influence on, MD 66; foreign influence on American abstract painting in the 1930s and 1940s, AP *116*, 117-124, *125-135*; and Matisse, MAT *119*, *173-182*; Monet's later art and, MA 109; New York School of Abstract Expressionism, AP *136*, 137-144, *145-159*; Op Art and reaction to Abstract Expressionism, MD 170, 172, 176-177, AP *182-184*; Picasso and, P 57, 60; Surrealism's influence on, MD 172

Académie des Beaux-Arts, Paris: avant-garde movement and, MA 27; cartoon on Salon, MA *26*; characteristics of, D 32, MA 16-17; Daumier's cartoon on, D *129*; early 19th Century Salon of, D *66-77*; Impressionism's revolt against Salon of, C 64, MAT 10; influence on French art, C 28, 37-38; influence on 19th Century sculpture, RO 52; neoclassicism espoused by, RO 17-18; Rodin's belief in ideas of, RO 16-17; Salon des Refusés and, MA 27; Salon rules and regulations, C 28, 37-38, D 66; split between "independents" and, MA 27

Adams, John: Declaration of Independence and, CO *181*; description of Nicholas Boylston's home in Boston by, CO 63; on likeness as achieved in Copley's portraits, CO 91; on Charles Willson Peale's character, CO 166

Adams, Samuel, political role of, in American Revolution, CO 72, 74, 90

African art, Picasso's and Matisse's interest in, MAT 74, P 54, *67*, *69*

Age of Reason, role of science,

philosophy and art in, V 10

Alba, Duchess of, Goya's relations with, GO *66-67*, 68, 74, 77, 79-80, 100, 102-104, *120-123*, 127

Albers, Josef, and Op Art, AP *182*

Allegory: Bruegel's proverbs, BR *81-87*, *151-159*; in Dürer, DU 12-14, 65, 70, *114*, 125, 126; in Dutch genre painting, V 78

Allston, Washington: life of, WH 9, 10; failure as painter, WH 10; works by, WH *9*, *18*

Altdorfer, Albrecht: interest in painting, DU 164; work by, DU *174*

America: Civil War, WH 66-70, *78-81*; Depression, AP 62-63; Gilded Age, WH 92-93, *95*; Matisse on American versus European civilization, MAT 142; 19th Century life in, WH 11, 48-50, 54, 56, 78; *nouveau riche*, WH 60, 91-93, 95; 17th Century Dutch trade in, RE 91. *See also* Revolution, American

American art: American artists in Europe, WH 71, 93-95, 97; anonymous painters of American folk art, CO 98, *99-105*; Armory Show, MAT 104, MD 33-34; Ash Can School and New York Realists, MD 52, AP *21-35*; colonial folk painting, CO 98; in early 1940s, MD 154, AP 117-124; history as subject of, CO 92; Hudson River School, WH 13, *17-25*, *52-55*; importation of European styles in 19th Century, CO 168, WH 10-11, 93-95; influence of Copley and West on 19th Century artists, CO 161; landscape painting in 19th Century, CO 162; Matisse's opinion of, MAT 141, 143; prominent painters of 19th Century, CO 91; quality of optimism, WH 35, 37, 48, 49, 50; Regionalists, AP 60, 61-68, *69-91*; role of landscapists, WH 15, 97; The Younger Men, of 19th Century, WH 95-96, 98, 115, 121, 140, 143. *See also* Colonial American art; Modern art

Amsterdam, The Netherlands: allegory of, RE *90*; artistic interests of burghers, RE 23; auctions in, RE 107; commercial importance, in 17th Century, V 34-36, 57; engraving of, RE *62-63*; etchings of countryside around, RE 114; *map*, RE *20*; old and new town hall, RE *164*; Rembrandt's life and success in, RE 17, 25, 46-47, 61, 62, 89, 93, 133-134; Rembrandt's town house, now Rembrandt Museum, RE 68, 69-70, 136, 138

Anatomy: Dürer's study of, DU 63; English artists' interest in, TU 29; Leonardo's studies and notes, L 14, 57-58, 76, 77, *103*, 104-105, *111*, *131*; Michelangelo's study of, M 66-67, 96; Verrocchio's interest in, L 38. *See also* Human figure

Andrea da Firenze, work by, G 183, *190-191*

Angelico, Fra, work by, M *50*

Animals in art: in American Colonial folk art, CO *108*, *109*; *animaliers* of 19th Century French sculpture, RO *55-57*; Degas' interest in horses, MA *152-153*, *166*, *167*; Dürer's interest, DU 63, 73, *136*; early 19th Century French depictions, D *38*, *39*, *60*, *61*, *86*, *180-183*; in French 18th Century genre, WA 149; Japanese influence on Manet's cats, MA 62, *102*; Leonardo's drawings, L *64*, *65*, 76, 77, *149*; Manet's interest, MA *74-75*; Rembrandt's drawings, RE *56*, *57*; Rubens' interest, R *40-48*, *120*; Snyders' mastery of depicting, R 57-58, *88-89*; Stubbs' horses, GA *160-163*

Antelami, Benedetto, work by, G *42-43*

Antiquity: Hubert Robert's interest in, WA *171*; Poussin's interest in, WA 10, 28; vogue, in age of Louis XVI, WA 163-164

Antwerp, Belgium: as artistic and cultural center, R 56-57, 84; Bruegel's life in, BR 69, 71; political conditions, at various periods, R 8, 10, 12,

122; cultural and economic prosperity in Bruegel's time, BR 21, 77; religious and political strife in Bruegel's time, BR 79, 92, 93, 97

Anuszkiewicz, Richard, and Op art, AP *183*

Apollinaire, Guillaume, poet and critic: and avant-garde literature, MD 8; character of, MAT 58-59; companion of Duchamp, MD 31, 33, 36, 37, 60; Matisse and, MAT 58-59; Picasso and, P 36, 75, 84; *Il Pleut* as example of pictorial typography, MD *99*; portrait of, MD *98*

Apprenticeship, custom of: Cennini's *Craftsman's Handbook* on, L 14; in Ghirlandaio's workshop, M 40-41; rules regarding, in Renaissance Florence, L 12-13; in Verrocchio's workshop in Florence, L 11, 12-14, 27-28, 36, 44

Archeology, finds at Herculaneum and Pompeii in 18th Century, CO 115, WA 163, 164

Architecture: Alberti's treatise on, G 134, L 15, 79; architects' status in Florentine guilds, G 32; in Bath, England, GA *67-73*; Crystal Palace, London, TU *172*, *173*; Florence, as Leonardo's school, L 14; Florentine architecture in Michelangelo's time, M *19*, *20-21*, *38-39*; Georgian architecture of Royall House, Medford, Mass., CO *47-57*; Giotto's interest in, G 159; Gothic churches, G 37; influence of church architecture on art in Northern Europe, BR 19; influence of Classical on Romanesque, G 36; Leonardo's interest, in Milan, L 79; Palace of Versailles, as monument to 17th Century France, WA 7, *16-29*; Petworth House, Lord Egremont's estate in England, TU 88, *89-107*, 146, 147; Renaissance interest in fortifications, L 54; Romanesque sculpture as decorations for, G *44*, *45*;

treatment, in Giotto's frescoes, G *146-147;* trends in Louis XVI's France, WA 163 164; Woburn Abbey, 17th Century English manor house, GA *109*

Aretino, Pietro, intimate of Titian, T 103-105; accusations of obscenity in writings, T 107; correspondence between Titian and, T 152, 154, 157; friendship with Titian and Sansovino, T 106, 107; remarks on Titian's personality and art, T 80, 108, 155,156;Tintoretto, friendship with, T 171; Titian's portrait of, T *100*

Armory Show of 1913. *See* Exhibitions

Arnolfo di Cambio: G 86-87; influence on Giotto, G 136-137; work by, G *52-53, 83, 136*

Arp, Jean (Hans): Dada movement and, MD 58, 63, 66; free-form designs, MD *56;* life and work, MD 56-58; photographs of, MD *69, 70;* Surrealism and, MD 98, 104; works by, MD *54, 56,* RO *174, 183*

Art. *See* Abstract art; Baroque art; Classical art; Classicism; Cubism; Dadaism; Expressionism; Fauvism; Gothic art; Impressionism; Mannerism; Modern art; Naturalism; Op art; Painting; Pop art; Realism; Renaissance art; Rococo; Romanesque art; Romanticism; Surrealism

Art market: art auctions in Amsterdam, RE 107, 112, 136-137; conditions in 17th Century Holland, V 11-12, 80; interest in genre scenes in Dutch market, RE 25, V 80, 98; interest in landscape paintings, V 97; interest in still-life painting, V 100-101; paintings sold at Dutch country fairs, RE 22; prices of Matisse's works on, MAT 100, 104; prices in Rembrandt's time, RE 23-24, 46; property rights in Copley's time, CO 42; value of Vermeer's works, V 124. *See also* Patronage

Ash Can School, of American art, MD *52-53,* AP 13-20, *21-35*

Astrology: Dürer's *Melencolia I* and, DU 13; in 16th Century Europe, BR 47

Astronomy: drawings of Ptolemaic and Copernican systems, BR *98, 99;*

Leonardo's views on, L 103, 105-106; Vermeer's interest in, V 62

Avercamp, Hendrick: and birth of Golden Age in Dutch art, V 13, 32, 76-77; skating as theme of, BR 165; work by, V *94*

Avery, Milton, and American abstract painting, AP *132*

Baburen, Dirck van: Caravaggio's influence on, RE 39; Vermeer and, V 75; work by, V *65, 75-76, 156*

Bach, Johann Christian, intimate of Gainsborough, GA 45, 106, 141

Baldung Grien, Hans: relations with Dürer, DU 51, 90, 161; works by, DU 127, *166, 167*

Banking: in Giotto's time, G 138-139; bankruptcy of Florentine bankers, G 178, 184; Florence, as papacy's banking house, G 84; Siena, as center of, G 60, 61

Barbizon School: establishment of, MA 20, 104; Homer and, WH 72; Inness and, WH 97

Bardi, House of: financial dealings and failure, G 139, 178, 184; Robert of Anjou's loans from, G 157; Giotto's work for, G 26-27, 139-140, 144-145, 157

Baroque art: in Caravaggio's art, RE 30; classical and Baroque elements in, B 107, RE 73, *82-85,* 105, 109-111, 120-121, 148-149; definition of, B 11, R 8; drama in, B 13, 19; Flemish art and, BR 170, 185; Poussin and, B 54; Rubens' interpretation of, R *40-50, 108-119;* and 17th Century religion and society, B 11-12

Bartolommeo, Fra, work by, M *68,* 88

Barye, Antoine-Louis, animal sculpture by, RO *55-57*

Bath, England: Gainsborough in, GA *57-65;* views of, GA *67-73*

Batignolles artists: avant-garde French artists, C 38-40, 57-58, 62, 162, MA *80-81, 82,* 107-108; Manet and, MA 110

Baudelaire, Charles Pierre: art critic, MA 21; bust of, MD *44;* career, D 144-145; on contemporary art and sculpture, RO 15-16, 18; on effects of French Revolution on art, C 35; on Goya's "black magic," GO 171; Manet and, MA 21, 64;

photograph of, D *68*

Bazaine, Jean: life and work, C 171, 182; work by, C *183*

Bazille, Jean-Frédéric, life and work, C 39, 58-59

Beard, William Holbrook, American genre works by, WH 52, *64-65*

Beardsley, Aubrey, works by, W *9, 173*

Belgium: cultural heritage, BR 20; history, BR 13; Van Gogh in, VG 13-16

Bellini, Gentile: life and work, DU 6, 63-64, T 11, 12; influence of oil technique on, T 14; Titian's apprenticeship with, T 30, 33; Vasari's comments on art of, T 85; works by, DU *65,* T *19, 20*

Bellini, Giovanni: death, T 63; Dürer and, DU 63, 64, 66, 93, 95, 159; influence on Giorgione, T 53; life and work of, L 119, T 11, 12, 22; Madonnas represented by, T 15, 31; oil technique employed by, T 14, 15; Titian and, T 62, 63; Venetian painting, role in, T 15; works by, DU *94,* T *22-24, 33*

Bellini, Jacopo: life and work, T 11-12, 128; sketch by, T *18*

Bellows, George, and Ash Can School, MD *53,* AP *30-31*

Bening, Simon, work by, BR *173*

Benton, Thomas Hart, American Regionalist, AP *69-73*

Berlinghieri, Bonaventura, G 58, 59; work by, G *24-25*

Bernhardt, Sarah, and rebirth of French theater after 1850, RO *34-35*

Bernini, Gianlorenzo: analysis of style of, B 9-10, 17, 18-19, 39; birth in Naples and youth in Rome, B 13; Bonarelli, Costanza, affair with, B 41, *131;* Borghese, Cardinal Scipione, work for, B *14-15,* 16, 20, *132, 133;* Borromini, antagonism between Bernini and, B 85, 86, 92, 102; Catholic Church, devotion to, B 38, 148; Christina of Sweden, friendship for, B 146, 147; criticism of Fountain of the Four Rivers, B 89-90; on drawing, B 115; estate left by, B 147; failure in construction of St. Peter's bell towers, B 85-86; financial prosperity, B 39, 41, 123; in France, B 124-127, 134; illness and death, B 146-147; influence of art, in Rome, B 96; Innocent X, relationship with, B 86, 87;

international reputation and political implications, B 123; life and work in Rome, B 10; Louis XIV's gift and pension to, B 127; marriage and establishment of large family, B 41; number of portrait busts, B 113; paintings produced by, B 61; Perrault episode, B 127; personality, B 39; physical appearance, B 125; portrait sculpture, excellence in art of, B 113, 114-115, 120, 121-122, 128, 134; prices paid for portrait busts, B 123; realism in art, B 18, 19, 114, 115; religious fervor, B 12, 38, 137-138, 141-142, 143, 148; religious subjects, treatment of, B 15-16, 143, 147; resentment among Roman artists against dominance of, B 39; revival of interest in, B 9, 10; Ruskin's contempt for, B 9-10; St. Peter's, B 39, 158-167, *168-180;* sculpting technique, B 18-19; self-portraits in *David* and in *Damned Soul,* B 26-27, 115; sense of time in sculpture, B 16-17; short period of disgrace after Urban VIII's death, B 85-86; space in sculpture, B 19, 140-142, 160; supernatural in work, B 142-143; theater interests, B 138-139; Urban VIII (Maffeo Barberini), relationship with, and patronage by, B 14, 31, 38-40, 41, 42, 85-86, 148; Velázquez, possible meeting with, VE 145; personality, B 39; physical appearance, B 125; portrait sculpture, excellence in art of, B 113, 114-115, 120, 121-122, 128

Bierstadt, Albert, contribution to American landscape painting, WH 55

Bigallo Master, work by, B *20,* 39

Bingham, George Caleb, American genre works by, WH 49, *58-59*

Biondo, Giovanni del, work by, G *176,* 182

Blackburn, Joseph: life and work, CO 19, 25; influence on Copley, CO 32, 42; work by, CO *25*

Blake, William, French Revolution and, TU 33; work by, TU 19, *24-25,* 105

Blume, Peter, and Social Realism, AP *110-111*

Boccaccio, Giovanni: on Giotto's physical appearance, G 9; plague as basis of *Decameron,* G 180; in Robert of Naples'

AP American Painting; B Bernini; BR Bruegel; C Cézanne; CO Copley; D Delacroix; DU Dürer; MD Marcel Duchamp; P Picasso; R Rubens; RE Rembrandt; RO Rodin; T Titian; TU Turner;

court, G 158

Boccioni, Umberto, expression of speed in bronze by, RO *180*

Borghese, Cardinal Scipione: art collection in Borghese Gallery, B 14, 20, *21-29;* Bernini's portrait busts of, B 14, 120-122, *132;* caricatured by Bernini, B 14, *15;* pagan subjects in art and, B 17; work by Bernini for, B 14-15, 16, 20, 21-29

Borgia, Cesare: drawing of, L *122;* Leonardo's employment with, L 122-124, 168; Machiavelli on, L 124

Borromini, Francesco: Bernini's assistant, B 85-86; Urban VIII's patronage of, B 42; works by, B *43-47, 161*

Bosch, Hieronymus: analysis of work, BR 20, 43-47, 51-52, 54; character traits and attitude toward religion, BR 52-53; influence on Bruegel, BR 43, 56, 65-67, 76; popularity in 20th Century, BR 45; Surrealists' admiration for, P 83; works by, BR *40, 42 47, 55-65,* MD 112-*113*

Boston: art in, CO 8, 11-12, 20, 41; Britain's repressive measures and conditions leading to American Revolution, CO 69-70, 89, 135; Bunker's Hill, Battle of, CO 91; Committees of Correspondence, CO 72-73; Copley's life and work in, CO 45, *59-65,* 67-75; economic and political changes, CO 14; Faneuil Hall, CO *15;* Feke's activities in, CO 17-18, 20, 24; Greenwood's work in CO 18; leading artists of colonial times, CO 20; Long Wharf in Revere's engraving, CO *6;* number of portraits painted by Copley during Boston period, CO 75; Peale's work in Copley's studio, CO 165; progress and description of, CO 37-38; prominent Bostonians painted by Copley, CO 8-9, 62, *63-64,* 76; rejection of Copley's project for Brattle Square Church, CO 67; riots provoked by Stamp Act, CO 69; Royall estate in Medford, CO 43, 46, *47-57;* Smibert's success in, CO 15-16, 24

Boswell, James, character and life, GA *81, 150-151*

Botticelli, Sandro: Leonardo and, L 14, 29; life and work, L 13, 121; painting style, L 32; works by, L *43,* M *25, 52-53*

Boucher, François: character,
WA 120-121; death, WA 124; destruction of paintings by Louis XVI, WA 163; early work, WA 118; influence on Fragonard, WA 167, 175; Marquise de Pompadour, relationship with, WA 118, 120-121, 131; marriage, WA 119-120; portraits painted by, WA 126; success and loss of popularity, WA 119-123; Watteau's influence, WA 118-119; works by, WA *6, 103, 114, 130-139*

Boudin, Eugène: Impressionists and, MA 83, 88, 108; plein-air painter, MA *54-55*

Bourdelle, Antoine: bronze by, RO *175;* works for Rodin, RO 144, 173

Bramante, Donato: Michelangelo, jealousy of, M 109, 112, 116; St. Peter's, plans for, M 108, *176;* Sangallo, rivalry with, M 108-109

Brancusi, Constantin: Duchamp and, MD 106; influenced by Rodin, RO *182, 183;* works by, MD *45,* RO *182*

Braque, Georges: in advanced guard of Cubism, MD 12-13, P 86; at Armory Show, MD 49; Cézanne's influence on, C 126, 170-172, P 56; collaboration and relations with Picasso, P 56, 58-59, 61-63; and the collage, MD 12, 29, 101; disparaging remark on Gertrude Stein, MAT 74; Fauvism and origin of name, MAT 52; works by, C *180,* P *93, 95, 97*

Brouwer, Adriaen: life, V 36, 78-79; Rembrandt's ownership of works by, RE 137; and Rubens, R 145-146, 180-181; works by, V *78, 92, 93*

Brown, Ford Madox, work by, W *74-75*

Bruegel, Pieter, the Elder: analysis and criticism of art, BR 14-15, 16, 53, 76-77, 114-115, 128, 147-148; attitude toward mankind and human foibles, BR 143, 146, 148-149, 150; Avercamp compared to, V 77; biographical data, BR 14, 70-75; birth, BR 13, 69, 70; blending of Biblical episodes with everyday life, BR 15, 94-96, 97, 100, 108, 109; Bosch's influence, BR 43, 56, 65, 76; caricature in art, BR 116, 118, 148; cripples in paintings, BR 119-120, *127, 132-133;* death, BR 70; drawings for prints, BR 71, 72, 74, 75-76, 80, *81-87,*
143, *144,* 164; evolution of realism in art, BR 14, 15, 115, 116, 121; friends and patrons, BR 78; hypothesis regarding Bruegel's possible medical training, BR 119, 121; influence on succeeding artists, BR 169; interpretations of paintings, BR 46, 96-99, 133; Italian influences on, BR 43, 76, *88,* 116; Mannerism and, BR 73-74; marriage, BR 70, 71; move to Brussels, BR 71, 76, 79, 97; *naer het leven* drawings, BR 121-122, 124, *125-129;* nickname of "Peasant" Bruegel, BR 69, 124; number of paintings and drawings, BR 14; Patinir's influence, BR 164, 168; paintings, in Jonghelinck's art collection, BR 78; paintings and drawings lost, BR 121; personal feelings in art, BR 99; physical appearance, BR 71-72; political and religious position, BR 14, 72, 79, 99, 133; popularity in 20th Century, BR 171; possible portrait by Philipp Galle, BR 71; proverbs in work, BR 143-145, 150, *151-159;* relationship with servant girl in Antwerp, BR 71; representation of 16th Century life, BR 114, 115, 117, 123; reputation, BR 14, 170; in Rome, BR 73-74; spelling of name, BR 14; symbolism and didactic comments in art of, BR 15, 114-115, 121; trip to Italy, BR 71, 72-74; Van Mander's account of life, BR 70-71, 72, 79, 121; *Wimmelbild* composition, BR *130-131,* 147-148

Brueghel, Jan: relations with Rubens, R 57, 78, 84, 100; portrait of, R *56;* works by, BR 74, *184, 185,* R 90-91

Brueghel, Pieter the Younger, works by, BR *184, 185*

Brunelleschi, Filippo: Massaccio and, M 37; on perspective, L 15; works by, M 17, *19,* 36, *59,* 135, 175

Burgkmair, Hans, Dürer's drawing of, DU 128; influence of Dürer, DU 69; work by, DU 124, 127, 164, *165*

Burke, Edmund, on French Revolution, TU 33; influence on West, CO 119; treatise on sublime and beautiful, CO 119

Burne-Jones, Edward Coley, testifies against Whistler, W 125; work by, W 72
Byron, George Gordon, Lord: Delacroix's idol, D 38; on inequalities in English life, TU 78; influence on France, D 79-80, 96; in Venice, TU 110

Byzantine art: Byzantine church influence on, G 35-36; illuminated manuscripts of iconoclasts, G *36;* influence on early Italian art, G 20, 35-36, 37, 39, 40, 62; influence on Tuscan art, G 58; Madonna and Child theme in, G 10-11; mosaics, G *28-29;* panel painting, G 16; Venetian art influenced by, T 10, 16, *17*

Calder, Alexander: Duchamp's invention of term "mobile" to describe works of, MD 170; mobile by, MD *171;* motion in sculpture by, RO *185*

Callot, Jacques: etching by, VE *110;* influence on Rembrandt's etching, RE 44; work by, RE *92*

Campin, Robert (Master of Flémalle), life and work, BR 16, *24, 30,* 114, 121; work by, V *20-21*

Canaletto (Giovanni Antonio Canal): art and style, T 181; works by, GA *113,* T *182-183*

Caravaggio, Michelangelo Merisi da: Carracci and, B 69; elements derived from, in Rembrandt's work, RE 34-35; influence on Dutch art, V 61-62, 67, 74-75; influence on Dutch painters, RE 25, 26, 30, 33, 39; influence on Rubens, R 38-39, 58, 167, 173; influence on Spanish art and Ribera, VE 90; influence on Utrecht painters, R 122; innovations in painting by, V 61-62, 67, 74-75; life and character of, B 61-70; revolt against artificiality, B 64-66; Rubens' admiration for, and criticism of, R 34, 122; Velázquez and, VE 39, 40; work by, B *71-79, 132, 161,* RE *30-31,* V *66, 179*

Carles, Arthur B., and American Modernists, AP *52, 53*

Carpaccio, Vittore: as Gentile Bellini's artistic heir, T 33, 34; work by, T *20-21*

Carpeaux, Jean-Baptiste, influence on Rodin, RO 58-*59, 92*

Carracci, Annibale: on Bernini, B *20;* Caravaggio and, B 69; influence on Rubens, R 34-35, 173; life of, B 68-69, 72, 78;

G Giotto; GA Gainsborough; GO Goya; L Leonardo; M Michelangelo; MA Manet; MAT Matisse; V Vermeer; VE Velázquez; VG Van Gogh; W Whistler; WA Watteau; WH Winslow Homer

revolt against contemporary art, B 68; works by, B 66, 80-83

Casanova de Seingalt, Giovanni: on Parisian society and fashion, WA 35, 57, 59, 83; in Spain, GO 50

Cassatt, Mary: on Cézanne's nature, C 101; on Pissarro, MA 86

Castagno, Andrea del, as Leonardo's predecessor, L 14; works by, L 80, 83, 96-97, M 55

Catholic Church: art and effect of spiritual renewal in, R 32-33; art in Middle Ages and, G 8-9, 11-12, 101, 155; art patronage in Spain, VE 35, 85-86; Bernini and, B 38, 148; Baroque art and, 13, 17; Bruegel and, BR 98; Byzantine art, influence on, G 35-36; changes in portrayal of Christ and, G 187; Charles V's attitude toward, T 146; conception of the devil and, BR 50, 52, 53; consequences in Germany of breach with Luther, DU 157, 158; Council of Trent's principles regarding religious art, VE 37; and Counter Reformation, B 34; decadence during early 14th Century, G 105; decline in art patronage in 17th Century Netherlands, RE 22; Diet and Edict of Worms, Dürer's religious attitude on, DU 15, 121, 129, 140; 14th Century attitude toward dissection, L 58; Galileo and, B 34-38; Huss' followers and, DU 34-35; influence on Flemish art, BR 170; influence on scientific thought, L 103, 106; inquisition depicted by Goya, GO 16, 26-27; inquisition, founded in 1235; GO 12; Leonardo's attitude toward, L 56; as major force in Spanish art, GO 11-12; Marsiglio of Padua, influence of treatise on medieval thought, G 153-154; opposition to Copernican system, BR 99; Philip II's attitude toward, T 145; Pietro d'Abano, proceedings against, G 133; position of, in 17th Century Spain, VE 34, 92; poverty and, G 154; Protestantism versus, T 140, 155; Protestantism in 17th Century Spain and, VE 28-29; Reformation and Counter Reformation, BR 13-14, 19-20, 41; religious struggles in Low Countries and, BR 79,

89, 91, 92; repression of witchcraft, BR 48-50; revival of orthodoxy, G 183; role in medieval life, G 11-12; St. Francis of Assisi and, G 12-14; sale of indulgences and Luther's theses, DU 127-128; in 17th Century, B 33-35, 41, 141; Spanish monarchy's defense of, VE 9; taxation of clergy, question of, G 103-104; Veronese's trouble with, T 170; Virgin Mary, evolution of image of, BR 50-51

Catlin, George, as chronicler of American Indians, D 148

Cavallini, Pietro, G 102; work by, G 86

Cervantes Saavedra, Miguel de: Philip IV cartooned after, VE 62; remarks on 17th Century, VE 116

Cézanne, Paul: analysis and criticism of art of, C 7-8, 29, 43, 63, 66, 75-83, 99, 122, 163-164, 171, 173; at Atelier Suisse in Paris, C 17, 18, 19, 39, 40; Batignolles group and, C 39, 57-58; birth, C 11; boyhood and youth, C 13-23; Catholicism and, C 10; correspondence with Zola, C 14, 15, 16, 23, 41, 73-74, 75, 97-98, 121, 122; death and grave of, C 7, 168; Delacroix's influence on, C 36, 73, 75, 83, D 118, 189; Denis' Homage to Cézanne, C 164, 176; development of personal style, C 30, 41-42, 73-91; diabetes, C 143, 167; distortions in work, C 18, 88-89, 96, 99; domestic difficulties, C 10, 117-118; education, C 13, 15; and Émile Zola, C 13-14, 18-19, 22-23, 50-51, 74-75, 97, 121-122, 143; evolution of art, MA 109; evolution of Cubism and, P 70, 88; exhibitions of works, C 8, 38, 49, 63, 64, 66, 70, 91, 163, 164, 168, 172, 174; financial situation, C 10, 11, 44, 98; Gauguin and, VG 77, 80, 120; habits of work, C 144-145; and Hortense Fiquet, his mistress and wife, C 55-56, 73, 94, 97, 98-99, 104-105, 118, 119; and Impressionism, C 41, 61, 64, 71, 161; influence on 20th Century art movements, C 169-170, 172, 178-179, 180, 182, MAT 60; and Louis-Auguste, his father, C 16, 17, 56, 73-74, 97; love affair with unknown woman, C 97-98; Maillol's tribute to, C 166; marriage, C 56, 97, 98; Matisse's

reverence for art of, MAT 20, 26, 27, 31-32, 49, 77, 90, 126; in Paris, C 17-18, 18-19 20, 40, 73, 94, 117-118; and Paul, his son, C 97, 98, 118, 167; personality problems and isolation, C 9-11, 14, 16, 17, 39, 44, 55, 93, 100-101, 117, 121, 141-143; photographs of, C 6, 17, 22, 39, 54, 173; physical appearance, C 17, 39, 96-97, 141; Pissarro and, C 59-61, 68-69, 93; poetry written by, C 14-15, 16; portrait style, C 98-99, 102, 104, 146; portrayal of, in Zola's novels, C 57; as Post-Impressionist, C 75; prices of paintings by, C 162, 164, 168-169, 184; Renoir's medallion bust of, C 167; Salon des Refusés and, MA 26-27; self-portraits by, C 9, 19, 99, 103, 106-107; still lifes by, C 8, 60, 94-97, 128, 129-139; theft and return of paintings by, C 120; theories of art, C 8-9, 11, 33, 41-42, 78, 82, 83, 84, 90; 20th Century art and, MD 8; Van Gogh and, VG 7, 40, 42, 51; visits the Louvre, C 17-18; watercolor technique, C 145-146, 148, 158-159; work influencing Duchamp, MD 47; work influencing Matisse, MAT 32; work influencing Van Gogh, VG 42

Chandler, Winthrop: follower of Copley, CO 93-96, 98; Moulthrop and, CO 96; portraits by, CO 93, 102

Chardin, Jean-Baptiste Siméon: analysis of work of, WA 148-149; death of, WA 149; influence on Cézanne, C 94; influence on Fragonard, WA 167, 175; life and character traits, WA 146-147; realism in, V 26; works by, V 26, WA 150-161

Charles I, King of England: Bernini and, B 122, 123; patronage of the arts, R 123-124; portrait of, R 85; and Rubens, R 80, 125-126, 141, 150-151; Van Dyck as painter to, B 122, 123, R 84, 173

Charles V, Holy Roman Emperor, BR 25-27, T 101-102, 130; abdication and retirement to monastery of San Geronimo de Yuste, BR 27, 89-90, T 130, 146, 159; Alfonso d'Este's portrait by Titian sent to, T 126; Antwerp reception, DU 137; armor collection, T 134-135; attitude toward Philip II, T 158; catafalque in Brussels in

memory of, T 159; coat of arms, VE 9; conflicts with Protestant German princes, T 130, 140; 155-156; coronation at Bologna, DU 129, 139, T 110-111, 131; death, T 159; descendants of, VE 9; Diet of Worms and, DU 140; Dürer's pension granted by, DU 129, 139, 140; Empress Isabella's portraits by Titian, T 142, 156; expansion of empire and wealth in New World, T 136-137; fighting against Turks in Europe and Africa, T 130, 138; meeting with Pope Paul III, T 150; Nuremberg's religious conflict and, DU 158; policies toward the Netherlands, BR 90-91; portraits by Titian, T 120, 141, 156; regard for Titian, T 156-157; religion, attitude toward, T 146; Titian summoned as official painter at Imperial court at Augsburg, T 154-155; wars between Francis I and, T 102-103, 130, 134, 155

Chase, William Merritt: as leader of America's Younger Men, WH 95-96; work by, 114

Chiaroscuro (light and shade): Caravaggio's new use of, RE 25, 30; Cézanne's avoidance of, C 81; Rembrandt's mastery of, RE 25, 30, 41, 108, 110-111, 135; Rubens' use of, R 40, 165-167, 173

Chinoiserie, Boucher and 18th Century passion for, WA 102, 138

Chopin, Frédéric: friend of Delacroix, D 145-148; portraits of, D 139, 147

Church, Frederic Edwin: estate of Olana on Hudson River, WH 54; life, WH 53-55; landscapes by, WH 24-25

Cimabue (Cenni di Pepo), G 64-65; Giotto's relations with, G 66, 85, 137; Vasari's account of "fly" episode, G 85; Vasari's account of Giotto's meeting with, G 82; works by, G 70-73

Civil War, American, effects on American life, and illustrations of, WH 66-70, 78-83

Civil War, Spanish: Dali and, MD 128, 140; events of, P 110-111; Miró and, MD 134, 145; Picasso's Guernica and, P 126-128, 132, 135-139

Classical art: archeological finds in Rome, M 103, 104; Baroque art and, B 107; Bernini and, B 13, 15, 20, 21-

AP American Painting; B Bernini; BR Bruegel; C Cézanne; CO Copley; D Delacroix; DU Dürer;
MD Marcel Duchamp; P Picasso; R Rubens; RE Rembrandt; RO Rodin; T Titian; TU Turner;

23; Brunelleschi influenced by, M 59; Cavallini's work and, G 86; Donatello and, M 38; features of, in Renaissance decoration, T 87, 88; fusion of Gothic and, G 52-53; influence on Italian art, G 35, 36, 40; influence on Venetian painting, T 16; Michelangelo's imitation of, M 72-73; naturalism and, B 68-69; Neoplatonism and, M 92; Nicola Pisano and, G 46; Renaissance collections of, T 82, 123; Rodin's interest in, RO 22-25, 148, 150; Rubens' interest in, R 32, 38, 78, 104, 145, 167; sculptures, RO 21-25

Classicism: cartoon satirizing classicists and Romantics, D 13; character of, C 35, WA 10; classical elements in Rembrandt's work, RE 47, 105-106, 121; David and revival of, WA 182; David's role in neoclassicism, D 15, 16, 20, 23; in English art theory, GA 102-105; French, WA 10; in French painting before Delacroix, D 14, 15; impulse of, toward structure versus color, C 9; Le Moine and, WA 118; Mengs and, CO 116; neoclassical style in French art, WA 137, 163-164, 170; neoclassicism versus Romanticism, D 13; Picasso and neoclassicism, P 80, 105; Poussin and, WA 10, 28; Realism's rejection of neoclassicism, MA 44; Rembrandt's tendency toward anticlassicism, RE 106-107; revival of, in French art, D 20, 142; revival, under Louis XVI, WA 163-164; Robert's fondness for monuments and ruins, WA 171; West's use of neoclassicism, CO 119-122

Claude (Lorrain): and English landscape, TU 14; Flemish art and, BR 170; influence on Turner, TU 43, 48, 58, 62, 71, 80; influence on Watteau, WA 64; mood in work, V 77

Coello, Sánchez, work by, VE 124

Colbert, Jean-Baptiste: grand political design of, WA 8-9; Le Brun and, WA 11

Cole, Thomas: comparison of self to Constable, WH 13; conception of "beautiful nature," WH 13; in Durand's landscape, WH 17; and the Hudson River School, WH 13-15; landscapes by, WH 14, 20-21; life of, WH 12-13

Colonial American art: artists before Copley, CO 20, 24-25; Copley's place in 18th Century portraiture, CO 7; early portraitists, CO 13, 24-25, 96-97; English art, influence on, CO 13, 18, 19, 41; examples of early American art, CO 8, 11, 94-95; folk painters, CO 91-97, 98, 99-111; Greenwood as first American genre painter, CO 19; landscape, CO 94-95; limners, CO 13-14, 100; Puritanism, influence on, CO 12; sign painting, CO 14; Smibert's influence on, CO 15-16; upper class society represented by painters, CO 76; West's and Copley's reception in London as painters of, CO 61

Color: in Bernini's sculpture, B 113-115, 121; in Bruegel's work, BR 167; in Carpaccio, T 21; color wheel used by Seurat, VG 73; comparison between Venetian and Florentine use of, T 153-154; critics on Rembrandt's use of, RE 108, 166; essence of, in Titian, T 85, 154, 173-174; in Flemish painting, BR 28; in fresco painting, T 12; in Giorgione, T 57, 67; Ingres-Delacroix dispute regarding, DU 128, 129; Kandinsky's symbolic use of, MAT 55, 56; Matisse's, MAT 24, 27, 33, 50-51, 57, 142-143; modeling attained by, in Cézanne's work, C 81-83; in Op Art, MD 177; Rembrandt's changes in use of, RE 41-42; Rubens' treatment of, R 40, 58, 63, 173; Seurat and Signac's scientific use of, MAT 37-39; Signac on colorists, MAT 50; Venetian painters' brushwork and, T 172-173

Constable, John: admiration for Gainsborough, GA 171; analysis of art of, TU 114, 118, 122, 143, 144; attitude toward his art, TU 14, 62-63, 83, 113-114; character traits of, TU 53, 116, 143; comparison between Turner's art and, TU 16, 144; courtship and marriage to Maria Bicknell, TU 63, 83, 127; death of, TU 149; friendship with Dunthorne, TU 54; Egremont, relations with, TU 90, 105, 147; exhibitions at Royal Academy, TU 55, 83, 117, 129, 144, 149; election as Academy Associate and Royal Academician, TU 111, 117; family and background,

TU 54-55; financial problems and personal difficulties, TU 62-63, 80, 82-83, 117, 143; Fisher, relations with, TU 68-69, 116; French admiration for, D 39, 40, 54, 55, 58; lectures on art as science, TU 148-149; life in London, TU 53-54, 55; portrait of, TU 52; Rubens' influence on, R 166; Salisbury sketches and oils, TU 83, 114, 124-125, 134, 143; success in France, TU 114-116, 118; Thomas Cole's comparison of self with, WH 13; Turner, relations with, TU 16, 43, 59, 82, 111; watercolors of House of Commons before and after 1834 fire, TU 148; works by, TU 118-137

Copley, John Singleton: American artists of 19th Century, influence on, CO 161; American Revolution, thoughts on, CO 136-137; artistic evolution and influences, CO 8-10, 23, 30, 41, 42; birth in Boston and family background, CO 38, 39-40; Blackburn's influence on, CO 18-19, 25, 32, 42; Boston, life and work in, CO 7, 11-12, 45, 59-65, 67-75; Boston portraits, analysis of, CO 8-9, 30, 41, 42, 43, 63-64, 76; Bruce, correspondence with, CO 61, 69; Carter, relationship with, CO 134-135; Chandler, influence on, CO 94; characterization in portraits by, CO 8-9, 30, 41, 43, 137; comparison between Boston and London work, CO 8, 9-10; death in London, CO 143; decision to undertake portrait painting, CO 40-41; decline and failures in later years, CO 142, 143, 158; description of European travels in letters to Boston, CO 133, 134, 135, 136; Earl, influence on, CO 93; early friendly relations with West, CO 7-8, 11-12, 61-62, 133; exhibitions at Royal Academy, CO 137, 138, 141, 142, 143; failure to obtain court patronage, CO 155; Feke's influence on, CO 28, 30; financial successes and later difficulties, CO 65-66, 76, 142, 143; George III, relations with, CO 132, 141, 142, 143; Greenwood's influence on, CO 18-19, 25, 28, 30; historical paintings, interest in, CO 10-11, 138-139, 144; hostility of London art circles, CO 142; independent exhibitions of

works, CO 139, 140, 142, 150; Liotard, letter to, CO 44; London, life and work in, CO 9-10, 137–143, 144, 147; marriage to Susanna Farnham Clarke, CO 64; Moulthrop, influence on, CO 96; Mount Pleasant estate on Beacon Hill, Boston, CO 65, 66, 142; New York, sojourn and work in, CO 65-67; Peale's work in Copley's Boston studio, CO 165; personality and interests, CO 8, 41, 135; politics, attitude toward, CO 8, 68-69; productivity in America and number of portraits still in existence, CO 64, 75; rivalry between West and, CO 10, 119, 137, 139, 142, 143; role as mediator in events preceding Boston Tea Party, CO 74-75; Royal Academy, membership in, CO 137, 138, 144; self-portrait, CO, 64; in Singleton's group portrait of Academicians, CO 137; Stuart's portrait of, CO 160; success and fame, CO 45, 59, 60-61, 67-68, 76, 138-140; at time of Turner's artistic debut, TU 19; training in Peter Pelham's engraver's shop, CO 20, 23, 39-40; Trumbull's visit to, in Boston, CO 161

Coppo di Marcovaldo, Giotto's predecessor, G 58, 59, 60, 61, 66; works by, G 66-69

Corot, Jean Baptiste Camille: nature in landscapes by, MA 20, 44, 54, 104; work by, MA 45

Correggio (Antonio Allegri): influence on Copley, CO 136; influence on 18th Century French art, WA 31, 41; influence on Rubens, R 31, 37

Cortez, Hernando, expedition of, T 136-137

Courbet, Gustave: analysis and criticism of art, MA 37, 40, 41-43, 52, 88; comparison between Manet's art and, MA 58; exile in Switzerland and death, MA 41; landscape painting outdoors, MA 104; life of, MA 37-43; Nadar's photograph of, MA 95; Pissarro, influence on, MA 85; political views and attitudes, MA 39-41; portrait of, and relationship with, Proudhon, MA 40; Renoir's admiration for, MA 85; retrospective exhibit of work, MA 39, 64; role in development of Realism, C 36-37, 75, 81, MA 20, 44, 88; Salon's early rejection and

G Giotto; GA Gainsborough; GO Goya; L Leonardo; M Michelangelo; MA Manet; MAT Matisse;
V Vermeer; VE Velázquez; VG Van Gogh; W Whistler; WA Watteau; WH Winslow Homer

late acceptance of paintings, MA 39, 52; seascapes, MA 54; self-portrait, MA 36; social implications of subject matter, MA 141; works by, MA 36, 38, 50-53, W 33

Couture, Thomas: Manet's training with, MA 17-19, 21; work by, MA 17

Coypel, Antoine, role in rise of French Rococo, WA 15, 27, 31, 32

Cozens, John Robert, mood in watercolors by, TU 36-37, 38, 43

Cranach, Lucas, the Elder: Dürer's influence on, DU 69; life and work, DU 143-144, 164, 168; works by, DU 129, 168-173

Crusades: role in Byzantine influence on Italy, G 37-38; Venice, in time of, T 28

Cubism: and abstract American art, AP 8-9; American reaction to, at Armory Show, MD 33-34, 43, 48-49; Analytical, P 57, 61; apogee in Picasso's work, P 80; Arp, influence on, MD 56, 58; Braque and, MD 8, 11; Cézanne's influence, C 9, 77, 96, 170, 181; Cocteau on, P 75; collaboration between Picasso and Braque, P 58, 61, 62, 63, 86, 92, 94; collage and papier collé, P 94, 97; Dada movement and, MC 57, 61; decline of movement and Kahnweiler sale, P 80-82; development of, MAT 74, MD 11, 12, 13, 18, P 60-61; Duchamp in relation to, MD 8, 13, 14, 22-23, 24, 30; Duchamp-Villon's bust of Baudelaire, MD 44; early geometric forms, P 86, 87; Golden Section group, P 63; Gris and, P 60, 72; growing number of adherents to, P 60; lettering as standard practice of, P 62; Lipchitz and, RO 174, 176, 181; Marcoussis' portrait of Apollinaire, MD 98; Masson, influence on, MD 103; Miró, influence on, MD 130; New York cartoons on, MD 34; origin of term, P 86; Picasso and, MD 8, 11, P 7, 57, 59, 63, 73, 74, 85, 90, 91, RO 174, 176, 181; Puteaux group, MD 13, 14, 21; reaction to Duchamp's works, MD 15, 26; realism and, in Picasso's work, P 115; rivalry between Futurism and, MD 12; Satie's music and, P 75; simultaneous invention of, by Picasso and Braque, P 86; Leo Stein on, P 39; Synthetic, P 60, 63

Curry, John Steuart and American Regionalists, AP 74-77

Cuyp, Albert: called the "Dutch Claude," V 97; English landscape and, TU 14; sketches by, V 108-109

Dadaism: aims and accomplishments, MD 57-58, 64-65, 66, 70; Arp's place in movement, MD 54, 58, 104; birth in Zurich of, MD 39, 55-56; Breton's quarrel with Tzara on proposed Congress of Paris, MD 62-63, 96; characteristics and development, MD 55-65, 66-75, P 82; contact between New York avant-garde and, MD 58-59; disintegration, MD 63, 96; Duchamp and, MD 7, 65, 66, 77, 78; 50th anniversary, MD 68-69; Futurism's importance in development of, MD 12; in Germany, MD 63-64; Gide and, MD 61; "Happening" indebted to, MD 158; magazines, MD 57, 58, 59, 60; Miró and, MD 133; in Paris, MD 60-63, 97; Pop art compared with, MD 166; Schwitters' role in, MD 64, 74; Surrealism as derivation from, MD 96; term and origin of name, MD 57; Tzara's role in, MD 55, 57, 60-61, 62, 63, 65

Daddi, Bernardo: death of, G 180; Giotto's influence on, G 149; works by, 140-142, 148, 182, 185

Dali, Salvador: Bosch's influence on, BR 43; Breton and, MD 127-128; films, work in, MD 111, 125, 127; life and work, MD 124-129, 136; object sculptures by, MD 151; photograph of, by Halsman, 136-137; position in modern art movement, MD 123; realism and, MD 123, 127, 154, 160; works by, MD 124, 125, 128, 139, 140-141, 142, 161, P 124

Dalou, Jules, quality of Baroque in sculpture of, RO 63

Dante Alighieri: admiration for Giotto, G 8; exile from Florence, G 103, 105, 133; influence on Rodin's sculpture, RO 59, 87-88, 96; portrait of, G 85, 155-156; visit to Giotto in Padua, G 106

D'Archangelo, Alan, and Op art, AP 178

Daumier, Honoré: cartoons

by, D 68, 83, 129; life and work, MA 19, 44, 46-47; paintings by, D 68, 83, 129, P 19; sculpture by, RO 18

David, Jacques-Louis: classicism under guidance of, WA 182; as exponent of classicism, D 14-17; and rise of neoclassicism, C 35; works by, D 21-25

Davis, Stuart, and American Modernists, AP 58, 59

De Chirico, Giorgio, Breton influenced by, MD 108; Ernst influenced by, MD 101; Magritte influenced by, MD 104; Tanguy influenced by, MD 104, 119; Surrealism and, MD 98-101, 114-115; works by, MD 109, 114-115

DeKooning, Willem: and American abstract painting, AP 150-151; art indebted to Miró, MD 135; Surrealism and, MD 154, 157

Degas, Edgar Hilaire Germain: analysis of art, MA 89, 137, 138-140; ballet scenes, MA 158-163; Cézanne and, C 58, 59, 142, 162-163, 165; interest in photography, MA 89, 92, 98-99; life, MA 86-87, 90, 137, 150; Manet and, MA 8, 21, 74, 86, 140; member of the Guerbois group, MA 86; preference for city life, MA 144; sculptures by, MA 162-167, RO 68; Van Gogh and, VG 40, 42, 49, 118, 124; works by, MA 6, 150-167, VG 42, W 30

De Heem, Jan Davidsz.: in Brouwer's work, V 78; flower and fruit pieces by, V 83, 101; influence on Matisse, MAT 77-78

De Hoogh, Pieter: confusion between Vermeer's works and, V 123, 150; genre realism in, BR 116; life and work, V 13, 100; possible influence on Vermeer, V 62; Van Meegeren's forgeries and, V 172, 174, 176; works by, V 89, 130

Delacroix, Eugène: Académie des Beaux-Arts membership, D 66, 171; admiration for Constable, TU 115-116; admiration for Courbet, MA 52; Bertall's caricature, D 128; birth, D 17; character traits, D 11, 12, 36-37, 165-166; death, D 173; exhibition at Exposition Universelle of 1855, D 171; formal education, D 18; George Sand's sketch, D 18; Géricault's portrait, D 10; Girard's caricature, D 84; influence on Cézanne, C 75,

83; influence on later painters, D 188-189; interest in photography, MA 89, 92; Manet and, MA 22; Nadar's photograph, D 173; number of paintings by, D 13; paternity question, D 17-18; Pauline Villot's sketch, D 126; physical appearance, D 11, 18; political and social views, D 102-103, 166, 167, 168; portraits of members of his family and friends, D 125-126, 134-135; rivalry between Ingres and, D 127, 128, 129, MA 19; stress of color over line, C 36; on Rubens' genius, R 40, 79, 175; on Watteau, WA 40-41

Delaunay, Robert: Cézanne's late works as influence on, C 170; work by, C 182

Delft, The Netherlands: Blaeu's map of, V 50-51, 60, 61; as Calvinist center, V 57; description of, V 57-58; development of Dutch merchant class, V 36; famous men born in, V 57; Vermeer's birth in, V 9, 58; views of, V 54-55, 56

Della Quercia, Jacopo: influence on Michelangelo, M 36; work by, M 37

Della Robbia, Andrea: Michelangelo's David and, M 90; work of, M 39

Demuth, Charles, and American Modernists, AP 56

Denis, Maurice: Cézanne and, C 96, 161, 162, 164; work by, C 176

Derain, André: art of, MAT 35-36; Fauvism and, MAT 52; Matisse's friendship with, MAT 34-36, 39, 49-50; photograph of, MAT 37; portrait of, MAT 63; works by, MAT 62-64; as World War II collaborationist, MAT 163

Descartes, René: in Leiden in Rembrandt's time, RE 24; as spokesman for Age of Reason, V 10, 11, 12

De Vlieger, Simon, studies of landscape perspective, V 77, 78

De Witte, Emanuel, V 102; church interiors as possible influence on Vermeer, V 62; work by, V 69

Diderot, Denis, on art, WA 85, 97; on Boucher, WA 122; couplet on age of Louis XVI, WA 163-164; encyclopedia by, WA 144; on fashionable hairdos, 85; on Greuze, WA 165; impact on 18th Century French thought, WA 166; on love, WA 120

AP American Painting; B Bernini; BR Bruegel; C Cézanne; CO Copley; D Delacroix; DU Dürer;
MD Marcel Duchamp; P Picasso; R Rubens; RE Rembrandt; RO Rodin; T Titian; TU Turner;

Diller, Burgoyne, and American abstract painting, AP *126*

Dine, Jim: Pop art and role in, MD 169; work by, AP *181*

Donatello: influence on Masaccio, M 37; influence on Michelangelo, M 31, 38, 47, 60; perspective in, L 15; Rodin's admiration for sculpture by, RO *30;* works by, B *18*, L *75, 76*, M *39, 60-61, 70, 91, 93, 135*, RO *30*

Dou, Gerard: as genre painter, V 79; work by, copied by 18th Century painters, WA *34*

Dove, Arthur, and American Modernists, AP *55*

Drawing: Bernini on importance of, B 115; comparison between Florentine and Venetian art, T 153-154; influence of Japanese woodcuts on Manet's drawing, MA 62; Ingres and Delacroix on importance of, D 128; Jacopo Bellini's style of, T 11, *18;* Leonardo's techniques in, L 31, 110, 152; Leonardo's views on, L 104, 128; portfolio of Rembrandt's drawings, RE *49-60;* portfolio of Rubens' drawings, R *131-139;* portfolio of Van Gogh's drawings, VG *149-159;* portfolio of Watteau's drawings, WA *89-95;* Rembrandt's techniques in 1640s, RE 113-114; Rodin's technique in representing the dance, RO 156; sinopia technique, G *180-181;* system for anatomical drawing created by Leonardo, L 105; Tintoretto and, T 171; Titian and, T 154

Dreyfus Affair, the: details of, C *52-53*, 122-125; Rodin and, RO 122–123

Duccio di Buoninsegna: influence of Giotto, G 137; works by, G *54, 61-64, 66, 76-79, 136-137*

Duchamp, Marcel: birth and youth, MD 11; *The Blind Man,* edited by, MD 39, 59; chess and, 106; Cubism and, MD 8, 13, 14, 22-23, 24, 30; Dadaism and, MD 7, 65, 66, 77, 78; Dali and, MD 124, 128; Katherine S. Dreier and, MD 77, 79, 80; education and early influences, MD 11, 16; experiments for painting on glass, MD 35; influence on contemporary art, MD 7, 9, 10, 167, 170-171, 172; International Surrealist Exhibition, New York, 1942, MD *162;* International Surrealist Exhibition, Paris, 1938, MD 161; on *Large Glass,* MD 93; Lebel's *Sur Marcel Duchamp,* MD 167; marriage, MD 152, 167; Munich, visit to, MD 29; Pasadena Art Museum exhibition, MD 170-171; periodicals issued by, MD 59; photographs of, MD *6, 10, 106, 173;* Picabia and, MD 13, 31-32; relations with brothers, MD 30-31; replicas of works of, MD 170-171; Retrospective Exhibition at London's Tate Gallery, MD 170; *Rongwrong,* MD 59; Rrose Sélavy, MD 79, 80, 98; sojourns and activities in New York, MD 37-38, 39, 59, 61, 78, 156-157, 165-167; portrait by Jean Crotti, MD 78; Puteaux group and, MD 21; on readymades, MD 39; Mary Reynolds and, MD 152; Sanouillet's *Marchand du Sel,* MD 167; Surrealism and, MD 7, 9, 107; thoughts on art, MD 8-9, 10, 171; withdrawal from painting, MD 10

Duchamp-Villon, Raymond (Duchamp's brother): life and art of, MD 13, 15, 36, 60; sculpture by, MD *44*

Dumas, Alexandre: costume ball given by, D 121-122; and Delacroix, D 84, 88, 121; one of young Romantics, D 82, 83

Duncan, Isadora: photographs of, RO *11, 153;* Rodin and, RO 10-11; Rodin's drawings of, RO *158-159*

Durand, Asher B.: life, WH 14-15; on nature as divine, WH 15; works by, WH *17, 32*

Durand, John: scarcity of early American works by, C 97, 98; work by, CO 66, *104*

Dürer, Albrecht: analysis and criticism of work, DU 8, 10, 15, 66-68, 120, 122, 145, 161-162; apprenticeship at his father's goldsmith shop, DU 7, 47-48; apprenticeship in Wolgemut's shop, DU 8, 48, 49-50; Bellini, Dürer's visit to, DU 63; birth at Nuremberg, DU 7, 39; career of, and fame acquired through woodcuts and engravings, DU 8, 66, 69-70, 98; character traits, DU 8, 39, 89, 158; comparison between art of Holbein and, DU 145; comparison between Rembrandt and, RE 70-71; death, 161; drawing technique compared to Mantegna's, DU 62; engraving technique, DU 8, 69-70, 108, 121, 162; establishment of own studio, DU 65; family background, DU 7-8, 37-38, 39; financial conditions, DU 90, 97; Frederick the Wise's patronage, DU 65-66, 71, 85; house in Nuremberg, DU 97; impact of mother's death, DU 123; journeys to Italy, DU 9-10, 53, 61-64, 94-97; letters from Venice to Pirckheimer, DU 94-96; Lodovico Dolce's criticism of, T 170; Luther's reforms, attitudes toward, DU 128-129, 140; map showing travels, DU *35;* Margaret of Austria, relations with, DU 139, 141; marriage and relationship with wife, DU 51-52; Maximilian's patronage, DU 123-124, 125; Michelangelo's admiration for, DU 138; Netherlands visit, DU 137-141; member of Nuremberg's Grand Council, DU 119; number of paintings and other works produced by, DU 15, 65, 72, 90-91; painting technique of, and Giovanni Bellini, DU 93; pension granted by Maximilian, DU 126, 129, 139, 140; physical appearance, DU 8, 50, 51, 71, 89; physical and spiritual decline, DU 141-142, 160; Pirckheimer's epitaph for grave of, DU 163; portrait of Frederick of Saxony, T *140;* religious attitudes, DU 15, 121, 129, 140; role in German art, DU 9, 15, 90, 161-162, 163; signatures of his works, DU 11, 120; social life and position in Nuremberg, DU 52-53, 71, 119; theoretical writings, DU 160-161; on treasures brought from Peru, T 137; on Venetian art world, T 60; "wanderyears," DU 50-51; woodcut technique, DU 66-67, 98, 99, 122; work on *Triumphal Arch* in honor of Emperor Maximilian, DU 125-126

Dutch art, Caravaggio's influence on, RE 25, 26, 30, 33, 39, V 61-62, 67, 74-75; changes in tastes in, RE 111; character of, V 11-12, 37-39, 80; craftsmanship and realism in, V 9; Dutch painting school versus Flemish art, BR 169-170, V 32-33; genre painting, V 12, 78, 84, 98-100; group portrait as art form of, RE 72; influence on Gainsborough, GA 40, 54, 172; influence outside Holland, V 97; influence of war of independence from Spain on, V 29; lack of interest in religious paintings, RE 112; landscape paintings, RE 96, V 76, 78, 104; Matisse influenced by, MAT 15, 16, 77; productivity of Dutch painters, RE 23; role of *vanitas* painting, V 101; seascapes, V 78; secularization of, V 11, 37, 61, 75, 78; separation into distinct divisions, V 12; still-life painting, V 82, 100-102. *See also* Golden Age, in Dutch art

Dutch Republic. *See* Netherlands

Eakins, Thomas: interest in perspective, WH *148;* interest in photography, WH *146;* as a leading 19th Century American painter, WH 135; life, WH 135, 139-143; works by, WH *134, 142, 145-151,* AP 22, 23

Earl, Ralph: Doolittle's engravings after works by, CO *90;* life, CO 91-93, 97-98; pro-British attitude during American Revolution, CO 92; work by, CO *88, 92*

Early Renaissance. *See* Quattrocento art

Eiffel, Alexandre Gustave, tower by, C *48-49*

El Greco (Domenikos Theotokopoulos): artistic education in Venice, VE 86; changes in style of, VE 88-89; distortion in, VE 88-90, 96; influence of Dürer on, DU 163; influence on Picasso, P 13-14, 15, 44, 154, *155;* life and work, VE 86-90; master of religious themes, VE 92; as painter of Spanish spirituality, GO 7-9; works by, VE *84, 87, 93-97*

Elsheimer, Adam, R 35, 38, 60; influence on Lastman, RE 25; influence on Rembrandt, RE 26; Rubens quoted on, R 73, 145; work by, RE *28*

England: alliance with Dutch Republic, R 126; American Revolution and, CO 68-75, 89, 90-91, 136-137, 140; countryside of, and landscape painters, TU 35-36; defeat of Spanish Armada, VE 24; effect of Industrialism upon society, TU 11; French emigrés in, TU 35; French Revolution, reaction to, TU 33, 34; Hogarth's depictions of, GA

G Giotto; GA Gainsborough; GO Goya; L Leonardo; M Michelangelo; MA Manet; MAT Matisse; V Vermeer; VE Velázquez; VG Van Gogh; W Whistler; WA Watteau; WH Winslow Homer

10, *22-27;* Industrial Revolution and, GA 146; interior decoration during Victorian Era, W 78, *104-107, 118-119, 169;* lower classes idealized, GA 167-168; "Macaronis" and Dandies in, GA *145;* Napoleon's Continental System and, TU 61; 19th Century Esthetic Movement and, W 147; painters' popularity in, GA 142-143; painters' status, GA 43, 77, 79; political and financial problems in 18th Century, CO 142; political and social conditions in Turner's time, TU 11, 34-35, 44, 78, 165-166, 172; "press gangs" forcing men into Royal Navy, TU 78; Prince of Wales at Spanish Court in Velázquez' time, VE 12-17; prosperity during Turner's boyhood, TU 18; railways, TU 140; Regency, TU 77-84; repercussions of July Revolution in France on, TU 140; role in European power politics, R 105-106, 121, 122; Romanticism in art of 19th Century, W 48, *52-56;* Rubens' association with, R 80-81, 127; Rubens' diplomatic mission to, R 125-127, 128; in 17th Century, GA 7; social conditions in 18th Century, GA 7-8, 15, 148, *150-151;* society in Bath, GA 59-61, 70; Victorian concepts of art, W 126; wars with France, TU 11, 34, 42, 56, 78, 84

English art: character of, in Victorian England, W 48, *52-53, 54-56;* classicism and, TU 22; collectors' disregard for English artists, TU 12; development of portraiture, TU 12, 13-14; Dutch influence on, V 97; in early 18th Century, GA 8, 75; French art versus, W 62; versus foreign painters, GA 7, 17, 75; Foundling Hospital, first English art display at, CO 59, GA 34, 36, 37, 39, TU 13; Gainsborough's influence on, GA 171; George IV's patronage, TU 79, 100-101; Golden Age of, TU 11-12, 13-16, 19; Hogarth and, GA 18, TU 13; influence on Queen Victoria, TU 167-168; 19th Century academicians and, W 61; Pre-Raphaelite movement, W 61, 62-65, 68, *69-75;* Reynolds and, GA 78-79, 84, 100-105; Romanticism and, TU 20, *21-31;* Royal

Academy, GA 97, 100, TU 13, 19, 60, 79-80, 100-101, 142; Ruskin's status as art critic, TU 170; at the Strand, London, GA 75, 97; Turner's position in, TU 149-150, 170; watercolor, special flair for, TU 36-37; West and, GA 105; Whistler's influence on, W 175

Engraving: development, in Germany, DU 54; development in 16th Century Netherlands, BR 75; Dürer's fame as designer in wood, DU 8, 9, 69, 98, 125, 162; Dürer's technique, DU 8, *12-13,* 66-70, 108, 121, 162; Holbein's popularity as designer of, DU 142-143; Homer's wood engravings for magazines, WH *42-43, 44-45, 78-79;* portfolio of Dürer's wood and copper engravings, DU *98-118;* primitive German woodcut in 1462 book, DU *9;* process for printing of, RE 42, *43;* Rembrandt's technique, RE 114-115; Rubens' interest in, R 61, 102; Schongauer's work in, DU 49, 58; in 17th Century Dutch art, V 107; technique for preparation of, DU *12-13,* R *78;* vogue in age of Louis XV, WA 125

Entertainments. *See* Games and entertainments; Fashion and costume; Music; Theater and ballet

Epstein, Jacob, bronze bust by, RO *177*

Erasmus, Desiderius: on Christianity, BR 20; Holbein's and Dürer's portraits of, DU *144, 145;* Holbein's illustrations for *Praise of Folly,* DU 144; moderation preached by, BR 97; political neutrality, BR 99; *Praise of Folly,* BR 142-143; quoted on Dürer's prints, DU 9; statue of, RE *23*

Ernst, Max: life and art, MD 101-103, 153-155; "oscillation" technique, MD 154-155; on painting, MD 123, 149; Surrealism and, MD 98, 102, 103, 116, 132, 153; works by, MD *73, 101, 116-117*

Este, Alfonso d': patron and collector of Ferrara, T 81, 88, *89;* Titian's work for, and payment problems with, T 79, 82-84, 88, *89,* 90-93, 108

Etching: Dürer's technique, DU *117;* Rembrandt's etchings, RE *142-157;* Rembrandt's work in, RE *40, 42-45,* 113, *114, 115;* in 17th Century Dutch art, V 107;

vogue in age of Louis XV, WA 125; Whistler's etchings, W *151-166*

Evergood, Philip, and Social Realism, AP *106,* 107

Exhibitions: Armory Show of 1913, introduction of Modern art in New York, MAT 104, MD 26-27, 33-34, *40-53,* AP 42-44; Foundling Hospital Exhibit of 1760, introduction of native art in London, CO 59, GA 34, 36, 37, 39, TU 13; Salon of the Académie des Beaux-Arts, founded 1667 in Paris, D 66; Salon des Refusés of 1863, introduction of avant-garde art in Paris, C 38, MA 27, MAT 10

Expressionism, birth and characteristics of, MAT *52-57,* 66; Cézanne's influence on, C 9; compared to realism in Klee and Munch, V 22, 23; debt to Cézanne, Gauguin and Van Gogh, MAT 60, 66-67; German Expressionism inspired by Cézanne, C 171, 179

Fabritius, Carel: and Vermeer, V 60, 70, 102, 103; works by, V *70, 71*

Falguière, Alexandre: Rodin and, RO *123;* works by, RO *60, 61*

Fantin-Latour, Henri: Manet and, MA 21, 23; in Paris art world, MA 82; refusal to participate in Impressionists' exhibition, MA 108; relations with Whistler, W 25, 26, *27;* Salon des Refusés and, MA 26-27; Whistler portrayed by, W 47; works by, D *189,* MA *80, 89-90,* W *30*

Farington, Joseph, quotes from diary, on Constable and Turner, TU 9, 53-54, 59

Fashion and costume: in age of Louis XVI, WA 164; bonnets in Paris fashion, WA *84;* Boucher's sketches of, W *120, 121;* competition between French and Spanish fashion at marriage of María Teresa to Louis XIV, VE 174; Delacroix's sketches of costumes, D *62, 93;* in 18th Century Bath, GA 59-60; English dandies, GA *145;* English wigs and hairdos in 18th Century, GA *144;* Gillot's drawing of actors' costumes, WA *36;* hair styles in 18th Century France, WA *84,* 122, 166; importance of, in 18th Century Paris, WA 82-85; influence of Olivares'

and Philip IV's reforms on, VE 11-12; influence of Paris fashion on Europe, WA 60; Matisse's costume designs for Ballet Russe, MAT *123,* 148; Rembrandt's love for costume, RE 9, *10,* 38-39, *65, 140;* shoes and dress of Titian's time, T *106,* 107; Spanish fan, GO *52;* Spanish *golilla,* VE 12; Terborch's sketch, V *98;* "Watteau gown," WA *85. See also* Furniture; Games and entertainments

Fauvism: Apollinaire on, MAT 58; Cézanne's influence on, C 9, 169, 178-179; characteristics of, MAT 51-52; color techniques of Fauvists, C 179, MAT 52, 60; Duchamp's experiments with, MD *18;* Matisse and, MAT 34, 52, 57-58, 60-61, 77; techniques of leading Fauvists, MAT *62-63;* works by Fauvists, MAT *61-65*

Fayd'herbe, Lucas, Rubens' assistant, R *68,* 170, 171

Feininger, Lyonel, and American Modernists, AP *49*

Feke, Robert: influence on Copley, CO 28, 30, 31, 41; life and work in Boston, CO 17-18, 20; works by, CO *24, 27*

Flanders: Breda's surrender to Spain, VE *65-66, 80-83;* as center of international trade, BR 77; as economic and artistic center, BR 20-22, 75; as part of duchy of Burgundy, BR 22-23; Low Countries in 16th Century, BR 89-94; nationalism and religion in, BR 14; progress in medicine in, BR 119; religious rebellion in, BR 92-93; representation of daily life in Bruegel's paintings, BR 117, 123. *See also* Belgium; Spanish Netherlands

Flémalle, Master of. *See* Campin, Robert

Flemish art: aims of, in 15th and 16th centuries, BR 8, 114; Biblical themes in, BR 94-95, 96; Bruegel's role in, BR 76-77; Caravaggio's influence on, B 66; character of, BR 16-18, R 8-9; comparison between Italian art and, BR 16-19; development of religious art, BR 170; didactic role in 16th Century, BR 141; difference between Dutch and Flemish art after 16th Century, BR 169-170; evolution of landscape in, BR 161-163, V 32, 33; first exhibition of Flemish masters in 1902, BR 17; genre

AP American Painting; B Bernini; BR Bruegel; C Cézanne; CO Copley; D Delacroix; DU Dürer; MD Marcel Duchamp; P Picasso; R Rubens; RE Rembrandt; RO Rodin; T Titian; TU Turner;

realism in, BR 116, V 12; historical influences on, BR 21-22; influence on German art, DU 9, 47-49; influence on Watteau and Chardin, WA 35, 42, *43*, 148; Italian influences on, BR 17, 76, 116, 163; lives of Flemish painters by Van Mander, BR 70; medieval legacy in, BR 8, 28; miniature painting and, BR 18; portrait painting, BR 38; relation between religious art and landscape painting, BR 161-162; Rubens' role in Golden Age of, R 15, 56

Florence, Italy: architecture, M 17, *19-23*, 38-39; artistic and cultural life, L 14, 23; M 14-16, 35, 36, 44-45, 48, 169, 178; artists' membership in guild, G 31, 141; banking activities, G *138*, 139, 184; Baptistry, G 160; M 20, 35-36, *38*, 58; Baptistry doors by Ghiberti, RO *89;* Black Death of 1348, G 180-181, 184; Campanili, G *158*, *159*, *160*, M 20, 38-39; Cathedral of, L 22, M *19*, *21;* contrast between Venetian and Florentine art, T 153-154; festivals in 15th Century, M 21, 22, 44, 48, 88-89; flood damage in, G 159; Florentine school of painting, G 62, 66, 141, 160, 162; French invasion of (1494), M 70; Giotto's activities in, G 82-83, 105-107, 135, 156; Giotto as chief master builder, G 158-159; government in, M 35, 63-64, 71; Leonardo's apprenticeship in, L 11, 12-14, 27-28, 36, 44; Leonardo's return to, L 59, 121-123, 124-127, 146-147; and Medici family, M 17, 43, 132-133, 153, 154, 156, 157, 159, 177-178; Michelangelo's return to, M 85, 109, 111, 178; origins of Renaissance in, T 10; painting in, M 40; political, social and economic conditions, G 14, *15*, 61, 66, 83-84, 177-179, 180-181, L 15-16, 121, M 15, 16, 63, 64, 69, 71, 87; republican government, M 153-154, 161; rivalry between Siena and, G 60-61; Savonarola in, M 67-69, 88-90; spirit of "genius" in, M 169; view of, L *20-21;* weavers' plight in Giotto's time, G 136

Folk art, characteristics of, CO 8, 91-98, *99-111*

Foundling Hospital Exhibit of 1760 in London. *See* Exhibitions

Fragonard, Jean-Honoré:

influence on Renoir, MA 84; life and work, WA 167-170; "pastoral frolics," GO 53, 54; works by, WA *172-183*

France: Avignon as seat of papacy, G 105, 138, 154, 179; Bernini in, B 124-127; declaration of war against Philip IV and Ferdinand II, VE 106; Franco-Prussian War, C 44, *46-47*, 56, MA 90-91, RO 46, *125;* Gothic style originated in, G 37, 63; invasion of Spain, VE 114-115, 116, 118, 119, 136; July Revolution in, TU 140; Leonardo's sojourn and death in, L 151, 163-165, 172, *176-177;* Louis XIV's relations with Papal States, B 124-125; Napoleon III, MA 15-16; and Netherlands after 14th Century, BR 22-24; 19th Century English tourists in, TU 56-57; Olivares' strategy in war against, VE 107; peace with Spain, VE 172-173; political and social conditions in 19th Century, C 12, 33-35, *44-52*; politics in mid-19th Century, MA 39-40; Revolution and Napoleonic wars, TU 11, 33-35, 56, 78, 84; rivalry in Italy between Spain and, VE 22; in 17th Century, B 33; victories in Flanders against Spain, VE 106, 172; vogue of Spanish culture in, MA 22-23; wars between Francis I and Charles V, T 102-103, 130, 134, 155; in World War I, MAT 117, 119. *See also* Revolution, French

Frederick, Elector of Saxony: Cranach as court painter to, DU 143-144; Dürer's patron, DU *65-66*, 71, 85, 92, 119-120; Luther and, DU 128, 140

French art: "art for art's sake" movement, W 45, 46; *art nouveau*, RO 141; comparison of Van Goyen with Poussin and Claude, V 77; critics' judgment of mid-19th Century painting, MA 20-21; currents before Delacroix, D 13-14; early bourgeoisie reaction to French avant-garde art, MA 27; English art versus, W 62; importance of the Salon, MA 26; mood at end of 19th Century, W 173; Neoclassicism and Romanticism in, RO 17-18; 19th Century painting and sculpture in, RO 16-18, 52, *53-63;* Realism and Naturalism in, MA 138, 140-141; rebellions against

traditionalism, MA 19-20, 52; Rodin's pride in heritage, RO 20; trends at end of 19th Century, P 29. *See also* Académie des Beaux-Arts; Classicism; Expressionism; Impressionism

Furniture: chair legs in 18th Century, WA *15;* 18th Century English furniture, in America, CO *50-51, 55;* Louis XV style, WA 125; Louis XVI style, WA *137*, *164;* Victorian rocking chair sketched by Matisse in Tahiti, MAT *142*

Fuseli, Henry: fantasy in work of, D *61;* life of, TU 19; work by, TU *30-31*, 55

Futurists, development and credo of, MD 11-12, 15, 55-56, 58

Gabo, Naum, plastic sculpture by, RO *184*

Gaddi, Taddeo: Giotto's relationship with, G 138, 140; work by, G 140, 141, 142, *150*

Gainsborough, Thomas: apprenticeship in London, GA 9, 16-17; art critic's remarks on work, GA 180; artistic experiments, GA 121-122, 123, 165-166; artistic influences on, GA 16-17; Bath, life and career in, GA 47, 57, 63-64, 65, 66, 72, 76, 105; biographies of, GA 39, 46-47, 61, 64, 122-123; birth and early life in Sudbury, GA 8-9; characterization of sitter in portraits, GA 19; correspondence, GA 39, 63-64, 119, 120, 121-122, 145, 147; cross-hatching technique, GA 121-122; death of, GA 170; development of new style by, GA 80-81, 82-83; drawing techniques, GA 174; drinking habits and behavior, GA 17, 145-146; Duke of Bedford's patronage, GA 108; family situation, GA 40, 44, 64, 145; "Fancy pictures" by, GA 166, 167, 169; financial and artistic success, GA 38-39, 44-45, 80, 83, 142, 169; Gilbert Stuart and, CO 163-164; Ipswich years, GA 40-47; on landscape painting, TU 15; in London, GA 107, 117, 118, 141, 145, 147, 165; marriage and relations with wife, GA 37-38, 44, 64, 145; music, love for, GA 44, *45*, 65, 80, 106, 141; personal belongings, GA *40;* personality, GA 17, 39, 44,

119, 170-171, 176; physical appearance, GA 44; poetry in art of, GA 65, 106, 176, 178; portrait painting, attitude toward, GA 42, 63, 106, 124, 142, TU 13-14; prices charged for portraits, GA 62, 83; Radnor, Lord, relationship with, GA 106-107; Reynolds' analysis of GA 170-171; Reynolds' personal relations with, GA 143, 170; Royal Academy and, GA 83, 105, 118, 141, 167-169; Royal family portraits, GA 167-169; Schomberg House, GA 117, *118*, 141, 169; seascapes, GA 165; self-portraits, GA *6, 49, 164;* Suffolk countryside represented by, GA 48, *53-54*, 172; theater, GA 65, 80, 141, 144; Thicknesse, patronage and friendship of, GA 45-47; Van Dyck's influence, GA 81, 82; West and, CO 116; Zoffany's portrait of, GA *171*

Galileo Galilei: influence of ideas of, B 141; struggle with Catholic Church, B 34-38

Games and entertainments: bullfighting in Goya's Spain, GO 156, *157-163*, 165-166; bullfighting, Picasso and, P 10, 78, *176*, *178-179;* café-concert life, Degas' and Manet's depiction of, MA 140-141, *146*, 157; café life in late 19th Century Paris, C 38-39, 62, 93, 94; circus scenes, P 36, *47-49; commedia dell'arte*, WA 36-37, *50-51*, 99, 103, 104, *105*, *112*, *113;* dwarfs and jesters as court entertainers, VE 56, 109-110, *119-121*, *124-133*, 178; English country fairs, GA 152-153; festivals in Florence in 15th Century, M 21, 22, 44, 46, 88-89; festivals in Rome in 15th Century, M 133; *fêtes galantes* (elegant festivals), and French society, WA 58, 60; Flemish peasant dance, by Watteau, WA 43; Folies-Bergère, variety show, MA 143, 172-174, *176*, *177-183;* German country dance, DU *124;* hunting scenes by Rubens, R *46-49; Kermesse*, Flemish festival, popularity of, BR 118, *136-139*, R 165, *180-181;* opera, theater and masquerades in Watteau's Paris, WA 57-59; pageants staged by Leonardo, L 56, 63, 164; puppet theater, WA 36, 37; Rubens' *Kermesse* painting, R *180-181;* in 16th Century Venice, T 46-49;

G Giotto; GA Gainsborough; GO Goya; L Leonardo; M Michelangelo; MA Manet; MAT Matisse; V Vermeer; VE Velázquez; VG Van Gogh; W Whistler; WA Watteau; WH Winslow Homer

stag hunts in Spain, VE *122-123;* theater in Spain, VE 60, 85, 140. *See also* Fashion and costumes; Music; Theater and ballet

Garrick, David, English actor and intimate of Gainsborough, GA 65, 142, 165

Gauguin, Eugène Henri Paul: admiration for Cézanne, C, 96-97, 169, 176; aid from the Symbolists, VG 120, 124; art theories, VG 119-120; artistic aims, MAT 53, 79; attempt at suicide, VG 126, 134; background and youth, VG 77, 80, 119; book by, VG 75; a "borrower" in his work, VG 118; burial on Hiva Oa, Marquesas, VG 127; Cézanne's judgment of, C 75; contemporary description of, VG 119; death, VG 117, 127; description of Van Gogh by, VG 75-76; display at Paris world's fair, VG 118-119; epithet on Manet's art, MA 7; final clearing of his estate, VG 127; final visit to his family, VG 120-121; friendship with Van Gogh, VG 76, 83; influence of Japanese prints on, VG 80, 85, 118; influence on Picasso, P *24;* Matisse, influence on, MAT 32, 50; and origins of 20th Century art, MAT 9, 16, 60; photos of, VG 77, *124;* portrait of Van Gogh, VG *97,* 98; prolific writer, VG 76; range of his work, VG 118; reaction to "yellow house" at Arles, VG 96, 117; sculpture and reliefs by, VG *118, 119, 123;* self-portrait, VG *82-83, 118;* strained relations with Van Gogh, VG 97-99, 110-111, 117, 137, 138, 147; symbolism of fox, VG *123;* Tahiti, VG 122-128, 134; taught by Pissarro, VG 77, 80, 120; use of nonprimary colors, VG 122; works by, C *177,* MD *46,* VG *43, 68, 81-87, 116, 118, 119, 120, 123, 126, 129-135*

Genre: *bodegón* as Spanish genre, VE 39-49; Bruegel's role in development of, BR 15-16, 116, 123, 124; Chardin and, WA 148-149; combination of landscape and, V *94;* Dutch society depicted in, V 84, 90, 92; in early American art, CO *19;* flowers and fruit in, V 101-102; in France in 18th Century, WA 35-36; in hierarchical order of painting in 18th Century

France, WA 147; humorous note in, CO *19,* V 87, 89; in 19th Century American art, WH 47-51; origins of, in Flanders and Holland, V 12, 79; Ostade and, V *90, 91;* peasants as favorite subject in, MA 38; popularity in Dutch art, RE 25, 112, 146-147, V 80, 90; scenes of Venetian life, T *178, 179;* Steen and, V *86-87,* 98; transition from religious painting to, V 78; Vermeer and, V 14, 99; Watteau and, WA 35, 37-38, 43, 79

George III, King of England: admiration for Gainsborough, GA 169; and American Revolution, CO 140; comment to West on contemporary dress in historical painting, CO 126; Copley and, CO 132, 141, *142,* 143; madness, TU 18-19; patronage of arts, GA 75; reign, TU 13, 60, 63, 111; Reynolds and, GA 142; Royal Academy and, GA 83, 99; West and, CO 117-118, 120, 128, 142-143

George IV, King of England: artistic interests and patronage, TU 19, 79, 113; birthday dinner at Royal Academy, TU 110-111; and Caroline, his wife, TU 40, 42, 61, 62, 77, 79, 111-113; coronation, TU 112; death, TU 139; decoration of St. James's Palace, TU 116; dissolute life as Prince of Wales, TU 18-19, 41-42, 77-78; Gillray's cartoon on engagement to Caroline of Brunswick, TU *40;* Lawrence's portrait of, TU *76;* as Prince of Wales, GA *122,* 134-135, 144, *150-151,* 168-169; Regency Ball, TU 77-78; remodeling of Royal Residence at Brighton, TU *112;* in Rowlandson drawing with Maria Fitzherbert, TU *19;* swearing in as Prince Regent, TU 63; violent criticism of, as Prince of Wales, TU 78-79; Wilkie's portrait of, TU 113

Géricault, Théodore: Constable and, TU 114, 115; influence on Delacroix, D 32-34, 51; works by, D *29, 48-49, 60*

German art: abstract art in, MAT 56; artistic life in 19th Century, MAT 53-54; Blaue Reiter, Expressionist School, MAT 66; Dadaist movement, MD 59, 63-64; Die Brücke

movement, MAT 54-55; Dürer's role in, DU 9, 15, 161-162, 163; Expressionism in, MAT 60, 66; Flemish influence on, DU 49, 53; Germanic quality in Dürer's woodcuts, DU 67; International style in, DU 40; Italian Renaissance and, DU 53; Matisse and, MAT 60, 76, 93, 148; primacy passing from Dürer to Cranach, DU 143; provincial character, DU 40; realism in, DU 44; 16th Century masters after Dürer, DU 164

Germany, rise of Protestantism and conflict between Charles V and Protestant princes, T 102, 130, 140, 155. *See also* Holy Roman Empire

Ghiberti, Lorenzo: admiration for Giotto, G 8; *Gates of Paradise* for Florence Baptistry, G 160, RO *89;* on Giotto's frescoes, G 102, 132; on Giotto's meeting with Cimabue, G 82; influence on Michelangelo, M 38; works by, M 35-36, 38, *58,* RO *89*

Ghirlandaio, Domenico: influence on Michelangelo, M 29, 56; Michelangelo's apprenticeship with, M 13, 14, 35, 40-41, 46; works by, L *43,* 80, M *56*

Giacometti, Alberto, sculptures by, MD *153,* RO *181*

Gillot, Claude: Lancret and, WA 75, 79, 80; losses in stock market, WA 101; theater interests, WA *36,* 37, 44, *45,* 69; Watteau and, WA 36, 37, 44-45, 69

Gillray, James: beheading of Louis XVI, engraving of, TU *35;* Thomas Paine, cartoon satirizing, TU *34;* Peace of Amiens, cartoon symbolizing, TU *56;* other works by, GA *62,* 146

Giorgione (Giorgio de Castelfranco): character of art, T 64, 66-67; comparison between Titian's art and, T 57, 70-71, *72-75,* 127; influence on Titian, T 35, 56-75, Leonardo's influence on, L 120; life and work, T 53-54; Titian and, T 54-56, 64; works by, MA *34,* T *65-69, 72-75*

Giotto: Abano, Pietro d', scholar and colleague of Giotto, G 133; authenticity of work, G 32, 88-89, 95, 139; analysis of work, G 7-10, 137, 183; appointment as chief master builder in Florence, G 158-159; apprenticeship in

Florence, G 82-83, 85; Arnolfo di Cambio and, G 86, 137; bell tower by, G 159-160, *158,* 159, L *21,* M *20,* 38-39; Benedetto da Maiano's *Portrait of Giotto,* G *6, 7;* birth, G 82; Boniface VIII's relations with, G 103; character traits, G 106, 135-136; Cimabue and, G 65, 82, 85, 137; controversy on birth date and birthplace, G 81-82; death, G 160; life and work, L 13, 54, M *20,* 28, 37; Masaccio's art in relation to Giotto's, G 183; Naples, sojourn in, G 157-158; Padua, sojourn and work in, G 108-111, 131-133; payment for work, G 102; Petrarch on, G 163; physical appearance, G *6, 7, 9;* on poverty, G 101; prestige and wealth achieved by, G 32, 135-136, 140; Rome, sojourns and work in, G 85-86, 102; signature on paintings, G *106,* 107, 156; wife, G 106; work in towns of north Italy, G 134

Girtin, Thomas, Turner's friendship with, TU 38; work by, TU *26,* 38

Giulio Romano, work by, T *87*

Glackens, William, and Ash Can School, AP 25-27

Glarner, Fritz, and abstract painting, AP *127*

Golden Age, in Dutch art, V 95-103; early painters, V 32-33; prominent artists in, V 13, 95; landscape painting, V 76; pioneer painters preceding, V 73; precarious situation of artists during, V 12; Vermeer's position among artists of, V 9

Goltzius, Hendrick, work by, V *106*

Gorky, Arshile: Abstract Expressionism and, MD *172,* AP *116, 133-135;* surrealism and, MD 174

Gothic art: Amiens cathedral, example of, RO *26-29;* in Arnolfo di Cambio's sculpture, G *52-53,* 86; characteristics, in northern Europe, BR 19, DU 9, 49; Duccio and, G 54, 64; Dürer's fusion of Renaissance art with, DU 10; Flemish Gothic influence on German art, DU 49; French origin of, G 37; in Giovanni Pisano's pulpit, G *48-51;* Grünewald as last of great Gothic artists, DU 15; and Italian art, G 35, 40, 63; Italian Renaissance development after, DU 144;

AP American Painting; B Bernini; BR Bruegel; C Cézanne; CO Copley; D Delacroix; DU Dürer; MD Marcel Duchamp; P Picasso; R Rubens; RE Rembrandt; RO Rodin; T Titian; TU Turner;

176

and Simone Martini, G 162
Gottlieb, Adolph, and Abstract Expressionism, AP 154
Goya y Lucientes, Francisco José de: advertisement for *Los Caprichos* by, GO 123, *125;* affair with Duchess of Alba, GO 12, 66, 102, 103-104, 121; ambiguous position during Napoleonic war, GO 150-151, 153; art studies begun by, GO 15; as bullfighter, GO 35-36, 156; birth of, GO 9, *10, 11,* 13; "Black Paintings," GO 22, 46, 51, 84, 116, 168-170, 172, *173-185; Caprichos* as spiritual purge, GO 124-125; change of style after illness, GO 98, 99; characterizations in his etchings, GO 122; childhood, GO 14; conflict with Francisco Bayeu, GO 56-57; continuing prosperity, 1789-90, GO 86-87; departure from Spain, GO 170; difficulties of postwar adjustment by, GO 165; early days in Madrid, GO 29, 31-32, 34; education, GO 14, 15; estrangement and reconciliation with son Xavier, GO 127, 165; etching undertaken by, GO 54; final home in Bordeaux, GO 170-171, 185; friendship with the Infante, GO 12, 59, 60, 63; friendship with Zapater, GO 14-15; goes to Madrid, GO 15, 29; his relationship with Napoleonic regime, GO 151; his techniques described, GO 82; influence on Manet, MA 61, 71-73; influences on, in Rome, GO 36; in Italian competition, GO 37; last days of GO 171, 185; late techniques, GO 166; lithography by, GO 166-167, 168; madness enters his pictures, GO *20-21,* 98-99, 107, *108-109,* 116; marriage of, GO 39, *48;* new country estate, GO *166,* 167, 172; new technical skills of, GO 54, 60; old-age portrait by Lopez, GO *171;* origin of the *Tauromaquia,* GO 165-166; painting of the royal family by, GO 60, 72-73, *74-75,* 125-126; paintings for the Alameda, GO 79; paintings in Prado Museum, GO 8; paintings of the queen by, GO 125; possible significances of *The Colossus,* GO 152; realism in *The Disasters of War,* GO 152; in royal competition, GO 34-35, 49; sense of humor, GO 126; simplified backgrounds used by, GO 80; tomb and memorial of, GO *91;* trip to Italy, GO 35; turning from Baroque, GO 38-39; unorthodox treatment in church fresco, GO 88, *89-95,* 107; use of caricature, GO 121; use of monsters in etchings, GO 122; Velázquez' influence on, GO 54, VE *150-151;* "war memorial" paintings, GO *130-135,* 155; witchcraft as subject, GO *22-23,* 107

Gozzoli, Benozzo, work by, M 17, *26-27*

Greenwood, John: work in America, CO 18, 20, 25, 40; works by, CO *19, 25, 27*

Gris, Juan: adherence to Cubism, P 60, 63, 86; works by, MD *21,* P *95, 98-99*

Gros, Baron Antoine-Jean: life and work, D 26, 34-35; work by, D *26-27*

Grünewald (Mathis Gothart Nithart): life and work, DU 15, 166; works by, BR *52,* DU *16-31*

Guido da Siena: life and work, G 58, 59, 60, 66; work by, G *74, 75*

Guilder, value, in 17th Century, V 59

Guilds: in Antwerp, BR 77, R 14, 75-76, 78; artists' membership in Italy, G 31-32, 141; in 15th Century Florence, L 12-13; in 15th Century Germany, DU 36; in 14th Century Florence, M 35, 36, 39, 63; in Middle Ages, G 85; in Renaissance Florence, L 12-13; in 17th Century Holland, V 11, *59,* 62, 63

Guston, Philip, and American Abstract Expressionism, AP *153*

Habsburg dynasty: Carlos II, last of Spanish line, VE 185; descendants of Charles V, VE *9;* Frederick III, DU 33-34, intermarriage of, VE 60; Maximilian I, DU 124; power in 16th Century Europe, R 81-83; relations between Spanish and Austrian branches of, VE 137; Richelieu and, R 124; Spanish branch, GO 9-10; Thirty Years' War and, R 148-149

Hals, Frans: brushwork of, V *74;* financial problems, RE 24; life, RE 18, V 32, 73-75; master of group portraiture, RE 72, *78-81;* as pioneer of new style, V 95; Rubens' admiration for, R 123; works by, V 12, 72

Hartley, Marsden, and American Modernists, AP *46*

Haydon, Benjamin Robert: classical interests, TU 22, 23; Turner on suicide of, TU 150; works by, TU 44, *45-51,* 138

Hayman, Francis: influence on Gainsborough, GA 16-17; plans for Royal Academy, GA 97

Held, Al, and Op Art, AP *183*

Henri, Robert, and Ash Can School, AP *21, 24*

Hobbema, Meindert: financial problems, RE 24; influence on English landscape, TU 14; landscapes by, V 95, 104; life and work, V 97-98; Ruisdael's influence on, V 117; work by, V *116-117*

Hodges, William, work by, GA *18-35,* TU 28

Hofmann, Hans, and American abstractionists, AP *125;* reality and, V *18, 26*

Hogarth, William: *Analysis of Beauty* by, GA 14; art exhibit catalogue, GA 98; conversation pieces by, GA 11; Foundling Hospital exhibition and, CO 59, GA 34, 36, TU 13; moralizing in art, GA 10, 11-14; portrait style, GA 13; satire on, GA *13;* works by, GA *118-135*

Holbein, Hans, the Elder, life of, DU 144

Holbein, Hans, the Younger: comparison between Dürer and, DU *145;* as court painter to Henry VIII, DU 146; Dürer's influence on, DU 69; as Dürer's rival in portrait painting, DU 144; life of, DU 146; works by, DU *145, 147, 150-151, 153, 154-155*

Holland. *See* Netherlands

Holy Roman Empire, The: abdication of Charles V in favor of brother Ferdinand, T 130, 146, 158, 159; church and state division in, DU *80-81;* electors of, DU 33; Florence and, G 83; Germany's position within, DU 33; map of, DU *35;* in 16th Century, BR 21, 24-27; struggles between papacy and, G 56, 57, 58

Homer, Winslow: Adirondack works, WH *124-125,* 160-161; affinity for liquor, WH 100; apprenticed to lithographer, WH 30-31; approach to art, WH 15, 55, 70, 73-75, 115; as art juror, WH 158-159; in Atlantic City, WH 116, 158-159; in Bahamas, WH 118; caricatures by, WH *30, 69, 121, 163-164, 169, 170-171;* Civil War and, WH 66-70, *78-81, 121;* color, WH 71, 75-76, 88, 110, 122, 125, 127, 130; death of, WH 165; decline in popularity, WH 77, 99, 118, 121; early years, WH 7-8, 29-31, 33, 38-39; family, WH 7-8, 38-40, 99-100, 109, *121, 157, 163, 166-169;* friends, WH 36, 70, 71, 163, 170; genre works, WH 29, 34-35, 37, 47, 56, 69, 72-73, 78-79, 99, 101; as Impressionist, WH *73,* 74-75, 77, 120; letters to family, WH 109, 159, *160, 164,* 168, 182; Native School and, WH 10, 15, 31, 93, 162; naturalism of, WH 30, 70, 116, 120, 164-165; in New York, WH 35-36, 78, 116, 117; in Paris, WH 70, 71-72; Prouts Neck retreat, WH 35-36, 100, 109, 116-117, 156, *168-175;* reactions to critics, WH 77, 81, 93, 99, 115, 121, 160, 172; recognition of, WH 160, 165; style and technique, WH 33-37, 99-101, 116-119; treatment of visitors, WH 157-159; in Tynmouth, England, WH 99-105

Honthorst, Garrit van, life and work, RE 39, V 74-75; works by, RE *32-33,* V *66*

Hoogh, Pieter de. *See* De Hoogh, Pieter

Hopper, Edward, and American Regionalists, AP *84-87*

Hoppner, John, portrait by, TU *19*

Houdon, Jean-Antoine, sculpture of Voltaire by, C *144,* RO 35, WA *61*

Housebook Master: engravings by, DU 54, *56-57;* life and work, DU 48-49

Hugo, Victor: caricatures of, D 83, *85;* Delacroix and, D 82-85; at Paris Salons, RO 71; on political situation in France, MA 21, 90, 91; portrait of, RO *118;* on Revolution of 1848, D 166; Rodin and, RO 113

Human figure: Adam and Eve paintings, DU *83,* 119; Cézanne's treatment of, and Matisse, MAT 32; *contrapposto,* G 60, RO 51; in Cranach, DU *170, 171, 172-173;* Delacroix's depiction of, D 60-61; difference of rendering between Northern and Southern European art, BR *16, 17;* disparaging remarks

G Giotto; GA Gainsborough; GO Goya; L Leonardo; M Michelangelo; MA Manet; MAT Matisse; V Vermeer; VE Velázquez; VG Van Gogh; W Whistler; WA Watteau; WH Winslow Homer

177

on Matisse's nudes, MAT 97; Donatello and, M *60;* Dürer's quest for mathematical principles for drawing, DU 63, *91, 161;* Dürer's view of, in painting, DU *83;* in Dürer's work, DU *90,* 91-92, *108-109,* 142; Manet's treatment of, MA 58, *70-71;* nudes in Spanish art, VE 150; Rembrandt's rendering of nude figure, RE *118-119,* 162, *172-173;* Rodin's fascination with, RO 107; Rubens' depiction of, R 28, *136, 137, 153-161;* Signorelli and, M *56;* Vitruvius' dimensions for, DU 91; Watteau's paintings of nudes destroyed, WA 97

Human flesh: Titian, Rubens and Renoir, as masters of depicting, R 78-79

Humanism: art patronage and, T 86; concept of, T 9-10; influence on Titian's works, T 80-81; influence on Venetian painting, T 16

Hunt, William Holman: and Pre-Raphaelites, W 62-65, 68, 70-72; works by, W *62, 70, 73*

Iconoclasm, influence on medieval art, G 36

Illuminated manuscripts. *See* Manuscripts, illuminated

Impressionism: approach to landscape, MA 105; Argenteuil, as home of, MA 103, 104, 106, 114-115; avoidance of chiaroscuro, C 81; birth, and origin of name, MA 91, 108, 112, 118; Boudin's influence on, MA 54; "broken-color" technique, C 58, 60, 61, 83; Bruegel contrasted with, BR 148; Caillebotte, a collector of Impressionist works, MA 105, 124; cartoons on outdoor painting by Impressionists, MA *106;* Cézanne and, C 41, 61, 64, 71, 134, 135, 153, 161; color and, MA 105-106, MAT 38; comparison between Cézanne and Vermeer, V 126; comparison between Munch's world and, MAT *52-53;* Cubism and, MD 8; Degas' attitude toward, MA 137; dissolution of group, MA 108-110; Duchamp and, MD 9, 11; failure of first exhibition, MA 114; group exhibitions, C 63, 64, 66, 67, 70, 99; influence on Van Gogh, VG 40, *42-43,* 51, 69, 72, 74, 77-79, 80, 85; Japanese art, interest in, MA 62; landscapes and out-of-

doors painting, C 58; Manet's attitude toward, MA 110-111, 142; Matisse's work as manifesto for, MAT 19, *24-25;* Monet's fascination with water, MA 106, 118, 120-121; neo-Impressionism versus, VG 74; 19th Century American artists and, WH 72, 74-75, 78; optical exploration, a guide in, MA 109; photography's contribution to, MA 100; Picasso and, P *22-23,* 29, 31-33; Pissarro and, MA 128; plein-air painting as new technique, C 58; recognition of Impressionists, C 162; rejection of Impressionist works by Salon juries, MA 107; Renoir's esthetics and, MA 122; revolt against academic art, C 64; rise of, C 35, 80, MA 103-111, 113-131; Rodin's dour attitude versus Impressionists' happy outlook, RO 91; Seine River and, MA 103, 104-105, 106; Vermeer's impact on, V 173; Zola's articles on, C 122

Indiana, Robert, Pop art and, AP *172-173*

Ingres, Jean-Auguste Dominique: Degas' parody of, MA *99;* influence on Matisse, MAT 18, 126; interest in photography, MA 89, 92; as neoclassicist, C 35; rivalry between Delacroix and, D 127-129, 171, MA 19; Salon snubbed by, MA 26; work of, D 24, 70, 128, 171; works by, C *38,* D *28,* 71, *136,* MA *99*

Inness, George: work by, WH *26-27;* and the Younger Men, WH 96-98

Inquisition: Galileo's trial by, B 38; proceedings against Pietro d'Abano, G 133; trials of Knights Templars, G 138

International Style, in late 14th and early 15th Centuries, DU 40, 42

Inventions: by Galileo, B *37;* by Leonardo, L 15, *57, 106, 107*-108, 168; by Morse, CO *167;* by Peale, CO *166. See also* Science & Technology

"Isaac Master," work by, G 89, *91*

Isabella, Archduchess, Governess of the Spanish Netherlands, R 54, 99, 126; portrait of, R *20;* position in struggle in Netherlands, R 82-83, 147; Rubens' relations with and diplomatic activities for, R 20, 53-54, 81, 94, 100, 106, 121, 146-148

Italian art: character of

Renaissance art, BR 13; chiaroscuro in, RE 41; comparison between northern European art and, BR 16-19; contribution to Northern art, BR 24, 96; development of painting in, DU 40; Dürer, influenced by, DU 53, 66, 77, 79, 144; English preference for, TU 12; Futurist movement, MD 11-12; German art, influence on, DU 9; Giotto's style in, G 110; Holbein and, DU 144; impact on Dutch painters, V 61-62, 67, 74, 75; influence on Bruegel, BR 88, 116; influence on Flemish art, BR 17, 76, 116, 163; influence on Rubens, R 29-39, 63, 152, 173; religious subjects in medieval painting, BR 18; Rubens and, DU 65; truth and beauty in Sienese and Florentine painting, G 62. *See also* Venetian art

Janco, Marcel, work by, MD 71

Jennys, William, early American work by, CO *97*

Johns, Jasper: Duchamp and, MD 167, 172; life and work of, MD 168-169; Pop art and, AP *170, 171;* works by, MD *182, 183*

Johnson, Eastman, and American genre, WH 50-51, *60-61*

Johnson, Samuel, life of, GA 79-80, 81, 146, 150-151

Jones, Inigo, works by, R 128, *129,* 150

Jongkind, Johan-Barthold, influence on Monet, MA 84; in Paris art world, MA 54; work by, MA *55*

Jordaens, Jacob: in Antwerp art world, R *57,* 84, 92, 172, 173; Rubens and, R *92-93,* 149

Kalf, Willem, life of, V 13, 101-102; still-life work by, V *82*

Kandinsky, Wassily: life and interests, MAT *55-57,* MD 8, 29; works by, MAT *56, 67,* MD *50-51*

Kane, John, and American regional painting, AP *82, 83*

Kauffmann, Angelica, works by, TU *21*

Kensett, John F., and Hudson River School, WH 22, 52-53

Klee, Paul: and Dadaists, MD 57, 105; influence on Miró, MD 132-133; reality and, V 23

Kline, Franz: Abstract

Expressionism and, MD 172; and American abstractionists, AP *148, 149;* Surrealism and, MD 152, *175*

Koninck, Philips, V 13, 95-96; panoramic views of, V 104, *110-111*

Lancret, Nicolas, comparison between Watteau and, WA 75, 79, *80*

Landscape: achievements in English art, TU 12, 14-16; aerial perspective in, V 126; Altdorfer's passion for, DU *174-175;* in Ambrogio Lorenzetti's work, G 163; American Hudson River School, WH 13-15, *17-27,* 52-55; Avercamp's combining of genre and, V *94;* Barbizon School and, MA 20; Bruegel's art and, BR 15, 16, 75-77, 165-169, *174-183;* Cézanne's approach to, C 8, 57, 77; Cézanne's integration of figures and, C 102, *112-115,* 146-147; Claude's influence on Turner's work, TU 71; comparison between French and Dutch art, V 77; Constable's art of, TU 115, 118, 120, 122, 148; Corot's importance in, MA 20, 44, *45;* "cosmic" or "universal" landscape, BR 163; in Cubist geometric forms, P *87;* Dürer's new understanding of, DU 64, 65; in Dürer's work, DU 49, 72, *112-113;* early American art, CO 92, *94-95,* 106, 110, 162; in English art, TU 15, 37, 55, 81; enormous numbers of, in Dutch art, V 97; Esajas van de Velde's role in, V 112; evolution of, in Flemish art, BR 170-171; Flemish art innovations in, DU 48; French Salon's contempt for, MA 104; in hierarchical order of painting, RE 25; Impressionism's approach to, MA 105; Impressionists and, C 58, 64, 153; influence of etchers and engravers on development, V 107; Jan Brueghel's floral still lifes in, V *90-91;* in Leonardo's work, L *48, 132, 133, 180-183;* nature in Manet's late works, MA 172; origins and development in Dutch art, V 12, 13, 76, 95, 104; panoramic views, V 95-96, 111, *114-115,* 116; popularity of, with Dutch artists, RE 96, 112; Poussin and, B *54-55;* realism and, MA 104; in Rembrandt's etching, V *104-105;*

AP American Painting; B Bernini; BR Bruegel; C Cézanne; CO Copley; D Delacroix; DU Dürer; MD Marcel Duchamp; P Picasso; R Rubens; RE Rembrandt; RO Rodin; T Titian; TU Turner;

Rembrandt's interest in, RE 97-103; in Renaissance works, L 42, 44, 48, 132-133; Hubert Robert's "scenic" landscapes, WA 166; Romantic schools and, TU 26; Rubens' depictions of Flemish countryside, R 138, 139, 182-183; Ruisdael's role in, V 96-97, 118; topobraphical drawing, vogue in England, GA 119, TU 35-36; in Watteau, WA 40, 48, 53. See also Seascapes

Landseer, Edwin, Queen Victoria and, TU 149, 168

Lanfranco, Giovanni, Urban VIII's patronage of, B 32, 42; work by, B 50-51

Lastman, Pieter, influence on Rembrandt, RE 25, 26, 29, 30, 38

Lawrence, Jacob, and Social Realism, AP 92

Lawrence, Sir Thomas: alleged affair with Princess Caroline, TU 61-63, 79; defense of Turner, TU 58; portraits by, TU, 19, 62, 109; as Regent's favorite, TU 79; works by, TU 62, 76

Le Brun, Charles: comparison between Watteau and, WA 98; final years, WA 13; tapestry designed by, VE 173; Versailles work, WA 11, 12, 16, 20-21

Leonardo da Vinci: admiration for Giotto, L 68, 82; aerodynamics, L 101-102, 116-117; apprenticeship in Verrocchio's workshop in Florence, L 11, 12-14, 27-28, 36, 44; armaments, L 53-54, 72-73; authenticity of works, L 27, 31, 46, 52, 53, 78, 142, 147; beliefs and attitudes, L 103-104, 151, 166-167; birth and boyhood in Vinci, L 9-10; botany, L 104, 150; Bramante and, L 79; burial and attempt at recovery of bones of, L 171; Carracci and, B 66, 71; critical trends after his death, L 165-166; death at Amboise, L 164, 165; education, L 10; in employ of Borgia family, L 122-124; engineering, L 102-103, 108-109, 123, 145, 164, 165; financial problems, L 59, 146-147, 168; Florence, his stays in, L 11, 12-14, 16, 18, 59, 121-123, 124-127; France, transfer to and sojourn in, L 151, 163-165, 172, 176-177; Francis I, friendship with, L 174, 177; Freud's psychoanalytic essay on, L 165-166, 169; grotesque heads by, DU 95; half-brothers, relations with, L 146-147, 148; homosexuality, L 116, 166; impact on art, L 171; influence on Dürer, DU 97; lack of success as scientist, L 110, 169; Leo X and, L 150; Louis XII and, L 145; Machiavelli, friendship with, L 123, 124; Melzi, friendship with and bequest of papers to, L 148, 149, 164, 168-169; Michelangelo, relationship with, L 29, 76, 125-126, M 37, 86, 94-95; Milan, in service of the French, L 127, 145-146, 147-149; Milan, in service of Lodovico Sforza, L 17, 53-59, 75-83; mother, L 9, 165; optics, L 104, 105, 107; personality and character traits, L 11, 12, 16, 17, 109, 167, 168; physical appearance, L 12, 150-151, 173; pupils, L 58-59, 145, 146, 147-148; religion, attitude toward, L 166-167; Rome, stay in, L 150; Rustici, friendship with, L 147; scientific and technological studies, L 53-55, 101-109, 110-117, 150; Sforza, employment at court of, L 17, 53-56, 60-73, 75-83; Vasari's biography of, L 11-12, 150, 165; Verrocchio and, L 13, 36; will of, L 148, 164; work, absorption in, L 81-82

Levine, Jack, and Social Realism, AP 108, 109

Lichtenstein, Roy: and Pop art, MD 169, AP 160; work by, MD 180

Light, in Caravaggio's works, V 62; in De Witte's architectural paintings, V 102; Descartes' fascination with, V 11; Rembrandt's treatment of, RE 110, 118-119; role in Dutch painting, V 26, 54, 69; Steen's treatment of, V 98; treatment of, by Caravaggisti, RE 33; Vermeer's mastery of, V 26, 126, 127, 128, 130, 132, 145; Vermeer's pointillés technique and, V 141

Limbourg Brothers, manuscript illuminations by, G 140

Limners, in American folk art, CO 13-14, 100, 101

Lipchitz, Jacques: admiration for Rodin, RO 173; Cubism and, RO 174, 181; influence on American artists, MD 154; work by, RO 181

London, England: Crystal Palace and Great Exhibition of 1851, TU 172, 173; new Houses of Parliament, TU 168-169, 154-155, 148; Thames River, W 32, 34-35, 108, 155-157; Waterloo Bridge, TU 130-131, 143-144; Whistler's early life in, W 26, 37-39

Longhi, Pietro, works by, T 178, 179

Lope de Vega, Spanish playwright, Philip IV's patronage of, VE 85

Lorenzetti, Ambrogio: life of, G 162-163, 180; works by, G 152, 162-163, 164, 172-175

Lorenzetti, Pietro: life of, G 162, 164, 180; work by, G 90, 162, 170-171

Louis XIII, King of France: Anthony van Dyck and, R 173; commission to Rubens, R 101, 102; Marie de' Medici's relations with, R 101, 126, 146; Richelieu's influence at court of, R 113, 146; Rubens' portrait of, R 20; in Rubens' series depicting life of Marie de' Medici, R 103, 111, 117

Louis XIV, King of France: attitude toward role of art, WA 9, 16; Bernini and, B 125-127, 134; death of, WA 7, 14; decline of, WA 12-13; depicted in Gobelins tapestry, WA 12; decoration of house for Duchesse de Bourgogne and, WA 31-32; emblem of, WA 8; French court during reign of, WA 7-8; history of life, in Le Brun's Hall of Mirrors, WA 20-21; Italian theater and, WA 36, 50; Le Brun's portrait of, WA 11; Maintenon, Mme. de, and, WA 11-12, 27, 36-37; Mansart's chapel at Versailles and, WA 27; portrait of, WA 32, 110-111; position of artists during reign of, WA 141; quoted, WA 12; Rigaud's portrait of, WA 17, 142; taste for food and meals of, WA 13; tennis game with Duc de Richelieu, WA 31; Versailles and, WA 16-27

Louis XV, King of France, WA 14, 83; Boucher and, WA 120, 124, 131; and his subjects, WA 163; Latour and, WA 145; makeup and hairdos, WA 122; Marquise de Pompadour and, WA 116, 117-118, 126; at masked ball at Versailles, WA 116; mistresses of, WA 116, 121, 131; morality under, WA 120; Nattier as official portraitist of Royal Family, WA 127, 129, 143; Regency and, WA 14, 15, 126

Loutherbourg, Philip James de, work by, AP 27

Low Countries. See Belgium; Flanders; Netherlands, The (Dutch Republic); Spanish Netherlands

Luks, George, and American Ash Can School, AP 32-34

Luther, Martin: comments on Dürer's death, DU 161; consequences in Nuremberg of breach between Catholic Church and, DU 157, 158; Cranach and, DU 143-144; Cranach's portrait of, DU 129, T 140; Diet and Edict of Worms, DU 140; Dürer's attitude toward, DU 140, 158; Dürer's Four Apostles viewed as Lutheran Manifesto, DU 14-15; life of, B 34, 35, DU 127-128, T 102, 130, 155

Macdonald-Wright, Stanton, and American Modernists, AP 45

Macke, August, work by, C 179

Madonna and Child theme: changes in treatment of, in relation to theological attitudes, G 10-11; comparison between Duccio's and Cimabue's treatment of, G 61-62; comparison between Giotto's and Duccio's treatment of, G 136-137; Dali's treatment of, G 11; in Flemish art, BR 23, 30; Giovanni Bellini's distinctive type of treatment, T 23, 31; medieval versus Renaissance artists' approach to, T 10; Michelangelo's treatment of, M 32-33

Maes, Nicolaes: life and work, V 13, 14; similarities between Vermeer and, V 99, 100; work by, V 89

Magdalen Master, work by, G 23

Magritte, René: life and work, MD 104-105, 124-125, 150; works by, MD 120, 121

Maillol, Aristide, lead sculpture by, RO 178-179

Mallarmé, Stéphane: Manet and, MA 7, 63, 135, 171; poems illustrated by Matisse, MAT 147-148, 150, 154-155; poetry likened to Whistler's painting, W 173; Whistler's friendship with, W 173

Manet, Édouard: analysis of art, MA 21, 24-25, 28, 60, 71, 89-90, 134-135, 140-143, 172, 176, 179; Argenteuil, sojourn at, MA 115; avant-garde artists' admiration for, MA 81;

G Giotto; GA Gainsborough; GO Goya; L Leonardo; M Michelangelo; MA Manet; MAT Matisse;
V Vermeer; VE Velázquez; VG Van Gogh; W Whistler; WA Watteau; WH Winslow Homer

Batignolles group and, C 38-39; Berthe Morisot, relationship with, MA 65-66, 87; birth and family background, MA 13; cartoon on, MA 64; a center figure of Café Guerbois group, MA 82, 88; Cézanne's admiration for, C 38, 66, 94; character traits, manners and tastes, MA 13, 65, 66-67, 134, 135; compared with Degas, MA 140; contemporaries' remarks on art of, MA 7; Couture, relationship with, MA 17-18, 18-19, 21, 22; criticism of, MA 23, 28, 57-58, 62, 64, 68, 81, 134-135; death, MA 175; and Degas, MA 8, 86; Delacroix's influence on, D 35, 127, 189; and Durand-Ruel, MA 107; education and artistic training, MA 14, 16-19; evolution from Realism to Naturalism, MA 140-142; in Fantin-Latour's Studio at Batignolles, MA 80; figure painting, interest in, MA 20, 21; Gennevilliers, Manet's family estate, MA 13, 103; Goya's work and, GO 155; identity of works, MA 141-142, 174; Impressionism and, MA 110-111, 112, 113, 142; influence on Van Gogh, VG 40, 42; and Isabelle Lemonnier, MA 169-171; and Japanese art, MA 61-62; late art of, MA 140-143, 172-175, 176, 177-183; Legion of Honor awarded to, MA 172; Léon Koëlla, question of Manet's possible paternity, MA 66, 67; marriage to Suzanne Leenhoff, MA 67; Matisse, influence on, MAT 38-39, 126; medal of 1881 Salon awarded to, MA 171, 179; and Monet, MA 110; Nadar's photograph of, MA 95; naval training and trip to Brazil, MA 14-15; painting, views on, MA 104, 111; in Paris, MA 18, 65, 133, 135-136, 144; past and present in art of, MA 23-24, 25-26; perspective, abolition of, MA 59, 61, 62; photography, interest in, MA 89; physical appearance, C 58, MA 6, 12, 65; portrait of himself in Concert in the Tuileries, MA 30-31; portrait painting and, MA 136; retrospective exhibition of 1867, MA 63-64; sickness and last years, MA 169-175, 176; Spanish themes in art of, MA 22, 23, 28; Velázquez' influence on, MA 22; Victorine Meurend, a model of, MA 22, 136;

yearning for official recognition and success, MA 81, 110, 135; Zola, relationship with, MA 68, 141
Mannerism: as precursor of Baroque art, B 72, R 31-32; successor of High Renaissance, M 175, 190
Mantegna, Andrea: Dürer's copy of engravings by, DU 62, 63; Dürer's interest in, DU 53, 96-97; Dürer's work and, DU 67
Manuscripts, illuminated: in Burgundian art, BR 23; Chludow Psalter, G 36; examples of, BR 18, 23, 97, 142; Golden Legend, G 12; as inspiration for Bruegel's art, BR 165-166, 168; scenes of 14th Century Florentine life in, G 14, 39; Vita Mathildas, G 58
Marin, John, and American Modernists, AP 48
Marsh, Reginald, and Social Realism, AP 104, 105
Masaccio (Tommaso di Ser Giovanni di Mano): compared to Van Eyck, BR 17; later peer of Giotto, G 183; life and work, M 28, 36-37; work by, M 29, 34
Masson, André: Miró and, MD 131, 154, 155; Surrealism and, MD 98, 103-104, 123; work by, MD 103, 159
Massys, Quentin: Dürer's visit to, DU 138; and Patinir, BR 163
Master of the Middle Rhine, work by, DU 42
Master of the Pala Sforzesca, works by, L 62, 63
Mathematics: Alberti's concern with relationship between art and, L 15; Dürer's quest for geometric formula for human form, D 63; Dürer's quest for mathematical formula for beauty, D 96; Dürer's treatise on human proportion, D 161; Leonardo's interest in, L 15, 58, 59, 104
Matisse, Henri: academic art and, MAT 11; analysis and criticism of art, MAT 16-17, 35-36, 50-51, 96-97, 104, 120-121, 126, 169; Apollinaire on art of, MAT 58-59; Armory Show work, MD 47; art, ideas on, MAT 59, 79, 98, 141; art education, MAT 11-15, 32, 34, 36; Berenson's support and admiration for, MAT 97-98; birth, MAT 7; Braque, remark on, P 56-57; bronze sculpture by, RO 176; Cézanne's influence on, C 98, 145, 178, MAT 26-27,

31-32, 77; Collioure, sojourns at, MAT 39, 49, 51, 64, 76, 117-118; color, treatment of, MAT 24, 27, 33, 50-51, 57, 60, 74, 98; Cone sisters, patronage of, MAT 75; cutouts, work with colored paper, MAT 146, 149, 168-171, 172, 173-182; Derain, friendship and artistic relationship with, MAT 34, 35-36, 49-50, 64; Derain's portrait of, MAT 62; at École des Beaux-Arts, MAT 12-13, 14-15, 20, 129; evolution toward personal style, MAT 20, 33-34, 36, 46, 76, 96, 98, 101; Fauvism and, C 169-170, MAT 52, 57, 58, 60, 77, P 39, 55; favorite subjects of paintings, MAT 120; financial problems, MAT 30, 31, 36; Gauguin's influence on, MAT 50; on Giotto, G 8, 11; Impressionism and, MAT 20, 29, 49, 59; Issy-les-Moulineaux villa, MAT 93-94, 101, 105, 120, 121; Kandinsky and, MAT 56-57; last years in Nice, MAT 164-167, 169-170, 182; law studies, MAT 8-9; lithograph of Apollinaire, Rouveyre and, MAT 59; marriage, MAT 30; music and, MAT 98, 123-124; New York, visits to, MAT 141-142, 143; Nice, life and work in, MAT 110, 114, 123-129, 137, 144; Nice paintings, character and success of, MAT 125-127, 129; odalisques as subjects of paintings, MAT 106, 107-115; personality and character traits, MAT 8, 9, 13-14, 33, 71-72, 105, 141, 146, 165-166, 167; Picasso, relationship with, MAT 73-75, 124, 168, P 7, 53, 54, 149; Pointillism and, MAT 39, 40, 46; poor health during last years, MAT 163-164, 165-170, 172; prices paid for works, MAT 100, 104, 125; religion, attitude toward, MAT 168; Russian trip, MAT 88, 102-103; sculpture, MAT 32, 127, 128; Sembat's monograph on, MAT 69; separation from Madame Matisse, MAT 148; Steins, relationship with, MAT 69-73, 76, 82, 93; Stieglitz Gallery in New York, exhibition at the, MAT 96, 97; success and recognition, MAT 16-17, 93, 96, 104, 105, 129; Tahiti trip, MAT 142-143; Vence Chapel, MAT 150, 158-161, 167-168; World War I, life and work during, MAT 117-

124; World War II, life and work during, MAT 151, 163-167
Maximilian I, Holy Roman Emperor: character traits and physical appearance, DU 124-125; chivalric deeds of, celebrated in Dürer's work, DU 125; death, DU 126, T 101; Dürer's portraits of, DU 128, 141; marriage to Mary of Burgundy, in Dürer woodcut, DU 125-126, 130-131, 134-135; patronage of Dürer, DU 123-124, 125; pension granted to Dürer by, DU 129, 139, 140; prayer book illustrations by Dürer for, DU 126-127; representations of, DU 80-81, 95, 118, 128, T 130, 131
Mazo, Juan Bautista Martínez del: assistant and son-in-law of Velázquez, VE 64; works by, VE 122-123, 128-129, 171
Medici family: coat of arms and crest, M 17; dynastic problems, M 153-154, 157; exile from Florence, L 121, M 132, 156; in Florence, M 16-17, 64-66, 69; genealogy, M 66; Leonardo's relationship with, L 16, 53, 149, 150; after Lorenzo the Magnificent's death, M 63, 66; obscure origins, G 180; portraits of, by Bronzino, M 141; power in Florence, M 132-133, 177-178; Savonarola and, M 89
Medici, Lorenzo de' (the Magnificent), bust of, M 24; death mask, M 47; medallion portrait, M 64; Michelangelo and, M 41-42, 43, 45; Neoplatonism and, M 92; Savonarola and, M 68, 69; tribute to Giotto, G 7
Medici, Marie de': marriage to Henry IV, King of France, R 31; Rubens and, R 96, 102-105, 113, 141, 108-119
Meister Francke, work by, DU 41
Metsu, Gabriel, life of, V 13, 99-100, 123; work by, V 88
Michel, Claude (Clodion), sculpture by, RO 34
Michelangelo Buonarroti: apprenticeship in Ghirlandaio's workshop, M 13-14, 40-41; architectural works and projects of, M 9; on Bramante, M 109; bust of, M 8; Capitoline Hill designed by, M 168, 171; compared to Caravaggio, B 60, 62; comparison between Bernini and, B 19, 164; Daniele da Volterra, Michelangelo's assistant, M 127, 179; description of, M 86; description of, as a great

AP American Painting; B Bernini; BR Bruegel; C Cézanne; CO Copley; D Delacroix; DU Dürer; MD Marcel Duchamp; P Picasso; R Rubens; RE Rembrandt; RO Rodin; T Titian; TU Turner;

genius in architecture, M 176; description of purpose in art of, M 92; Dürer and, DU 49, 138, 161; early life, M 13-14, 41, 43, 45, 71, 72, 73; El Greco's disparaging remarks on, VE 86; family of, M 11-13, 14, 41-43, 138, 161; on Flemish art, BR 17, 161; Florence, return to, M 85, 109, 111, 178; fortifications of Florence and, M *157;* funeral oration for, M 10; on Giotto, G 156; Giotto's works and, M 37; influence on Bruegel, BR 43, 76, 88; influence on Leonardo, L *124;* Laurentian Library, M *148-149,* 178; Leonardo and, L 29, 76, 125-126; menus by, M *87;* Pope Clement VII and, M 160; Pope Julius II and, M 104, 109, 110-111, 113; Pope Paul III and, M 170; possible influence on and criticism of Titian, T 153; Rodin on sculpture by, RO *31;* St. Peter's, Rome, and, B *172,* M 171, *175-177, 178-179, 181-187;* Sansovino's sculptures compared to, T 105; Sistine Chapel figures, RO *50;* sonnets by, M 46, *113,* 172, 173; tomb of Julius II and, 160-161; Tommaso dei Cavalieri, relationship with, M 172-173; Torrigiano, Pietro, and, M 41; Vittoria Colonna, relationship with, M 173-174; work in Florence, L 54, 121, 124, 125

Millais, John Everett: and Pre-Raphaelites, W 62-65, 68, 111, 121, 145; romantic aspect of works, TU *25;* works by, TU *25,* W *70-71*

Millet, Jean-François: and Barbizon School, MA 20; as painter of rural life, MA 42, 44; work by, MA *46*

Miró, Joan: American art and, MD 154, 155; ballet designs by, MD 103; Dali and, MD 124; life and work, MD 129-135, 136; Surrealism and, MD 103, 123, 131, 132; works by, MD *102, 122, 134, 135, 144-147*

Modern art: American regional painters, AP *60,* 61-68, *69-91;* Ash Can School in American art, AP *12,* 13-20, *21-35;* first modern American artists, AP *36,* 37-44, *45-59;* foreign influence on American abstract painting of the 1930s and 1940s, AP *116,* 117-124, *125-135;* New York School of Abstract Expressionism, AP *136,* 137-144, *145-159;* Op

and Pop art of the 1960s, AP *160,* 161-168, *169-184;* Social Realism in American art, AP *92,* 93-100, *101-115*

Monet, Claude, analysis of art of, MA 88-89, 106, 109, 116, 142; in *Apotheosis of Delacroix,* C *83;* in Argenteuil, MA 103, 104, 114-115; and Batignolles group, C 39; Boudin and, MA 54; at Café Guerbois gatherings, MA 87-88; Caillebotte's relations with, MA 105, 124; Clemenceau, episode at funeral of, MA 105; Durand-Ruel's assistance, MA 106, 107; in Fantin-Latour's *Studio at Batignolles,* MA 80; friendship between Manet and, MA 110; at Gleyre's studio with Manet, MA 16-17; influence on Van Gogh, VG *42;* on Japanese art, MA 62; landscape painting, C 58; life of, MA 83-84, 120-121; London, sojourn in, MA 91; in Manet's *Monet in His Studio Boat,* MA 110, *115;* photograph of, C *59;* relationship with Cézanne, C 39, 40, 59, 93, 100-101, 142, 163; Renoir and, MA 84, 116, 122; in Renoir's *Monet Painting in His Garden,* MA *115;* role in Impressionism, MA 107, 108; Rouen Cathedral paintings, MA 109; water and color in paintings, MA 106, *118, 120-121;* works by, C *65,* MA *114-121*

Montesquieu, Baron de, on Paris society, WA 56, 57, 58, 83-84

More, Sir Thomas, Holbein and, DU 145, *150*

Moreau, Gustave: life and art, MAT 12-13, 23; Matisse's teacher and friend, MAT 12, 14-15, 18-19; photograph of class of, MAT *15;* work by, MAT *22*

Morisot, Berthe: as Impressionist painter, MA 87, 107; Manet's sister-in-law, MA 87; in Manet's works, MA *76, 79,* 134; relationship with Manet, MA 65-66; sketch by, MA 87

Moro, Antonio (Antonis Mor), BR 22; works by, VE *124,* 125

Morris, William, designer of artistic utilitarian objects, W *64-65,* 105

Morse, Samuel Finley Breese: ambition to be a painter, WH 10-11; description of Copley, CO 143; life of, CO 161, 167, 179; painting by,

CO *178-179;* and telegraph, CO *167;* works by, WH *10, 18*

Mosaics, Byzantine, G *28;* Giotto's work in, G 102, 103; 13th Century use of, G *52-53*

Motherwell, Robert, and Abstract Expressionism, AP *155*

Moulthrop, Reuben: life of, CO 96, 98; early American work by, CO *102*

Mount, William Sidney: as a "literal" genre painter, WH 48-49; works by, WH *46, 56-57*

Munch, Edvard: artistic aims of, MAT 79; life and art, MAT 52-55; Matisse on, MAT 59; work by, MAT *53,* V 22

Murillo, Bartolomé Estéban, characteristics of art of, VE 90-92, *100, 101,* 105

Music: carnival songs of Florence, M 44, *46,* 65; Dadaism and, MD 56, 57; Delacroix's interest in, D 18, 145-146, 169; destruction of "old order" in, MD 8; Gainsborough's interest in, GA 44, *45, 65,* 80; humor in 20th Century, MD 32, 35; Leonardo's interest in, L 12, 53, *54;* Lorenzo de' Medici's patronage of, M 133; Matisse's love for and knowledge of, MAT 98, 123-124; new tastes in age of Louis XVI, WA 164; Schönberg's 12-tone technique, MD 8; stage designs for opera, B *139;* Stravinsky's, MD 8; as subject in Watteau's works, WA *41, 52, 72, 81, 82, 86, 88, 91;* Vermeer's interest in, V 62, *134,* 146-147, 157

N apoleon I, Bonaparte: abdication and exile, TU 84; Aboukir, Battle of, TU 41, 42; art treasures taken by, TU 57; Continental System, TU 60; David's work for, D 15-16; England and war with, TU 11, 34, 56; exile, D 19; in Gillray's cartoon on Peace of Amiens, TU *56;* portrait of, D *21;* Spain and wars with, GO 128, 131, 142, 145-150, 152; Trafalgar, Battle of, TU 61, 165

Nash, John, architect to Prince Regent, TU 85, 112

Nash, Richard (Beau), in Bath, GA *59-61*

Nattier, Jean Marc, work by, WA *126-127, 129,* 142-143

Naturalism: Barbizon School

and, MA 20; in Caravaggio's art, RE 25; Dutch burgher's preference for, RE 23; early movements toward, B *61-62;* Manet's shift from Realism to, MA 140-141; Matisse on interpreting rather than copying, MAT 59; Moreau on, MAT 14-15; Rembrandt's interpretation of nature, RE 96; theories on, in painting c. 1900, MAT 30; 20th Century art's contempt for, MAT 11; in Zola's works, MA 138

Netherlands, The (Dutch Republic): allegory of Amsterdam's prosperity, V *34-35;* alliance of England with, R 126; art market development in 17th Century, V 80; artist's position in Rembrandt's time, RE 22-23; Charles V and, BR 24-25, 27, 90-91; colonial expansion and economic prosperity, V 33-35; conditions of life for 17th Century artists, V 11, 15; cultural heritage and the Catholic Church, BR 20; Duke of Alba's rule, BR 94; economic and social conditions in 17th Century, RE 89-92; Eighty Years' War, BR 13, 94; emergence of merchant class, V 36-38; establishment of province of Holland, BR 13; European recognition of independence, R 11; France's policy toward, R 105; French wars against, V 121, 122; Granvelle's rule, BR 90, 91, 92; history of war of independence, V 29-32; importance of overseas trade, V 46-47; leading role during Age of Reason, V 10; maps, BR *24, 25,* RE *20,* V *187;* middle-class life in 17th Century, V 37-38; nationalism and gradual decadence after 17th Century, V 39; Philip II and, BR 27, 90, 91, 92; political and economic conditions in Vermeer's time, V 40; political situation in Rembrandt's lifetime, RE 20, 22; proverbs of, BR 146, 150-159; religious conflicts in, BR 27, 79, 89; religious struggles in Europe, and, R 82-83; role of Dukes of Burgundy in political unification, BR 23; Rubens' role in negotiations between Spanish Netherlands and, R 82, 106, 128-129, 146-148; Rubens' visit to, R 122; scarcity of

G Giotto; GA Gainsborough; GO Goya; L Leonardo; M Michelangelo; MA Manet; MAT Matisse; V Vermeer; VE Velázquez; VG Van Gogh; W Whistler; WA Watteau; WH Winslow Homer

information on life of 17th Century painters, RE 18; slavery and, RE 92; spread of nationalism and Protestantism, BR 13; struggle between Spanish Netherlands and, R 54, 81, 83, 121-122, 168; William of Orange and, BR 92-93. *See also* Flanders; Spanish Netherlands

New York City: Armory Show in, MAT 104, MD 33-34; as center of mid-20th Century art world, AP 117-124, *125-136,* 137-144, *145-159;* Dali's visit to, MD 37, 39, 59, 78, 80, 106; Duchamp's residence in, MD 156; Homer in, WH 35-36, 78; and Hudson River School, WH 48; illustrated by Ash Can painters, AP *12, 22-35;* Matisse in, MAT 96, 97, 129, 141-143; Surrealism in, MD 128, 149-155; Thomas Cole and birth of Native School in, WH 12

Newman, Barnett, and Abstract Expressionism, AP *159*

Noland, Kenneth, and Op art, AP *183*

Nolde, Emil, work by, L *98-99*

Nuremberg, Germany: description of, DU 36-37; Dürer in, DU 7, 47, 49, 52-53, 71, 97, 119; plague of 1505 in, DU 93; as printing capital of Europe, DU 37; religious conflict between Catholics and Lutherans in, DU 157, 158

O'Keeffe, Georgia, and American Modernists, AP *36, 54*

Op Art: in American painting, AP 161-168, *182-184;* development of, MD 9, 170, 172, *176-177*

Oriental art: collected by Whistler, W 78-79, 88, *94,* 148; early 20th Century rage for, RO 151; fashion in England of, in 18th Century, GA *114-115;* Hiroshige, Japanese printmaker, influence on Gauguin, VG *69, 70;* Hokusai, Japanese artist, influence on Gauguin, VG 69, 118; Hokusai, influence on Manet, MA 62; influence on Degas, MA 139; Japanese influence on Manet's drawings, MA 61-62; Japanese influence on Van Gogh, VG 45, 69-70, 79; Japanese prints and influence on Gauguin, MAT 11; K'ang

Hsi china, W *81;* Utamaro, influence on Manet, MA 62; Whistler's interest in, W 79-80, *81, 89-94*

Orléans, Philippe, duc d', as Regent of France, WA 14-15, 98

Ostade, Adrian van: genre realism in, BR 116, 123; life of, V 13, 79; tobacco smoking as subject of, V 36, *90-91*

Oudry, Jean-Baptiste, work by, WA *149*

Pacheco, Francesco: *Art of Painting* by, VE 9-10; life of, VE 36-37; religious views, VE 36, 37-38; Velázquez and, VE 7, 9, 33, 36, 38-39, 42-43

Pacher, Michael, work by, DU 9, *45*

Paine, Thomas: *Rights of Man* by, TU 33-34; satirized by Gillray, TU *34*

Painting: Academic versus modern art, MA 27; action painting, MD 155, 157, 165, 169; Alberti's treatise on mathematics and, L 15; analysis of Dürer's art, DU 8, 62; *art nouveau,* P 30, W 165-166; "automatic" technique in Abstract Expressionism, MD 172; brush technique in Hals' and Vermeer's art, V 74; buon technique, G 33; on canvas, in Venetian art, T 12; Caravaggio's realism and influence on, R 34; Cennini's handbook on, L 14; change from the literal to the emotional, T 85; change in taste, represented by Tintoretto and Veronese, T 173; changes in early 20th Century, MAT 9, 30; chiaroscuro, L 33-34, 35, 48, *134-137,* RE 25, 30, *82-83,* 110, 111, V 62, 66, 179; comparison between Giorgione's and Titian's art, T 57, 70-71, 72, 74; Copley's change in technique in London period, CO 10, 137; Delacroix's technique in details, D *51, 55;* Dürer's techniques compared to Giovanni Bellini's, DU 93; Dürer's theoretical writings on, DU 72, 160-161; 15th Century art theory, L 15, 103; Flemish artists credited with development of oil painting, BR 18, 28; forgeries in, V 174-185; French currents before Delacroix, D 13-14; fresco in Ghirlandaio's workshop, M 40; fresco technique, G 27, 33-34, T 12; fresco technique used in Assisi, G *32;* frescoes,

in Rome, B *48-51, 56-59;* Gainsborough's technique in details, GA *125, 132-133, 139, 182-183;* Giorgione's purpose in, T 56; Giorgione's use of oil technique in, T 54; as group effort, in 16th and 17th Centuries, R 75; group portraits in Dutch art, RE 72; Hals' technique in detail, V 74; landscape development in Europe, DU 64; Leonardo's comparison between sculpture and, L 126; Leonardo's thoughts on, L 29, 80-81, 104, 128-132, 170-171; Leonardo's *Treatise on Painting,* value of, L 170; Manet's technique in details, MA *9-10, 180-183;* Matisse's brushstrokes and color, MAT 32-33; nature versus art, W 62, 68, 149, 167-168; oil painting developed in Venetian art, T 13-14; oil technique, influence on Bellini brothers, T 13-14; oil versus egg tempera, L 28-29; opposition of paint and image, MA 43; in Paris at end of 19th Century, P 29; photography and, MA 82, 92, 97, 98, 100; Picasso's remarks on, P 142, 157, 160, 162, 164; plein-air painting, MA 54, 104, *106,* 115-116, 118, 122, W 43; *pointillés,* in Vermeer's work, V 127, 141, 176; Pointillism, MA 109, 111, MAT 37, 40, 44-46, VG 40, 69, 71, 73; preparations for, in medieval Italy, G 30; Protestant limitations on religious paintings, DU 146; Rembrandt's style, RE 108-109, 130; revolution leading to Realism, MA 38-39, 44; Rubens' method, R 73, 76-77, 82, 138, 169; Rubens' technique in rendering human flesh, RE 78, 79; Ryder's faulty technique in detail, WH *139; secco* technique, G 33; *sfumato* technique in Renaissance, L 31, 35, 127; sinopia drawing technique, G *180, 181;* spectator's participation in art, G 8; Surrealistic techniques, MD 95, 96, 98, *150, 151;* techniques of Titian, Veronese and Tintoretto, T 71, 171, 172-173; tempera on wood technique, T 12-13; trade in paintings in 16th Century Flanders, BR 77; *trompe l'oeil,* WA 27; Van Eyck's achievements with oil painting technique, DU 40; Van Gogh's technique in

detail, VG *101, 112-113, 172-173, 180;* variety of styles in 15th Century Germany, DU 9; Venetian painting techniques, T 184-185; Vermeer's only statement on, V 63; Winckelmann's theory on, CO 116; X-ray used in detecting forgeries, V *178, 179, 181, 183. See also* Genre; Landscape; Panel painting; Pastel; Portraiture; Still life; Watercolor painting

Palmer, Samuel, work by, AP *26*

Panel painting: adoption in Italy, G 16; crucifixes, G *17-19,* 38-39; decorative panels in 18th Century France, WA 37, *47;* technique for, G 34

Papacy: art patronage, in 16th Century, T 149; Avignon as seat of, G 105, 138, 154, M 105; church and state struggle, G 56-57, 103-105, 138; 15th and 16th Century crests of, M *152;* finances and taxation, G 179; Marsiglio of Padua's attack on, G 153-154; political role, G 83, 138; position after Reformation, B 34, 63; in 17th Century, B 31-33; relations with Florence, G 84; Siena and, G 61

Paris, France: as art center in 19th Century, D 130, MD 15, 16, 29, 60-61, 66, 98, 105, 149, 169, P 29; artistic tastes of bourgeoisie in, WA 36; Bernini in, B 113, 125-127; Café Guerbois as artists' meeting place, MA 81-83, 87-88; Casanova's comments on Paris life, WA 35, 57, 59, 83; Communist Peace Congress held in, P 149-150; Eiffel Tower, *48-49;* entertainments, WA 58, 59; exhibitions of Picasso's work, P 32, 109, 146, 153; fashion, WA 60, 83-85; Ferrier and Solier's photograph of, MA *100-101;* Folies-Bergère, MA 176; during Franco-Prussian War, C *46,* 47, MA 90-91; Haussmann's remodeling of, C 34, D 168, 169, MA 18, 134; île de la Cité, two views of, MA *18;* literary salons, D 62, 84-86, 92; Louvre Palace, B *125;* Manet in, MA 18, 65, 133, 135-136, 144; map of, C 74, D *132-133,* MA *104;* Matisse and Picasso in, P 53; Montesquieu's remarks on, WA 56, 57, 58, 83-84; Montparnasse replaces Montmartre, P 63; Nadar's first aerial photograph of,

AP American Painting; B Bernini; BR Bruegel; C Cézanne; CO Copley; D Delacroix; DU Dürer; MD Marcel Duchamp; P Picasso; R Rubens; RE Rembrandt; RO Rodin; T Titian; TU Turner;

MA *95;* Picasso in, P 15, 16, 21, 29, 31-39, 130-131; Revolution of 1848, D 166-167, MA 15; Salon's importance in artistic life, MA 26; salons in 18th Century, WA 58, 141-142; social life, MA 64-65, 133-136, W 22-25; Stein home as center of bohemian art world, MAT 70; Universal Exposition of 1889, C *33, 48, 49;* vogue of Spanish culture in, MA 22-23; Walpole's comments on, WA 122; during World War I, P 73; during and after World War II, P 130-131, 142, 145-146

Pastel: Chardin's use of, WA 149, 160-161; Copley's work in, CO 44-45, *64;* Degas' use of, MA 139, *155, 158-160,* 161; Manet's use of, MA *187, slipcase*

Pater, Jean-Baptiste: Watteau and, WA 76, 79, 80, 81, 103; works by, WA *76-77, 81*

Patinir, Joachim: influence on Bruegel, BR 43, 164; life of, BR 163-164

Patronage: American Colonial patronage, CO 20, 102; artist's status in 16th Century Flanders, BR 77; church role in Middle Ages, G 11-12, 101, 155; Durand-Ruel, patron of Impressionists, MA 106-107, VG 167; by Gertrude and Leo Stein, MAT 69-72, P 37-39; influence of French Government on art, RO 16-17; lack of, in 17th Century Netherlands, V 11, 12, 37; by Medici family, L 16, 53, 149; medieval painter's need for, G 32; of modern artists by Peggy Guggenheim, MD 154, 155, 157; in Netherlands in Rembrandt's time, RE 22-23, 62, 64, 134; printing leading to artists' independence from, DU 69; rising trend in private patronage, G 63, 164; in Titian's time, T 86; Urban VIII and beautification of Rome, B 31, 38-40, 42, 133, 148

Peale, Charles Willson: invention of polygraph, CO *166;* life of, CO 165-166; paintings by, *169-173;* scientific interests, CO 172-173

Perspective: aerial perspective in Dürer's work, DU 64; aerial perspective in Leonardo's work, L 29, *35,* 140-141; aerial perspective in Van Goyen's work, V 78; Brunelleschi's principles of linear perspective, L 15;

Cézanne's distrust of aerial perspective, C 79; concept of foreshortening, D 44; in De Vlieger's sketches, V *77;* development in Italy of laws, DU 40; distortion, in Picasso, P *57, 160-161;* Dürer's preoccupation with, DU 49, 64, 91, 96; Eakins' drawings, WH *148;* in Flemish art, BR 17, 147, 163, 168; Giotto's grasp of, G 9, 141; landscapist's use of color to obtain aerial perspective, V 126; in Leonardo's work, L 33, 83, *134;* Manet's rejection of, MA 59, 61, 62; obtained in Vermeer's work, V 65, 134-135, 137; Pacher's interest in, DU 44; photography and, MA 100; in Saenredam, V 102. *See also* Three-dimensionality; Two-dimensionality

Perugino, Pietro, work by, L *41*

Peruzzi family, financial dealings and failure, G 139, 178, 184

Petrarch: life of, G 138, 163; at Robert of Naples' court, G 158; sketches of, G *162, 163*

Philip II, King of Spain: Flemish art and, BR 22; Netherlands and, BR 27, 90-93, 97

Philip IV, King of Spain: accession of, VE 8-9, 30-31; appearance in Velázquez' portraits, VE 13, 14, 15, 18-19, 119; Baltasar Carlos and, VE 57-58, 136-137; commission to Rubens, R 32, 78, 92, 169-170, 176, 178-179; death of wife Isabel, VE 135-136; Don Juan, illegitimate son, VE 58, 116; upbringing, VE 59-60; financial situation, VE 167-168, 170-171; genealogical table, VE *9;* Golden Fleece insignia worn in most portraits, VE *65;* hunting a favorite sport, VE 111-112, 123; illness of 1627 and recovery, VE 21; Isabel, marriage to, VE 60, 61; last years and death, VE 175; map of Spain during reign, VE *10;* Mariana of Austria, marriage to, VE 138, 166, 167; at marriage of daughter María Teresa to Louis XIV of France, VE 173-174; Olivares, relations with, VE 11, 59-61, 62, 106, 107, 115, 117; Order of Santiago, role in acceptance of Velázquez as knight of, VE 172; personality and character, VE 59, 118-119, 167; physical appearance, VE 17-18, 19, 58; political cartoon about, VE

62; portait by Rubens, R 20; relations with England, R 121, 124, 126; reversion of Netherlands' sovereignty to, after Archduke Albert's death, R 99; Rubens' relations with and comments on, R 20, 124-125

Photography: as aid to painting, MA 89, 92, 97, 98, 100; Alfred Stieglitz and, AP 37-40; Daguerre, Louis, and, D *69,* 169, 172, MA *92-93;* Delacroix and, D 169, *172, 173;* Eadweard Muybridge and action photographs, MA *98;* Eakins' interest in, WH *146;* Edward Steichen's photograph of Matisse, MAT *100;* Edward Steichen's photograph of Rodin, RO *6;* Halsman's surrealist photographs, MD *136-138;* Nadar (Gaspard Félix Tournachon), MA 82-83; Nadar's photographs, D *173,* MA *94-95, 97;* as a "new vision" in 19th Century Paris, MA *92-101*

Picabia, Francis: Dadaism and, MD 36, 37, 49, 60, 65; Duchamp's friendship for, MD 31-32; life of, MD 13, 36, 37, 60; Surrealism and, MD 98, 105-106, 133; works by, MD *48, 72, 73*

Picasso, Pablo: art, remarks on, 154, 157, 158, 160, 162, 164; ballet, interest and work for, P 75-80; baptismal name, P 8; birth, P 8; Braque, collaboration and relationship with, P 56, 58-59, 61-62, 63, 79, 86, 92, 94; ceramic work, P 148-149, 174-177; Cézanne's influence on, C 170, 172, *181;* collages, MD 29, 101; Communism, activities on behalf of, P 145, 149-151; Dada movement and, MD 57, 62, P 82; distortion in art, P 44, 55, 84-85, 112, 126, 127; Dora Maar, relationship with, P 109-110, 128-129; early training, P 9-10, 11-12, 13, 16, 19; Eva, relationship with, P 61-62, 63, 73, 74; exhibitions of his work, P 15, 32, 109, 146, 153; Fernande Olivier, relationship with, P 35, 38, 57, 58, 61; and Gertrude Stein, MAT 73; Françoise Gilot, relationship with, P 146-147, 150, 151; *Guernica,* explanation and criticism of, P 127-128, 134; Jacqueline Roque, his second wife, P 8, 151-152, 153, 158; lithography, interest in, P

146; and Marcel Duchamp, MD 8, 12-13, 24, 36, 40, 49, 56; Marie-Thérèse Walter, relationship with, P 103-110, 151; and Matisse, friendship with, MAT 73-75, 105; Miró and, MD 131, 133; "objets trouvés," MD 151; Olga Khokhlova, his first wife, P 78-79, 84, 85, 103, 106, 107, 112; photographs of, P *6, 9, 81, 128, 144, 147, 166, 168-175, 178-179, 180-183;* poetry written by, P 107, 125; portraits by Gris and Dali, P 72, *124;* prestige and world fame, P 53, 128, 148, 167; sculpture by, RO 176; Spanish Civil War, sympathies in, P 111, 125, 126, 132, 134; Spanish heritage in art, P 10-11, 22-23, 67, 69; stylistic influences on, P 7, 15, 24, 31-32, 67, 69, 70, 74, 83-84, 88, 104, 117, 131, 152, 160; Surrealism and, MD 98, 105-106, 133

Pietro da Cortona: Urban VIII's patronage of, B 32, 42; work by, B *56-59*

Pisano, Andrea, work of, G 160

Pisano, Giovanni: Arnolfo di Cambio and, G 86; Duccio and, G 63; work by, G *48-51*

Pisano, Nicolo: life of, G 46, 63; training of Arnolfo di Cambio, G 86; work by, G *46-47*

Pissarro, Camille: art of, C 58, 61; attitude toward Manet, MA 81; and Batignolles group, C 39; Cézanne and, C *54,* 59-61, 68, 69, 82, 93, 122, 142, 163; Impressionism and, MA 106-108, 116; influence on Van Gogh, VG *43;* life, MA 85-86, 126; optical theories, MA 106; photograph of, C *54;* Pointillist period, MA 109; Salon des Refusés and, MA 26-27; works by, C *68, 69,* MA *116-117, 126-129*

Plagues: Black Death of 1348, G 180-181, 184; consequences and influence on religion, G 187; Dürer's drawing of King Death, DU 92; in Milan (1484-85), L 55-56; outbreaks, in Germany, DU 35, 53, 93; in 16th Century Europe, BR 47; in 16th Century Rome, M 169

Plantin, Christopher, publisher, BR 76, R 10

Poetry: Apollinaire's modern poetry, MAT 58, 59, MD 8, 99, P 36; Lorenzo de' Medici's carnival songs, M 44, 46; Lorenzo de' Medici's patronage of, M *133;*

G Giotto; GA Gainsborough; GO Goya; L Leonardo; M Michelangelo; MA Manet; MAT Matisse; V Vermeer; VE Velázquez; VG Van Gogh; W Whistler; WA Watteau; WH Winslow Homer

Michelangelo's sonnets and love poems, M 113, 172, 173; Picasso's, P 107, 125; Urban VIII's poem, B 32; and Vittoria Colonna, M 173-174

Polk-Smith, Leon, and Op art, AP 183

Pollaiuolo, Antonio del, L 14; influence on Matisse, MAT 144; work by, L 42, 58

Pollock, Jackson: and Abstract Expressionism, AP 136, 145-147; Surrealism and, MD 154-155; work by, MD 175

Pompadour, Marquise de (Jeanne-Antoinette Poisson): Boucher and, WA 118, 120-121, 138; character of, WA 123; Latour and, WA 145; life of, WA 115-118; and Louis XV, WA 116, 117-118; portrait of, WA 114; role in art and taste, WA 126

Pop art: establishment of, MD 9, 166, 169, 170, 180-181, AP 161-168; examples of, AP 160, 169-181

Pope Julius II (Giuliano della Rovere): in Dürer's work, DU 80-81, 94-95; life of, L 149, M 90, 103-104, 110, 113, 132; Michelangelo and, M 14, 104, 106-107, 109-111, 113, 116, 131; Michelangelo's Sistine Ceiling and, M 112-113; tomb of, M 98, 134, 135, 163-167

Pope Urban VIII (Maffeo Barberini): Bernini, relationship with and patronage of, B 14, 31, 32, 38-42, 85-86, 133, 162; Caravaggio and, B 64; death, B 41, 85-86; Galileo and, B 36-38; nepotism and financial gain, B 32-33; poem by, B 32; political dealings with England, B 123; Rome during reign of, B 31-32; tomb of, B 30, 158, 166

Portraiture: achievements in English art, TU 12, 13-14; British artists and, GA 75, 84; children in Reynold's portraits, GA 79, 84; in Colonial America, CO 8, 13, 24-27; comparison between Dürer and Holbein, DU 145; Constable's commission, TU 54, 83; contraffazione (true-to-life likeness) demanded by Renaissance patrons, T 123; in Cubism, P 90, 91; Delacroix's family portraits among his finest, D 125-126; double portraits in Dutch art, RE 64-65; in Dürer's art, DU 8, 72, 79, 142; in Dutch art, V 12, 13; Dutch burghers' preference for, V 37; in Flemish art, BR 38; Gainsborough's imagination

and style, GA 41, 42, 48, 76, 106, 167-168; Gainsborough's prices, GA 62; group portraits popular in Dutch art, RE 72, 78-79, 80, 81; Hals' genius, V 72, 73-74; Hogarth and, GA 11, 13, 34; Holbein's gift for, DU 144, 146; landscape blended with, in Gainsborough's art, GA 52-53, 166; limners in American folk art, CO 13-14, 100-101; Rembrandt's unconventional treatment of group portrait, RE 73, 82-87, 107, 109-111; Renaissance vogue of copying portraits, T 122; Reynolds and, GA 78-79, 90, 102, 103, 144; Rubens' attitude toward, R 81-82; Titian's mastery of, T 61, 96; Van Dyck's excellence in, R 76, 84, 85-87, 123; vogue for, in 18th Century French art, WA 126, 128-129, 142

Portugal: independence of, VE 15, 172; map, VE 10; Olivares' plan for unification with Spain, VE 11; Spanish defeat by, VE 175

Poussin, Nicolas: influence on English landscapists, TU 14; influence on Turner, TU 58; Louis XIII and, WA 10-11; mood in works, V 77; principles of beauty and, WA 83; rivalry between "Rubenists" and "Poussinists," R 174; work by, B 54-55, L 97, WA 10, 28-29

Pratt, Matthew, painting of West's London studio, CO 162

Prendergast, Maurice, and American Post-Impressionists, MD 53

Pre-Raphaelite Brotherhood: concepts spread by Morris' designs, W 64; loss of prestige, W 147; origin, W 61, 62-65, 68, 69-75; realism and, W 68, 70; Ruskin's support, W 64; theories on art, W 68; Whistler and, W 11, 88

Printing and publishing: Basel, a publishing center, DU 50; Bruegel and, BR 80-87; different "states" of Rembrandt's etchings, RE 42-43, 144-145; engraving technique, DU 12-13, 54; etching and engraving techniques in Rembrandt's time, RE 42-43; graphic arts, birth of, DU 54; movable type, invention of, DU 54; Nuremberg as Europe's printing capital, DU 37; printing press, invention of, DU 9; role in distribution of

Dürer's works, DU 8, 69, 98, 162

Protestant Reformation: attitude toward art by zealous Protestants, DU 145, 146; Catholic versus Protestant attitude toward art, R 73; Charles V and, T 130, 140, 146, 155; Counter-Reformation and, R 7, 8, 11; Cranach as portraitist of, DU 129, 143-144; Diet and Edict of Worms and, DU 140; Dürer's works and, DU 8, 14-15, 66, 157; Huguenot revolt in France, R 124; Hus, John, and, DU 34; influence on Dutch art, V 11, 30; Lutheranism, spread of, in Germany, DU 157-158; sale of indulgences and, DU 127-128

Protestantism: Bruegel and, BR 97, 106-107; Calvinism in The Netherlands, BR 91, 92; Calvinism's influence on religious art in The Netherlands, V 11, 36, 57; capitalism in 17th Century Holland and, V 36; Catholicism and, in Spanish wars in Flanders, VE 9, 28-29; influence on Dutch art, V 11, 30, 33, 37; influence on Dutch art after 16th Century, BR 169; Philip II's efforts to suppress, BR 27, 91-92; Rembrandt's attitude toward Calvinism, RE 89, 159-160; rise of, in Netherlands, RE 22; spread of, in Netherlands, BR 13, 14

Quattrocento art (1400-1499), characteristics of, L 32, 35, 43, 97, M 36

Quidor, John, as American genre painter, WH 48, 62

Ramsay, Allan: life and work, GA 17, 78, 79, 84; work by, GA 92

Raphael (Raffaello Sanzio): Dürer and, DU 162; Leonardo and, L 125, 150; life and work, M 95, 133, 155; on painting beauty, T 85; Turner's analysis of composition of, TU 82, 110; works by, L 127, M 102, 140, 141

Rauschenberg, Robert: life of, MD 167-168; and Pop art, AP 169; works by, MD 178, 179

Ray, Man, and American Modernists, AP 50, 51, MD 94, 96, 111

Real (Spanish coin), in Philip

IV's reign, VE 20

Realism: Braque and, P 60, 62-63; in Bruegel, BR 12, 14-15, 114-116, 121, 148; in Campin's Annunciation Altarpiece, V 20-21; in Caravaggio's work, R 34; and classicism, B 68-69; concept of, in Renaissance art, T 10; in Copley's art, CO 43, 64; Courbet as "creator" of, MA 20, 38-39, 41-42; in Cranach's figures, DU 162; Cubism and, P 95, 115; development of, MA 44; in De Witte's architectural painting, V 102; in Dutch art of 17th Century, V 9, 10, 11, 33, 61; fear depicted by Klee and Munch, V 22, 23; in 15th Century Italian art, M 37, 38, 48, 55, 56, 60; in 15th and 16th Century Flemish art, BR 114, 116; Flemish landscape and, BR 162; in French art, W 11, 25, 42; in German art, DU 9, 44; in Housebook Master, DU 49; influence of Caravaggio's new realism on northern European art, B 64-66, 72, V 62, 67, 74; influence of Courbet's realism on Whistler, W 26, 33, 42, 88; in Koninck, V 96; light and, V 26; Manet's position versus, MA 58, 89-90, 140-141; meaning in 19th Century France, BR 114; in mid-19th Century France, MA 39, 44; and mid-19th Century interest in contemporary themes, C 36-37; Monet's concept of reality, MA 142, V 24; naturalism and, MA 138; naturalism favored over originality in Renaissance, T 123; in 19th Century American art, WH 48-51, 135, 140-144; Picasso and, P 10, 62-63, 78, 112; and plein-air painting, MA 54; in portrait painting, V 12; Pre-Raphaelites and, W 68, 70; rejection by 20th Century sculptors, RO 174; Rembrandt's compared to Rubens' treatment, RE 67; in Rubens' works, R 74, 168; in Ruisdael, V 96; and Social Realism in American art, AP 92, 93-100, 101-115; in still-life paintings, V 82; struggle against Gothic conventions, T 10-11; symbolism and, DU 108, 109; Tobey's conceptual reality, V 24; Vermeer's approach to, V 15, 16, 126; Wyeth's versus Hofmann's, V 19

Redon, Odilon: awed by Delacroix, D 12; work by,

AP American Painting; B Bernini; BR Bruegel; C Cézanne; CO Copley; D Delacroix; DU Dürer; MD Marcel Duchamp; P Picasso; R Rubens; RE Rembrandt; RO Rodin; T Titian; TU Turner;

MD *112*

Reformation. *See* Protestant Reformation

Regency, British (1812-1821), of Prince of Wales. *See* George IV, King of England

Regency, French (1715-1723): under Philippe II, duc d'Orléans, WA 14-15, 32, 56, 79, 126

Regnault, Henri, work by, C *29*

Reinhardt, Ad, and Abstract Expressionism, AP *158*

Religion. *See* Catholic Church; Protestant Reformation; Protestantism

Rembrandt van Rijn: Amsterdam, life and work in, RE 17, 25, 46-47, 61, 62, 89, 93, 133-134; analysis of art, RE 63, 105-106, 108, 112-113, 141, 142, 168; apprenticeship in Leiden, RE 24-25; art collecting, passion for, RE 39, 65, 91, 107, 136, 139; art school and pupils in Amsterdam, RE *68*, 70, 111, 135, 139; authenticity of paintings, question of, RE 62-63; best-known paintings by, RE 20; Biblical illustrations, RE 34-35, *36*, 104, *143-145*, 161, *169-179;* biographical data, difficulties concerning, RE 18-20, 133; birth, RE 21; Caravaggio's influence on, RE 30, 34; catalogue of paintings, RE 116; characterization in art, RE 34, 95, 134; Classicism and, RE 47, 105-106, 121; costumes, love of, RE 9, 38-39, *140;* death, RE 167; difficulties in identifying drawings, RE 21, 48; drawing techniques used by, RE 45-46, 113-114; education, RE 24; etching technique, RE 42-45, 114-115, 142, 143-144, V *104-105;* film on life of, RE 18; financial conditions and final insolvency, RE 22, 65, 90, 111 135-137, 139; Goya's "master," GO *46;* Hendrickje, relationship with, RE 95, 160, 165; high regard of critics for, RE 166-167; Houbraken's description of, RE 19; house acquisition and sale of, RE *69,* 70, 136, 138; Huygens' relations with, RE 46, 47; identification of earliest painting, RE 21; influence on English painting, TU 14, 57, 71; influences on, RE 26, 30, 34, 44, 107; inventory and sale of possessions, RE 18, 112, 136-138; Lastman's influence on, RE 25, 38;

Leiden, early work in, RE 37-46; marriage and life with Saskia, RE 65, 94-95; Mennonites, spiritual affinity with sect, RE 160-161; misfortunes in life, RE 17-18, 69, 94, 112-113; monogram of, RE 21, 24; *Night Watch,* most revolutionary painting produced by, RE 109-110; number of works by, RE 20-21, 48, 112; as painter of "truth before beauty," RE 159; painting technique and personal style, RE 108-109; personality and character traits, RE 19, 89, 92, 93-94, 112-113; physical appearance as shown in self-portraits, RE 8, 21, 93, 135; portrayal of death by, B *165;* possible reasons for decline in popularity, RE 111-112; prices paid for works, RE 19, 23-24, 45, 89, 110, 112, 159; realism in portraits, V 12; religion, attitude toward, RE 24, 66, 89, 159-161; restoration of works, RE 108, 109, 180; Rubens' influence on, RE 34, 65; self-portraits, number of, RE 7, 21

Renaissance: character of, in Italian art, B 15, 16, 68-69, 80-83, BR 13; chiaroscuro in art of, RE 41; development in northern Europe, BR 18, 23; development of Venetian painting, T 16; difference between northern and southern Europe, BR 16-17, 161, 163; Dürer's fusion of Gothic art with, DU 10; fashion during, T *106, 107;* Giorgione's art as expression of, T 53, 56; High Renaissance and mannerism, B 72; influence in Dürer's time, DU 8, 53, 144; interest in classical art during, T 82; manners of prince and courtier, T 9, 96; naturalism, preference for, T 123; and 19th Century art, MA 19, 26; in northern Europe, BR 18, 23, 76; role of painter during, T 85

Reni, Guido: and Galileo, B 37; work by, B 31, 42, *52, 53*

Renoir, Pierre-Auguste: admiration for Rubens, R 175; at Argenteuil, MA 103, 115; and the Batignolles group, C 39; disparaging comment on Leonardo, L 165; in Franco-Prussian War, C 59; friendship, and admiration for Cézanne, C 40, 43, 59, 93-94, 97-98, 127, 163; Impressionism and, C 58, 59, MA 106-107, 122, MAT 9,

29; influence on Van Gogh, VG *43;* last period of art, MA 109, 110; life of, MA 84-85, 91; Manet and, MA 81; Monet and, MA 84, 116, 122; in Paris, MA 136-137; photograph of, C *59;* remarks on importance of Salon, MA 26; rheumatism of, MA 110; on Vermeer's work as best in the world, V 173; works by, C *70,* MA *115-117, 123-125,* P *21*

Restoration techniques: of Duccio's work, G 76-77, 180; of Rembrandt's paintings, RE 108-109, 180

Revere, Paul: Copley's portrait of, CO 71-72, *84;* engraving of Boston Massacre by, CO 70, *71;* engravings and silverwork by, CO 6, *71, 72, 73;* political activities in Boston, CO 89-90

Revolution, American: Battles of Lexington and Concord depicted by Earl and Doolittle, CO *90;* Boston Massacre, CO 69, *71;* Boston Tea Party, CO, 72-75; conclusion of, CO 91, 140; effect on England and Gainsborough, GA 146, 147; events of CO 90-91; events leading to, CO 68-75; outbreak of, CO 136-137; Revere's cartoon satirizing, CO *73;* Trumbull's paintings of, CO 162, 181

Revolution, French: the "common man" at time of, GA 167; effect on Fragonard, WA 170; end of Rococo Age and, WA 182; English reaction to, TU 33, 34; Gillray's cartoon, TU *35*

Revolution, Industrial: effects on English society, TU 11; Gainsborough's lack of concern for, GA 146; impact on America, WH 49, *50,* 91-93; impact in France, MA 15

Reynolds, Sir Joshua, GA 76-80, 100-105; admiration for Rubens' technique, R 174-175; analysis of Gainsborough's art and character in 14th Discourse, GA 170-171; birth and early training, GA 76-77; character traits and planned career of, GA 17, 77; Classicism and contemporary portrait painting in work of, GA 78-79, 103-104, 144, TU 13; and Copley, CO 7, 61, 62, 133; Countess of Harrington, GA 144; Discourses delivered at Royal Academy, GA 100-103, TU 19; Dr. Johnson's portrait, GA *80;* English art, role in development of, GA

84; English Royal Family, relationship with, GA 142; in engraving of Royal Academy exhibit, GA *122;* on esthetics, GA 101, 103; Fitzwilliam, Lady Charlotte, GA 79; friendships and social life in London, GA 79-80; Gainsborough's personal relations with, GA 143, 170; knighthood of, GA 99; patrons, TU 79, 90; plan to raise social status of British artists, GA 77, 79, 99; role in Royal Academy, GA 83, 97, 98, 99, 100, 142; self-portrait, GA *74;* and West, CO 116, 118; works by, GA *85-91, 112*

Ribera, Jusepe de (Il Spagnoletto), VE 90-91; realism in religious works, VE 92, 103; works by, VE *91, 102-103*

Richelieu, Cardinal: attack against Spain, VE 114; Bernini and, B 33, 124; death, VE 117; declaration of war, VE 105; Habsburgs and, R 105, 124; Marie de' Medici's attempt to undermine power, R *146;* Rubens and, R 104-105, 113, 141

Rivers, Larry, and Pop art, AP *174*

Robert, Hubert, life and work, WA 166, 168, *171*

Rococo: in age of Louis XVI, WA 163; Classicism and, WA 118; in Copley's work, CO 40, 42; Fragonard and, WA 172; in French art, WA 31; in 19th Century Europe, CO 42; Paris society during French Rococo, WA 56-60; replaced by new Classicism, C 35

Rodin, François Auguste René: and Académie des Beaux-Arts, RO 17; accusations of "casting from life" against, RO 51, 79, 87, 122; art, thoughts on, RO 11, 12, 15, 16, 68-69; and Balzac controversy, RO 122-123; Baudelaire's influence on, RO 92; and Beuret, Rose, RO 43, 45, 46-50, 65-66, 74, 75, *82,* 118, 148-149, *152-153, 154,* 166, 169, 170, *171,* 172; birth and family background, RO 37-38; bronze casts and marble replicas of works, RO 143-144; and Camille Claudel, RO 74-75, 118, 121-122, 149; Carrier-Belleuse, association with, RO 18, 43, 45-46; *Cathedrals of France* written by, RO 12, 169-170; Cézanne's disinterest in works of, C 11; characteristics of art, RO 11, 14-15, 19, 43; controversies

G Giotto; GA Gainsborough; GO Goya; L Leonardo; M Michelangelo; MA Manet; MAT Matisse; V Vermeer; VE Velázquez; VG Van Gogh; W Whistler; WA Watteau; WH Winslow Homer

raised by work of, RO 14, 19, 51, 76, 79, 113-114, 118-119, 122-123, 136, 173; and Countess von Nostitz, RO 151; dance, fascination with, RO 151, 156-163, 168; death, RO 172; as decorative sculptor, RO 12-13, 38-39, 40, 45-46, 70, 76; and Duchesse de Choiseul, RO 155, 166-167, 169; economic conditions and prices paid for work, RO 12, 13, 45-46, 145, 147, 172; education and artistic training, RO 12-13, 20, 42; eroticism in work, RO 14, 73-74; exhibit with Monet, RO 8, 117; *Exposition Rodin* at Universal Exposition of 1900, RO 142-143; flight to England during World War I, RO 170; and Isadora Duncan, RO 10-11, 151, 156, 158; and Judith Cladel, RO 142, 149; Legros' portrait of, RO *72;* in London, RO 144-145; Maillol on art of, RO 178; at Meudon, RO 147-150, 154; Michelangelo's influence on, RO 15, 20, 30, 49-50, 51, 66, 79, 88, 92; in monastery, RO 41-42; and Nijinsky, RO 162-163, 168, 169; Oxford doctorate received by, RO 152; personality and attitude toward life, RO 8, 9, 10, 11, 71, 90-91, 119, 149, 150, 170; physical and mental decline, RO 169, 171-173; physical appearance and photographs, RO 7, 8, *11, 75, 86, 152-153, 154, 155, 168, 171;* private life and problems, RO 43, 65, 74, 90-91; quotations from writings, RO 20, 23, 25, 27, 28, 30, 32; reputation of, RO 19, 173, 174, 178; and Rilke, RO 148-150; social life in Paris art circles, RO 43, 71, 76; success, RO 69-70, 141, 143-145, 151-152; Turquet's friendship and patronage, RO 72, 79, 85, 87; vision of art and life expressed in *The Gates of Hell*, RO 90-91, 93, 96; working methods and techniques, RO *9,* 10, 11-12, 93-94, 145-146

Romanesque art: emergence of, and relation to Church, G 36-37; as inspiration for Rodin's work, RO 90; Italian art and, G 35, 40; sculpture, G *42-45*

Romano, Giulio: influence on Rubens, R 169, 173; life of, R 31-32

Romanticism: art and science during age of, TU 29; Cézanne's and Zola's

admiration for, C 14; Classicism and, C 9, D *13,* 107; Copley and West as precursors of, CO 11, 119, 143; in England, D 60-*61;* examples of, TU *20-31;* in France, D 122; in French art, C 36, 37; in mid-19th Century, RO 18, 92; nature and, TU 26, 57-58; in 19th Century American art, WH 11, 13, 14; Pre-Raphaelites on, W 88; rejection of, by Realists, MA 44; in Rembrandt's works, RE 69, 96, 102, *122, 123;* and revival of landscape, BR 171; themes popular in, D 142; Turner and, TU 60, 71; vein of melancholy an element of, D 61; in Victorian England, W 48, 52-53, 54-55

Rome, Italy: Aretino's life in, T 103-105; as art center in 16th and 17th Centuries, B 34, 96, T 149, 176; Bruegel in, BR 73-74; Copley in, CO 135-137; El Greco in, VE 86; fountains in, B 87-95, *101-105;* in Giotto's time, G 85-86, 101-102; Goya in, GO 35; history of, M 103-105; Picasso in, P 112, 117; Rubens in, R 32-35; St. Peter's Basilica in, B 157-158, 161-164, *170-171, 176-177,* M *75-81, 176-177, 179, 181, 183, 184-187;* Sistine Chapel, M 112-114, *117-129;* Titian in, T 151-154; Turner in, TU 109, 110, 117; Vatican, B 159-160, *170-171, 181;* Velázquez in, VE 23, 145-147, *158, 159*

Romney, George: style in portraiture, GA 84; works by, GA *93-95*

Rosenquist, James, and Pop art, MD *180-181,* AP *176, 177*

Rossetti, Dante Gabriel: photograph of, W *66;* portrait of, W 62; as Pre-Raphaelite, W 61-68, 80, 83, 91, 111; works by, W *69, 70*

Rothko, Mark, and Abstract Expressionism, AP *156, 157*

Rouault, Georges: characteristics of work, MAT 51; as favorite pupil of Moreau, MAT 13, 15, 23; lithograph of Moreau by, MAT *12;* Matisse and, MAT 13; work by, MAT *23*

Rousseau, Jean-Jacques: bust of, WA *167;* philosophy, WA 164

Rowlandson, Thomas, works by, GA *68, 70, 72, 140, 149-159,* TU *19*

Royal Academy, London: art school and focus of English artistic life, GA 100;

factionalism and problems, TU 60, 142; founding of, CO 117, GA 13, 83, 97, 99; Regent's support, TU 79-80; rules and organization, GA 99-100, TU 19; Somerset House, home of, GA *102*

Rubens, Peter Paul: admirer of Terbrugghen, V 75; analysis of art and career, R 8-9, 16, 47, 59-60, 78, 79, 130, 152, 173-174, 176; antiquarian studies, R 38, 78, 145; apprenticeship, R 13-14; Archduchess Isabella, relations with, R 20, 53, 54, 81, 94, 100, 106, 121, 146-147, 148; art collection of, R 23, 121, 145, 151, 176; auction of drawings in 1658, R 172; Baroque style and, R 8, 16, 40, 173, 175; birth and family background, R 9; book illustrations: collaboration with Plantin press, R 61, 98, 144-145; Brouwer's influence on, R 146; Bruegel's influence on, BR 176, R 57, 78, 84, 100; Caravaggio and, B 66, R 34, 58, 122, 167, 173; Carracci's sketching technique and, R 34-35; Catholic faith of, R 7, 60, 64, 69, 73, 74, 152; character traits and interests, R 7, 8, 16, 57, 122-123, 173-174; Charles I of England, relationship with, R 80, 126, 129; Château de Steen, R 151, 165-166; as court painter to Albert and Isabella, R 55, 100; daily routine in nephew Philip's account, R 98; death, R 171; debate between "Poussinists" and "Rubenists," R 174; diplomatic activities, R 16, 20, 80, 97, 105-106, 121-122, *124,* 125-129, 146-148; domestic life, R 61-62, 74-75, 99, 151, 172; Duke of Mantua's patronage, R 20, 30-32, 37, 39; engraving, interest in, R *61;* family chapel in church of St. Jacques, R 68, 69, 171; Fourment family, friendship with, R 98-99; Giulio Romano's influence on, R 32, 169, 173; health, R 149-150, 169-171; honorary M.A. from Cambridge University, R 124, 127; house in Antwerp, R *25, 26-27,* 61-62, *63, 94-95;* influence on Delacroix, D 40, 47, 51. 180; Italian sojourn and influence of art on, R 9, 29-39, 63, 167; Jan Brueghel and, BR 185; Jesuits as patrons of, R 37, 64, 66, 75; Jordaens, comparison with Rubens, R 92-93; knighting by Charles I of

England, R 129; Leonardo and, L 125, *155;* loss of first wife, R 107, 121; marriage to Hélène Fourment, R 141-142, 143, 176; marriage to Isabella Brant, R 16, *55-56;* methods of work in studio and question of contributions of assistants, R 73, 75-77, 82, 138, 169; Peiresc's friendship and correspondence with, R 16, 101-102, 103, 127, 149, 150-151, 166-167; prestige and fame, R 8, 78, 97-98; as publisher *(Palazzi di Genova),* R *100;* relations with other artists and patrons, R 57-58, 73-74; Rembrandt influenced by, RE 34, 65; self-portraits, R *6, 17, 61, 123, 170, 184;* Snyders' relationship with, R *57,* 88; Spain, diplomatic missions to, R 36-37, 124-126; studio, R *94-95;* tapestries designed by, R *102;* Tintoretto's influence on, R 29-30, 167; Titian's influence on, R 23, 29, 143; Torre de la Parada paintings, R 169-170, 178; travels, map of, R *124;* Turner on, TU 57; Van Dyck, relationship with, R 76-77, 78, 145; variations in reputation and criticism of work since his death, R 174; Velázquez, meeting with, VE 21-22; will, provisions regarding his works, R 135, 165, 172; work for Philip IV, VE 111; Watteau influenced by, WA 38, 41; youth, R 12-13

Rude, François, sculpture by, RO 53

Ruisdael, Jacob van: English landscapists and, GA 16, 38, 173, TU 14; influence on Hobbema, V 117; life of, V 96-97; role in development of landscape painting, V 95, 104; Turner's rediscovery of, V 118; work by, V *118-119*

Ruskin, John: admiration for and friendship with Turner, TU 170-171; cartoons of, W *128, 129;* comments on Turner, TU 9-10, 17, 173, 178, 185; contempt for Bernini, B 9-10; on difference between Italian and Flemish art, BR 19, 116, 170-171; disparaging view of Leonardo, L 165; on Giotto, G 10, 81, 183; *Modern Painters* by, TU 171; photograph of W *66;* Pre-Raphaelite support by, W 64, 67; Whistler's quarrel with, and trial, W 111, 121-123, 125-130, 132, 134, 136, 138

Russian art: absence of Western European artistic

AP American Painting; B Bernini; BR Bruegel; C Cézanne; CO Copley; D Delacroix; DU Dürer; MD Marcel Duchamp; P Picasso; R Rubens; RE Rembrandt; RO Rodin; T Titian; TU Turner;

186

tradition in, MAT 96; art collecting in Moscow, MAT 94-95; color sense of Russian people, MAT 55; folk art in, MAT 55, 95; Matisse's works and, MAT 86-89, 102-104; Picasso and, P 149, 150-151

Ryder, Albert Pinkham: life of, WH 136-139; as one of leading 19th Century American painters, WH 135; vision of, WH 163-164; works by, WH *152-155*

Saenredam, Pieter, church interiors by, V *68-69*

Salon, establishment in 1667. *See* Exhibitions

Salon des Refusés exhibit of 1863. *See* Exhibitions

Sandby, Paul: satire on Hogarth, GA *13*; topographical drawings as precursors of English landscape painting, TU 36

Sansovino, Andrea, inspiration for Rodin, RO *89*

Sansovino, Jacopo: architect and intimate of Titian, T 105-106, 108; work of, T 154, 169

Savonarola, Girolamo: hanging and burning of, M 90; life, M 67-70, 88-90; portrait, M *68*, 88

Schongauer, Martin: death of, DU 50; Dürer's admiration for, DU 48, 49; work by, DU *58-59*

Science and technology: camera obscura (box-type viewing camera of 17th Century), V *138, 139*; camera obscura, Vermeer's possible use of, V 127, 137, 141, 142; Copernican system, B 35-36, 38; developments in and influence on art in late 19th Century, MAT 40; Leonardo's drawings, L *13, 59, 104, 110-117, 168*; Leonardo's studies in, L 53-55, 101-109, 110, 150. *See also* Inventions; Photography; Revolution, Industrial

Sculpture: Alberti's treatise on, L 15; by Bernini, B *21-29, 97-105, 129-135, 149-155, 170-183; contrapposto* in, B *131*, G 60, RO 51; by Degas, MA *162-167*; by Donatello, B *18*, RO *30*; equestrian statues, B *126, 180*, L 75-76; Frédéric Auguste Bartholdi's *Statue of Liberty*, C *34*; Greek sculptures, RO *21-25*; Houdon's busts of Voltaire, C *144*, WA *61*; Leonardo's views on, L 126, 147; Matisse's clay modeling, B

115, MAT *183;* Matisse's phases in, MAT *128;* by Michelangelo, B 18, M *30-33, 75-83, 84, 139, 142-147, 150, 163-167, 192-193, 195-197*, RO *31*; Picasso's work in, P 85, 104-105, 142, 150; by Rodin, RO *64, 77-84, 97-112, 125-140, 162-164;* Verrocchio as master of, L 36, *39*. *See also* Bernini; Michelangelo; Rodin

Seascape: and De Vlieger, V 77, 78; in Dutch art, V *111;* in Manet's work, MA 60, *73;* Ruisdael and, V 96; Van de Velde the Elder, V *44-45;* Van de Velde the Younger, V *111*

Seghers, Hercules: character of, V 77; influence on Rembrandt, RE 24, 102; Ruisdael and, V 96; work by, RE *28*

Seurat, Georges Pierre: color wheel of, VG 73; concepts of light and color, VG 74; influence on Matisse, MAT 49, 50, 57; influence on Van Gogh, VG 74-75; objection to Impressionism, VG 72; pioneer of new art, MAT 10-11; Pointillism devised by, MAT 37, 39, 40, VG 73-74; as Post-Impressionist, C 75; works by, MAT *42-43, 44*, VG *43, 44*

Shahn, Ben, and Social Realism, AP *102-103, 112-113*

Schamberg, Morton, and American Modernists, AP *51*

Shaw, George Bernard: bust of, RO *82;* friendship with Rodin, RO 145-147

Sheeler, Charles, and American Modernists, AP *51*

Shinn, Everett, and Ash Can School, AP *22, 23*

Siena, Italy: Bernini's work in, B 102, *150-151;* Black Death in, G 184; early artists in, G 58; Florence and, G 60-61; political, economic and social conditions in, G 57, 61, 160-161, 164

Signac, Paul: on color, MAT 50; Matisse and, MAT 38, 39, 46; Pointillism and, MAT 40; Seurat and, MAT 37, 42; works by, MAT *41, 45*

Signorelli, Luca: life of, M 37-38; work by, M *57*

Simone Martini: Avignon, work in, G 163; life of, G 161-162; Naples, work in, G 157, 158; work by, G *157*, 161-162, 165, *166-169*

Sisley, Alfred, and Batignolles group, C 39; Impressionism, fidelity to, MA 116; landscapes, C 58, MA 109;

life, MA 83, 103, 130; Renoir's first meeting with, MA 122; works by, MA 116-117, *130-131*

Sloan, John, and Ash Can School, AP *12, 28, 29, 34*

Smibert, John: in Boston, CO *15*, 40-41; life, CO 15-17, 20, 24; works by, CO *24, 26-27*

Snyders, Frans: collaboration with Rubens, R 60, *72;* relations with Rubens, R 57, 78, 84; work by, R *88-89*

Soyer, Raphael, and Social Realism, AP 101

Spain: Armada, VE 24, 25; Baltasar Carlos, male heir to Crown, VE 57-58; bankruptcy of government and Crown, VE 141, 167-168; card games in, VE 108; Carlos II, last Habsburg king of Spain, VE 185; Catholic Church, influence and position of, VE 9, 34, 92; colonial possessions, VE 24, 34; conditions at accession of Philip IV, VE 8-9; control in The Netherlands, R 8, 10-11; cultural and social life in Philip II's reign, VE *85-86;* currency, VE 20, 21; decline of power of, VE 24, 30-31, 34, 169, 185; downfall of, GO 145-150; Dutch Rebellion against, V 29-32; economic, political and social problems, VE 21, 105, 106-107, 115, 119, 135, 170-171; Europe and, B 33, VE 10-11, *26*, 144; Felipe Próspero, male heir to Crown, VE *164*, 171; Flanders, war with, VE 28-29, 65-66, 106, 118, 172; French invasion and war with, VE 114-115, 116, 118, 119, 136; kings of Spain, *table*, VE 9; *maps*, GO 12, VE 10; nobility and, VE 9, 33, 34; Olivares' policies, VE 19, 61-62, 106-107, 114-116; peace with France, VE 172-173; Philip IV's reforms, VE 140; Picasso's support of Loyalists in Civil War, P 111, 125, 126, 132; Portugal's independence from, VE 115, 172; rivalry in Italy between France and, VE 22; royalty in Goya's time, GO 29-31; Rubens' role in negotiations with England and, R 121, 122, 124-129; in 17th and 18th centuries, GO 7-13; social customs in Seville, VE *35;* taxation, VE 59, 62, 117; Thirty Years' War and, VE 9, 59, 61-62, 105-106; Union of Arms, VE 11, 19-20, 62, 115; at war in The Netherlands, V 41-45; wars

with France, GO 49-53, 85-86, 99-100, 105-106, 128-129, *130-135, 138-143*. *See also* Civil War, Spanish

Spanish art: *bodegón* paintings, VE 39-43, 44, *45, 46-47;* Caravaggio's influence on, VE 90; Catholic Church and, VE 35, 85-86; El Greco, VE 86-90; influence of Flemish art and Romanism on, VE 37; influence on Manet, MA 22, 23, 28, 32-33, 60; influence on Picasso, P 38, 67, 68; nude figures in, VE 150; as a reflection of the Spanish character, GO 7-8; religious subjects favored in, VE 92; style of 16th and 17th Century court painters, VE 124

Spanish Netherlands: acceptance of rule of King of Spain, R 11-12, VE 10; Archduchess Isabella's appointment as governess of, R 99; coalition of European states against, R 105; Ferdinand's appointment as governor of, R 148; gradual revival of Antwerp, R 12; political situation in, R 15, 166; Richelieu and, R 146; Rubens' role in negotiations between Dutch Republic and, R 83, 106, 128-129, 146-148; struggle between Dutch Republic and, R 54, 81, 83, 121-122, 167, 168; war with Spain, in VE 28-29, 65-66, *80-83*, 106, 118, 172

Steen, Jan: life of, V 98; Metsu and, V 99; work by, V *86-87*

Steenwijck, Harmen van, *vanitas* by, V *80, 81*

Stein, Gertrude: admiration for Picasso, MAT 73, P 153; as art collector, MAT 82; descriptions of Matisse by, MAT 72-73; home, as center of bohemian art world, MAT 70; Matisse and, MAT 69-72, 76, 93; photographs of, MAT *71*, P *38;* Picasso and, P 37-39, 53, 55; Picasso's portrait of, P 38-39, *66*

Stella, Frank, and Op art, AP *184*

Stella, Joseph, and American Modernists, AP *47*

Still, Clyfford, and Abstract Expressionism, AP *152*

Still life: Jan Brueghel's work, R *90-91;* Chardin and, WA 146-156; comparison between Cézanne's and Matisse's, MAT 77; evolution of Cubism and, P 88-89, 97; in Flemish and Dutch predecessors of Chardin, WA 148; in the Golden Age of Dutch art, V 12; in

G Giotto; GA Gainsborough; GO Goya; L Leonardo; M Michelangelo; MA Manet; MAT Matisse; V Vermeer; VE Velázquez; VG Van Gogh; W Whistler; WA Watteau; WH Winslow Homer

hierarchical order of genres of painting, RE 25, WA 147; Manet's work in, MA 60-61, *170-171*, 174; popularity, in Dutch art, V 80, *81*, *82-83*, 100-102; Snyders' work, R *88-89; vanitas* in Dutch art, V *80-81*, 101

Stuart, Gilbert: in Europe, CO 161, 163-164, 168; life of, CO 163-165, 174; Washington's portraits by, CO 163, *164*, 165; works by, *160, 174-177*

Stubbs, George: life of, GA 148, 160; works by, D 61, GA *161, 162-163*

Surrealism: Abstract Expressionism in reaction to, MD 175; in America, MD 128, 153-154, 155, 157; automatism and, MD 123; Bosch and, MD 112; Breton and, MD 95, 97, 98, 107, 108, 153, 154, 156-157, 165; characteristics of, MD 95-108, *109-121*, 149-151, 153-158, *159-163*, P 82-83; Communism and, MD 107, 127; Dada and, MD 65, 66; Dali and, MD 124, 125, 126, 127; De Chirico and, MD 98-101, 114; *Decalcomania* technique, MD *150;* Duchamp and, MD 7, 9, 107; Ernst and, MD 101-102, 116; "Exquisite Corpse," MD 102; First Manifesto, MD 98; Freud's influence on, MD 96; *fumage* technique, MD *151;* Giacometti and, RO *181;* inspired by Cézanne, C 171; Masson and, MD 103-104; Matta and, MD 155; Miró and, MD 103, 123, 131, 132; object sculptures, MD 151; Picasso and, MD 98, 105-106, 133, P 7, 83, 107, 125; Pop Art and, MD 166; Second Manifesto, MD 107; sources and derivations, MD 96-97; Surrealists on outing near Paris, MD *163-164; VVV* periodical, MD 157; word coined by Apollinaire, P 78

Talleyrand, Charles Maurice de, and Delacroix, D 17-18; portrait of, D *18*

Tanguy, Yves, Surrealism and, MD *118, 119*

Terborch, Gerard: life of, V 13, 99; works by, V *84-85, 98*

Terbrugghen, Hendrick: life of, V 75, 95; works by, RE *32, 39,* V *67*

Theater and ballet: Ballet Russes, P 75-78, 115-117, RO 168; ballet scenes and figures by Degas, MA 87, 89, 137, 138, *158-163,* RO *68;* and Baroque era, B 139, 140; Bernini's comedies, B 138-139; Boucher's work in, WA 131; Cézanne's interest in figures from, C *108, 109,* 118-119; Drury Lane Theatre, London, GA 138, 141; as entertainment in 18th Century Paris, WA 57-58; Gainsborough's relations with theatrical people, GA 65, 80, 141, *142,* 144, 165; Gillot and, WA 36, 37, 44-45, 69; "Happenings," MD 158, *163,* 169; Harlequin, C *108, 109,* WA 36, *56,* P *48-49, 100-101,* 115; Hogarth's inspiration from, GA 11, 13; Isadora Duncan as Rodin's model, RO *158-159;* Lancret and, WA 75; Louis XIV's expulsion of *commedia dell'arte* players, WA 50-51; Marquise de Pompadour and, WA 118; in 19th Century France, D 58, 82-84; Picasso's interest in, P 115, *116-117;* Rodin's interest in ballet, RO 69, *158-163;* in Spain, VE 60, 85, 140; Watteau and, WA 45, 69, 80, 104

Three dimensionality: apparatus for transforming three dimensional objects into two-dimensional, DU *160;* in Bernini's portraits, B 128; Degas' preoccupation with, MA 139, 165; in Dürer's work, DU 91; in German art, DU 42

Tiepolo, Giovanni Battista, life in Madrid, GO 32-34; work by, GO *41*

Tintoretto, Il (Jacopo Robusti): brushwork technique in oil painting, T 172-173; Dürer and, DU 162; influence on Rubens, R 29-30, 58, 125, 167; life and work, T 171-172; Velázquez' purchase of work of, VE 145; works by, L 96, T *162-165*

Titian (TizianoVecellio): Alfonso d'Este, work for, T 83-84, *90-93,* 108; analysis and criticism of art, T 57, 61, 78, 80-81, 85, 118, 153, 154, 160, 175; apprenticeship in Venice, T 30, 33; Aretino, friendship and correspondence with, T 103, 105, 106, 107, 152, 154, 157; Augsburg, sojourn in, T 155, 156-158; battle scene for Great Council Hall, questions regarding, T 62, 63, 77, 84, 129; Bellini, relations with, T 30, 32, 33, 62, 63, 84; birth, T 7-8; brushwork technique in oil painting, T 71, 172, 173; changes in work of last decade, T 160, 173-174; color as essence of painting, T 85, 154, 173-174; comparison between Rubens and, R *123;* death, and burial in Frari church, T 78, 175; della Rovere, collection of paintings by, T 127; development of style of, and comparison with Giorgione, T 57, 61, 64, 70-71, 72, 74; early commissions, T 32-33; efforts to obtain benefice for son Pomponio from the Farnese, T 151, 154, 155; El Greco's training in workshop of, VE 86; Emperor Charles V, patronage of, T 110, 111, 154-155, 156-157; fame and success, T 112, 117, 121, 155, 159; family relationships and love for his children, T 8, 108, 150; Federigo Gonzaga, relations with and work for, T 94, 109-110; financial questions and attitude toward money, T 108, 128, 129, 158; Giorgione, influence, and association with, T 35, 54-55, 56-57, 64; influence on Rubens, R *23, 35, 37, 143, 154-155,* 165; Ippolito de' Medici, relations with, T 124; Padua, stay and work in, T 58-59; personality and character traits, T 7, 108, 129, 159; Philip II's commissions, T 158; *poesie* by, T 80-81, 85; portrait painting, mastery in, T 61, 112, 117, 118, 121-122; Pordenone's relations with, T 80; Priscianese's description of celebration in house of, T 110; Rome, visit and work in, T 151-154; Velázquez and, VE 142; Venetian government, relations with, T 62, 63, 77; Veronese's friendship for, T 169; wife, T 108-110

Tobey, Mark: abstract painting and, AP *130-131;* reality in, V 24

Tomlin, Bradley Walker, and American abstract painting, AP *128-129*

Tooker, George, and Social Realism, AP *114, 115*

Torrigiano, Pietro: episode with Michelangelo, M 41, *42;* Goya and work by, GO 105

Toulouse-Lautrec, Henri Marie Raymond de: ancestry of, VG 52, 162; appreciation of Van Gogh as artist, VG 52; book illustrations by, VG, *56;* a caricaturist, VG 55; circus drawings from memory, VG 60; contemporary evaluation, VG 57; death, VG 57, 58; defense of Van Gogh, VG 162; favorite subjects, VG 55, 56-57, 58, 62, 64; fondness for the Moulin Rouge, VG 54-55, 64-65; friendship with Van Gogh, VG 51, 162, 163; interest in lithography, VG *56,* 58, 60, 62; lithographed party invitation from, VG 6, *59;* love of horses, VG 60; night life in Montmartre, VG 54-55, 58; not "immoral," VG 57; photograph of, VG 51; physical collapse, VG 57; physical handicaps, VG, 52, 58, 162; portrait of Van Gogh by, VG *48,* 52; posters by, VG *56,* 58, 62; relations with Suzanne Valadon, VG 53, 57; self-portrait, VG 54; self-taught artist, VG 53; studio in Montmartre, VG 53; use of alcohol, VG 54, 56, 57, 58, 60; works by, P *21,* VG *43, 48, 55, 59-67*

Trade: between Holland and America in 17th Century, RE 90-91; route around Cape of Good Hope, T 29; routes of, in 12th and 13th Century Italy, G *56, 57;* Venetian decline in, T 169-170; Venice as great international center of, T 10, 26-27, 28, 29

Trumbull, John: life of, CO 161-162; remarks on Copley, CO 68; works by, CO *180-183*

Turner, Joseph Mallord William: and American landscapists, WH 54, 97; analysis and criticism of art, TU 8, 44, 58-59, 62, 81, 110, 116, 152, 166, 169-170, 175, 176, 185; art training, TU 17-18, 37, 64; attitude toward his own art, TU 80; Bequest, TU 8, 173, 174, 175; birth and early life in London, TU 16-17; Booth, Sophia, liaison with, TU 10, 154, 174; cartoon deriding, TU *59;* comparison between Constable and, TU 16, 43, 59, 82, 111; daughters by Sarah Danby, TU 59, 80, 151; death, TU 173; demand for drawings for reproduction, TU 8, 39, 60, 116-117, 146; Egremont, relations with, TU 105, 146, 147; election to Royal Academy as Associate and Academician, TU 43, 55-56, 64; exhibitions at Royal Academy, TU 18, 40-44, 55, 58, 60, 62, 110, 117, 142,

AP American Painting; B Bernini; BR Bruegel; C Cézanne; CO Copley; D Delacroix; DU Dürer; MD Marcel Duchamp; P Picasso; R Rubens; RE Rembrandt; RO Rodin; T Titian; TU Turner;

165, 169, 172; *Fallacies of Hope,* poetry by, TU 82; family relationships and problems, TU 9, 42, 59, 62, 117; galleries opened in London by, TU 60, 110, 174; Girtin, friendship with, TU 38; *Hannibal,* poetry composed to accompany, TU 81-82; and Homer, WH 119-120; influence on Monet and Pissarro, MA *91;* innovations in painting techniques, TU 81, 145-146; Italy, visits to, TU 109-110, 117, 144, 157, 176; *Liber Studiorum* of, TU 62; Monro, relations with, TU 37-38; old masters' influence on, TU 71; output, TU 8; Paris, trip to, TU 57; in Parrott's picture, TU *17;* personality and character traits, TU 8-10, 40, 82, 150, 171, 185; at Petworth, TU 88-108, 147; physical appearance, TU *6, 9, 32;* physical and artistic decline, TU 116, 166, 172-173; prices paid for drawings and paintings by, TU 39-40, 55, 59; reputation of, TU 10; Royal Academy activities, TU 59, 62, 82, 110-111, 150, 173; Ruisdael rediscovered by, V 118; Ruskin and, TU 9-10, 17, 170-171, 173, 175, 185; Sarah Danby, liaison with, TU 10, 42, 59, 151; sketchbooks in British Museum, TU 39; sketching tours, TU 39, 86, 146; success and financial prosperity, TU 8-9, 38-39, 55-56, 149-150; Thornbury's biography of, TU 10, 175; Varley's portrait of, TU *6;* Venice paintings, TU 144-146; women in life of, TU 10, 42, 59, 151, 174

Tuscany: artistic and cultural life in medieval times, G 55-56, 58, 66, 177; economic and political conditions, G 56-57, 83-84, 178-179, 184; map of, G *57*

Uccello, Paolo, work by, M *54-55*

United Provinces. *See* Netherlands, The (Dutch Republic)

Utrecht, School of, V 74-75; Italian influence on, V 62, 67; Vermeer in style of, V 125

Van de Velde, Esajas, work by, V *112, 113*

Van de Velde, Willem, the Elder, seascape by, V *44-45*

Van de Velde, Willem, the Younger, seascape by, V 104, *111*

Van der Veen, Adriaen, work by, VE *28-29*

Van der Weyden, Rogier: influence on German religious pictures, DU 47; life of, BR 16, 17; work by, BR *34-35*

Van Dyck, Anthony: and Charles I, GA 80-81, R 76, 84-*85;* etchings by, R *56, 57;* excellence in portrait painting, R 76, 84, 87, 123; rise in popularity of, RE *66,* 111; role in Antwerp, R 172-173; Rubens and, R 76-77, 78, 145; works by, GA *82, 113,* R *56, 57,* 76, 77, *86,* 87

Van Eyck, Jan: Bruegel's influence on, BR 43; influence of International Style on, BR 24; influence on Pleydenwurff, DU 47; new technique in oil painting, DU 40; works by, BR 22, *29, 31-33, 38,* 161-162

Van Gogh, Vincent Willem: admiration for Hals, V 73; admiration for Vermeer, V 160; admirer of Impressionists, MA 108; adverse reaction to success, VG 162; affinity for Japan, VG 69, 79, 89; anxiety in last paintings, VG 165, 176-177; appreciation of Seurat, VG 74-75; arrival in Paris (1886), VG 39, 40, 49, 58; art a means of communication, VG 16; artistic aims, MAT 79; association with other artists, VG 50-51, 75, 79, 163; attitude toward abstractions, VG 97; to Auvers-sur-Oise, VG 163, 168, 171; beginnings of religious brooding, VG 11; belief in social function of art, VG 38-39, 78, 93; as bookstore clerk, VG 12-13; at the Borinage, VG 13-15, 16; in Brussels (1880-1881), VG 29; buried beside Theo, VG 167; changes in art at Saint-Rémy, VG 142, 168, 171; changes in subjects, VG 46, 78; on Chardin's art, WA 154; childhood and youth, VG 7-11; chronic undernourishment, VG 29, 50; color explosion at Arles, VG 90, 93, 100, *101-115;* contemporary description of technique, VG 92; correspondence with Theo, VG 10-12, 14-15, 18-22, 29-36, 69-71, 79, 89, 90-98, 100, 110, 113, 138-139, 145, 147, 161, 163, 165, 167-168, 174, 176; critical evaluation of his color, VG 161; cutting off of

ear, VG 7, 99, 137, 141, 168; decision to become an artist, VG 15, 29; description of, by Gauguin, VG 75-76; description of death as "reaper," VG 146, 148; destruction of paintings, VG 71; device for perspective, VG 34, *35;* difficulties with the mistral, VG 91, 139; early beginnings in art, VG 9, 12, 15; early drawing, VG *10;* exhibitions of work, VG 70-71; explanation of *The Night Café,* VG 93; family background, VG 8-9; a father of modern art, VG 7; fear of Theo's reduced circumstances, VG 164-165; first article written about, VG 161, 162; first love affair, VG 10-11, 12; first meeting with Gauguin, VG 76, 77; with Goupil in Paris, VG 11; his house in Arles, VG 93, *94-95,* 117, 138, 139; hopes for an artists' commune, VG 94-96, 167; hospitalized at Arles, VG 99, 118, 137-138, 148; idealism of, VG 138, 145; impressionism and, VG 46, 51; incipient mental breakdown, VG 113, 117; increased exposure to color, VG 39; influence of Pointillism on, VG 29, 35; interest in reading, VG 9-10, 119; Japanese pictures and prints, VG *45,* 69, 70, 80; and La Segatori, VG 45, 70-71; later use of complementary colors, VG 75, 122; layout of his palette, VG *35;* lessons with Cormon, VG 50; life in Auvers, VG 110-111, 163-164; in London, VG 10-11; loss of his paintings at Le Tambourin, VG 70-71; Matisse and, MAT 17; mental collapse, VG 90, 99, 137-148, *160,* 168, 171; a metamorphosis in colors VG 40, 46; move to The Hague, VG 32; new museum for his works, VG 162; new techniques, VG 45; and origins of 20th Century art, MAT 9, 54, 60; outings with Signac, VG 75; paintings at night, VG 113, 171; paintings and drawings of weavers (1884), VG *38;* passion for peasant subjects, VG 16, 22-23, 24, 30-31, 37, 38, 46; on pathos and intimacy in Rubens' work, R 175; and Père Tanguy, VG 40, 42, 51, 69, 163; personality evaluation by Theo, VG 79; philosophical ramblings, VG

165-166; Picasso, influence on, P *24;* portrait of, by Toulouse-Lautrec, VG *48;* or Post-Impressionists, C 75; power of his later sketches, VG 148; recollections of him by contemporaries, VG 75-76, 139, 164; references to suicide, VG 146; rejection of the Church, VG 15, 32; relations with Gauguin, VG 75, 76, 78, 83, 94-99, 110-111, 117, 137, 138, 142, 145, 147, 171; relations with Toulouse-Lautrec, VG 58, 163; relationship with Sien, VG 32, 33-34, 36, 37; return to the parental household (1883), VG 36, 37; as schoolteacher in England, VG 12; second love affair, VG 31-32; self-portraits, VG *6, 7,* 69, 75, 138, 168, *169, 178-179, 180;* a self-taught artist, VG 7, 24, 30; Signac's visit to, VG 139; subsidized by Theo, VG 30, 34, 36, 50, 70, 76, 91, 95, 142, 145, 164, 165; suicide, VG 8, 10, 30, 49, 145, 164, 166; tastes in art, VG 10; use of impasto, VG 35-36, 75, 171; visit to Theo's family, VG 162-163, 168; volume of output, VG 7, 71, 90-91, 100, 146, 164, 167, 168

Van Goyen, Jan: life of, V 77-78, 98, 104; as painter of skating scenes, BR 165; work by, V *114-115*

Van Meegeren, Hans, forger of Dutch 17th Century paintings, V 170-185

Vanderlyn, John: as importer of European style to America, WH 10; work by, WH *19*

Vanitas, as type of still-life painting in 17th Century, V *80-81,* 101

Vasari, Giorgio, first modern art historian: on Bellini brothers, T 11, 12, 31, 85; on Charles V and Titian, T 111; on Cimabue, G 85; on Dürer's prints, DU 13, 14, 70; on Giorgione, T 53, 54, 55; on Giotto's art and life, G 97, 103, 134, 135, 137-138, 158; on Giotto's meeting with Cimabue, G 82; on Leonardo, L 11-12, 15, 27, 83, 120, 122, 125, 147, 150, 164-167, 169; life of, M *10;* on Michelangelo's funeral, M 179; on Michelangelo's life and work, M 9-10, 41, 70, 85, 92, 141, 148, 175; on Sansovino, T 105, 108; on Signorelli, M 38; on Tintoretto, T 172; on Titian's art and character, T

G Giotto; GA Gainsborough; GO Goya; L Leonardo; M Michelangelo; MA Manet; MAT Matisse; V Vermeer; VE Velázquez; VG Van Gogh; W Whistler; WA Watteau; WH Winslow Homer

189

80, 118, 152, 153, 173; on Torrigiano, M 42

Velázquez, Diego Rodriguez de Silva: analysis and evolution of art, VE 19, 40, *65, 67, 135,* 148; apprenticeship in Pacheco's studio, VE 9, 36, 38-39; arrival in Madrid and early position at Court, VE 8, 10, 16-17, 20-21, *57;* as Assistant Superintendent of Works, VE 117; attachment to grandchildren shown in Mazo family portrait, VE *171;* birth of, VE 34; *bodegones* paintings by, VE 39-43, 44, *45, 46-47;* Buen Retiro assignment, VE 64-65; Caravaggio's influence on, VE 39, 40; career and early successes, VE 9, 20-21, 22, 23, 33; in Catalonia and Aragon with Philip IV during war with France, VE 119; characterized as painter of Spain's pride and power, GO 7; comparison between Rubens' art and, VE 21-22; depiction of court dwarfs and jesters, VE 125, 131, 132; difficulties in receiving payments owed by Crown, VE 106-107, 136, 141, 165-166; early years and education in Seville, VE 9, 33, 35-36, 43, 44; hidalgo heritage and ambitions for higher status, VE 33-34, 43, 165, 169; humanistic interests, VE 38-39; hunting lodge of Torre de la Parada, work on, VE 110-112; illness and death, VE 175; influence on Goya, GO *46-47,* 68, 72; influence on Picasso, P 22, 23, 152-153, *160-161;* involvement in rivalry regarding construction of Octagonal Room in Alcázar, VE 141; Italian trips, VE 22-23, 68, 72, 144-147; knighting, in Order of Santiago, VE 34, 159, 172; letter to friend still extant in his own handwriting, VE 174-175; marriage to Pacheco's daughter Juana, VE 41; Mazo, collaboration with, VE 64; meeting with Rubens, R 125, VE 21-22; mythological subjects, VE *68,* 71, 72; number of works produced by, VE 105; Olivares' patronage, VE 10, 17, 57, 68; Pacheco's artistic relationship with, VE 43; personality, VE 7, 22, 63-64; Philip IV, patronage, and personal relationship with, VE 18-19, 33, 57, 114, 136, 146-147, 165, 169; realism in

art, VE 39, 41, 44, 48-49, 90; religious paintings, VE 42, 43, 54; role in arrangements for wedding of María Teresa to Louis XIV, VE 173-174; self-portrait in *Las Meninas,* VE *6, 7, 177;* signature, on *Brown and Silver Philip* portrait, VE *58;* studio in Alcázar depicted in *Las Meninas,* VE *178-179;* titles and functions as court painter, VE 64, 68, 105, 110, 117, 144, 165

Venetian art: contrast between Florentine art and, T 153-154; decline and revival in early 18th Century, T 176; Giovanni Bellini's role in development of, T 22; influence on 18th Century French art, WA 31; influence of school on Rubens, R 150, 173; influences on, T 16; music as theme in painting, WA 81; techniques of, T *184-185;* Vivarini's innovations in Venetian painting, T 10-11, T *184-185*

Veneziano, Domenico, work by, M 37, *51*

Venice, Italy: in Carpaccio's paintings, T 33, 34; in Dürer's time, DU 61-64; fashion in Titian's time, T *106, 107;* government, T 26, 36; history of, T 25-29, 57; influence of Venetian art on Dürer, DU 67, 79; as international trade center, T 10, 26-27, 28, 29; life and character of Venetians, T 34-35; maps of, T *26-27, 38-39;* as printing and publishing center, T 59-60; in Rubens' time, R 29; social life and entertainment, T 27-28, 29-30, *46-49,* 58, 170; Venetian glass, T *35;* views of, GA *113,* T *37, 40-44, 50-51, 80-83,* TU *108-109, 156-157, 181,* W *140, 158-161*

Vermeer, Jan: Amsterdam auction of paintings, V 123; authenticity and chronology questions, V 125, 146, 150, 169-170; and Baburen's *Procuress,* V 67, 76; birth, V 9, 58; camera obscura, possible use of, V 127, *138-139,* 141, 142; death, V 63, 122; De Hoogh compared with, V 100, 130-131; enrollment as Master-Painter in Guild of St. Luke, V 59; Fabritius and, V 60, 70, 102-103; financial circumstances, V 59, 63, 121; cultural influences on, V 53, 60-62, 64, 102; "enigmatic" quality, observed by Marcel Proust, V 14, 15; "In the Light of

Vermeer" exhibition in 1960, V 173; as a judge in dispute over authenticity of a collection of paintings, V 63, 121; Kalf's painting in relation to, V 102; lack of interest in paintings by, during 18th and 19th centuries, V 123, 124; light of Delft and, V 58; light in work of, V 26, 126, 127, 128, 130, 132, 145; Maes's link to, V 100; marriage, V 59; Mechelen, home in Delft, V *50-51,* 57, 58, 63, 121-122; Metsu compared with, V 99-100; number of authentic paintings, V 145, 169; painting techniques, V 127, 141; possible self-portrait in *The Procuress,* V 64; photographic perspective, questions regarding, V 137; physical appearance, V 147; poetic meaning in paintings, V 15, 152; realism in work, V 15, 16, 126; religion, V 59; rise in value of works, V 124; signatures, V *59,* 125, *150,* 169; similarities between genre painters and, V 99; Steen and, V 98; themes of paintings, V 14, 157; Thoré-Bürger and revival of interest in, V 124; Van Gogh's admiration for, V 160; Van Meegeren's forgeries, V 170-173, 174, *177, 178-179, 180-181, 183;* works at his death, V 63, 122

Veronese (Paolo Cagliari), T 169-171; art of, T 160, 166, 170; influence on Watteau, WA 40-41; Rubens' admiration for, R 29, 39, 60, 125; Tintoretto and, T 172; works by, T *166-167, 168*

Verrocchio, Andrea del: Leonardo's apprenticeship with, L 11, 12-14, 27-28, 36, 44; life, M 37, 39, 135; portrait of, L 38; works by, B *18, 19,* L 13, 27-29, *37, 39, 40, 41,* 44-45, 74-75, M 24

Villon, Jacques, Marcel Duchamp's brother, MD *10,* 11, *13,* 15, 16, *20,* 36

Visscher, Claes Jansz., works by, V *34-35, 107*

Vivarini, Antonio, innovator in Venetian painting, T 10-11

Vlaminck, Maurice: color experiments, MAT 51; life and art, MAT 34-35, 64-*65;* portrait of, MAT *63;* work by, MAT *65*

Voltaire, François-Marie Arouet de: bust of, WA *61;* French Revolution, premonitions of, WA 170, 171; on French society, WA

57-58, 61, 164, 165; poem by, WA 87; relationship with Mme. Pompadour, WA 115, 118, 123

War of Independence, Dutch, V 29-30, *41, 42-43,* 44-45; Dutch artists' failure to depict, V 39

Warhol, Andy, and Pop art, MD *169, 181,* AP *175*

Washington, George, Houdon's sculptures of, RO 17; Peale's portrait of, CO *165;* Stuart's portraits of, CO 163, *164,* 165

Watercolor painting: adaptation of technique, in Turner's Venetian paintings, TU 145; establishment of watercolorists' society, TU 60; Girtin's art, TU 38; Homer's art, WH *122-133;* Rodin's dancing figures, RO *157-161;* success of English watercolorists, TU 36-37; Turner's treatment of color, TU 40, *177-184*

Watteau, Antoine: admiration for Rubens, R 144, 174; apprenticeship in Gérin's shop, WA 33; apprenticeship at Gillot's, WA 36, 37, 44-45; birth, WA 32, 33; Boucher's allegory honoring (engraving), WA *103;* Boucher's drawing after lost self-portrait of, WA *6;* changes in later works, WA 100-101; character traits, WA 39, 97-99; collaboration with Audran, WA 37-38, 47; comparison between Le Brun's art and, WA 98; death, WA 100, 103; and decline of Rococo, C 35; development of personal style, WA 39; difficulties in dating paintings, WA 32; drawing, preference for, WA 86, 88, 98; early career, WA 35, 39, 42, 44-45; engravings of works, WA 50, 118; fashion plates by, WA 78, *85; fêtes galantes,* WA 41, 53-56, *62-77,* 86-87, 99, 126, 178; financial speculations, WA 101; Flemish influences on, WA 35, 42; genre painting and, WA 35, 36; illness, WA 87, 97, 101; influence on Boucher, WA 118-119; influence on Gainsborough, GA 52; influence on new era, WA 126; Lancret, Pater and, WA 75-77, 79, 80, 81; Louis XIV and, WA 16; military scenes painted in Valenciennes, WA 38-39,

48-49; painting techniques, WA 50, 86, 98; Paris, arrival in, WA 33; Pater, relationship with, WA 76, 80, 81, 103; physical appearance, WA 99-100; reality and illusion in work, WA 53-54, 67, 69, 100; reputation in later centuries, WA 79; Royal Academy and, WA 38, 40, 48, 62, 98, 106; Rubens' influence on, WA 38; in Tardieu's engraving *Assis auprès de toy*, WA 50; theater, interest in, WA 45, 69, 80, 104; Valenciennes, return to, WA 38, 48; voyage to England, WA 101; women, WA 67, 99

Weber, Max, and American Modernists, AP *53*

Wesselmann, Tom, and Op art, AP *181*

West, Benjamin: Constable and, TU 55; decline and old age, CO 143; and dissension in London art world, GA 98, 99, 105; "Dread Manner," CO 119; early friendly relations with Copley, CO 7-8, 11-12, 61-62, 133; George III's friendship and patronage, CO 117-118, 120, 142-143; historical themes, preference for, CO 10, 116-117, 119, 120, 122; London, social and financial success in, CO 59, 61, 120; Morse's studies in London with, CO 167, 179; Peale's work in London studio of, CO 165; Philadelphia, studies and work as portrait painter in, CO 114-115; Pratt's depiction of London studio, CO *162*; projected paintings on religion for chapel of Windsor Castle, CO 118, 119, *124*; rivalry between Copley and, CO 10, 119, 137, 139, 142, 143; Rome, visit to, CO 115-116; Royal Academy, founder and president of, CO 117, 118, 142, 143; Stuart's apprenticeship in London studio of, CO 163; at time of Turner's artistic debut, TU 19, 43; Trumbull's training with, CO 162; use of contemporary dress in historical paintings, controversy regarding, CO

118, 119, 126; wife and children's portrait, CO *116;* and Copley, CO 62; works by, CO *112, 119, 120-131,* GA *103*

Whistler, James Abbott McNeill: and abstract art, W 12, 42, 85, 175; "Address" to Queen Victoria, W 169; analysis of influences on, W 42, 86, 88, 92, 94, 97; apprenticeship in Paris, W 11, 22-25; art theories, W 8 12, 43, 84-85, 125-127, 149; art collection by, W 78-79, 88, 148; on art as truth or illusion, BR 169; assessment of work, W 174-175; birth, W 11, 12, 14; Boxall's portrait of, W 18; butterfly insignia, W 80-81, 141; and Carlyle, W 101-102; in cartoons on trial, W *128, 129;* changes in art of, W 11, 12, 82, 86; in Chelsea, W 61, 66-67, 77-79, 146, 180; with the Coast Survey, W 21-22; and Courbet, W 25, 26, 42, 81-82; death, W 175; death of mother, W 145; drawing for sheet music, W *19;* and du Maurier, W *24, 39, 44;* education, W 16-17, 19, 23; Esthetic Movement and, W 147; etching technique, W 12, 24, 143, 150; explanation of his work at Ruskin trial, W 125-130, 134; expatriate American, WH 93-94; and Fantin-Latour, W 25, 26, 38, 43, 47, 67, 82; financial situation and bankruptcy, W 123, 130-131, 172; and Freer, W 176, 182-183; and Fumette, W 23-24; *Gentle Art of Making Enemies* published by, W 170; health, W 18, 175; "ideal style" period, W 85; illegitimate children, W 41, 145; incidents of violence, W 83-84; and Jo Heffernan, W 41-43, 79, 81, 83, 103; and Leyland, Mrs., W 103-104; libel suit against Ruskin, W 111, 121, 122-123, 125-130, 134, 136, 138; lithography, W 123-124; marriage, W 166, 169-170, 173-174; and Maud Franklin, W 103, 142, 145, 170; miniature with brother, W *14;* and mother, W 15-16,

77-78; Nocturnes, meaning of, W 109-111, 125-127; Oriental art and, W 79-80, 86, 88, 110; painting techniques, W 43, 82, 102-103, 110, 141, 147; pastels of Venice, W 141, 144; Peacock Room episode, W 106-107, 118; personality and behavior, W 7, 8, 11-12, 16, 20, 39-40, 41, 84, 102, 107-109, 131, 141, 142, 175; photograph of, W *142;* physical appearance, W *6-10,* 108-109; popularity of portrait of mother, W 12, 114; portrait painting, W 101-104, 146-147; portraits and caricatures of, W *6-10;* Pound's poem to, W 185; prestige and success, W 168-169, 172, 174; Royal Academy exhibition of works, W 25, 39, 42, 44, 79, 87; and Ruskin trial, W 111, 121-130, 134, 136, 138; St. Petersburg, life in, W 14-18; self-portraits by, W *95, 120, 184;* small oils painted late in life, W 171; Society of British Artists, presidency of, W 169; South America, W 82-83; table palette of, W *40;* "Ten O'Clock" lecture, W 167-168; and Thames River, W 37-38, *152, 155, 156-157;* theater interests, W 124; titles given to his works, W 12, 47, 85; trips to France with Jo Heffernan, W 42-43, 81-82; voyage to Italy and sojourn in Venice, W 131, 141-144; West Point, W 20-21; White House, W *122;* and Wilde, W 148, 149

Wilde, Oscar: life and friendship with Whistler and estrangement, W 148-149; on Rodin as "greatest poet," RO 143

Wilkie, David: death, TU 169, 171; portraits by, TU 113, 171

Wilson, Richard, as early English landscapist, TU 15, 19

Winckelmann, Johann: artistic theories of, CO 115-116; influence of West, CO 116; Meng's portrait of, CO 115; on "perfect beauty," MA 17; revival of classical interest by, CO 33, 34

Witchcraft: in Goya's Spain, GO *84,* 107, 169, *180-182;* in 16th Century, BR 48-50

Wolgemut, Michael: Dürer's apprenticeship with, DU 8; Dürer's portrait of, DU *48;* influence on Dürer, DU 66; life, DU 47-48; work by, DU *55*

Wood, Grant, and American regional painting, AP *80-81*

World War I: effect on development in art, MD 36, 55; effects on Rodin, RO 170; political situation before start of, MAT 53

World War II: effect on American art, AP 117, 125-135; Picasso and, P 128-131, 142; political situation before start of, MAT 148

Wright, Joseph (Wright of Derby), TU 19, *28;* failure as painter of high fashion, GA 107; as painter of the Industrial Revolution, GA 146

Wyeth, Andrew: and American regional painting, AP *60, 88-89;* reality in work, V *19*

Zola, Émile: auction of art collection, C 165-166; boyhood friendship with Cézanne, C 13-14, 15, 22; career and success, C 50, 57, 74-75, 120; Cézanne and, C 18-19, 39-40, 50-51, 74-75, 120-122; Dreyfus Affair, role in, C 122, 124, 125; exile in England, C 165; favorable criticism of Manet, MA 7, 56, 62; on French Academy, RO 17; on Impressionists, C 122; last years and death, C 165; Manet's portrait of, MA *69;* Manet's relationship with, MA 68, 141; *Nana,* Cézanne's letter to Zola about, C 121; *Nana,* influence on Manet, MA 145; naturalistic novels, MA 138; photographs of, C *22, 50-51;* realism in writing, RO 8; and Rodin, RO 119, 120, 121; on Whistler's Salon des Refusés exhibit, W 46

Zurbarán, Francisco de: attitude toward Velázquez, VE 172; life of, VE 90-92; work by, VE *98-99*

G Giotto; GA Gainsborough; GO Goya; L Leonardo; M Michelangelo; MA Manet; MAT Matisse; V Vermeer; VE Velázquez; VG Van Gogh; W Whistler; WA Watteau; WH Winslow Homer

The typeface employed in this book is called Janson, after Anton Janson, the Dutch typefounder who popularized it in Leipzig in the late 17th Century. The face was first cut, however, by Nicholas Kis, a Hungarian working in Amsterdam in the 1680s.

x

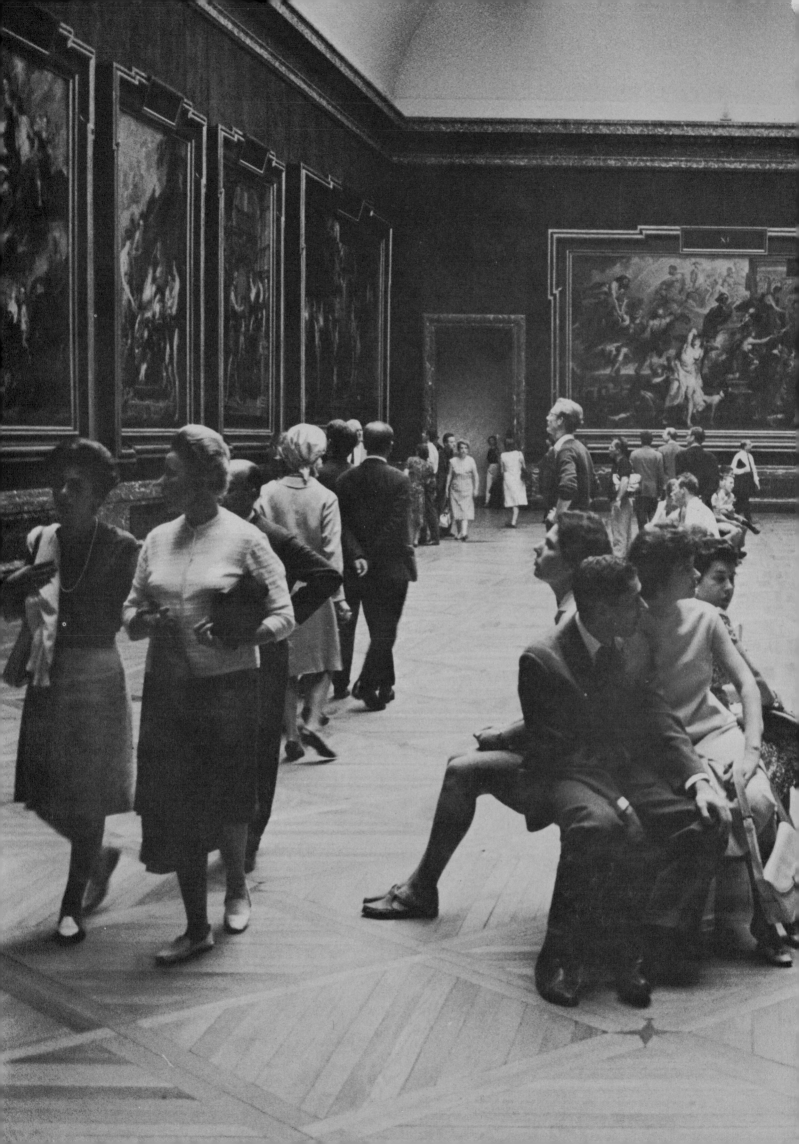